UKIYO-E

Roni Neuer
Herbert Libertson

Susugu Yoshida

UKIYO-E
250 YEARS OF JAPANESE ART

GALLERY BOOKS

UKIYO-E
250 YEARS OF JAPANESE ART

Text
Roni Neuer
Herbert Libertson

Collaborator
Stephanie Kiceluk

Introductory and biographical passages
Susugu Yoshida

This edition published by Gallery Books,
a division of W. H. Smith, Inc., 112 Madison
Avenue, New York, New York 10016

Originally published in Italian in 1979 by Arnoldo
Mondadori Editore, S.p.A., Milano under the title
Ukiyo-e 250 Anni di Grafica Giapponese.

ISBN 0 8317 9041 5

Printed and bound in Italy by Officine Grafiche di
Arnoldo Mondadori Editore S.p.A., Verona.

Contents

Foreword

A major form of Japanese artistic expression, *ukiyo-e*, or pictures of the floating world (picture: *e*; of the floating world: *ukiyo*) chronicle everyday life in Japan between the seventeenth and nineteenth centuries.

Art had previously been the exclusive domain of the upper classes; now mass-produced by means of wood-block printing, *ukiyo-e* were able to reach the people, recording their pleasures and amusements in all their various aspects. The prints served as book illustrations, theatre signposts and playbills, bringing to life colourful scenes from the *Kabuki* theatre with pictures of famous actors and wrestlers. Portraits of celebrated courtesans were particularly popular, and they elevated feminine beauty on to an ideal plane.

This book traces the development of *ukiyo-e*, placing the genre within the historical, social, political, and economic conditions which favoured its evolution. Both East and West unite to celebrate the artistic achievement of *ukiyo-e* in the contributors of this work: Susugo Yoshida is a well-known Japanese art historian, while Roni Neuer and Herbert Libertson manage the Ronin Gallery in New York, the largest gallery in the United States for *ukiyo-e* prints.

The impressive array of prints reproduced here acts as an invaluable historical and artistic document, bringing to life the customs of the day, and revealing the technical and artistic mastery behind the creation of *ukiyo-e*. The pictures are backed up by an ample introduction, biographical notes on each artist, and a chapter on the technique of wood-block printing.

Thus the floating world of the *ukiyo-e* artists comes alive for us, its delicate romanticism tinged throughout with varying degrees of sensuality, treasuring and glorifying the ephemeral delights of life.

Images of the floating world

It was an extraordinary breed of men who deserted the easy comfort and elegance of civilized Europe to journey into the remote and perilous waters of the Orient. The men who conceived and commanded these expeditions were daring, innovative entrepreneurs, often coming from the highest ranks of society. They stopped at nothing to secure new ports and markets for the growing number of commodities the Western world was beginning to manufacture. It was very unlikely that many of them would survive the long and arduous voyage across the Pacific, and chances of their ever returning home to see their families and friends were even smaller. The seas were treacherous and often uncharted, food and water supplies frequently ran out, and the inhabitants of strange lands could prove to be deceitful and menacing. Yet, stronger than the fear of any ordeal they would have to suffer was the lure of exotic Oriental empires and the unimaginable riches they harboured. As early as the thirteenth century, Marco Polo had written of the fabulous stores of gold and pearls to be found in the East. The prospect of such wealth was a tantalizing charm that enthralled the minds of all adventurers. Fascinating and irresistible, it drew them like a magnet halfway across the globe.

In 1542, half a century after Columbus landed in America, a Portuguese ship, bound for Macao, an island off the coast of China, was driven off course by a raging storm. After being tossed about on the seas for days, the crew managed to land the ship on the jagged and rocky coast of southern Kyushu. These were to be the first Europeans to live in and fully experience the culture of Japan, for it is reported that Marco Polo had only a brief encounter with the Japanese. Ragged and starving, these Portuguese received a greeting which must have seemed fabulous and incredible to them. Although the Japanese government was at first reserved and cautious, it treated its guests with courtesy and kindness, eventually allowing them free access to any part of Japan. Travelling extensively throughout Japan, the Portuguese began to be awed by the beauty and fertility of the land and the abundance of gold, silver, and copper that it yielded. Having believed till now that their region of the world was the only civilized one, they were also immensely surprised to find that the Japanese people had developed an extremely sophisticated and complex culture. In turn, we know that the Japanese were favourably impressed with their foreign visitors, for they drew portraits of Antonio Mota and Francesco Zeimoto so that they could remember with affection the first two Portuguese who set foot on their soil.

Some time after the landing at Kyushu, an arrangement with the prince of Bungo was made which allowed a Portuguese vessel to be sent there each year to trade woollens, furs, and various other commodities. In 1549, seven years after the West's first real discovery of Japan, there occurred what seemed to be an insignificant incident; a young Japanese escaped to the Portuguese settlement at Goa, on the Malabar coast, and coming across some Catholic missionaries, he was converted to the Christian faith. Within a short time he had convinced both priests and merchants that Japan was fertile ground for spiritual as well as commercial enterprise. And so, in a ship loaded with merchandise and gifts, the first Jesuits made their way to Bungo, along with their young Japanese convert and several eager merchants. Among the missionaries who made this first voyage was the heroic and high-born Spaniard, Father Francisco Xavier, whose work with the poor and afflicted natives of Japan was ceaseless and untiring. The example he set soon accomplished almost miraculous results, for it is said that his immediate successor founded fifty churches, and baptized more than 30,000 converts with his own hands.

At the same time, the merchants of Goa were meeting with a success far beyond their wildest dreams. Lacking a strong central government, Japan was a tangled complex of independent provinces and warring princes who were forced to compete with each other for trade and goods. As a result, the newly arrived merchants were beset with invitations to ports and towns along the entire length of the island. In addition, these Portuguese traders had the benefit of being near three of their own commercial strongholds – Macao, Manila, and Goa – all of which could furnish them with unlimited supplies at a moment's notice. With all these factors working to their

advantage it is no wonder that the Portuguese established in Japan such a spectacular trading empire in so short a time. By 1566, they had expanded their dominion even further by suggesting that the port of Nagasaki, whose harbour was superior to any other, be made into the predominant centre of Portuguese commerce. During this period, they had unlimited freedom to import and export whatever they liked without any constraints on quantity of quality. It is recorded that close to 300 tons of gold, silver, and copper were exported every year from the combined ports of Portuguese merchants. "It is believed," says Kämpfer, an early historian of Japan, "that had the Portuguese enjoyed the trade to Japan but twenty years longer, upon the same footing as they did for some time, such riches would have been transported out of this Ophir to Macao, and there would have been such a plenty and flow of gold and silver in that town, as sacred writs

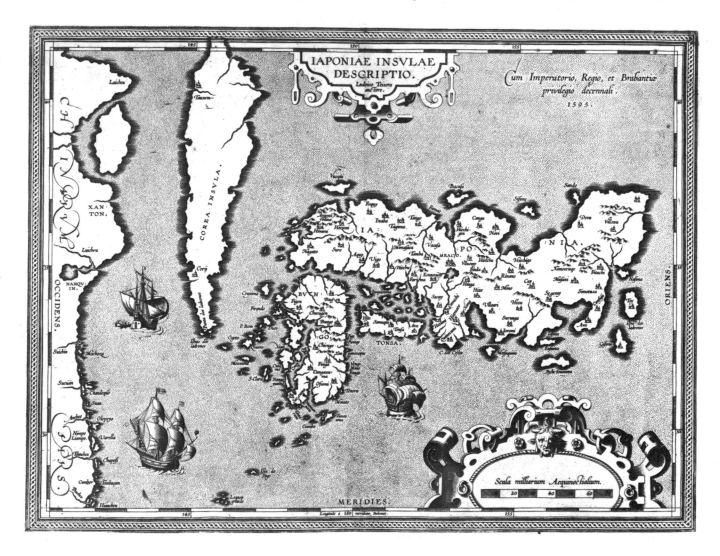

mention there was at Jerusalem in the time of Solomon."

Macao, of course, was never granted the twenty years it needed to reach such legendary status. The courage and ingenuity of one great Englishman would not only rob Macao of her future destiny but would also set in motion a series of events that would finally overturn the Portuguese monopoly on Japanese trade. Because of this Englishman, William Adams, the ports of Japan were for the first time in history opened up to the Dutch, who would relentlessly build their empire on the ruins of Portuguese hopes. For nearly half a century, the commercial fate of Japan was to lie in the hands of these two European powers, whose bitter feuding would almost put an end to all Western commerce with Japan.

As we know from his own writings, William Adams was a Kentish man, born sometime near the middle of Elizabeth's reign, in Gillingham, two miles from Rochester, and just over a mile from Chatham, where the Queen's ships lay. From the age of twelve he was brought up in Limehouse, near London, and was apprenticed for twelve years to one

master, Nicholas Diggins. After his apprenticeship was over, he became master and pilot in Her Majesty's service, and for about twelve years he worked in the company of the Barbary merchants, until the Indian traffic from Holland began. "In which traffic," Adams writes, "I was desirous to make a little experience of the small knowledge which God had given me. So, in the year of our Lord 1598, I hired myself for chief pilot of a fleet of five sail of Hollanders, which was made ready by the chief of their Indian company, Peter Vanderhaag, and Hans Vanderguct; the general of this fleet was called Jacques Mayhay, in which ship, being admiral, I was pilot."

In those days, it was common practice to load a fleet with as much cargo as it could hold and point it in the general direction of the Orient, where it would hope to find ready markets for the commodities it bore. Trade routes were not yet clearly demarcated and merchant vessels, for the most part,

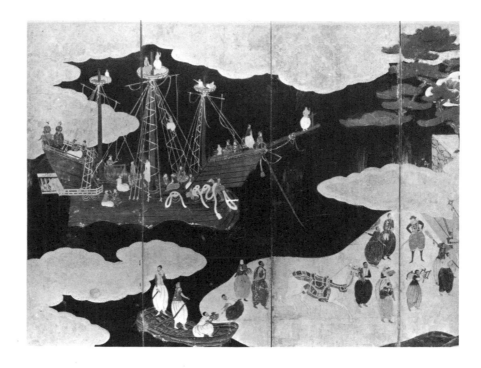

had to pass through unfamiliar waters and climates, whose unpredictable gales and currents often spelled disaster. Frequently, strange diseases which Europeans had little or no immunity from would decimate a ship's crew. Adams' fleet was, unfortunately, spared none of these calamities. By the time it reached the Straits of Magellan, the admiral and many of its crew were dead from some sort of sickness and, to add to the general misery, winter had arrived, bringing with it freezing gusts of wind and driving torrents of sleet. His crew weak and exhausted, the captain decided to drop anchor for a few weeks, allowing his men to get some supplies and refreshment. Though the treacherous straits were rarely used by European vessels, Adams had decided that the risk they involved was preferable to the long and arduous task of rounding Cape Horn. However, by the time the five ships had taken on fresh provisions, the straits had become completely impassable. As a result, the fleet was forced to winter there from April to September by which time it finally managed to pass through the hazardous straits into the Pacific. On reaching the open sea, it was immediately dispersed by a storm, and after waiting on the coast of Chile for 28 days in the hope of being joined by the others ships, the *Erasmus*, which was piloted by Adams, set sail for the island of Mocha.

The cool reception Adams had met with on the coast of Chile had taught him to be wary of regions controlled by the Spanish and Portuguese; any land in which these two nations had a secure foothold was certain to be unfriendly or hostile to any Dutch vessel. Since this was the case with Mocha, Adams dared not anchor there but proceeded to direct his course for the nearby island of Santa Maria, whose natives were totally unknown to him. As it turned out. Adams' choice was an unfortunate one. As soon as his men set foot on shore, the people of the island attacked them,

injuring eight or nine members of the crew. Adams describes what happened the next day: "Two or three of the people came straight to our boat in friendly manner, with a kind of wine and roots, making tokens to come and land, and signs that there were sheep and oxen. Our captain, with our men, having great desire to get refreshments for the ship, went on land. The people of the country lay in ambush, a thousand and more, and straightaway fell upon our men, and slew them all; among which was my poor brother Thomas Adams. By this loss we had scarce so many men whole as could weigh an anchor."

A day or two after this incident, the *Erasmus* met up with one of the ships that had strayed in the storm. Its crew had a similar story of horror to report about their encounter with the natives of Mocha. It seemed as though no coast was exempt from the watchful suspicion and jealousy of

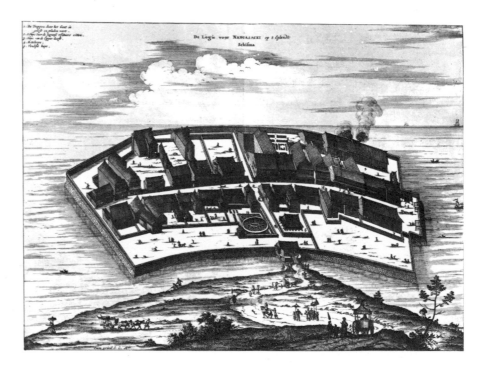

Spain and Portugal. Adams also learned that the Spanish had seized one of the Dutch vessels, but he could get no information as to the whereabouts of the other two. In all likelihood, they had foundered at sea. Both ships now being anchored off the coast of Mocha, a council was held to decide where they would next direct their course, for it was now certain that they would never be joined by the rest of their fleet. As Adams tells us, their decision was made on the basis of a casual rumour and a rather ordinary insight: "At last it was resolved to go for Japan; for, by report of one Dirreck Gerritson, which had been there with the Portugals, woollen cloth was in great estimation in that island; and we gathered, by reason that the Malaccas, and the most part of the East Indies, were hot countries where woollen cloths would not be much accepted. Therefore it was we all agreed to go for Japan."

On November 29, 1599, they set sail for their newly chosen destination. After several months at sea, they ran up against an island inhabited by an unusually fierce tribe of cannibals, who supposedly ate several of the crew. They sailed again and on February 24, 1600, a violent storm separated the two ships. They lost sight of each other and never met again. Of the five ships that had left Holland, Adams' was the only one remaining. By March 24, the island of Una Colonna was spotted, apparently just in time, for from Adams' description of the crew's condition, we can surmise that they could not have lived much longer: "Great was the misery we were in, having no more than nine or ten men able to go or creep upon their knees; our captain, and all the rest, looking every hour to die." At last, on April 11, 1600, the remaining four or five men caught their first glimpse of the high land of Japan. The next day they anchored at Bungo, where, as Adams reports, "many country barks came aboard (the ship), the

people whereof we willingly let come, having no force to resist them.''
After an agonized passage entailing inconceivable horrors, the first Dutch
vessel finally lay at rest in the fabled and mythical kingdom of Japan.

It appears that some of the Japanese took advantage of the crew's
defenceless position, for the next day several goods were found to be
missing from the ship. As a gesture of apology, the local authorities set a
guard around the ship to insure that nothing else would be stolen. The
captain and sick men on board were taken to a large house where they
waited for news of their arrival to reach the principal sovereign of that area,
who would subsequently send back orders as to what their next move
should be. In the meantime, disaster was in the air. Several Portuguese had
arrived from Nagasaki and, upon spying the Dutch vessel, began to spread
rumours that its crew were thieves and pirates who wanted nothing in the

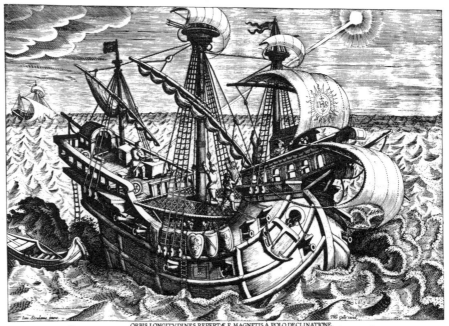

ORBIS LONGITVDINES REPERTÆ E MAGNETIS A POLO DECLINATIONE.
Magnete paulum vtrinque sæpe deuia Dat inuenire portum vbique Plancius.

way of honest merchandising. According to Adams, the situation had
become quite serious : ''The evil report of the Jesuits and Portuguese
caused the governor and common people to think ill of us, in such manner
that we looked always when we should be set upon crosses, which is the
execution in this land for piracy and some other crimes. Thus daily more
and more the Portugals incensed the justices and people against us.''

To the minds of the Spanish and Portuguese such accusations were, of
course, justified, for by virtue of a papal bull, they claimed all the new, and
a good half of the old world, as their exclusive domain. The absurdity of
their demand that the dictates of a pope be obeyed by Protestant nations,
who had long since repudiated his authority, never occurred to them, and
any foreign ship venturing into waters patrolled by them was seized as
contraband. Although such a policy was, to a great extent, motivated by a
stubborn determination to maintain their monopoly over Japanese trade,
the Spanish and Portuguese were also driven by an unshakeable prejudice
against the religious faith of the Dutch. As MacFarlane notes in his
nineteenth-century account of Japan, '' the hatred between (these)
European nations was as irreconcilable as it was violent – no gust of
passion, but a deep-welling perpetual hatred. If the Portuguese called the
Dutch vile Lutherans, schismatics, accursed heretics, the Dutch were
always ready to retort by calling the Portuguese worshippers of wood and
rotten bones, lying papists, foul idolaters.'' As a result, the Portuguese
would have witnessed the crucifixion of the Dutch crew with a great deal
of satisfaction had not an order from the emperor, summoning Adams to
the imperial court at Osaka, put an end to their intrigue.

On May 12, 1600, Adams entered the legendary royal city of Kyoto,
and being ushered into a palace abundantly gilded with gold, he came
before the shogun Teyosu. Here is Adams' account of what must have

13

been a dramatic confrontation: "He viewed me well, and seemed to be kind and wonderful favourable. He made many signs unto me, some of which I understood, and some I did not. In the end there came one that could speak Portuguese. By him the king demanded of what land I was, and what moved us to come to his land, being so far off. I showed unto him the name of our country, and that our land had long sought out the East Indies, and desired friendship with all kings and potentates in way of merchandise, having in our land divers commodities, which these lands had not; and also to buy such merchandises in this land as our country had not. Then the great king asked whether our country had wars? I answered him, yea, with the Spaniards and Portugals, being in peace with all other nations. Further, he asked me in what I did believe? I said, in God that made heaven and earth. He asked me divers other questions of things of religion, and many other things, as what way we came to his country. Having a chart of the whole world with me, I showed him through the Straits of Magallaens; at which he wondered, and thought me to lie. Thus, from one thing to another, I abode with him till midnight."

The shogun then asked Adams to show him samples of the merchandise on board ship, and taking this to be a favourable sign, Adams asked if permission might not be granted for the Dutch to set up a regular trade with Japan. Apparently, something in his request displeased the shogun, for Adams was immediately carried off to prison. Within two days, the shogun had grown inquisitive again and he commanded that Adams be brought before him for another round of questioning. His curiosity satisfied, the shogun once more ordered Adams to prison, not calling for him again till forty days had passed. The Portuguese, of course, did not waste this interim, but spent it in a continuous effort to dissuade the shogun from having anything more to do with the Dutch. Their arguments, however, failed to persuade him and, calling Adams before him, he gave him leave to return to his ship, which had by now been brought nearer to the city. Adams describes the happy reunion: "Wherefore, with a rejoicing heart, I took a boat and went to our ship, where I found the captain and the rest recovered of their sickness. But at our first meeting aboard we saluted one another with mourning and shedding of tears; for they were informed that I was executed, and long since dead. Thus, God be praised, all we that were left alive came together again." As everything had been taken out of the ship, even the nautical instruments, which especially fascinated the Japanese, the shogun ordered that all these things be given back to the crew. Yet, this gesture of reparation was of no use to them, for he remained adamant about one crucial issue: no one was to make any preparations for departure. Instead, the ship was to follow the shogun to the eastern coast of Quanto, near the city of Edo, where he was now staying.

For a long while, the crew of the *Erasmus* lived in constant expectation of returning home until, at the end of two years, the shogun extinguished all such hopes by announcing that they were never to leave Japan again. All the men were to be provided with approximately two pounds of rice a day and a substantial sum of gold every year for the rest of their lives. Most of the seamen eventually began to lead a routine existence, settling in whatever area of Japan they found to be most appealing. However, this was not to be the case with Adams, who in the course of several years ingratiated himself with the shogun and ultimately rose to eminent heights in his court, attaining the highest honours that could be bestowed on a foreigner.

The event which was initially responsible for Adams' great fortune was the building of a magnificent ship for the shogun. Greatly impressed with Adams' knowledge and skill, the shogun, who was, it seems, very liberal minded and fond of learning, engaged him as tutor. Besides instructing the shogun in subjects such as geometry and mathematics, Adams was also placed in charge of constructing another ship, with which, together with the first one he built, Adams ran several diplomatic missions for the shogun. By 1611, he was living like a lord: "Now, for my service which I have done, and daily do, being employed in the shogun's service, he hath given me a living like unto a lordship in England, with eighty or ninety husbandmen, who are as my servants and slaves. The precedent was never done before.

Thus God hath provided for me, after my great misery; to his name be praised for ever. Amen. Now whether I shall come out of this land I know not. Until this present year there hath been no means; but now, through the trade of Hollanders, there may be means."

Adams, who had a wife and children in England, had never really given up the idea of returning home. In 1609 two Dutch ships came to Japan with the intention of waylaying the great Portuguese galleon, which every year at that time left the harbour of Macao laden with precious Oriental goods. Being five or six days too late for this prize, the two Dutch captains came to Firando in the hopes of setting up permanent trade arrangements with the shogun. They were received at court with great kindness, and due to the negotiatory efforts of Adams, a satisfactory bargain was sealed: from now on a Dutch ship would come to Japan on a yearly basis. Though Adams was refused permission to depart with these first two Dutch vessels, he waited for the arrival of next year's ship. None came the following year, but in 1611, "a small Holland ship", Adams tell us, "arrived with cloth, lead, elephants' teeth, damask, black taffeta, raw silk, pepper, and other commodities; and they have showed cause why they have missed the former year, 1610, according to promise to come yearly." We can picture Adams anxiously awaiting the arrival of a Dutch ship each year, only to learn once more, upon its departure, that passage home on it had been denied him.

The shogun never did bring himself to part with such a knowledgeable and useful man as Adams, and after living in Japan for almost twenty years, Adams died in Firando sometime round 1619, having made several unsuccessful attempts to return to the land of his birth. Although he never gave a full account of his experiences in Japan, he did not omit to express his admiration for the Japanese: "The people of this land of Japan are good of nature, courteous above measure, and valiant in war. Their justice is severely executed, without any partiality, upon the transgressors of the law; they are governed in great civility; I think no land better governed in the world by civil policy." At the time of Adams' death, the Dutch had already established a profitable trade with Japan and spread their influence there, neither of which would have been possible without the courage and ingenuity of Adams, who ranks as one of the truly great pioneers of early naval enterprise. In an age when seas were often navigated by sheer conjecture and half the globe loomed sinister and forbidding, he undertook his mission, an ambassador of commerce and prosperity, bringing with him a gentility and grace, that for one brief moment, held East and West in a bond of friendly interchange.

A few decades after Adams' death this bond was all but dissolved by a succession of disastrous episodes which actually began in 1549, when the first Jesuit missionaries gathered up courage and made the hazardous crossing from Goa to Japan. In a short space of time their efforts at conversion met with an incredible success which was made possible by a number of factors. To begin with there did not exist in Japan one single predominant religion; its most ancient faith was split into diverse sects and the prevalence of several religions imported from different foreign countries further added to the confusion. In addition, the impressive formality and pomp surrounding many rituals of the Roman church must have appealed to a people whose way of life is so profoundly rooted in love of ceremony. These factors, added to the Jesuits' superior knowledge of medicine and their solicitous care of the sick and unfortunate, soon led to the creation of an enormous following whose devotion to the Catholic faith culminated in an extraordinary event: in 1582, an embassy of seven persons, who would not return to Japan for eight years, left on a journey to the Vatican with the intention of demonstrating, on behalf of all Japanese Christians, their supreme homage to the Church of Rome.

Had the process of conversion remained in the politic hands of the Jesuits, all would have continued smoothly. However, by the turn of the century, a host of other missionaries – Franciscans, Dominicans, Augustines – flocked in from neighbouring Portuguese settlements. Among their number were many who came with dishonourable intent; in their desire for power and wealth, some missionaries went so far as to

disregard imperial edicts, encouraging their converts to do the same. It was not long before the combined force of outraged local authorities and native priests, who were steadily losing both their revenues and influence over the people, bore down upon the foreigners who had invaded their domain. In 1597 the first serious persecution occurred, with twenty-six Christians being executed on the cross. Some say the incident was triggered by a Japanese prince who became infuriated when a Christian beauty refused the honour of becoming his concubine; others blame the event on an arrogant Portuguese bishop, who on meeting a high official of Japan, refused to descend from his sedan and pay his respects.

This initial show of displeasure on the part of the Japanese government, apparently did not make much of an impression on the Christian constituency. It dampened neither the zeal of those missionaries motivated by a sincere religious fervour, nor the ardour of those driven by pride and rapacity. Both of these groups continued to regard native priests with contempt, urging the Japanese to smash their heathen idols and temples. Such open defiance soon created another explosive situation, which was worsened by exaggerated Dutch reports of every Portuguese transgression. In 1612 a severe persecution began and raged on for two more years. Eight years later a bloody massacre of native Christians and some of their Portuguese instructors was carried out near the harbour of Nagasaki. Japan's rebellion against the foreign intruders who had violated her ancient laws and traditions had begun.

During this harrowing period, the Portuguese traders and merchants remained exempt from harassment only because the Japanese could not do without the commodities they brought. But as the Dutch trade grew more and more reliable, the Portuguese, who refused to stop smuggling in missionaries, were eventually deprived of the free use of any port and confined, instead, to the little islet of Nesuama. In an attempt to dislodge their competitors, the Portuguese began a concerted campaign to blacken the reputation of the Dutch, representing them to the emperor as rebels against their former sovereign, the King of Spain. They also stressed similarities between the Protestant religion and their own, hoping to incense the government against the Dutch even further. As a result, the Dutch were reduced to ludicrous demonstrations, such as smashing images of saints or trampling on crucifixes, as proof of their disaffection with the Catholic faith. Though the emperor's anxiety was in part allayed by such displays, the Dutch were fully aware of the fact that suspicion against them had been planted in his mind by the cunning Portuguese. Frustrated and embittered, the Dutch waited for their moment of revenge.

Some time after these developments, a Portuguese ship, returning to Lisbon from the East, was captured by the Dutch near the Cape of Good Hope. Included among the treasures found on board were certain treasonable letters outlining a plot, which Japanese Christians, in league with several Portuguese, had made against the emperor's throne. Addressed to the King of Portugal, the letters were written by a native Japanese known to his fellow conspirators as "Captain Moro". According to his evaluation of the situation, the only thing stopping the rebels was their lack of soldiers and ships, which Portugal had promised to supply. The documents also revealed the names of the Japanese leaders who had entered into the conspiracy and established, beyond doubt, their connection with the Church of Rome, for the Pontiff himself had set his seal of approval on their subversive activities. With this stroke of fortune, the Dutch gained possession of enough information to accomplish the ruin of the Portuguese ten times over; the incident presented the opportunity for a reprisal far beyond their wildest expectations.

In 1637 Moro was burned alive at the stake, and shortly after his death, a royal proclamation was issued, decreeing that, "the whole race of the Portuguese, with their mothers, nurses, and whatever belongs to them, shall be banished for ever." The same proclamation also declared that any Japanese ship or person daring to leave the country did so under pain of forfeiture or death; that any Japanese returning from a foreign country be put to death; that no nobleman or *samurai* purchase anything from a foreigner; and lastly, that all Christians be seized and executed. Upon

assurance from the Dutch that they would provide the Japanese with whatever commodities they needed, the emperor banned from the harbours of Japan all Portuguese goods, with the exception of port and sherry, for which he had evidently acquired an irrepressible taste. By 1639, branded as enemies of the state, the Portuguese were totally expelled from Japan. After nearly a century of prosperity, one of the most promising of all trading empires in the East lay in ruins.

What was most tragic about all this turmoil was the plight of Japan's Christian natives. Deprived of their spiritual leaders and menaced by the local authorities, they quietly persisted in their faith until brutal oppression drove them into open rebellion. After several skirmishes with the army, they took refuge in the province of Shimabara, where they made a heroic stand against the emperor's troops. As proof of their good faith, the Dutch were

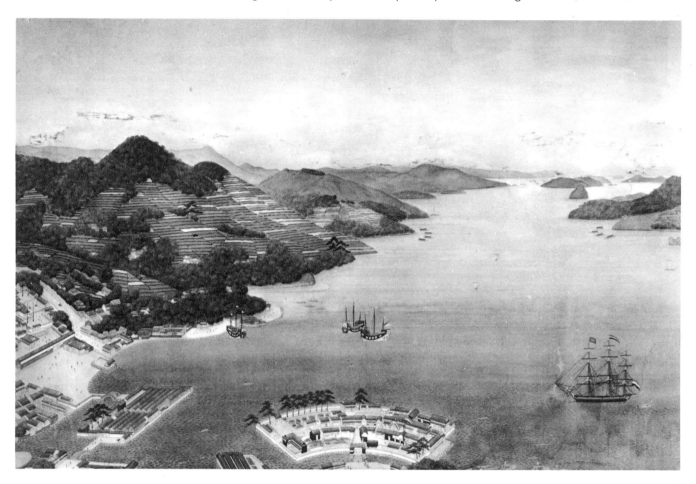

asked to assist the government in its assault, and fearing the loss of their trading privileges, they co-operated with what turned out to be a pitiless massacre. When a good number of the besieged converts had been eliminated by famine and disease, the army entered the fortress, butchering men, women, and children. According to the most moderate estimate, 40,000 lives had been sacrificed – a grim testament to the tenacity with which these Japanese believers refused to abjure their Roman Catholic faith. Over the vast common grave of its martyrs there was placed this malignant warning: "So long as the sun shall warm the earth, let no Christian be so bold as to come to Japan; and let all know, that the King of Spain himself or the Christians' God, or the great God of all, if he violate this command, shall pay for it with his head."

Ironically, the Dutch gained nothing by their efforts to appease the Japanese government; neither their success at uncovering the plot against the emperor nor their compliance with the troops at Shimabara worked to their advantage. Instead, the conduct of the Dutch towards their fellow Christians was, in the end, judged to be shameful and disquieting: a nation that participated in the destruction of its spiritual compatriots could hardly be trusted to deal honourably with a foreign state which it considered to be heathen. The Dutch had only succeeded in arousing Japan's general suspicion of all foreigners, and in 1641 they were ordered to quit their

comfortable quarters at Firando and to confine themselves, under very rigid inspection, to the small islet of Nesuama, an area of about 240 by 600 feet.

Nesuama's only link with the rest of civilization was a small stone bridge, at the end of which stood a strong Japanese guard-house whose watchmen made certain no one entered or left without permission; as a further security measure, the entire islet was enclosed with a strong paling of high boards on top of which were planted double rows of iron spikes. In the harbour, a few paces from the Dutch encampment, loomed thirteen tall posts to which were affixed wooden tables bearing the governmental order that any Japanese person or boat approaching farther did so at the risk of incurring severe punishment. The only natives allowed in the area were those employed by the Dutch as servants, but even these were frequently changed for fear that they would grow too attached to their masters and begin to adopt Dutch manners and habits. They and anyone else having close dealings with the Dutch were obliged to take a solemn oath of renunciation and hatred of the Christian religion several times a year.

The circumspection of the Japanese grew especially intense when a Dutch ship pulled into the harbour. Immediately upon its arrival, the ship was stripped of its guns and ammunition, every corner of it investigated, and all its passengers placed under guard. Yet such humiliating treatment was not new to the Dutch, for in addition to all these constant reminders of their untrustworthiness, they were continually subjected to the intrusion of the restless, fanatic police of Nagasaki, as well as a host of other special guards, agents, spies, and corporations. Kämpfer, a German who happened to be in the Dutch service at that time, describes their demeaning predicament: "So great was the covetousness of the Dutch, and so strong the alluring power of the Japanese gold, that rather than quit the prospect of a trade (indeed most advantageous) they willingly underwent an almost perpetual imprisonment, for such in fact is our residence at Dejima . . . we live all the year round little better than prisoners, confined within the compass of one small island, under the perpetual and narrow inspection of our keepers."

Despite such hardship and degradation, the Dutch persisted in their trade with Japan, which had been reduced to two ships a year, and resigned themselves to a sordid and miserable way of life for the sake of maintaining their monopoly. What Adams had begun as a splendid enterprise promising access to the whole of Japan ended as a squalid little operation on the islet of Nesuama. The grasping, malevolent hand of European greed had reached for the dazzling wealth of the Orient only to have it slip through its fingers. Japan had recoiled from its touch with a vengeance; she was not to extend another welcome for nearly two hundred years.

In 1542, when the first Portuguese vessel happened to be tossed up on its shores, Japan was a land torn apart by the strife and upheaval which characterize any state plagued by incessant civil feuds. Wars among the *daimyo*, or feudal lords, who provided only the merest semblance of government, were so prevalent that during this period Japan earned the name of *Sengoku* or "Country at War". Out of this constant struggle for power there arose a young territorial general, Oda Nobunaga, who by 1560 had seized enough control to begin the unification of Japan. In 1582, dying at the hands of a traitorous vassal, Nobunaga was succeeded by the great Hideyoshi, a brilliant strategist and ruler, whose rise to power was swift and dazzling. Within three years, Hideyoshi single-handedly subdued the leading warlords, rising to be dictator of a Japan newly unified under his rule. To promote the growth of peace and stability in his domain, he issued two historic edicts: the first prohibited any individual other than a member of the military class to bear arms; the second declared that no farmer could change his occupation, and that every military retainer was perpetually bound to his trade as well as to his master. As a result of these injunctions, the social and economic class structure of Japan was virtually frozen; it began to assume the rigid and highly stratified form whose final crystallization would endure much future stress.

In 1598 Hideyoshi died, his mind darkened and oppressed by presentiments of treachery. In a desperate attempt to preserve the Regency

he had founded, Hideyoshi had bound together the five great feudatories, demanding at the hour of his death that they take an oath of loyalty to his son and heir, Hideyori, who was merely a child at the time. The strongest of the great five, Ieyasu Tokugawa, fearing that the unity Hideyoshi achieved would be destroyed by the time Hideyori came of age, immediately took steps to consolidate his own strength in the hopes of deterring internal conflicts. His campaign was so successful that by 1603 he had solidly established the Tokugawa Shogunate, a military dictatorship which was to rule Japan effectively for close to three centuries.

Ieyasu ruled through a small group of loyal friends who slowly began to lay the foundations for Japan's new government. Though the feudal lords were free to run their domains as they wished, they were always at the command of the shogun and under his strict supervision. Any disobedience brought swift reprisal. The emperor, whose function had been slowly reduced through the years, was almost totally confined to traditional ceremonial duties. As a nominal gesture of respect, a substantial revenue was allocated to the imperial court, which was allowed to remain at Kyoto. The capital of the new state, however, was moved to Edo, a small town that was to serve as the shogun's military camp. This administrative action, together with Ieyasu's practice of abolishing the fiefs of his antagonists, would prove to be decisive for the course of Japan's future development. In a short time, both measures would create circumstances favourable to the rise of the middle class.

By the time Hidetada succeeded his father, the Shogunate's power was absolute. It decided all matters of foreign as well as domestic policy and had amassed enough strength to enforce its programmes. While in office, Hidetada reaffirmed the ban on Christianity and proceeded with the confiscation of fiefs, continuing Ieyasu's attempt to build a strongly centralized state. When his son, Iemitsu assumed control in 1623, this objective was still uppermost in the minds of the Shogunate councillors, and he was advised to take further steps towards the consolidation. As a result, Iemitsu instituted various civil service agencies, out of which there eventually evolved a bureaucracy capable of keeping a strict check on all citizens, high and low. The strongest *daimyo*, especially, were closely watched for any signs of unruliness, since any breach of discipline left unpunished could potentially encourage rebellion. In 1635, to facilitate this surveillance, Iemitsu initiated a programme which required all the lords to reside in Edo. This shrewd manoeuvre was perhaps the single most important factor responsible for that city's sudden and luxuriant affluence. After centuries of civil warfare and adversity, Japan was entering an extraordinary phase of cultural and economic growth. Unprecedented prosperity would soon sweep through the streets of her cities.

Under Iemitsu's rule, the feudal system finally reached its height; every individual's role and status were not only sanctioned by centuries of tradition but permanently fixed by law. The Shogunate's policy of legislating against change had, for the moment, produced a stable and flourishing society. To preserve Japan's newly found equilibrium, Iemitsu issued a series of exclusion edicts, hoping to protect his empire from any foreign influence, which had of late become a serious threat to internal security. There was no doubt in his mind that the Shimabara trouble had been instigated by Portuguese missionaries and the Tokugawa government wanted no repetitions of the event. What little they had heard of European intrigue was enough to prevent them from joining the struggle for land and trade currently disrupting the Pacific. The sentiments of the Shogunate were neatly summed up by Iemitsu's reaction to some lessons in world geography, which Francis Caron, the director of the Dutch trading station in Japan, had given him. Recording the incident, Caron says that, "after investigating the size of the world, the multitude of its countries and the smallness of Japan . . . (Iemitsu) was greatly surprised and heartily wished that his land had never been visited by any Christian." From now on, Japan would develop in total isolation and complete self-sufficiency; wrapped in the iron mantle of the Tokugawa warlords, its people would continue to thrive in secrecy, shielded from the prying gaze of most of the world.

The Tokugawa Shogunate had succeeded in establishing a social structure which was based on a rigid division of classes. Heading the structure, was the Soldier, followed by the Farmer, the Craftsmen, and finally, the Merchant. Though the military class consisted of all who bore weapons, from the greatest war baron to the lowest *samurai*, it comprised barely ten per cent of the total population, eighty per cent of which was composed of peasants, by far the largest class. The farmer's relatively high rank in society offered him little consolation since it was accompanied by no political power and provided him with no protection against landlords who chose to be severe. As Japan's commercial areas expanded, the prospect of finding employment there grew more likely and many peasants absconded to the cities, where they formed a new class of manual

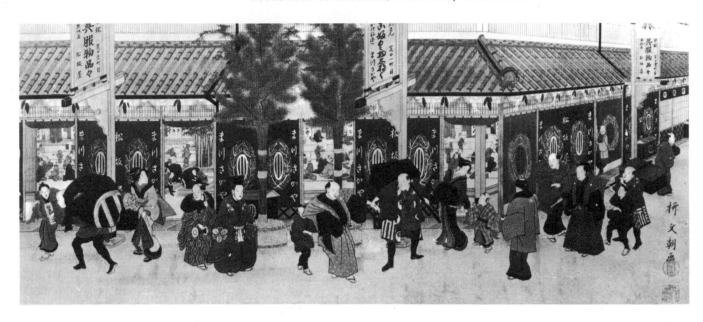

labourers. Those who developed skills, however, were absorbed into the third social class, the artisans, who had already accumulated a fair amount of wealth owing to the constant demand which had been placed on their services during Japan's period of civil strife. This period of dissension had also benefited the merchants and traders, whose profits had been made from the sale of necessary supplies and materials. Ironically, it was this class, the lowest on the scale, that would soon amass enough financial force to topple the imposing social framework which had been so painstakingly erected by the early shoguns.

The first signs of strain appeared in Japan's most prestigious class, that of the military. As the empire gradually entered upon peaceful times, it became apparent that there was a growing surplus of soldiers whose energies were no longer being absorbed by incessant civil conflicts. The warriors whom Ieyasu had set free as a result of abolishing his enemies' fiefs presented an especially dangerous situation. Not only did these *ronin* have no significant function in society, they had also been deprived of their masters. As a result, when the last vestiges of war vanished, these *samurai* had nowhere to reside and no means of subsistence. The whole problem was further intensified by the Shogunate's insatiable greed for land, which drove it to confiscate more and more feudal estates without any concern for their expelled inhabitants. By 1651 the number of unemployed *samurai* is said to have soared to 500,000. Although some found employment as farmers, most poured into the cities, where their general discontent erupted into violent and unpredictable behaviour. Many of them formed terrorist groups with the *hatamoto*, high-ranking warlords, whose anger against the government had been aroused by its decision to give them fixed incomes which grew more and more inadequate in the face of a steadily rising standard of living. Such a state of affairs clearly indicated that the Tokugawa administration was building a peace-time economy at the expense of its most privileged class.

Japan's new prosperity was most evident in its commercial centres, especially in its most rapidly growing city, Edo, where a number of factors

combined to hasten the rise of its merchant class. Since 1635, when Iemitsu had moved the capital to Edo, requiring that all *daimyo* establish residences there, the population of the city soared. Vassals from all areas of Japan gravitated towards the country's new political and military centre, accompanied by long winding trains of *samurai*, artisans, and servants who were part of their magnificent retinues. In establishing and maintaining their new households these feudal lords spent huge sums of money, giving employment to many labourers and craftsmen, as well as fattening the purses of merchants whose well-stocked shops provided them with a steady flow of all kinds of goods. No doubt the merchants of Edo would have flourished had the *daimyo* been their only customers, but in addition to carrying on a lively trade with the shogun's retainers, they

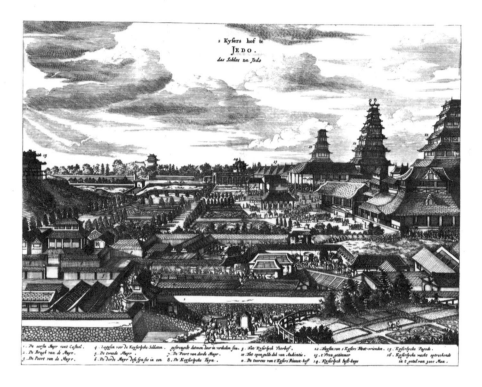

found another substantial market for their products among the vast number of bureaucrats who earned their livelihood in the nation's capital. Although these government officials could not afford as grandiose a life-style as that of the *daimyo*, many were wealthy enough to employ a large domestic staff. As a result, Edo was populated with a multitude of servants and attendants who alone would have created a constant demand for rice, oil, and other necessities.

As business boomed, a growing stream of people from all areas and social classes of Japan poured into Edo – labourers in search of work, tourists eager for new sights and experiences, adventurers and pleasure-seekers attracted by the sensation and glamour of a thriving metropolis. Eventually, the combined purchasing power of Edo's population became astounding; before long, the city was a virtual mass of consumers, most of whom had little or no financial sense. Their gullibility, and careless, spendthrift ways made them easy targets for any merchant who happened to cross their path. It is no wonder, then, that many great fortunes were made in Edo. Ironically, at the same time that the tradesmen and shopkeepers were prospering, the military class was slowly being drained of its resources. Because of the Shogunate's insistence that they reside in Edo for at least part of the year, all *daimyo* were forced to lead an extravagant double life; already responsible for the management and upkeep of their provincial estates, they were now burdened with a second household, whose expenses began to outstrip the rather fixed revenue provided by their land. Journeying back and forth between two domains was in itself costly, especially since all members of the aristocracy were expected to travel in grand fashion. As debt after debt mounted, many *daimyo* were forced to mortgage their incomes to merchants, who had

built up large cash reserves, in return for desperately needed loans. In this way, Japan's lowest class began gradually to insinuate itself into the upper reaches of the feudal structure. However, the event which would both jolt the aristocracy from its secure place in the economy and firmly entrench the merchant class in a favourable position was yet to come.

Like most military strongholds, Edo was designed to be invulnerable. In the centre of the town stood the shogun's castle; built on the summit of a hill, its imposing structure dominated the entire city. Adjacent to it were the mansions of the great *daimyo*, whose retainers and servants lived in near-by houses. Surrounding this nucleus were all the other buildings, a network of homes, shops, and inns owned by the residents of Edo. In this way, using the entire town as a buffer, the Shogunate hoped to make its fortress impervious to any attack. However, despite its precautions, on the eighteenth day of the new year, 1657, a disaster struck its headquarters. A conflagration which was to rage on for three days started in the southern outskirts of the city. At the time a powerful gale was sweeping through the area and the fire spread with devastating speed, easily enveloping the small, wooden houses which lined the streets of Edo. By the evening of the second day it had reached the shogun's palace, consuming in its wake the magnificent homes of many *daimyo* and their attendants' quarters. On the third day the wind and flames finally abated. Nearly 100,000 lives had been lost, and more than half of Edo lay in smouldering ruins.

To rebuild the city, large sums of money were needed and enterprising merchants did not hesitate to advance cash to the nobility, many of whom had lost all of their urban possessions, and could pledge only their rice stipends. Since natural calamities such as drought and floods were frequent, many *daimyo* and *hatamoto* failed to keep up their payments and eventually sank into abject poverty. Though the government attempted to aid them with loans or jobs, it could not turn the tide in their favour and stem the wholesale transfer of capital from its highest class to its lowest. The Shogunate itself needed funds as well as supplies and was forced to give large government contracts to rich merchants. By the eighteenth century, a few decades after the Edo fire, the merchant class had become indispensable to both the government and the nobility in the day-to-day transaction of their business affairs. Some of its members even succeeded in obtaining minor government posts in return for bribes, always a sure indication that a class is beginning to gain a considerable foothold in its society.

However, despite these advances, the merchant class was still regarded, for the most part, with contempt and mistrust. Unlike the emerging merchant class in Europe, it failed to acquire any significant political influence or social prestige. Businessmen and entrepreneurs, who had wealth far beyond that of the highest aristocrat, had to grovel before the lowest petty official. Their commercial enterprises were closely watched by the authorities, and any violation of government injunctions or regulations elicited severe punishment. Tokugawa administrators realized that the survival of the military autocracy was dependent on their ability to curtail the power of money, and besides imposing rigorous restrictions on the ways it was made they also placed restraints on how it could be spent. In the streets of Edo it was not uncommon to see a rich shopkeeper's daughter wearing finer clothing than the wife of a *daimyo*. Such discrepancies proved to be a source of vexation and embarrassment to the military class, which struggled to assert its superior social status in the face of the bourgeoisie's lavish display of wealth.

Although many sumptuary laws were issued forbidding tradesmen and their families to dress in a particular fashion or to style their hair in certain ways, ingenious merchants would devise methods of circumventing these orders. Often, poorly tailored *kimono* made of simple fabrics would be worn over layers of sumptuous silks and exquisite brocades. However, though the authorities could be outwitted in minor cases, conspicuous demonstrations of affluence were not tolerated, and the property of those who failed to comply in such matters was confiscated. Nevertheless, in spite of all its efforts, the Shogunate was not able to subdue the spirit of its newly emerging class, and in the course of its rise to prominence there

sprang up a culture whose gaiety and exuberance would be without parallel in the history of Japan.

The tastes and inclinations of the merchant class were, to a large extent, determined by its inferior position in the feudal structure. Barred from any active participation in the political life of Edo, its members were not bound to the state or the values it represented by any strong ties of loyalty or duty. Being the lowest social class, they were not particularly inclined to follow a strict code of behaviour, for they were looked upon with disdain no matter how excellent their conduct. As a result, their amusement tended to be frivolous and lighthearted, with an emphasis on the sensual side of life. Together with Edo's prosperous craftsmen and artisans they had formed a formidable middle class which demanded its own form of diversion and entertainment. Since money could not be used to better their social status, enjoyment of the present became all-important and their expenditure in pursuit of such fleeting pleasures was truly extravagant. Picnics, festivals, and outings to the countryside or to famous shrines became the rage of the day, as did the more sordid type of revelry taking place along the stretch of dried river beds, soon to become Japan's most renowned brothel district – the Yoshiwara.

It was not long before these various trends and pastimes crystallized into a definite urban culture whose aesthetic norms and conventions were a bold departure from ancient classical traditions. Whereas the art and literature of the court, often being the work of Buddhist monks, had both an elevated style and subject matter, the novels and paintings of popular artists took their themes from the day-to-day life of Edo's townspeople. A favourite and inexhaustible source of inspiration was the "floating world", a constantly shifting subculture of travelling performers and fashionable beauties.

Many of those who observed and chronicled this ephemeral community were to become brilliant masters of *ukiyo-e*, colour prints and sketches which captured the essence of Edo's rootless, urban society. Despite the fact that these artists strove to make their work accessible to a wide and diverse audience, their technique, guided by strict canons of judgment, often produced flawless masterpieces. As the literacy of the middle classes increased, they began to develop sophisticated standards of criticism alongside their taste for an art that was gay, avant-garde, and inexpensive. Whether they purchased portraits of famous theatre idols or landscapes of popular tourist spots, discriminating customers expected each print to be exquisitely executed. Competition for society's approval often became heated, and though the demand for *ukiyo-e* was prodigious, artists felt compelled to produce prints of the finest quality for fear that their work would decline in popularity.

New editions were often awaited with intense anticipation since they were a valuable indication of what was in vogue. Women scanned them for the newest styles and fashions, while men looked to them for ravishing portrayals of actors or courtesans who had lately captured the public's imagination. Well-established printing houses were kept constantly busy, for city crowds were restive and changeable, always demanding new themes and compositions. For nearly three centuries the populace of Edo continued to patronize an art form which had their unmistakable stamp; in their exhilarating pursuit of *la dolce vita*, they had unwittingly promoted the birth of an aesthetic tradition that would produce works of unsurpassable craftsmanship and breathtaking beauty.

The most legendary of all brothel districts in Tokugawa Japan was the Yoshiwara in Edo. Though its beginnings were shabby, it eventually grew to be an elaborate miniature city, with its own network of parks, shops, restaurants and gardens. According to a census taken in 1869, it comprised 153 "green houses" (brothels), 3289 courtesans, and 394 tea-houses. In part, the Yoshiwara's enormous success can be attributed to the unique social and economic circumstances surrounding Edo at the time. All roads led quite naturally to the shogun's capital; men from all walks of life, prompted by varying degrees of ambition, were drawn to it for political, military, or commercial reasons, their wives and families conveniently remaining at home. As a result of this constant influx of male

travellers, by the end of the seventeenth century Edo had truly become, in the words of the novelist Saikaku, "a city of bachelors". A carefully constructed dream world, the Yoshiwara was a labyrinth of sensual gratification, designed to arouse as well as to indulge even the most furtive of desires. In a rigidly structured society, which revolved around pre-arranged marriages, it beckoned as the only avenue of social and erotic adventure, a twilight world of secret trysts and dark illusions in whose seductive shadows even the most lowly bourgeoise could find himself regaled like one of noble birth.

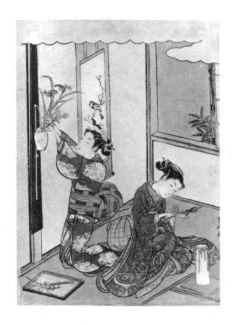

The Yoshiwara (literally "Moor of Rushes") was so named because of the reedy swamp where it was first situated. Prior to its establishment, there was no fixed area in Edo for brothels, and they could be found scattered throughout the city – unregulated, disorderly haunts which were frequented by the lowest and most dangerous elements of the population. In 1612, taking advantage of a municipal building project, a group of commercially oriented brothel-keepers petitioned the government for the right to set up a permanent brothel quarter within Edo's city limits. Being shrewd businessmen, they did not fail to play upon the Shogunate's general dislike of idlers and its especial fear of conspiracy; among the advantages enumerated in their request they placed an added emphasis on the political merits of their scheme, pointing out that the concentration of all existing brothels into one regular place would facilitate the surveillance and apprehension of insurgent *ronin* and any other political agitators or malcontents. The petitioners also indicated that by implementing their plan the local authorities could limit a customer's visit to twenty-four hours; in this way, long bouts of carousing could be prevented, ensuring a client's quick return to duties and responsibilities which might otherwise be neglected during extended periods of debauchery. In light of all these benefits, the government granted its approval, and in 1618, construction of the Yoshiwara got under-way. Its apartments were moved only once, after the great fire of Meireki, which ravaged half of Edo in 1657. At that time it was moved near the Asakusa Temple, where it remained until it was finally outlawed and closed in 1958.

Although legalization of the Yoshiwara had, to a great extent, eliminated the kidnapping and selling of children into prostitution, many young girls were there against their will. Despite its façade of gaiety and glamour, life in the Yoshiwara was tinged with bitterness and misery. Young girls were usually recruited near the age of five by special agents who were adept at procuring them from poverty-striken families. News of an earthquake, famine, or any other calamity would attract swarms of pimps eager to purchase any surplus daughters who had become a burden to parents suddenly made destitute by some disaster. Though most recruits usually came from poor, rural families, a few were of noble background, sold into prostitution because of some disgrace they had brought upon themselves and their ancestral house.

Once inside the Yoshiwara walls, girls would have little hope of any escape; they were seldom allowed to venture beyond the great *Omon*, or Gate of Entrance, which separated their world from that of the townspeople. To all intents and purposes, they were little better than slaves, coerced into a life of bondage and degradation. It has been said that one of the reasons no *samurai* was permitted to enter a brothel with his sword was to prevent the possibility of any courtesan taking her life with it.

A prostitute's only chance of liberation was for a man to fall in love with her; if he were rich, he could purchase her freedom. Owners of brothels were always prepared for such an event; all of them kept exact records of how much they had spent raising and training each courtesan from the day she arrived at their establishment. Very often enormous sums of money would have to be paid for her past upkeep before she could be released. However, a courtesan's chances of meeting someone who was both devoted to her and wealthy enough to settle her "debts" was very remote. Like most of her companions, she would continue in her servitude till she was near the age of twenty-seven, at which point she would be turned out of doors, her abilities at an end. If she were clever, she would go on to become the manager of a brothel; if not, she would be reduced to being a

street prostitute of the lowest order, wandering from corner to corner with her bedroll under her arm, soliciting any male who gave her a glance.

In a society built around a complex system of social distinctions and rules of decorum, it was only natural that the Yoshiwara should have its formalities also. All prostitutes were divided into ranks of varying prestige, each having its own ceremonial trappings and regalia. When a young girl was first brought to a brothel she was given a new name by her master and immediately assigned to a courtesan. As a *kamuro* (the term for young females who served in the imperial court), she would accompany her mistress everywhere, attending to her every need. If a child were exceptionally beautiful and showed signs of grace and talent, she would be given daily instructions in poetry and music, as well as training in the art of flower arranging and the tea and incense ceremony. New arrivals who showed no promise were ignored and eventually condemned to lives of drudgery and abuse. These poor unfortunates were treated like beasts of burden, forced to perform the most menial and unsavoury of tasks.

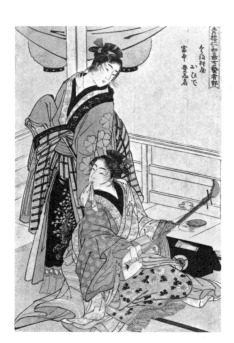

By the age of thirteen or fourteen a *kamuro* was ready to participate in every aspect of Yoshiwara life. To mark her entry into the world of the courtesan a great pageant was held. Adorned and pampered, she was paraded up and down the streets of the Yoshiwara, remaining the centre of attention for five days of jubilant celebration. It was only after this elaborate rite of initiation that a girl would begin to learn the various erotic techniques she was expected to use in gratifying her customers. At this stage, because a *kamuro* was a freshly formed courtesan, she was called a *shinzo*, which literally means "newly constructed". Shortly hereafter, she would take her place among the other prostitutes in the cages and begin catering to her clients' sexual needs.

If a *shinzo* were gifted with unique abilities, in a few years she could hope to attain the highest rank of *tayu*. Courtesans in this class possessed consummate beauty and skill, being highly accomplished in all the arts and refinements of their trade. A *tayu* was constantly attended by two *kamuro* who indulged her every whim. Clothed in a delicately embroidered *kimono* made from the most exquisite silks, her hair ornamented by an elegant array of pins, she would entertain in the most sumptuous of rooms, surrounded by articles of luxury and ease. To all outward appearances, a *tayu* commanded the same attention within a brothel as would a princess in the royal household, unfortunately for the men who frequented the Yoshiwara, her charms commanded a comparable price. Like all royal personages, she was encircled by a wall of formality which only the strictest deference could surmount. Before a man could spent the night with a *tayu*, three meetings had to be held, and it was not until the end of their third encounter that any sexual intimacy was permitted. This peremptory routine was, of course, quite costly, for the client would have to supply food, drink, and entertainment on all three occasions. It is no wonder, then, that a *tayu* was treated so royally by her owners; one of her engagements often proved to be more lucrative than a week's work by some of her less accomplished consorts.

All but the lowest houses of prostitution had some preparatory amenities. To arrange his assignation, a man would first visit a *hikite-jaya*, or "house of introduction", where he would be helped in selecting a brothel and courtesan; when the terms of the rendezvous had been negotiated, the client would be escorted to the appropriate brothel by a serving girl who would arrange the meeting, wait on him during dinner, and generally take care of all his wants until he entered his sleeping compartment and the courtesan arrived. For large banquets a guest would frequently hire *geisha* to entertain him. These charming and gracious performers are thought to have appeared in Japan sometime around 1750, from which point on courtesans were no longer being trained in music and dance. *Geisha* usually played the *samisen*, sang, provided witty conversation, and sometimes danced. As a rule, they did not offer any other form of amusement, although some lower-class *geisha* were known to oblige their customers.

Life in the Yoshiwara supplied *ukiyo-e* artists with a large percentage of their themes. Many prints served as advertisements for leading brothels,

displaying the names and addresses of courtesans and their respective houses. *Tayu*, especially, were portrayed in every manner possible, since their exclusive allure never failed to arouse men's imaginations. Every intimate aspect of a courtesan's daily activity, whether she be adorning herself at the mirror, making love, or hanging the morning laundry, was ultimately captured in line, form, and colour. Under the sensitive glance and masterful stroke of the *ukiyo-e* artist, the world of the Yoshiwara, at best a vulgar travesty of imperial splendour, was metamorphosed into a myriad of lovely, radiant fragments which together embody a universal vision of womanly grace and beauty that remains incomparable.

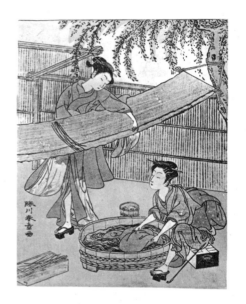

Japan's *Kabuki* theatre arose in response to an emerging urban population which demanded a form of dramatic entertainment that was more popular in theme and conception than the *No* theatre, whose traditional dramas were written and staged for aristocratic audiences. Its name, *Kabuki*, betrays its origins in a modern, rapidly changing culture, for it is a sixteenth-century expression which means "to lean in the direction of fashion". Like other art forms that evolved during that period, *Kabuki* was a synthesis of many traditions. It combined elements of classical *No* drama with those of folk plays and dances, early religious ceremonies, and even puppet shows. As *Kabuki* grew and developed, three distinct categories of drama began to take shape: the *jidaimon*, plays which revolved around historical subjects; the *sewamono*, those about the domestic life of common people; and the *shosagoto*, those which were dance dramas. Occasionally, plays would parody a public official, or contain some social commentary or satirical message that would provide the government with an excuse to close the theatres. This practice became quite common, since actors in general were looked upon with suspicion and contempt; most local authorities considered them to be agents of moral corruption and political disorder, and the slightest provocation became an opportunity for harassment. But, though the *Kabuki* was, from its beginnings, plagued with government injunctions and prohibitions, it never lost the enthusiastic support of the public; each ban and restriction merely served to increase its popularity by making its appeal all the more tantalizing.

The most primitive form of *Kabuki* is said to have made its appearance during the sixteenth century, just after Japan's period of civil war had ended. It was largely the creation of a curious group of people called *Kabuki-Mono*; wearing rather garish apparel and behaving in an outrageous fashion, they eventually began to attract large crowds of townspeople. When Okuni, a Shinto maiden from Izunio came to Kyoto to perform on the dry banks of the Kano River, she capitalized on the notoriety the *Kabuki-Mono* had achieved and began to incorporate their extraordinary conduct and outfits into a popular religious dance called *Nembutsu Odori*. By 1603, Okuni's dance, which had gradually taken on suggestive erotic overtones, was widely known as *Kabuki Odori*. Before long, groups of enterprising prostitutes who saw potential profit in exploiting Okuni's success, began to tour Japan, performing her provocative dances wherever they could find an audience. The total effect of their displays was rather exotic and seductive, every gesture conveying some subtle sexual nuance. Men were naturally drawn to these exhibitions and as *Kabuki Odori* became more and more explicit in nature, its audience grew in size as well as in unrestraint. As a result, many performances soon degenerated into drunken brawls, with men grabbing at the dancers and fighting one another.

It was not long before these disruptive gatherings came to the attention of the government, and in 1629 all female dancers and performers were banned on the grounds of their being detrimental to public morality. The ban, however, did not produce the desired result; rather than discontinue a very lucrative business, many impresarios began to hire attractive young boys to play female parts, and in a short time, these children were being abused and molested, having become nothing more than male prostitutes. Realizing that it had merely allowed the substitution of one vice for another, the government banned these boy actors, and after 1652, all female roles were assumed by male performers called *onnagata*. As a

further precautionary measure, all actors were henceforth required to shave their heads and wear forelocks, in the hope that the physical appeal of a troupe's younger members would be somewhat diminished. These regulations finally succeeded in curbing *Kabuki*'s pornographic. tendencies, and from this time on it began to take on the dramatic aspect and character that would eventually make it a great art.

Within a short while, *Kabuki* grew to become a flamboyant, electrifying spectacle, thrilling its public with extraordinary sights and sounds. Yet, the audiences who poured in to see its stunning productions came not only for the play itself but also for the sheer excitement of being inside a *Kabuki* theatre. Filled with fabulous shops, restaurants, and souvenir stalls, it provided theatre-goers with a total social and cultural environment while they savoured long dramas which would often last the entire day. However, the main attraction by far lay in the charismatic allure of the actors, who were adored and idolized despite their low rank in Japanese society. Though the upper class regarded these performers as *kawaramono*, or "River-bed Beggars", scandalous love affairs between them and various ladies of the shogun's court would frequently come to the public's attention. Such news, of course, would only serve to heighten a performer's mystique, and a fresh wave of adulation would sweep through the wives and daughters of Edo's wealthy merchants. Theatre managers were quick to seize upon this impassioned response, and in no time at all, their stalls were replete with sensational prints, posters, and playbills depicting leading actors in their latest roles. *Kabuki* was, above all, a visual experience, and the lavish costumes, fantastic make-up, and incredibly magnificent sets which transfixed its audiences could be effectively captured by the medium of *ukiyo-e*. Because of this affinity, by the end of the seventeenth century, there was established between *Kabuki* and *ukiyo-e* a long-lasting partnership that would ultimately propel them both towards international recognition.

The term *ukiyo-e* is Buddhist in origin, and therefore its initial meaning had a solemn religious connotation. It referred to the ephemeral nature of human life and was literally translated as "this wretched world" or "this world of misery". Not until the middle of the seventeenth century, when Asai Ryoi used the word for the title of his book, *Ukiyo Monogatari* (*Tales of the Floating World*), did it come to define a certain style of life. Ryoi aptly captured its significance for the pleasure-loving crowds of Edo by describing it as "living only for the moment, gazing at the moon, snow, cherry blossoms and autumn leaves, enjoying wine, women and song, drifting along with the current of life, like a gourd floating down a river". Though Ryoi surrounds *ukiyo* with charming implications, he also associates it with an image of aimlessness and empty-headedness, retaining some of the word's original Buddhist overtones. This slight note of criticism, mixed with an obvious sense of delight. formed an appropriate commentary on the profligate yet congenial lifestyle of Edo's rising merchant class. Oppressed by a Shogunate that severely curtailed any productive development of their wealth, they had no alternative but to dissipate it on momentary diversions and amusing trifles. A culture grounded in such illusory pursuits was understandably transient, yet the ever-shifting depths of this "floating world" (*ukiyo*) were to yield pictures (*e*) that would someday immortalize its evanescent beauty.

The history of the wood-block print extends as far back as 770 AD, when close to a million copies of some Buddhist charms were made and distributed in Japan. Although these are the oldest existing prints in the world, the Chinese, who invented paper and printing, were producing them long before the Japanese. During the Han Period (206 BC–220 AD) they are known to have made ink prints from stone engravings, many of which were used as chops or seals for stamping names on paintings and official documents. It is difficult to tell when the Chinese first began to carve blocks for pictorial purposes though it is certain that near the end of the sixth century the founders of the Sui Dynasy had surviving classical books and their illustrations engraved on wood. By the end of the T'ang Dynasty (618–904 AD) wood-block prints were being used as a means of reproducing popular images of Buddha for the masses, and when

Buddhism was introduced into Japan in the early eighth century, it was through these religious prints that her craftsmen became acquainted with the technique of woodcutting. For centuries they would continue to use it for the propagation of Buddhist teachings and the illustration of literary works till the coming of *ukiyo-e* would at last free it from these subordinate roles and raise it to the status of an independent art.

The first artist to design and publish single-sheet wood-block prints (*ichimai-e*) was Hishikawa Moronobu (1618–1694). His perceptive insights into Japan's changing cultural climate led him to the realization that Edo's *nouveau riche* were ripe for an art form especially suited to their particular expectations and needs. Neither the Kano school, which served only the Shogunate and its lords, nor the Tosa school, which was officially engaged by the old Kyoto court, was producing work that could satisfy the townspeople's desire for small, vivid compositions dealing with life as they saw and experienced it. Bored by the unwieldy, pseudo-Chinese screens that lined the halls of upper class homes, Edo's populace began to rebel against the moralistic content of these Confucian tableaus and turned increasingly towards paintings which depicted the sexual intimacies and passions of the *demi-monde. Ukiyo-e* arose to meet this demand, and therefore, like *Kabuki*, it began as an erotic form of entertainment ultimately destined to capture the patronage of the wealthy bourgeoisie; in fact, its content was at first so explicitly sexual that the terms *higa* (erotic picture) and *ukiyo-e* were often used interchangeably during the Edo Period.

However, in pioneering the *ukiyo-e* school of printmaking, Moronobu and his followers produced art objects that conformed to popular standards not only in subject matter but also in form. The single-sheet format, combined with the process of wood-block reproduction, encouraged the publication of large amounts of new, ever-varying prints at relatively little expense to middle-class consumers, who were exasperated with costly, ponderous murals designed to endure for decades. The populace's love of novelty and variety must have impressed itself on Moronobu's mind during the years he spent as a designer of textile patterns while assisting his father, a well-known embroiderer and cloth-dyer. When Moronobu came to Edo in the late 1660's, this familiarity with the vagaries of public taste proved invaluable in his development of an art form that was capable of adjusting itself to any trend or sudden shift in fashion. Eventually, it was because of this protean quality that the *ukiyo-e* print became the most characteristic expression of a "floating world" which was as mutable and multifarious as the aesthetic tradition it had inspired.

Though he had produced many admirable paintings, Moronobu did not attract any attention until the 1660's, when he began creating wood-block designs for *ehon* (picture books). These works in which he could utilize his talents in a unique way, were so much to his liking that, by 1673, he had conceived the idea of designing single-sheet prints and presenting them to the public as objects worthy of aesthetic merit in their own right. In addition to the merchant class's expanding assertion of its own tastes and preferences, there was one other factor which made the moment propitious for such a venture. Having destroyed more than half of Edo in 1657, the great fire of Meireki had succeeded in obliterating almost every trace of the Kyoto-Osaka culture that had dominated the early Edo Period. Artists and craftsmen of all kinds were beginning to rid themselves of a weighty influence which had often inhibited originality and experimentation. Moronobu was, of course, no exception and in a short while he had explored every aspect of his new medium, using the wood-block process of his time to its fullest capacity. However, since engravers had not yet developed a great deal of expertise, he was forced to work within certain limitations. As a result, he kept his compositions simple and made striking use of solid black areas. Apparently, the difficulties of mastering a new genre must have stirred Moronobu's imagination all the more, for his single-sheet prints possess a spontaneity and energy that were rarely duplicated by later *ukiyo-e* artists. Unfortunately, very few of his prints have survived and most of these are unsigned.

Moronobu's most productive and successful pupil was Sugimura Jihei, who worked during the years 1680–1698. Though very little is known about this early artist of *ukiyo-e*, there is evidence that he designed some of the first *ichimai-e*. However, most of his work was done for *ehon* and it is estimated that over three-quarters of his illustrations were *shunga* (erotica). On the whole, his prints were executed only in black ink (*sumi-e*), though a few of these were then hand-coloured in soft, delicate hues as the public began to express more and more delight in this subtle new feature. Yellow and green were often used in these prints, together with vermilion, which was by far the predominant colour. Because of this characteristic, they were called *tan-e* or "vermilion pictures".

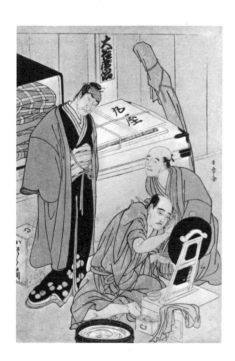

Another of Moronobu's outstanding students was Furuyama Moroshige who worked from 1678–1698 and made his reputation as an *ehon* illustrator of courtesans. His work was of such superior quality that he was allowed to use his master's name, though in time he reverted to his own signature. Regrettably, very little of his work has survived. Within a comparatively short period, the Hishikawa School of printmaking which Moronobu had established went into decline. After several years of designing *ehon* and *shunga*, Moronobu's eldest son and pupil, Hishikawa Morofusa, whose work covered the period 1685–1703, left his father's trade and returned to work as a dyer and embroiderer of fabrics in the family's traditional business. Though he was not as gifted as some of Moronobu's other students, his absence left a gap which the Hishikawa School could never overcome. However, despite its brief duration, it succeeded in dominating the field of *ukiyo-e* during the entire Genroku Era (1688–1704) with a distinctive, new style of genre art that even today evokes the halcyon days of Edo's first flowering.

In 1687, a young *onnagata* (a *Kabuki* actor who played female roles) left Osaka and came to Edo with his family. His name was Torii Kiyomoto and in a few years he was to found a school of *ukiyo-e* whose style would, for nearly a century, be assiduously copied by every Japanese printmaker attempting to portray an actor. This impressive achievement started rather modestly in 1691, when Kiyomoto designed some large promotional posters for the theatre. From this simple beginning, there emerged the long line of Torii artists who, till the 20th century, were to serve the *Kabuki* as its official illustrators. The first link in this hereditary chain was Kiyomoto's second son, Torii Kiyonobu (1664–1729), who, following in his father's footsteps, began his career as a designer of theatrical billboards and programmes. These works were so successful that Kiyonobu soon expanded the scope of his enterprise by trying his hand at some *ehon* and *ichimai-e*. This undertaking was to change the course of *ukiyo-e*, for till now no artist had considered the *Kabuki* as a major subject for prints. It was not long before the potential of such a theme burst upon the great publishing houses, but to no avail, for by 1695 Kiyonobu had astonished his rivals by securing a monopoly on all the actor prints of every major *Kabuki* theatre in Edo. Kiyonobu's work had virtually exploded on the public scene; influenced by Moronobu and Kaigetsudo, he had developed a remarkable style characterized by a striking use of scarlet pigment (*beni*) and bold, sweeping lines which dramatically conveyed the swaggering bravura and bombastic histrionics that typified the contemporary *Kabuki* stage.

The next generation of Torii artists has caused scholars considerable confusion. It was at first believed that the work of Kiyomasu I, who worked during the years 1696–1716, was really that of Kiyonobu, who supposedly began signing himself as "Kiyomasu" after 1714. However, there is now considerable evidence which points to Kiyomasu's being either the eldest son or a younger brother of Kiyonobu. Though the work of the two is at times almost indistinguishable, Kiyomasu's style tends to be more delicate and graceful, especially in his illustrations of Yoshiwara beauties and *kacho* (birds and flowers). The second matter of dispute centres round the figure of Torii Kiyomasu II (1706–1763), who is assumed to be either Kiyonobu's adopted son-in-law or the same artist as Kiyonobu II, a son of Kiyonobu. He produced principally actor prints and was one of the first designers to colour his work with *beni* and *urushi* (a lacquer-like black).

Contemporaneous with Kiyomasu II's work are the prints of Torii Kiyotada (active between 1720–1750) and Torii Kiyoshige (active between 1720–1760), two of Kiyonobu's pupils. Those of Kiyotada are marked by a briskness and clarity of outline while Kiyoshige's exhibit a bolder, more vigorous use of space. Though both artists adhered to the basic Torii style, their work reveals the distinct influence of Okumura Masanobu, the eminent master of *ukiyo-e*, whose innovative concepts and techniques changed the face of Japanese painting and printmaking.

The next artist to appear on the Torii horizon was Kiyomitsu (1735–1785), the son and pupil of Kiyomasu II. Prior to the rise of Harunobu's popularity in the 1760's, his work was a favourite with Edo's crowds. True to the Torii tradition he excelled in the creation of prints dealing with actors and dramatic motifs, but at the same time, he was one of the most versatile *ukiyo-e* artists of the day. In addition to illustrating novels and theatre programmes, he was a skilful designer of *hashira-e* (pillar prints) and executed some exquisite *bijin-ga* (pictures of beautiful women), the most popular of which were usually accompanied by poems and depicted women in bathing scenes. Though most of Kiyomitsu's work was printed in two or three shades, he also produced some of the first multi-coloured prints by means of a polychromatic technique in which he was a pioneering force. His accomplished pupil, Torii Kiyohiro (active between 1737–1776), continued Kiyomitsu's experimentation with this method and by the 1750's was producing superb *benizuri-e* (primitive polychrome prints) in delicate hues of pink and green. Kiyohiro's métier was the genre print, and his compositions of fair young men and women in everyday scenes are among the best of his works, possessing an irresistible quality of charm and innocence. Unfortunately, like much of the early work done by his family, his prints are quite rare.

The history of the Torii artists discloses, to a great extent, the history of the technical developments which served to enhance the art of *ukiyo-e* throughout the eighteenth century. *Tan*, a red lead pigment used by the early Torii masters to hand-colour their prints, was within a decade replaced by *beni*, a more subtle crimson dye. *Urushi*, a black paint mixed with glue, was also popular during this period and colourists would apply it by hand to create an intense effect in isolated spots or to add a lacquer-like lustre to the entire print. Eventually, no matter how hastily and carelessly it was done, hand-colouring became too slow to keep pace with the accelerating demand for coloured prints. To meet this challenge, in 1741 the colour-printing process was finally invented, and the hand-tinted *beni-e* of the previous decades was forever superseded by the polychromatic *benizuri-e*, whose pink and green shades were used with such success by Kiyomasu II. By the time Kiyomitsu and Kiyohiro came into prominence, two other colours, purple and yellow, had been added to the printmaker's palette. As more and more shades began to be employed, the process of printing them was even further complicated, and it soon became apparent that a device was needed to facilitate proper register. As a result, in 1745 a publisher named Kichiemon Kamimura introduced the *kento*, or location mark, into wood-block printing; these marks were carved in relief at exactly corresponding points on each colour block involved in the making of a particular print. By using this simple method, printmakers were, from this time on, assured accurate register of all their colour prints.

From the very first days of Kiyomoto's posters, the Torii School had set itself up as a bridge between the two worlds of *Kabuki* and *ukiyo-e*. As both flourished and expanded in the pleasure-loving culture of Edo, each art enriched the other in a continuous exchange of themes, concepts, and images. In certain instances a definite intersection of their paths can be detected, and at such points *Kabuki* begins to take on the painterly aspect of *ukiyo-e* while *ukiyo-e* moves farther in the direction of its own theatricalization. For three generations, the Torii School occupied itself chiefly with the liaison between print and stage producing some of the most powerful works in the history of Japanese woodcutting. But as the store of *Kabuki* prints mounted day by day, it became increasingly difficult for Torii artists to design fresh, new compositions centred round what had

become for them an all too familiar subject. Gradually, many of them began to look for additional sources of inspiration, and by the second half of the eighteenth century their attention had primarily focused on the inherent possibilities of *bijin-ga*, prints depicting beautiful women. By applying certain elements of the Torii technique to this branch of *ukiyo-e*, they brought considerable vitality to a tradition that was beginning to languish and fade. The style they developed was eventually to culminate in the works of the great Torii master – Kiyonaga, whose unerring sense of form and proportion would raise it to sublime heights.

By the end of the seventeenth century another entire group of artisans, the Kaigetsudo, had attached themselves to the *ukiyo-e* school. As the Torii specialized in actor prints, so the Kaigetsudo excelled in courtesan portraits, capitalizing on the growing number of Yoshiwara habitués. Though its artists designed a substantial number of prints, much of what they produced consisted of large-scale paintings, which today constitute the bulk of their existing work. Despite the fact that the Kaigetsudo School (1700–1725) flourished for only a short time, it succeeded in creating an enormous impact on the culture and art of Edo's merchant class. Its ingenuous yet provocative courtesans, loosely draped in rich, billowing *kimono*, were to inaugurate that image of ideal feminine beauty which would be so ardently pursued by Japan's affluent parvenus, eventually becoming the very hallmark of *ukiyo-e* itself.

The master and founder of this school was Kaigetsudo Ando. Very little is known about his life except that he was banished to the desolate volcanic island of Izu Oshima in 1714 for his part in an infamous love affair between the *Kabuki* actor Ikushima and Ejima, lady-in-waiting to the shogun's mother. Before his expulsion from Edo, Ando had painted several very elegant portraits of courtesans; his beguiling figures, outlined in swelling strokes of black, seem to surge forward out of their impeccably empty backgrounds. Though several of his pupils attempted to reproduce the chic glamour of these idealized coquettes, very few of them were able to match Ando's flair and sophistication. Most of the prints produced by the Kaigetsudo studio were executed by five leading draughtsmen: Choyodo Anchi, Kaigetsudo Dohan, and Kaigetsudo Doshu; of these, only Choyodo was allowed to use *an*, the first character of his teacher's given name, which has led some scholars to believe that he was a relative of Ando. The illustrations done by this group so closely resemble one another that, for a long while, many experts believed they were all the work of one artist. A survey of their extant *onna-e* (pictures of women) gives one the impression that their combined efforts in this domain must have been a series of endless and at times almost imperceptible variations on a single theme – the stylized, faultlessly refined form of Ando's courtesans.

One of the great *ukiyo-e* artists to be influenced by the Kaigetsudo style in his own portrayals of women was Okumura Masanobu (1686–1764), whose real name was Genroku. Originally an Edo bookseller and publisher, Masanobu rose to become the most honoured and influential *ukiyo-e* artist of his generation, his work so successful that many times he could not resist signing it with the boastful epithet, "Okumura Masanobu – Originator of *Ukiyo-e* Pictures". His imaginative theatrical prints were quite popular, but on the whole his fame hinged upon his enchanting *bijin-ga*, gay, affectionate vignettes of women engaged in various pastimes and duties. Because he was often his own publisher, Masanobu exercised an unprecedented amount of control over the technical execution of his print designs, and as a result, their colouring and detail were superior to any other works of the time, being carefully planned and beautifully carried out. His experience with all facets of the printmaking process also proved to be a decisive factor in the formation of his aesthetic perception and creativity, for it enabled him to see, and experiment with, possibilities that remained hidden to those without his technical expertise. Versatile and inventive, he applied his talents in a number of broad-ranging ways. As well as being the originator of the *hashira-e* – long, narrow pictures used to decorate posts, Masanobu, after studying Dutch perspective engravings, conceived of designing *uki-e*, or "bird's eye-view" pictures. In addition to these innovations, the first use of lacquer in the

urushi-e is attributed to him, and some scholars even believe he was the first to change from hand-colouring to colour printing. However, heading the list of Masanobu's achievements is his outstanding work with the album (a series of prints on a given theme), of which he continues to remain Japan's uncontested master.

Masanobu had two major pupils, Okumura Toshinobu (active between 1717–1750) and Okumura Genroku (active between 1710–1740), both of whom were probably his adopted sons. Toshinobu was highly talented and his portrayals of courtesans and *onnagata* are rendered with great sweetness and delicacy. Most of his prints are intricately hand-coloured *hosoban*, embellished with skilful touches of lacquer. For some reason, perhaps because he feared the quality of his prints would deteriorate, Toshinobu stopped working soon after colour printing was invented. Like his fellow pupil, Genroku also left his profession rather abruptly, producing fewer and fewer prints after 1724, the year he joined Masanobu's newly established print-publishing business. For many years Genroku's work was confused with that of Masanobu's, since scholars generally considered the signature "Genroku", which was Masanobu's pseudonym, to be an indication of his work; however, it is now believed that prints signed with this name were done by the pupil and not the master.

Another remarkable artist of this time was Nishimura Shigenaga (1697–1756). Born in Edo, he became the proprietor of a tea-shop and then a book store until, inspired by Kiyonobu and Masanobu, he began designing prints. Following their example, Shigenaga was a boldly innovative and original artist, becoming one of the first printmakers to work with an amazing variety of relatively untried formats: *uki-e*, *hashira-e*, *urushi-e*, *hosoban*, and the triptych. His choice of subject matter was equally diverse; though he specialized in *bijin*, often using the novel approach of partial nudity, Shigenaga also did prints of *kacho* (flowers and birds), actors, and scenic views, a genre he renovated by introducing human figures into the landscape. However, one of his finest contributions to *ukiyo-e* was his ability to impart the knowledge and experience he had acquired, for besides being an accomplished artist, Shigenaga was an inspirational teacher, guiding and shaping the styles of such students as Kitao Shigemasa, Utagawa Toyoharu, Ishikawa Toyonobu, and perhaps even the famous Harunobu.

The work of Ishikawa Toyonobu (1711–1785), Shigenaga's famous but mysterious student, is still surrounded by a great deal of controversy. A feudal retainer by birth, Toyonobu married the daughter of an innkeeper and eventually inherited the inn when his father-in-law died. Up to this point he had produced a great number of prints, using the name of Nishimura Shigenobu from 1730 to 1747, and then that of Ishikawa Toyonobu from 1747 to 1765, after which he made almost no prints. Although most critics adhere to this theory, a few feel that the radical discrepancy between the work of the earlier period and that of the later, which is more polished and refined, warrants the claim that Shigenobu and Toyonobu are actually two different artists. In any event, there is no doubt that the later prints were done by Toyonobu and that they are of superior craftsmanship, displaying the fluid yet disciplined sense of line and form which made him the master of the difficult *kakemono* format. The majority of his prints are of *bijin* and *Kabuki* actors, who are portrayed with remarkable nobility and elegance.

Although *ukiyo-e* had initially taken root in the hotbeds of Edo's *demi-monde*, its offshoots were beginning to bloom in environments once considered hostile to its ethos. One such place was the ancient, imperial city of Kyoto, birthplace of the artist Nishikawa Sukenobu (1671–1751), who successfully established a school of *ukiyo-e* there. Somewhere about 1710 he started designing picture-book illustrations, many of which are among the most beautiful ever produced in Japan. Though his work was unquestionably influenced by the Edo *ukiyo-e* artist, whose *ehon* were continually circulating in Osaka and Kyoto, Sukenobu had received his primary training under the Kano master, Eino, as well as the Tosa master, Mitsusuke; as a result, his style reveals traces of classical restraint and understatement, making the character of his work much more genteel than

that of other *ukiyo-e* artists at the time. Most of his designs are of *bijin* – delicate, winsome creatures who assume calm, idealized poses – and it is quite possible that Harunobu's sensitive treatment of this popular subject owes much to the spirit of these lovely, fragile figures. Sukenobu was succeeded by his pupil, Tsukioka Settei (1710–1786), who also initially studied with the Kano school. Because of his aristocratic training, Settei's best work, like Sukenobu's, possesses the quiet grace and harmony that characterize Kyoto *ukiyo-e*.

As early as 1745, Sukenobu was attempting to turn out six-colour prints in Osaka. However, it was not until 1765 that *nishiki-e*, or full-colour prints, made their first successful commercial appearance in Edo with Suzuki Harunobu (1724–1770), the brilliant luminary of the age. The honour of actually inventing the process of colour printing does not go to

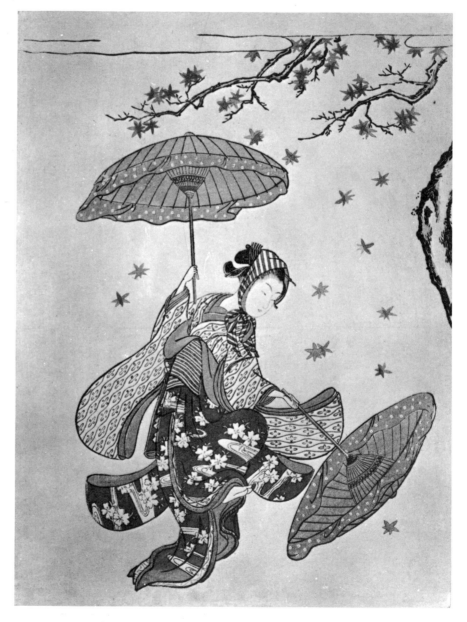

Harunobu, but it is certain that he was the first artist to employ this technique, and for this reason he is considered to be the father of the colour wood-block print. In reality, *nishiki-e* was the brainchild of the leisure class, originating among the wealthiest connoisseurs of Edo, where it became the vogue for these sophisticates, men of great urbanity and impeccable taste, to meet and hold competitions in which they would submit their most exquisitely designed *e-goyomi* (small, esoteric calendar prints) for the discriminating verdict of their peers. Because government regulations forbade the issuing of calenders by anyone other than registered calendar publishers, *e-goyomi* were made in relative secrecy and surrounded by considerable intrigue. Their enigmatic ciphers and images would often conceal their true, temporal purpose, and the task of

outwitting the authorities, combined with that of integrating practical functionality and aesthetic beauty, proved quite challenging to the ingenious creators of *e-goyomi*. No expense was spared in the printing of their compositions; only the finest pigments and most flawless paper were used, along with elaborate gauffraging techniques which further enhanced the lush effect of the final product. It was inevitable that such intricately designed and beautifully crafted objects should find their way into the world of *ukiyo-e*, and it was from them that its artists and impresarios developed the first *nishiki-e*.

Nishiki-e, literally "brocade pictures", were so named because of their deep, rich texture and colouring, which easily distinguished them from the old *benizuri-e*, whose paper was of poor quality and range of colour limited. It was not until very late in his life, when Suzuki Harunobu began producing these new, full-colour prints, that his creative powers reached full maturity. From 1765 to the time of his death he achieved an immense output, drafting well over five hundred prints within the brief span of five years. Besides this astounding prolificacy, Harunobu's shift to a new technical process sparked a dramatic change in his style and subject matter as well. Whereas he had been designing primarily actor prints up to this point, at the age of forty-one he seems to have shaken off the influence of the Torii School, and set out to create that beguiling universe of innocent, fair youth with which he enchanted the hearts of Edo's public. Though he did produce some successful *hashira-e* and *hosoban* prints, most of his work was done in the *chuban* size, whose proportions were particularly suited to the expression of his unique gifts.

In almost all of his later prints he depicted his female subjects in a somewhat sentimental and diminutive manner, giving them slight, supple bodies with delicately small hands and feet. Nonetheless, this idealistic treatment of lovers and courtesans was adequately matched by the earthiness of his erotica, whose robust spirit and execution offer a sharp contrast to his more romantic pieces. On the whole, however, Harunobu's conceptions, which are meticulously worked out and superbly rendered, have a rare lyric beauty that is subtly communicated by his faultless handling of tone and texture. With his work, the *ukiyo-e* colour print, cultivated and refined down through the years by such artists as Moronobu, Kiyonobu, and Masanobu, finally came to fruition.

After Harunobu's death, Shiba Kokan (1747–1818) capitalized on the old master's popularity and started making prints that closely imitated his style. In some instances Kokan signed his work with the name of "Harunobu" but he eventually became disturbed by the implications of such a practice and adopted the pseudonym of "Suzuki Harushige", under which he continued to publish uncannily precise copies of Harunobu's work for several more years. In time Kokan grew tired of what must have been a tedious, mechanical enterprise; dissatisfied and bored with Oriental art, whose spirit he felt was exhausted, Kokan restlessly searched for new directions until his felicitious discovery of the West.

By 1782 he was deeply absorbed in the study of Dutch engravings which had been smuggled into Edo from the forbidden port of Nagasaki, where he had also seen books on European art. Excited by these revelations, he began to work in the Western manner, producing some oil paintings as well as some exceptionally rare copperplate engravings of European perspectives. Kokan's infatuation with the West did not, however, yield only pictorial results, for it also prompted two literary endeavours: one an essay extolling the virtues of Western art as opposed to Japanese and Chinese, and the second a travel book about Nagasaki containing illustrations of its Dutch settlers and their living quarters.

The other artist who designed prints almost indistinguishable from those of Harunobu was Isoda Koryusai (active between 1764–1788), whose real name was Masakatsu. Originally a *samurai* for the Tsuchiya family, Koryusai renounced his high military status to become a *ukiyo-e* artist. When he first arrived in Edo, it is likely that he studied under Nishimura Shigenaga; however, the main influence on his work was ultimately to come from Harunobu, who gave him the name of "Koryusai", the *go* he had once used himself. So great was Koryusai's respect for his teacher that

he began to evolve a style of his own only when Harunobu died, gradually emerging from his master's shadow to develop into one of *ukiyo-e*'s most prodigious talents.

By the late 1770's he had demonstrated expertise in several different areas, producing lovely examples of *kacho* and *bijin* in addition to his stunningly designed *hashira-e*, whose stylistic excellence is still without parallel among other prints of this kind. However, besides his commanding use of this format, Koryusai was also expert in his handling of the large *oban* format, which he used to portray famous courtesans, most of whom are sumptuously draped in *kimono* whose sensuous folds and bright tangerine tones became the rage of the day. Somewhere in the early 1780's the prestigious rank of *hokkyo* was conferred on Koryusai, and soon after this, duly impressed by the honour, he stopped designing prints and devoted all his time to a Kano-influenced style of painting.

Katsukawa Shunsho (1726–1793) marks a milestone in the development of *ukiyo-e* for with his unprecedented attempt at realism he singlehandedly revolutionized the *Kabuki* print. Originally a pupil of Katsukawa Shunsui, a painter of beautiful women in the *ukiyo-e* style, Shunsho first began designing prints when he fell under the influence of Harunobu. As a result, most of his early prints were of *bijin*, and it was not until the mid-1760's, when he drafted his initial series of actor prints, that he found his true province. Having abandoned the school of painting with which he had once associated himself, Shunsho did not at this time have a seal of his own, and he was forced to borrow the jar-shaped insignia of the publisher Hayashiya, whose encouragement and financial support smoothed the way for his ultimate success as a printmaker. Because of this seal, which appeared on many of the *Kabuki* prints he designed at the outset of his career, Shunsho became known as *Tsubo*, or "The Jar", for this small emblem was often the only means of identifying his prints, which were otherwise left unsigned.

It was not long, though, before Edo's avid theatre fans came to identify his work on the basis of its unmistakably unique approach; whether Shunsho chose to depict an actor performing on stage or lounging in his dressing room, he would be sure to give him the individual traits and features that set his personality apart from all others. For the first time in history, *Kabuki* audiences thrilled to the prospect of being able to recognize their idols in a print, and Shunsho's bold departure from the traditionally stereotyped representation of actors was rewarded with overnight fame. Heartened by the public's enthusiasm, he started to design prints of non-*Kabuki* subjects and in time became as adept at portraying the massive bulk of a *sumo* wrestler as at sketching the slender lineaments of a celebrated beauty. In 1776 his talents in the latter area culminated in the remarkable illustrations he did for the famous *ehon*, *Mirror of Beautiful Women of the Green Houses*, on which he collaborated with Kitao Shigemasa.

Heading the impressive list of Shunsho's students is his first pupil, Katsukawa Shunko (1743–1812), who also used a jar-shaped seal and as a result is sometimes referred to as *Kotsubo* or "Little Jar". He followed Shunsho's style quite closely, producing principally *Kabuki* prints in the *hosoban* size. Some scholars have suggested that he is the *ukiyo-e* artist responsible for the invention of the *okubi-e*, prints displaying only the head or head and upper torso of their subject. When he was about forty-five years old he suffered a stroke which left his right side paralyzed, and from that time on he worked with only his left hand, adopting the *go* of *Sahitsusai*, or "Studio of the Left Brush". In his old age Shunko seems to have forsaken his occupation for the more tranquil joys of the priesthood. Like Shunko's, the life of Katsukawa Shun'ei (1762–1819), another of Shunsho's brilliant students, is also noted for its singular circumstances. In addition to being a gifted painter and printmaker, Shun'ei was also a formidable musician and an expert on the theatre; however, numerous as his talents were, Shun'ei was also known for his many eccentricities. His contemporaries would frequently comment on his odd, unpredictable behaviour, pointing out his somewhat comical attire and capricious exploits. Nonetheless, his skill as a designer was so outstanding that after

Shunsho's death he became the undisputed head of the Katsukawa School. His witty, often sardonic portrayals, the best of which reveal his strong sense of the uncanny, are typified by the dramatic composition and eerie colouring that influenced Sharaku and Toyokuni I.

After Shunsho and Shun'ei, there are several other artists whose work represents the best of the Katsukawa style. Katsukawa Shuncho (active between 1780–1795) began his training under Shunsho, but early in his printmaking career became so enthralled with Kiyonaga's *bijin-ga*, and later Utamaro's, that he turned from his *Kabuki* subjects to do prints of Yoshiwara courtesans. Though many of these, with their softly luminous hues, proved to be quite popular, Shuncho eventually gave up his craft to write novels. Working during almost the same period as Shuncho was Katsukawa Shundo (active between 1780–1792). Very little is known about his life except that he was a pupil of Miyagawa Shunsui, Shunsho's teacher, and then studied with Shunsho himself, whose technique he followed very closely. Though his forte was the illustration of books, he executed some superior *Kabuki* prints, very few of which survive today. Katsukawa Shunjo (?–1787), whose given name was Yasuda Ganzo, also studied under Shunsho. He began his career as an illustrator of *kibyoshi* or "yellow books" (cheap popular novels), and it was not until the mid-1780's that he began designing actor prints in the Katsukawa style. Because he is buried near Shun'ei there is some speculation that he may have been a relative of his. Katsukawa Shunsen (1762–1830), one of Shun'ei's students, stayed within the Katsukawa tradition for a while, working only with theatrical themes, but eventually branched out into genre scenes, *bijin*, and landscapes. In the early 1820's, finding a more congenial trade, Shunsen abandoned printmaking and became a porcelain designer. Finally, we come to Katsukawa Shunzan (active between 1782–1798), another of Shunsho's students who was captivated by Kiyonaga's genius. Like Shuncho, he pushed aside his early artistic preoccupation with *Kabuki* actors and historical warriors to concentrate solely on *bijin*.

There is one other artist who, although not a student of Shunsho or a member of the Katsukawa School, was nevertheless an important contemporary of Shunsho and worked with him on a number of projects, including the three-volume work, *Portraits of Actors in Fan Shapes*. This man was Ippitsusai Buncho (active between 1765–1792). A *samurai* by birth, he was trained to paint in the Kano tradition but was gradually drawn toward Harunobu's technique and, much to the dismay of his family and friends, became a printmaker. While many of his actor prints show traces of Shunsho's realistic approach, they are as a whole more stylized and less vigorous than his. Even Buncho's *bijin-ga*, though they are similar to Harunobu's, are informed by a distinctly individual flavour and sensibility which reside in his elegant, measured lines and subtly muted tones. Towards the end of his life, to the great satisfaction of his relatives and close associates, Buncho quit his profession, and returned to activities considered more suitable for *samurai*.

During the latter half of the eighteenth century there arose another school of importance – that of Kitao Shigemasa (1739–1820), son of the publisher Suharaya Saburobei. A precocious and primarily self-taught child, Shigemasa possessed such outstanding calligraphic skill that, at an early age, he was already being commissioned to make almanacs. As the artistic promise of his youth realized itself, he branched out into other disciplines, and growing inspired by the work of such *ukiyo-e* masters as Kiyomitsu and Harunobu, he began painting, designing prints, and illustrating *ehon*, many of which exhibit superb form and craftsmanship. In 1776, working with Shunsho, he produced the celebrated *Mirror of Beautiful Women of the Green Houses*, whose enthusiastic reception by Edo society prompted his brilliant pupil, Kitao Masanobu (1761–1816), to follow suit with the flawless specimen of *ukiyo-e* printing – *Mirror of the New Beauties among the Yoshiwara Courtesans*. Unfortunately, in 1785, a year after his spectacular album was published, Masanobu's fame as a novelist soared and he ended his career as a printmaker to pursue his literary ambitions, eventually becoming known as a Santo Kyoden. Both

Shigemasa and Masanobu specialized in the subject of *bijin* as did many *ukiyo-e* artists before them. Signs of a distinctly novel approach in their work and that of their followers can, however, be discerned. Just as the Katsukawa School had introduced an element of verisimilitude into its portrayals of *Kabuki* actors, the Kitao School began to aim at a more natural, life-like conception of women. The thread of realism running through their compositions would soon appear as a precious filament in the glistening web of fantasies that *ukiyo-e*'s greatest artists would weave around the Japanese courtesan; in time, its singular lustre was to spark that dazzling projection of sensual beauty which ushered in the "Golden Age" of *ukiyo-e*.

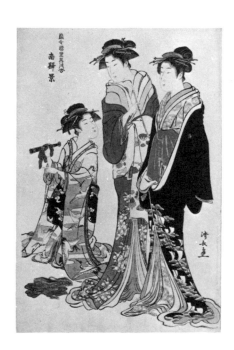

By the third quarter of the eighteenth century *ukiyo-e* reigned supreme among the graphic arts enjoyed by Japan's rapidly expanding middle class. Nearly two centuries of peace under Tokugawa rule had brought, for her aspiring tradesmen, an unbroken chain of auspicious economic circumstances. Its wealth now consolidated and its taste educated and defined, the merchant class began to assert itself within the cultural life of Japan's great urban centres. No longer content with the rather vulgar trifles aimed at plebeian appetites, bourgeois aesthetes sought out only those objects that were lucidly conceived and faultlessly rendered. It was an age when the hedonistic culture they had established in Edo broke into luxuriant bloom, sending its lush scent across the entire land. Before long, Japan's newly aroused sensibilities elicited an unprecedented outpouring of artistic productivity from the rising generation of *ukiyo-e* masters, a small band of young artists in whose hands the *ukiyo-e* print was destined to reach its extraordinary apex.

The "Golden Age" of *ukiyo-e* seems to have begun with the first stirring of Kiyonaga's awesome genius. The age-old influence of the Primitive Masters no longer exerted itself and the last traces of their naive charm had disappeared from the *ukiyo-e* print forever. By the same token, the bright-eyed, innocent creatures of Harunobu's idyllic world had metamorphosed into the more robust, lusty figures of Koryusai's later work.

It remained for Torii Kiyonaga (1752–1815), the son of an Edo book-seller, to restore to the image of the Yoshiwara beauty that bright aura which had traditionally surrounded her erotic allure. While still a child, Kiyonaga was apprenticed to Kiyomitsu, who shaped and guided his early attempts at *Kabuki* portraiture. Although his abilities in this area were far from ordinary, it was not until he encountered Harunobu and had shifted from theatrical subjects to those of the "floating world" that his true potential for greatness asserted itself. By the early 1780's he had developed a style which swept the populace of Edo off its feet. Flawless in body and calm in spirit, the courtesans who inhabit the imaginary dominions of his art distilled their intoxicating presence throughout the fashionable world of the Temmei Era. Their immaculate flesh seems to be suffused with light, and in manner and bearing they recall the serene goddesses whose luminous marble effigies once graced the Athenian Acropolis. Kiyonaga communicates the mysterious ebullience of their lithe, supple forms by the undulating, almost hypnotic, flow of line which so captivated the Katsukawa artist, Shuncho. Though Kiyonaga had a son (Kiyomasa) and a grandson (Kiyomine), who would later take his place as fifth-generation head of the Torii School under the name of Kiyomitsu II, neither carried on his style, and it was Shuncho alone who continued to produce prints in the manner of his beloved and unsurpassable master.

Kubo Shunman (1757–1820), whose emergence during the "Golden Age" was of a more quiet nature, came to be one of the period's most polished and accomplished artists. Like others of his generation, he spent the early years of his career under the spell of Kiyonaga's genius, and only later started to produce markedly original prints whose subtly gradated colouring added to their understated elegance. However, in 1791, Shunman stopped making these delicate *oban* sheets and began devoting his time to the designing of *surimono*, deluxe, limited-edition prints. *Surimono*, literally "printed things", were the natural offspring of *e-goyomi*, or calendar prints, which had originated a few decades earlier. Initially, they were privately commissioned by exclusive clubs of poets,

artists, or scholars who wished to mark the printing of certain lavishly crafted *surimono* designs. In time, wealthy merchants began to order these prints to commemorate special occasions such as the opening of a new *Kabuki* drama or the wedding of a favourite child. As more and more sheets were produced, the art of the *surimono* was perfected and it came to represent the highest standards of engraving and printing, often yielding masterpieces which are still today considered as absolute gems of *ukiyo-e* artistry.

By the time Shunman had started to design and write verse for his own *surimono*, Kiyonaga's fame was all but eclipsed by the awesome figure of Kitagawa Utamaro (1753–1806), who would continue to tower above his contemporary rivals for nearly a quarter of a century. The date and place of

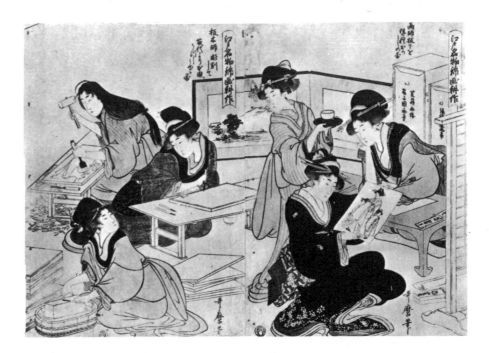

Utamaro's birth have never been ascertained but it is known that, as a young boy, he moved to Edo and began studying with Toriyama Sekien, the famous Kano-trained master who founded a school of *ukiyo-e* painting. Like all artists of the day, Utamaro launched his career by drafting illustrations for playbills and yellow books, but within a short time his talents had so outstripped these commonplace projects that he began designing his own *ehon*. With the appearance of such albums as *The Insect Book*, *The Silver World*, and *Gifts of the Ebb Tide*, breathtaking treasuries of the natural world, his reputation was established, and by 1790 he was the undisputed master of the age. Utamaro's prodigious fame did not, however, rest entirely on his stunningly recorded observations of flora and fauna, for during this period he was deeply engrossed in another type of phenomenon – the Yoshiwara courtesans. Having moved in with the renowned publisher Tsutaya Jusaburo, the eminent patron of *ukiyo-e* art, whose residence was on the edge of the licensed brothel district, Utamaro lost no time in availing himself of its enticing denizens. Wholly immersed in the delirium of sensuality, Utamaro was to conjure up the infinitely nuanced image of erotic beauty that would mesmerize the world.

Marked by the careful attention to detail that characterizes his finest *ehon*, Utamoro's women are imbued with a sense of warm, palpable flesh which seems to be animated from within by the quivering, flame-like essence of their being. The very perfume of their garments seems to linger round them, and at times the peculiar bent of their necks or curve of their shoulders has the power of suggesting voluptuous depths of sensuality. This quality of subtle intimation is especially apparent in the *okubi-e* designed by Utamaro, who was the first to use this type of format for the portrayal of courtesans. In these sensitive facial studies, we can see a deliberate attempt to go beyond the conventional image of femininity

created by his predecessors and an effort to capture the elusive intimations
of personality. Such a purpose pervades his later work, which begins to
embrace every form and aspect of womanhood, whether it be the
instinctual energy of a wild mountain woman or the quiet self-containment
of a shopkeeper's wife. As intimate depiction of human passion and
temperament, these compositions embody the culmination of the natural
style in Japanese *ukiyo-e*.

Besides his stylistic innovations, Utamaro made many technical
contributions to the art of the colour print. The new yellow (*kizuri*) and
grey background (*nezumi-tsubushi*) prints, though not originated by him,
were perfected and popularized because of his expert craftsmanship.
However, his most spectacular achievement by far lay in his brilliant use of

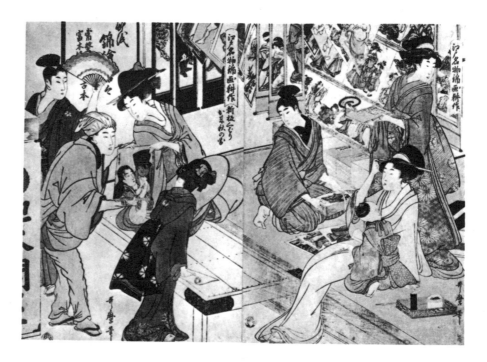

the mica background, whose invention was largely the product of
Jusaburo's ingenuity. Though centuries back mica had been used to
decorate the texts of early Buddhist manuscripts, it was not until the early
1790's that it made its first appearance in an *ukiyo-e* print. The process
involved in mica printing, while costly and tedious, produced stunning
results. Ground into a fine powder, the shimmering mica was sprinkled on
sheets whose surface had been prepared with a special mixture of rice
paste; when the silvery substance had settled, it was imprinted with the ink
design. The total effect of a finished *kirazuri* print was quite gorgeous;
glistening with frosty iridescence, its pristine background made figures
stand out with razor-edged clarity. Understandably, any such print soon
became a highly coveted object among Edo's affluent townspeople, who
came to regard the possession of one as a symbol of great prestige.

Yet, for all its fashionableness, within a few brief years, the mica print,
like all other exotic manifestations of bourgeois wealth, was on its way out.
In 1790, displeased and alarmed by the extravagant squandering of money
by the merchant class, the Shogunate was compelled to issue a series of
edicts placing restrictions on all articles of luxury and frivolous forms of
entertainment. A large part of these sumptuary laws provided for rigorous
governmental control of printed and illustrated matter. By way of example,
in 1791 Tsutaya Jusaburo suffered the confiscation of half his estate for
publishing a novel about the Yoshiwara written by Santo Kyoden.

The full thrust of such political reprimands, whose impetus came from a
desperate desire to curb the powerful forces overwhelming Tokugawa
feudalism, was aimed at the heart of Edo's middle-class culture. The
Shogunate was unyielding, and its ominous hints of coercion and duress
heralded the coming of that tyranny over the arts which would, in a few
decades, almost succeed in bringing about the demise of *ukiyo-e*.
Regrettably, this momentous contest of wills between the old order and

39

the modern was not without its martyrs. In May of 1804 Utamaro was imprisoned for designing the triptych, *The Taiko and His Five Wives Picnicing at Rakuto*, whose subject matter violated censorship laws. On his release, he was manacled for fifty days in a manner that was imposed on only the lowest sort of citizen. Broken in spirit and badly overworked by mercenary publishers, he died two years later.

There was now to enter upon the *ukiyo-e* scene one of the greatest portraitists of all time – Toshusai Sharaku. During an incredibly short career span, ten months between the years 1794 and 1795, Sharaku executed masterpieces which critics have placed alongside the portraits of Rembrandt and Velazquez. In 1795, having produced some 150 *Kabuki* prints, he disappeared from the art world forever. Though there is some speculation that he may have been a *No* actor retained by the lord of Awa, nothing further is known of his life. His compositions are generally *oban okubi-e* or full-figure portraits in the *hosoban* size; shrewd and incisive, they reveal a relentless, almost merciless, eye for detail. No quirk of behaviour or personal idiosyncrasy is left unrecorded, and the merest arch of an eyebrow or downward plunge of the mouth is made to convey the elusive substance of character. Sharaku is a brilliant master of innuendo, and while some of his prints express a whimsical affection for his subject, most are permeated with a sardonic, devastating wit. There is no question, however, that his most extraordinary moods are achieved with *kirazuri*; in the eerie void of black or grey mica-ground prints, his figures emerge like macabre apparitions, stark and spectral. At moments, one seems to detect in the steely glint of an eye a hint of madness, or lurking behind a crooked smile, something sinister and fiendish. This overpowering sense of melodrama, which is so superbly suited to the *Kabuki* stage, lies at the heart of Sharaku's ability to form images that haunt the mind's eye long after we have seen one of his prints. Like some fantastic wizard, Sharaku continues to stand at the summit of Japanese portraiture, creator of a world in which the demonic often assumes human shape and illusion stealthily dons the cloak of reality.

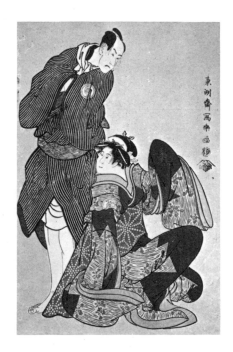

There were a great number of remarkable artists whose work imparted an added lustre to the "Golden Age"; many, unfortunately, have been overshadowed by the colossal talents of men such as Utamaro and Sharaku. Such an undeserved fate is especially apparent when we come to the figure of Chobunsai Eishi (1756–1829). Born of a *samurai* family that was part of the prominent Fujiwara clan, Eishi, like many children of aristocratic birth, was trained in the art of Kano-style painting. He was so successful at his studies that he was engaged as court painter by the tenth shogun, Tokugawa Ieharu; but, in a short time, growing weary of his duties, he bequeathed his position to his son and took up his true love, designing *ukiyo-e*. Since much of his work deals with themes taken from the Yoshiwara, it is inevitably tempered by the styles of Kiyonaga and Utamaro; however, despite this influence, his prints display an elegant purity of line that is distinctively his own. Perhaps it is because of his aristocratic breeding that Eishi's treatment of the female form seems to sift from the fleshly image of the courtesan only the most refined elements of her nature, discarding what is vulgar and coarse. For this reason, his women often appear to possess a quiet, queenly dignity that is expressed in the graceful slope of their shoulders and majestic sweep of their luxuriant robes.

Before his death at the age of seventy-three, Eishi had succeeded in attracting and training an assorted group of students, many of whose prints continued to be popular during the last years of the nineteenth century. Among his best-known students are Chokosai Eisho (active between 1780–1800), Rekisentei Eiri (active between 1790–1800), and Ichirakutei Eisui (active between 1790–1823). Eisho, perhaps the most famous of the three, took the slender, stately women of Eishi's designs and brought a more earthy flavour to them. His most successful compositions, some of which have mica-grounds similar to those of Utamaro, use the *okubi-e* format. The portrayal of courtesans was also Eiri's speciality, and he was quite skilful in designing *shunga* which depicted various erotic encounters against the background of peaceful, idyllic scenes. As with

Eishi's other pupils, little is known about the personal life of Eisui, the last of the three; the best of his remaining work is an assortment of delicately designed *okubi-e* showing young girls from the pleasure-quarters.

Among those artists who worked during the "Golden Age" there were a few whose fame rests upon a handful of exquisite, truly superlative designs. Eishosai Choki (active between 1780–1800) is exactly such an artist. Very little information is available about his early life though there is evidence that he may have been a low-ranking *samurai*. He is thought to have studied under Utamaro's teacher, Sekien, and to have been one of the select number of artists and writers within the orbit of Jusaburo's prestigious publishing house. Therefore, like many of the best designers sponsored by this great impresario, Choki produced a substantial amount of mica-ground prints, some of which are the finest and rarest in all of *ukiyo-e*. These *kirazuri* prints bear the stamp of a unique and highly refined aesthetic sensibility. The courtesans they portray are at times so fragile that there is something ineffably poignant about them. This air of mystery and pathos is perhaps achieved through Choki's tendency to elongate forms and to protract his hair-thin, meticulously articulated lines, which seem to unravel themselves along the length of his designs like skeins of fine, gossamer thread.

As the last gleams of the "Golden Age" began to fade from the scene of Edo's cultural resurgence, there began to emerge a school of artists whose sudden, powerful wave of productivity would carry the *ukiyo-e* print through the nineteenth century, sweeping it to the shores of its final, inevitable decline. Last of the major *ukiyo-e* lines, the Utagawa School was to become the most prolific in all of *ukiyo-e* history; by the end of the Edo Period it would succeed in totally dominating the print market with a vivid, sometimes flamboyant, style that gratified the populace's taste for increasingly sensational designs. Its founder, Utagawa Toyoharu (1735–1814), received his initial training under a Kano master, but in the early 1760's he moved to Edo and began to study with Sekien. *Uki-e*, or perspective prints, immediately captured his imagination, and by the 1770's he had become one of the first *ukiyo-e* artists to concentrate in this area. Within a decade, Toyoharu had designed an astounding variety of these prints, whose subject matter ranged anywhere from legendary love affairs to the interiors of tea-houses.

However, most remarkable of all were his landscapes; often modelled on Dutch engravings, these minutely detailed prints were intricate networks of trees, rivers, hillsides, and buildings, executed with a fine understanding of perspective and a technical precision unprecedented in *uki-e*. Since travel was rigorously restricted by law, the public was undoubtedly fascinated by these miniature recreations of distant, unfamiliar regions they could never hope to see at first hand. Toyoharu even went so far as to depict the Roman Forum, which must have indeed been an exotic curiosity for the townspeople of Edo. During this period, Toyoharu was also experimenting with perspective paintings, and as they became more popular than his prints, he focused his attention on the more profitable venture of producing them, leaving the Utagawa tradition of printmaking to his successor, Toyokuni I (1769–1825).

Though Toyoharu's lasting reputation was made with *uki-e*, in his early days as a print designer he had drafted a considerable number of actor and courtesan portraits, and it was his experience in these areas that he passed on to his pupil, Toyokuni I, whose artistic talents were clearly divided between the two. From the late 1780's to the mid 1790's, Toyokuni occupied himself primarily with the stylistic subtleties of *bijin-ga*, producing prints that skilfully incorporated the techniques of its greatest masters – Kiyonaga, Utamaro, and Eishi. Then, sometime near 1795, he seems to have lost interest in this subject and become absorbed in *Kabuki* portraiture. Until 1805, when his abilities began to decline, he executed many fine prints, combining the manners of Shunsho and Sharaku. The best of these compositions reveal an exceptionally strong sense of dramatic pose, gesture, and expression, all portrayed with great power and authenticity. While it is true that Toyokuni's work often appears to be a mosaic of techniques borrowed from some of his most gifted

contemporaries, it cannot be denied that the artistry which so beautifully binds these various fragments remains uniquely his own.

Equally talented but not as popular as Toyokuni I, Utagawa Toyohiro (1773–1828) was the second artist to emerge from Toyoharu's studio. Unlike Toyokuni, who cleverly manipulated the public's insatiable thirst for actor prints, Toyohiro did not really concern himself with the most profitable areas of *ukiyo-e*. Instead, he chose to work with relatively uncommercialized genres, devoting much of his time to the delicate art of designing *surimono* and *bijin-ga*. It is said that a good deal of rivalry existed between Toyohiro and Toyokuni, but they did manage to remain on friendly terms long enough for the completion of several joint projects, many of which contain some of Toyohiro's finest *bijin*. Supple and willowy, his graceful figures possess a regal demeanor reminiscent of

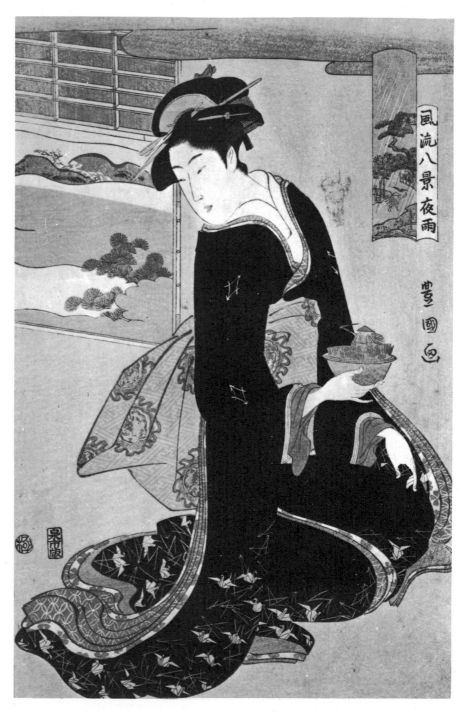

Eishi's rarefied beauties, and many critics judge them to be superior to those of Toyokuni. But, successful as these figures are, Toyohiro's true province was the landscape print, and his designs in this area have a fresh, ingenuous charm that reflects an unending delight in nature, a quality which would find its ultimate expression in the work of his pupil, the great Hiroshige.

Toyokuni I had a formidable array of followers and pupils, and among all of these, Utagawa Kunimasa (1773–1810) can be regarded as the most accomplished designer of *Kabuki* portraits. Executed with the biting wit of Sharaku as well as the finesse of his teacher, Toyokuni I, Kunimasa's *okubi-e* are quite superb and highly sought after by collectors. Eventually, however, his interest in facial depiction led him towards the profession of mask-making, and sometime around 1805 he stopped producing prints. Utagawa Toyoshige (1777–1835), Toyokuni's son-in-law, was another of his pupils to try his hand at actor prints. When Toyokuni died in 1825, Toyoshige took the name Toyokuni II and assumed leadership of the Utagawa School until his death ten years later. Unfortunately, his portraits do not have the verve and originality of Kunimasa's and are often in the style of his master's later, less successful compositions. More worthy of attention are Toyoshige's landscapes, which are enlivened by the marked influence of Hokusai's incomparable style.

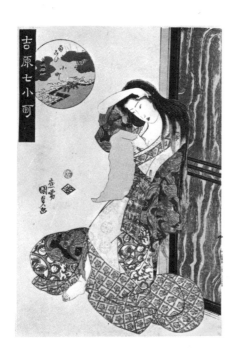

The next of Toyokuni's pupils to achieve prominence was Gototei Kunisada (1786–1864), who in 1844, upon becoming the new head of the Utagawa School, adopted the name of Toyokuni III. Kunisada had come to Toyokuni's studio at the early age of fifteen and after seven years of apprenticeship began designing actor prints as well as *bijin-ga* under his own *go*. Within a short while, his work achieved astounding commercial success; supported by clever management and advertisement, Kunisada created an ever-increasing demand for his prints which was unfailingly met with his ever-rising output. It is doubtful if any other *ukiyo-e* artist ever equalled him in popularity or production; yet, though he worked till his death at the age of seventy-eight, it was only during his first decade or so as a printmaker that he designed any compositions deserving of praise. Of these, Kunisada's portraits of beautiful women are most evocative of Edo's waning opulence; their faces dreamy and vacant, their movements heavy and languorous, his courtesans portend the moral lethargy that would overcome the age and finally bring it to a close.

The last important student to be trained by Toyokuni I was Utagawa Kuniyoshi (1798–1861), a major artist of the early nineteenth century. Coming from a long line of textile dyers, Kuniyoshi had already developed an eye for colour and design by the time he left his family business to study *ukiyo-e* with Toyokuni. Unlike other members of the Utagawa School, whose talents centred around *bijin* or actor prints, Kuniyoshi had a wild and eccentric imagination that was naturally drawn to unusual and bizarre subjects, especially those taken from Japan's heroic past. Although he was a man of humour, often designing comical prints that revealed his affection for animals, it is unquestionable that his peculiar genius found its true expression in a world of epic grandeur, where legendary battles decided the fate of empires and fierce, demonic warriors clashed to the death. Such subjects seemed to strike a hidden chord among the populace, perhaps because they caught the temper of the times, responding to that rumble of discontent which carried the faint but unmistakable sounds of approaching revolution. However, popular as they were in their day, Kuniyoshi's warrior prints are now much less prized than his landscapes, the best of which are comparable to Hiroshige's. A few of his scenes, populated with strange creatures and mythological beasts, seem to take on a fantastic, almost surrealistic aspect that is intensified by peculiar viewpoints and angles of vision. Despite the fact that Kuniyoshi was at times an uninspired artist, he will always be remembered as *ukiyo-e*'s greatest master of legendary and historical prints, and if he did not succeed in influencing followers by his choice of subject matter, there can be no doubt that the spirit of their work was transformed by the unique power and sensibility he brought to his own.

As the first half of the nineteenth century drew to an end, it became increasingly apparent that the collapse of the mighty Tokugawa regime was at hand. Effete and ineffectual, the last of the shoguns struggled to maintain control of an empire torn by inner strife and the inexorable pressure of the modern world, a fate it could no longer escape. The gloom and apprehension of these years inevitably left a scar on the cultural life of Edo, as governmental backlash conspired with the dissipated sensibilities

of its citizenry to bring about the slow degeneration of all the arts. Nowhere was this tendency more clearly marked than in the *ukiyo-e* of the period. With every aspect of its production limited by stringent restrictions and the whole of Edo clamouring for wood-block designs, it was not long before the *ukiyo-e* print began to show signs of stress and deterioration. This is not to say, however, that all of the compositions produced during this phase were of inferior quality; in fact, many of the most exquisite pieces in all of *ukiyo-e*, such as the late masterpieces of Hokusai and Hiroshige, were produced at this time. Besides these exciting developments in the landscape print, a new style of *bijin-ga* was beginning to make its appearance in publishers' stalls as it became more and more evident that Edo's cultural renovations had prompted a re-definition of feminine beauty and an attempt to adjust the old ideal to the exigencies of declining bourgeois tastes.

The two artists whose work is most representative of this altered conception of womanhood are Kikugawa Eizan (1787–1867) and Keisai Eisen (1790–1848). Eizan, who is said to have been a manufacturer of artificial flowers as well as an *ukiyo-e* designer, was originally trained in Kano-style painting by his father, a fan-maker and painter. He eventually came to study under Hokusai's student, Hokkei, and by 1800 had evolved a style of *bijin-ga* based on Utamaro's later prints that would dominate *ukiyo-e* for the next three decades. Characterized by a natural, earthy appearance, his courtesans are almost always portrayed against a simple, flat background that serves to accentuate the sinous curves of their fully ripened figures. After the 1840's Eizan seems to have faded into obscurity, and the Kikugawa tradition was left in the hands of his most talented pupil, Eisen. Though he was once a Kano-style painter and had even succeeded in securing a court position, Eisen somehow fell on bad times and was forced to give up his post. Lamenting his misfortune, he came to live at the house of Eizan's father, and it was at this point that he decided to take up *ukiyo-e*. He soon began to demonstrate a special flair for designing courtesan prints, and in time his fascination with the subject grew so great that many rumoured he was managing a brothel on the outskirts of Edo. Being in the truly decadent style, his courtesans exhibit a harsh, almost abrasive, beauty that manifests itself in their heavily made-up faces and their angular, curiously proportioned bodies.

As well as turning out huge numbers of courtesan portraits, Eisen was also an expert and prolific draughtsman of landscape prints, and is probably best-known for his work on the series, *The Sixty-Nine Stations of the Kiso Kaido*, which was later completed by Hiroshige. The popularity of his scenic views reflected a dominant trend in nineteenth-century *ukiyo-e* towards the depiction of natural scenes, not as mere background for other objects or figures, but as things of beauty worthy of appreciation in their own right. It is in this realm of *ukiyo-e* that we encounter the two names most universally associated with Japanese art – Katsushika Hokusai (1760–1849) and Ichiryusai Hiroshige (1797–1858), the great masters of the landscape print. Both were without question the most important Japanese artists of the nineteenth century; their unerring sense of line, colour, and form engendered masterpiece after masterpiece, producing flawless works that left a deep impression on the art of their contemporaries and even today continue to exert a strong influence on artists around the world.

Born the son of a poor peasant in the suburbs of Edo, Hokusai was apprenticed at an early age to a maker of mirrors; restless in spirit, he soon grew tired of this trade and set out to seek his fortune, only to find himself apprenticed once more, this time to an *ukiyo-e* engraver. It was here that Hokusai's genius was to find its true vehicle. By the time he was eighteen he had joined the prestigious studio of Katsukawa Shunsho and had begun illustrating books under the *go* of Shunro or "Spring Brightness". This was to be the beginning of a long serious of names, over fifty in all, used by the artist whose passion for his craft finally earned him the epithet, "the old man mad about painting". Incredible as it seems, Hokusai designed prints for nearly seventy years. During this period he studied almost every style and type of painting available to him, and with each

change in his own technique, he would adopt a different pseudonym. There is probably no subject or genre in *ukiyo-e* that his brush did not master: *Kabuki* actors, Yoshiwara beauties, birds and flowers, landscapes, legends and folktales – all fell within the prodigious compass of his artistry.

In the early 1820's Hokusai began designing what many experts consider to be his masterwork, *The Thirty-Six Views of Mount Fuji*, a stunning series of landscapes whose production would occupy him for nearly a decade. Some fifty years later the Western world, upon its discovery of *ukiyo-e*, would respond to these prints with the same delight that greeted them on the occasion of their first appearance in Edo. Like all of Hokusai's best compositions, these works are imbued with an indomitable energy that in some instances erupts into daring, almost violent, design: yet, at the same time, they possess an ineffable stillness of

form which bespeaks Hokusai's tranquil, never-ending contemplating of nature. Perhaps it was this deep, Zen-like communion with the essential form of things that enabled him to endow his subjects with the vibrance and substantiality of living, organic matter. Such a demiurgic ambition is eloquently expressed by Hokusai: "From the age of six I have had a mania for sketching the forms of things. From about the age of fifty I produced a number of designs, yet of all I drew prior to the age of seventy there is truly nothing of any great note. At the age of seventy-three I finally came to understand somewhat the true quality of birds, animals, insects – the vital nature of grasses and trees. Therefore, at eighty I shall gradually have made progress, at ninety I shall have penetrated even further the deeper meaning of things, at one hundred I shall have become truly marvellous, and at one hundred and ten, each dot, each line shall surely possess a life of its own."

Hokusai died at the age of eighty-nine, leaving behind him many students of which the two most noteworthy are Totoya Hokkei (1780-1850) and Shosai Hokuju (active between 1789-1818). Hokkei was the son of a fishmonger but eventually left his father's trade to study painting with a Kano artist, finally joining Hokusai's ever-widening circle of pupils. He soon established himself as an expert draughtsman of

surimono designs as well as an illustrator of satiric verse. Though quite remarkable, his landscapes are extremely rare since he produced only a few single-sheet prints. Hokuju, on the other hand, designed a great number of landscape prints, whose verve and audacity are the result of a highly original style that combined the spirit of his master's work with the techniques of Western painting. Especially effective are his fanciful cloud formations and his elegantly chiseled mountain ranges, which at times assume an almost cubistic geometry.

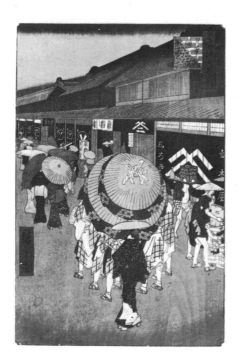

In 1797 Ichizyusai Horoshige was born in Edo. This *edokko*, or son of Edo, was to exert a crucial influence not only on the artistic conventions and styles of his own country but also on those of the Western world, for it was through Hiroshige's woodcuts that the Post-Impressionists first encountered the aesthetic which would urge them in new directions and in time alter the course of European painting. Even as a young child Hiroshige was drawn towards the artistic vocation, but being a dutiful son, he followed in his father's footsteps and became a fireman. Despite this commitment, he managed to gain entry into Toyohiro's studio and started training as a *ukiyo-e* artist under the name of Hiroshige. By the age of twenty-seven, having achieved some success as a designer of scenic prints, Hiroshige left the Edo fire department, no longer able to resist the lure of travel. Five years later he would embark on the journey that was to result in his legendary masterwork, *The Fifty-Three Stations on the Tokaido*, a series of breath-taking landscapes which would win him immediate fame in Japan and eventually bring him international acclaim. As many scholars have noted, the most remarkable prints in this series are invariably those containing one member of Hiroshige's magical trilogy – the moon, rain, and snow; the presence of any one of these in his work seems to endow it with a mysterious quality which sets it apart from the compositions produced by any other *ukiyo-e* artist.

As the Shogunate's power slowly ebbed away and its grip on the populace relaxed, unfettered travel became possible at last. With this sudden and dramatic acquisition of mobility, all of Japan lay open to its people, and when the verdant beauty of its countryside burst upon them, a type of euphoria took hold of the crowds journeying along the Tokaido. It is precisely this sense of wonderment that suffuses the best of Hiroshige's compositions; more than any other *ukiyo-e* artist, Hiroshige based and sustained his art on direct observation of nature, remaining true to the imperatives of a Japanese tradition which aimed at an unmediated vision of the natural world. Because of his capacity for such a vision, he was able to breathe a new life and spirit into the *ukiyo-e* of the late Edo Period, and to shield it, for one brief moment, from the tide of Western influence that would soon engulf it. For nearly half a century he laboured to record with fidelity and exactitude every aspect of Japanese life that presented itself during his ceaseless travels across the land. The thrilling lyricism of his landscapes and the sweet winsomeness of his woodland creatures remain without parallel in the annals of Japanese *ukiyo-e*.

In 1858 Hiroshige died of cholera, leaving his studio to his adopted son, Shigenobu, who later married Hiroshige's daughter and assumed the name Hiroshige II (1826–1869). Much of his work is a direct off-shoot of Hiroshige's in style as well as in subject matter, though it seldom succeeded in achieving his master's finely tuned perspicacity. After quarrelling with his wife in 1865, Hiroshige II left Edo to set out for the port of Yokohama, where he reverted to his old name Shigenobu, and began drafting designs for such export articles as tea chests and lanterns. As more and more of these objects began arriving at continental ports, Shigenobu's simple, unaffected illustrations became quite popular among European connoisseurs and even served as sources of inspiration for many Western painters.

On a sunny day in July, 1853, Commodore Perry's black warships entered Uraga Bay, bearing a message from President Millard Fillmore to the Emperor of Japan. The communique expressed the United States' desire to establish friendly and formal relations with Japan after her long period of isolation, for with the exception of the small islet of Dejima, and a few illegal or stranded boats arriving on her shores, Japan had been closed

to the world for nearly two and a half centuries. During this time, though European ships had on numerous occasions attempted to penetrate the shroud of seclusion surrounding Japan, little headway was made. However, as early as the 1820's the Shogunate had begun to realize that its isolationist policies were becoming impossible to maintain, and despite its pretence of obduracy upon Perry's arrival, when he returned the next year, it offered no serious opposition to his terms. By March, 1854, two ports were opened to limited trade, and an American consulate was set up in Japan; three years later the great port of Yokohama was established as a European settlement. The Westernization of Japan had begun.

The mere signing of a treaty, however, did not effect immediate trust and amicability between the people of Japan and the United States. After withdrawing so thoroughly from the arena of international affairs, the Japanese were naturally wary of any foreign intrusion. Many *samurai* who were reluctant to abandon their country's isolationist traditions saw the treaty negotiations as an opportunity to arouse hostility against a government which had robbed them of status and power. Under their provocation, an anti-foreign *Joi* movement gathered impetus, and within a few years the cry "Revere the Emperor, expel the foreigner" resounded across the land. Though the prospect of strangers suddenly pouring into Japan was undoubtedly perceived as a threat to her ancient values and customs, anti-foreign sentiment was, to a large extent, the mask for a deeper, more serious disaffection that would soon explode with revolutionary force. In August, 1866, weak and without any great following, Iemochi, the last of the shoguns died; his successor was able to prevail for only a few months before insurrectionary clans forced his resignation in the autumn of 1867. After a series of swift, but bloody, civil conflicts, the country was once again an imperial state, to be governed by the emperor whose reign would become known as the Meiji or "Period of Enlightened Rule". After more than 250 years, the feudal order of the mighty Tokugawa warlords was at an end.

Having resolved their domestic troubles, the Japanese people were now free to direct their energies towards the monumental task of modernization, and they began to grasp at all that was Western and new. Spellbound by the mechanical wonders and triumphs of modern civilization, the people of Edo developed a virtual mania for locomotives, telegraphs, and other technological marvels, as well as for the more humble achievements of the West, such as trousers and feathered bonnets. In the face of this intoxication, the *ukiyo-e* artist of the Meiji Era could hardly resist designing prints which chronicled all the extraordinary sights and events of this momentous confrontation between two cultures. Realizing that the attention of the Edo public could no longer be held by traditional portrayals of the *Kabuki* or the Yoshiwara, many printmakers sought to incorporate Western methods of shading and drawing, sculpture and design, into their own work. But above all, a peculiar looking box, with seemingly magical powers, held them in its sway; as the world of *ukiyo-e* stared in rapt fascination, little did it suspect that it had come face to face with the instrument of its own demise – the camera.

However, even though the *ukiyo-e* print was destined to be lost in the stream of photographs and lithographs which would soon issue from Japan's studios, there did emerge at this time two great masters who struggled to keep its traditions alive and pure – Tsukioka Yoshitoshi (1839–1892) and Kobayashi Kiyochika (1847–1915). Very few *ukiyo-e* artists managed to achieve the tremendous popularity that Yoshitoshi enjoyed during his lifetime. The son of a physician, Yoshitoshi revealed his artistic bent at a very early age; by the age of twelve he had become one of Kuniyoshi's students and three years later he produced his first wood-block print, the beginning link in the bright, multi-coloured chain of his diverse opus. His career spanned the early, difficult years of Westernization, when *ukiyo-e* was almost reduced to a primitive type of pictorial journalism that documented the ever-changing kaleidoscope of Japan's cultural scene, where bits and fragments of her past collided with the present to achieve a momentary crystallization. Yoshitoshi's work is itself not only a record but a product of this period of assimilation, for in it we can see traces of this

47

master's heroic effort to harness the conventions of Western art and channel them into the age-old traditions of *ukiyo-e*. Such an intent also pervades the work of Kiyochika, who while living in Yokohama studied photography with Renjo Shimooka and Western oil painting with Charles Wirgman. Unable to formulate a style of his own on the basis of either man's technique, Kiyochika moved to Edo, where he began to study the craft of *ukiyo-e*. In 1860 he designed his first print, and from then until 1882, he produced many highly innovative prints that, for the first time in the history of *ukiyo-e*, are almost completely dominated by Western principles of lighting and depth. However, though the best of these designs are novel and provocative, one cannot say that they were conceived in the true spirit of *ukiyo-e*, whose emphasis has always fallen on the meticulous arrangement of lines and forms across a flat surface. Although Kiyochika laboured to infuse it with new forms and ideas, *ukiyo-e* became, in his hands, something other than itself. Even towards the end of his life he continued to search his mind for the aesthetic that would once again enliven the beloved craft of Edo, until stricken with rheumatism, he could no longer hold a brush in his hands. After his death, despite several more attempts to revive it, the art of *ukiyo-e* languished.

No one knows for certain how *ukiyo-e* prints initially found their way to the West, though it is rumoured that they first arrived there as tattered scraps of wrapping used to cushion fragile shipments of china on its journey from Japan to Europe. We do know, however, that one of the first Europeans to collect these prints was Carl Peter Thunberg, a Swedish naturalist who, in 1775, spent a year in the Dutch settlement at Nagasaki. Soon, various connoisseurs began to follow in his stead, and by the beginning of the nineteenth century, export lists and journals contained numerous references to the "little printed picture books" of Japan. As early as 1806, the collection of one Dutchman, Captain Isaac Titsingh, had caught the attention of certain enthusiasts in Paris, the city which, in a few years, would become the hub of *ukiyo-e* prints in Europe. Yet, until Perry returned from Japan, with such treasures as Hiroshige prints, very few Westerners had seen Japanese art or even knew of its existence. When more and more of these woodcuts began arriving at its ports, Europe became as infatuated with *ukiyo-e* as the Japanese had become with Western art, and by the 1860's, Japanese curio shops were springing up in major cities across the Continent. Men of taste and sensibility everywhere began to accumulate *ukiyo-e* prints, and as the great portfolios of Bing and Hayashi became dispersed, connoisseurs like Vever, Gonse, and Goncourt started amassing their legendary collections. In America, whose museums house the finest array of Japanese prints in the world, lovers of the art such as Fenollosa, Bigelow, Spaulding, Frank Lloyd Wright, and James Michener also assembled impressive collections, and laboured to awaken their countrymen to the priceless gems strewn across their own doorstep. Of ultimate importance, however, was the powerful impact of *ukiyo-e* on the minds and visions of late nineteenth-century artists; one after the other – Bracquemond, Manet, Degas, Lautrec, Van Gogh, Whistler – it enthralled them, luring their art towards the threshold of Modernism. It is one of the sad ironies of history that at the moment *ukiyo-e* was breathing a new life and spirit into Western art, it lay exhausted in its own land. That this momentous revitalization was not then reciprocal is surely a tragedy, but as the years have proved, the spirit of *ukiyo-e* has surely been resurrected, and continues to be as vital and compelling a force today as it was in the "floating world" of Japan.

The technique of ukiyo-e

Ukiyo-e prints are obtained by means of xylographic printing, using various cut wood-blocks which correspond to the number of colours required by the picture to be reproduced.

All the parts which must remain devoid of colour are carved out from the surface of each wood-block: the printing part thus remains raised. Cherry wood should be employed for the cut blocks in this type of printing; it should be taken from a rather large trunk which has been left to dry completely, and is smoothed out very carefully in the direction of the fibre.

A copy of the drawing, previously prepared on sufficiently transparent paper, is pasted onto the wood-blocks which have been cut out in this way, with the original turned towards the table. The drawing is thus reproduced on the cutting block, its lines traced heavily on the paper. Depending on the colours which are to be used, more sheets of special paper are prepared, together with an equal number of carved blocks, each for the single part of colour to be printed on the paper.

The combination of each separate printing process leads to the final result, bearing the complete picture of all the colours.

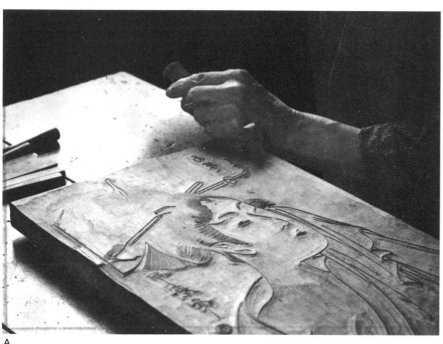

A

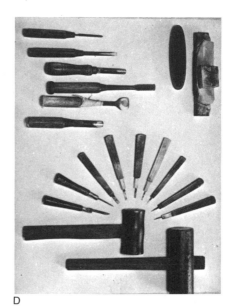

D

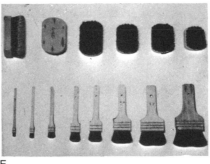

E

Cutting of a wood-block (A), by means of a block-cutter's tools: burins, gouges, gravers, hammers (D). *Colouring* (B), with the necessary utensils: brushes, tampons, paint brushes (E). *Printing* (C), on special Japanese paper, using bamboo tampons and string (F).

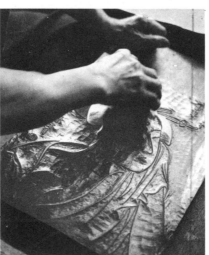

B

F

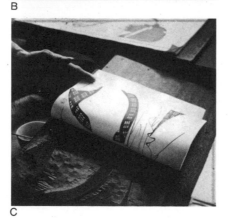

C

Illustrated below are the various printing phases necessary for the creation of this work by Utamaro, carried out by means of the *nishiki-e* polychrome printing technique. The result is the fruit of various specialized methods of drawing, cutting and printing. In the following illustrations, it is possible to distinguish the printing of individual colours from the different wood-blocks (1, 2, 4, 6, 8, 10, 12, 14, 16) and the effect of the successive superimpositions of the various colours on the paper (3, 5, 7, 9, 11, 13, 15), up to the final result (17).

The printing superimposition of wood-blocks 1 and 2, relating respectively to black and yellow, creates the partial result of picture 3; while picture 5 is obtained by the successive printing of black+yellow+brown.

Picture 7 shows – the only feature which distinguishes it from picture 5 – the part of the *kimono* which is coloured in a deeper red, obtained by washing the block (4) and re-colouring with a deeper shade (6).

Picture 9 is the result of the successive printing of black+yellow+red+green. Picture 11 reveals the sophisticated nature of the *nishiki-e* technique, particularly for the drawing of the *kimono*. Pictures 13 and 15 are the combination of the separate printing of black+yellow+red+green+indigo.

Picture 17 shows the final result, after the printing of the last two wood-blocks (14 and 16).

4

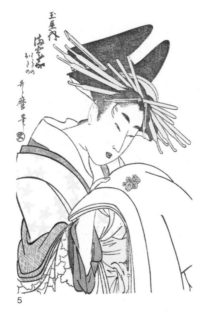

5

6

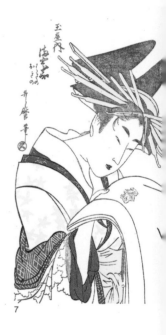

7

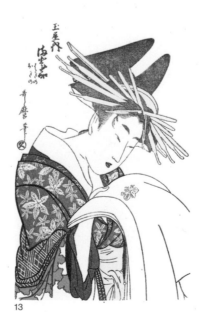

13

14

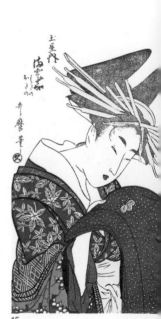

15

1

2 3

9

10

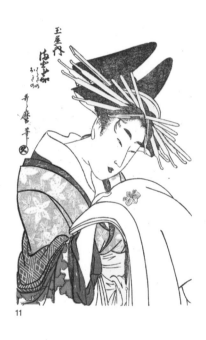

11

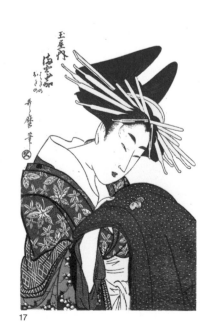

17

51

The dawn of ukiyo-e

What are ukiyo-e?

The "ukiyo-e" or pictures of the floating world which began to appear in the 17th century are realistic representations of the actual world of the day. The idea that life is a floating world can be found in both East and West. For instance, it is stated in the Chinese classic *Chuang-tzu* that human life is adrift on the flowing water called death, and Heraclitus, a Greek philosopher, said that all things were in a state of flux. This way of thinking became stronger in Japan than in China through the influence of Buddhism.

The term *ukiyo* originally was used in the Buddhist sense of the "transient and sad world". But when, after going through a period of incessant civil war, Japan became a society in which people could achieve success through ability, the term came to mean the "floating world" in which the fleeting pleasures of life were prized. In other words, the term came to be used in a worldly sense rather than in a religious one.

Ukiyo-e (floating world-picture) at first referred only to pictures of everyday life at the time, but later came also to include those treating historical or fantastic subjects, whether they were painted on sheets of paper and silk or mass-produced by means of wood-block printing. At any rate *ukiyo-e* invariably represent the vital interests and concerns of the populace of the day, providing us with a good record of them.

The mass production of pictures by wood-block printing allowed the populace to enjoy art, previously the monopoly of the upper classes. This was an epoch-making event in the long history of Japanese art; the populace finally began to produce works of art for their own enjoyment.

They wanted *ukiyo-e* that were diverting, showy, and easily understood. It was natural, therefore, that *ukiyo-e* should be concerned largely with amusements and the world of men and women. Courtesans and actors provided good subjects for *ukiyo-e*; moralistic *ukiyo-e* were a reflection of the policies of the government. For although the culture of the townsmen gradually developed, advanced, and became a rich one, it was still limited by the framework of feudalism. The common people still had to wait years before they could consider educating their children and improving the quality of their own lives.

The government made a sharp distinction between the *samurai* and the other classes, and did not particularly favour the intellectual improvement of the masses. It banned political criticism and restricted news to keep the ordinary people ill-informed. It was for that reason that *ukiyo-e* tended to be common, although they reflected popular wishes and yearnings. Under the pressures of this feudal system, a major problem faced by the artists was how to satisfy these popular demands and at the same time move a step beyond them.

The dawn of ukiyo-e

Japan, consisting of many large and small islands, extends north and south along warm sea currents. It belongs to the temperate zone, and the four seasons in Japan are clear-cut ones. In winter, when cold currents of air flow southwards, snow falls in much of the country. Thanks to this temperate and humid climate, Japan is covered with green and produces wood of fine quality.

In ancient times, the secret of manufacturing paper was transmitted to Japan from China, enabling the Japanese to use paper from an early date. In the modern period, improvements in the method enabled the production of a thicker, high-quality paper. These domestic products laid the foundation for the production of excellent wood-block prints.

Wood-block printing in Japan goes back to about the 8th century. It was used for dyeing cloth but not paper. Woodcuts were also used as prototypes in the production of copperplates of the Buddhist scriptures. These were printed on paper, but consisted of characters alone, with no pictures. According to the records, it was not until after the 10th century that wood-block prints of Buddhist paintings began to be produced.

Paintings had remained the exclusive possession of the court, the monasteries, and the upper classes. Paintings depicting the life of the populace, such as the cultivation of fields by peasants, had been displayed at court since early times. However, in the latter half of the 16th century, *daimyo* (feudal lords) and then rich townspeople began to commission artists to paint scenes of town life such as festivals and public performances. This marked the first step towards the popularization of painting, which formerly had been used to record the lives or the manners and customs of the lower classes.

Thus a large number of genre paintings were produced, depicting groups of people at festivals, public entertainments, and theatrical performances. This development was due to the rise of cities in various parts of the country and the accumulation of economic power on the part of the townspeople. (The names of most of the genre painters of this period are unknown.)

These genre paintings were followed by figure paintings, which at first portrayed several figures but later came to focus on a single figure, particularly that of a beautiful woman. Thus appeared *bijin-ga* (pictures of beautiful women). After the middle of the 17th century, pictures of full-figure, beautiful women became very popular, almost coinciding with the establishment and stabilization of the regime of the Tokugawa Shogunate over the entire country.

The production of a single picture at a time was not enough to meet the demands of the many people wanting them, but it was some time before the stage of mass production of pictures by wood-block printing was reached. First, woodcuts came to be used to print not only Buddhist scriptures and Buddhist literature but also stories and narratives, into which illustrations were inserted. This set the stage for the mass production of genre pictures by wood-block printing. These book illustrations were followed by *ehon* (picture-books) produced by wood-block printing, which were in turn followed by *ichimai-e* (single-sheet prints).

At the outset, the subject-matters of *ukiyo-e* were mainly scenes of gay quarters and landscapes of famous places, and then popular figures like actors, beauties in town, sumo-wrestlers and the like. However, the everyday life of ordinary town people was also one of the major subjects of *ukiyo-e*. Among many pictures of this genre, those depicting men and women loving each other, to be more exact, sexual love, continued to flourish until the later period of *ukiyo-e*.

Sexual love was depicted so openly and cheerfully in *ukiyo-e* that they were sold in shop-fronts until the 7th year of Kyoho (1722). When the government prohibited the sales of this sort of picture, however the style became secretive, more elaborate in technique, aiming towards eccentricity.

Generally speaking, however, it can be said that the main feature of this genre picture in Japan is to express, besides sexual love, a sense of the seasons and sentiments, trying to capture sexual love within the scope of people's daily life.

In this way, genre pictures and wood-block printing, a method for mass production, were combined for the first time in the second half of the 17th century.

The following are leading artists of the early period of *ukiyo-e*.

Hishikawa Moronobu
(1631-1694)

Moronobu had a wide range of activity. In addition to *sumizuri-e* (prints from a single block in black ink), he produced in his later years excellent brushwork paintings of genre pictures such as *Beauty Looking Back*. But his woodcut prints are within the limits of the primitive stage of *ukiyo-e*. These works are simple in nature: the men and women are delineated in broad lines, the depiction of landscape is simplified, and even the erotic pictures are generally simple with a rather healthy ambience.

He dealt with a wide range of themes including men and women in the gay amusement quarters and in town, their manners and customs, and famous scenic views, all of which were familiar to the populace. He also designed patterns for clothing used by the populace.

Sugimura Jihei (active c.1680's–1690's)

Jihei, a contemporary of Moronobu, was one of the important artists of the early period of *ukiyo-e*. He produced many erotic prints and also illustrations for books. His style resembles that of Moronobu. Nothing is known about his life.

Kaigetsudo Ando Yasunori (active c.1700–1714)

Ando was the founder of the Kaigetsudo school. Artists of this school such as Dohan (Norishige) and Anchi (Yasutomo), both active early in the 1700s, produced many brushwork paintings of beautiful women as well as some wood-block prints. Their beautiful women were full-figured and substantial, displaying an open, unaffected spirit. This style distinguishes the Kaigetsudo school from the others. For as the Edo period progressed, such paintings of large-bodied beauties became unpopular, while those of lovely, slender and even rather sickly-looking ones came into vogue.

Torii Kiyonobu (1664–1729)

Kiyonobu, the son of Torii Kiyomoto, was the founder of the Torii school. His family line has specialized in signboards for *Kabuki* theatres to the present day. To heighten the effectiveness of the posters and vividly depict the *aragoto* acting style (a stylized and exaggerated one used in *Kabuki* to emphasize superhuman strength), he devised a distinctive style with strong lines emphasizing the muscles. This style was further developed and refined by his son, Kiyomasu (1694–1716), the second titular head of the Torii school. Interacting with this style, the stop-action poses of *Kabuki* actors on the stage, with their poster-like effect, have continued to retain their classical, stylized beauty up to the present day.

As the Torii school passed from Kiyonobu to Kiyomasu and then to Kiyomitsu (1735–1785), an elegance was gradually added to the style invented by the founder to make possible the expression of not only the beauty of the *onnagata* (female impersonators of *Kabuki*) but also a purely erotic quality as seen in the pictures of women just from the bath.

Okumura Masanobu (1686–1764)

Masanobu had no teacher, but made himself into a *ukiyo-e* artist by studying the art of Torii Kiyonobu, which he greatly admired. He was also engaged in the wholesale publication of woodcut prints. He is known for his contributions to the progress of woodcut prints. His innovations include *uki-e* (perspective pictures), *habahiro-hashira-e* (wide pillar pictures: long prints to be hung on a pillar), and *beni-e* (pink pictures which are printed in black only and hand-coloured with pink, the pink parts of which are painted with lacquer or glue for lustre).

The *ukiyo-e* prints of this early period are either *sumizuri-e* (plain black-ink prints) or hand-coloured *sumizuri-e*. *Tan-e* are prints which are hand-coloured mainly with tan, a red-lead pigment, but also with green and yellow. *Urushi-e* or *beni-e* are prints painted with lacquer or glue to emphasize the black or red parts. Then comes *benizuri-e* (pink-printed pictures), which are prints in two or three colours.

Besides Okumura Masanobu, such artists as Okumura Toshinobu (active c.1720's–1740's) and Nishimura Shigenaga (active c.1720's–1756) were also active in the period of the development of woodcut prints. Shigenaga invented the *hoso-ban sanpuku-tsui* (narrow-size triptych) and *ishizuri-e* (stone-printed pictures), which show a picture with white lines against a coloured or black background.

Ishikawa Toyonobu (1711–1785)

Toyonobu married into a family which owned an inn. Besides running the inn, he studied under Nishimura Shigenaga. He excelled at brushwork painting, *urushi-e* and *benizuri-e*. His refined lyrical style is shown in such works as: *Beauty under Cherry Blossoms* and *Strolling Minstrels: The Actors Onoe Kikugoro and Nakamura Kiyosaburo*, which, for primitive *ukiyo-e*, show a harmonious beauty and exquisiteness leading the way into the next period.

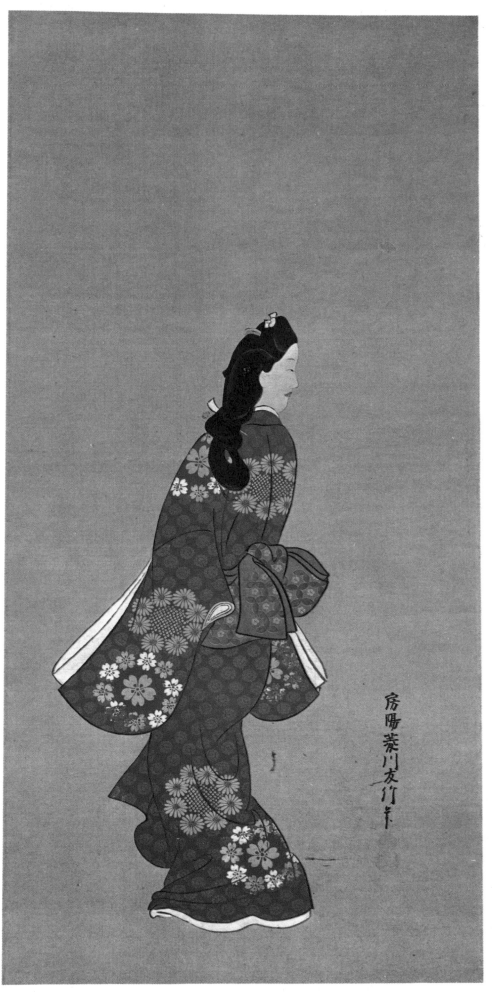

Moronobu *Beauty Looking Back*
Painting on silk, 63 × 31.2 cm
Date: c. early 1690's. Tokyo National Museum

Moronobu's later work. A masterpiece of *ukiyo-e*
painting, used as a design for the first of the Japanese
ukiyo-e postage stamps.

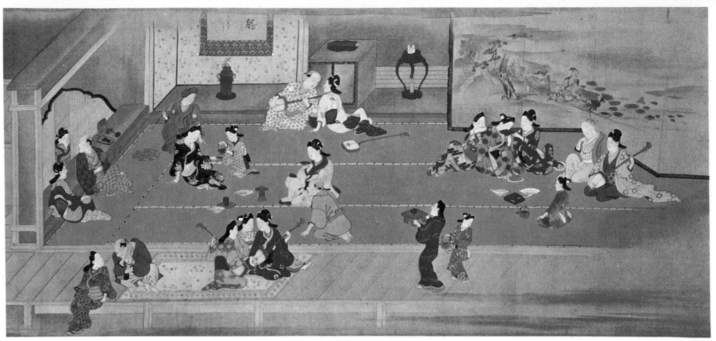

Moronobu Detail of the scroll *Scenes at Yoshiwara and Asakusa*
Painting on silk, one scroll, 39.1 × 903.7 cm
Date : c. late 1680's. Kyusei Atami Art Museum, Japan

A scene of daytime entertainments in a tea house at Yoshiwara in the Genroku period, with a clear depiction of the interior.

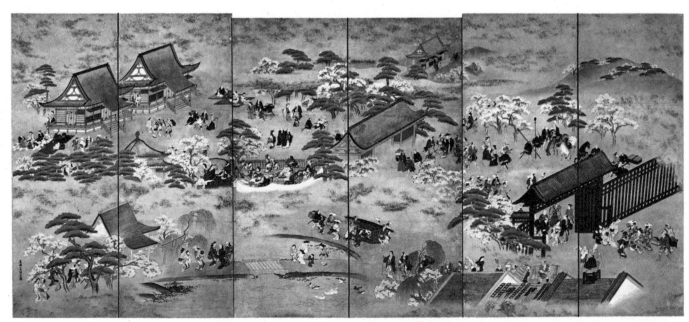

Moronobu *Cherry Blossom Time at Ueno*
Painting on paper, a six-folding screen,
165.6 × 397.8 cm
Date : c. 1680–90. Freer Gallery of Art, Washington

Cherry-blossom viewers, both *samurai* and townspeople, at the Kanei-ji temple in Ueno, some drinking *sake* and dancing on straw mats spread on the ground. Part of the Shinobazu Pond is also depicted.

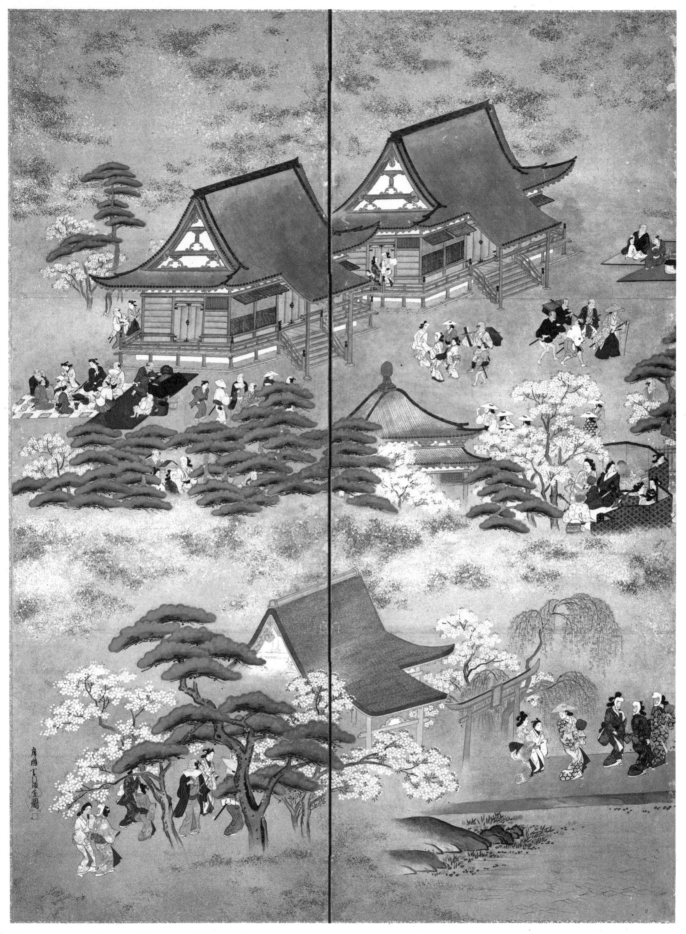

Moronobu *Cherry Blossom Time at Ueno*
The first two panels of the screen.

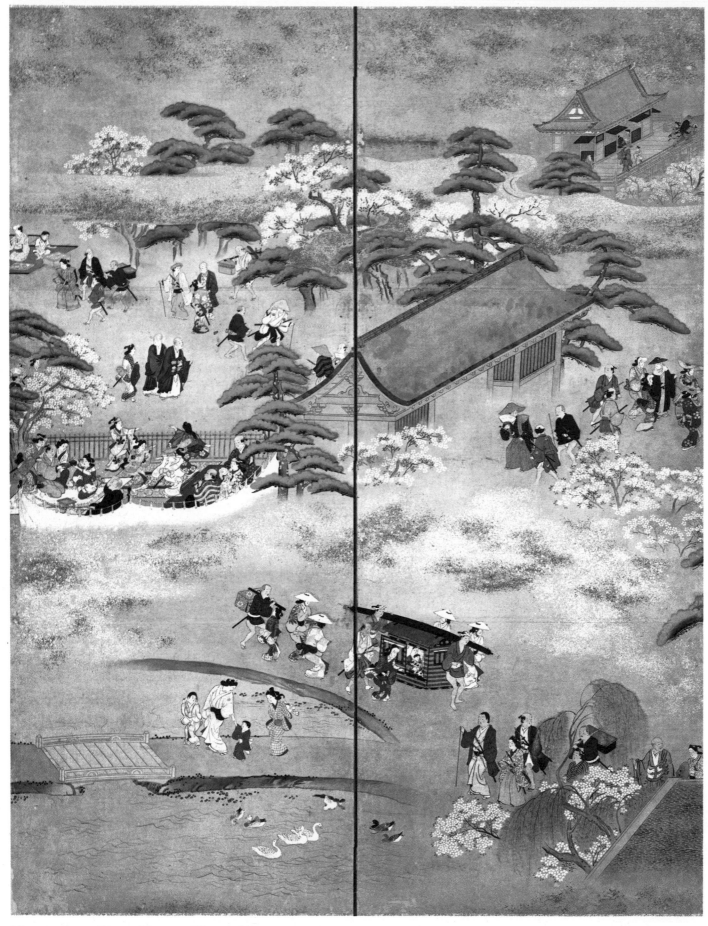

Moronobu *Cherry Blossom Time at Ueno*
The two central panels of the screen.

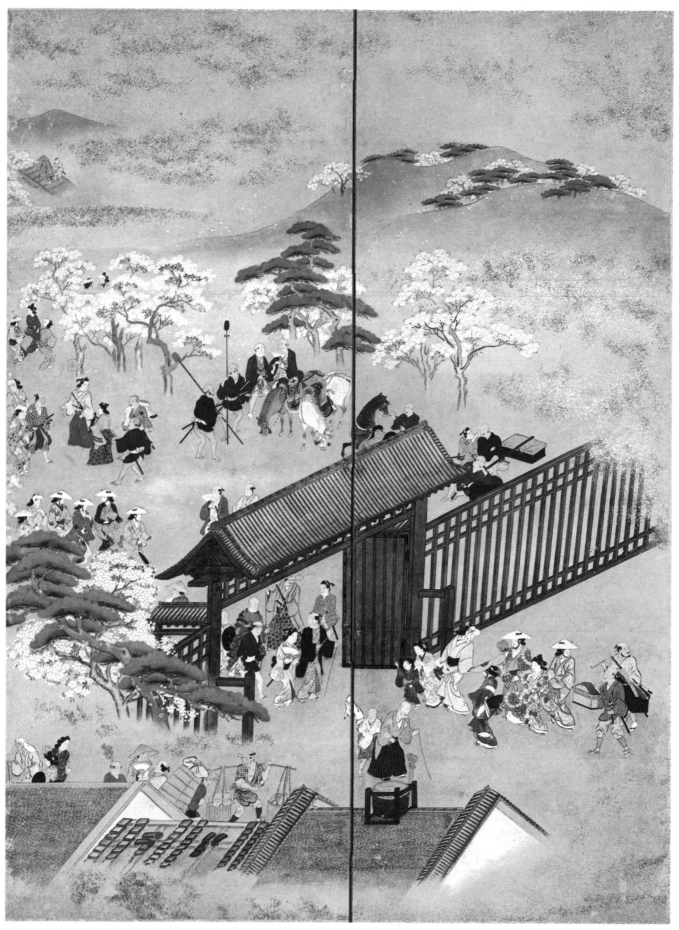

Moronobu *Cherry Blossom Time at Ueno*
The last two panels of the screen.

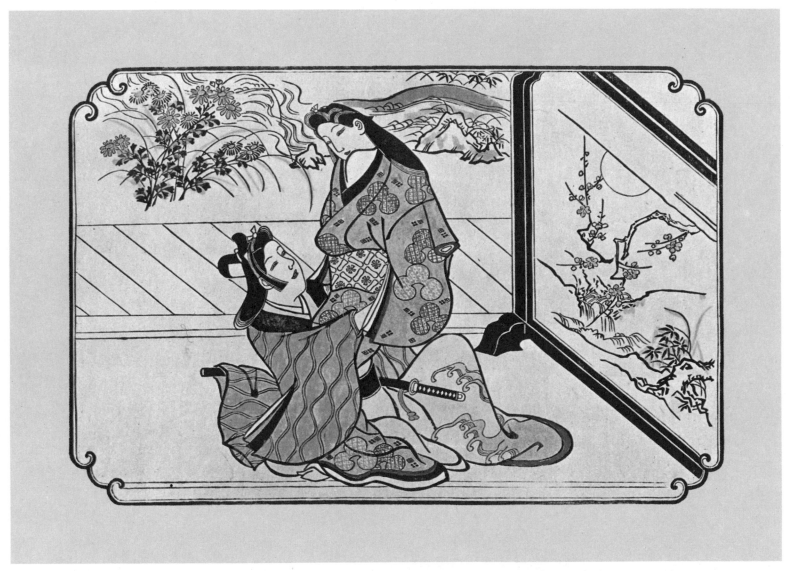

Moronobu (Unsigned) *Young Dandy and His Mistress*
Oban, sumizuri-e, hand-coloured, 30.6 × 36.8 cm
Publisher: unknown. Date: c. 1680's. Riccar Art
Museum, Japan

The first picture in one of Moronobu's ten to twelve-
sheeted erotic albums, each consisting of one ordinary
picture, the first one, and the rest pornographic ones.
The flowers in the garden are chrysanthemums.

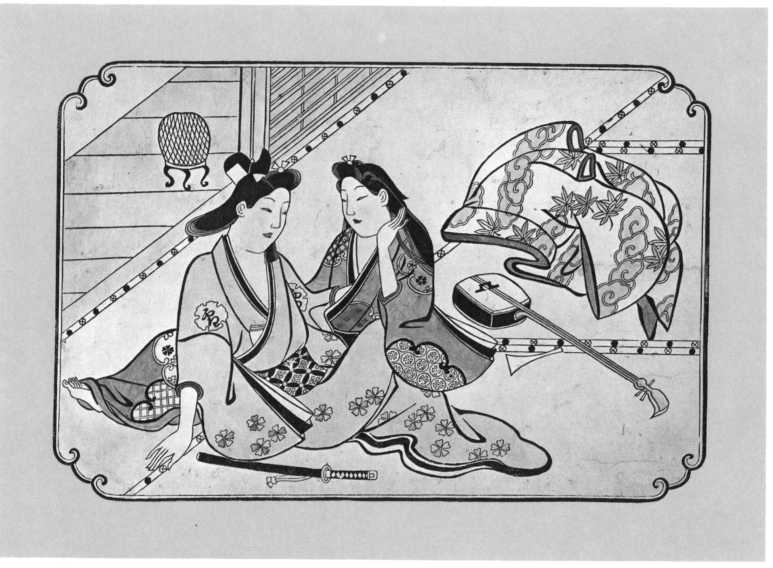

Moronobu (Unsigned) *Happy Lovers*
Oban, sumizuri-e, hand-coloured, 26.5 × 34.8 cm
Takahashi Collection, Japan

A young *samurai* with a courtesan.

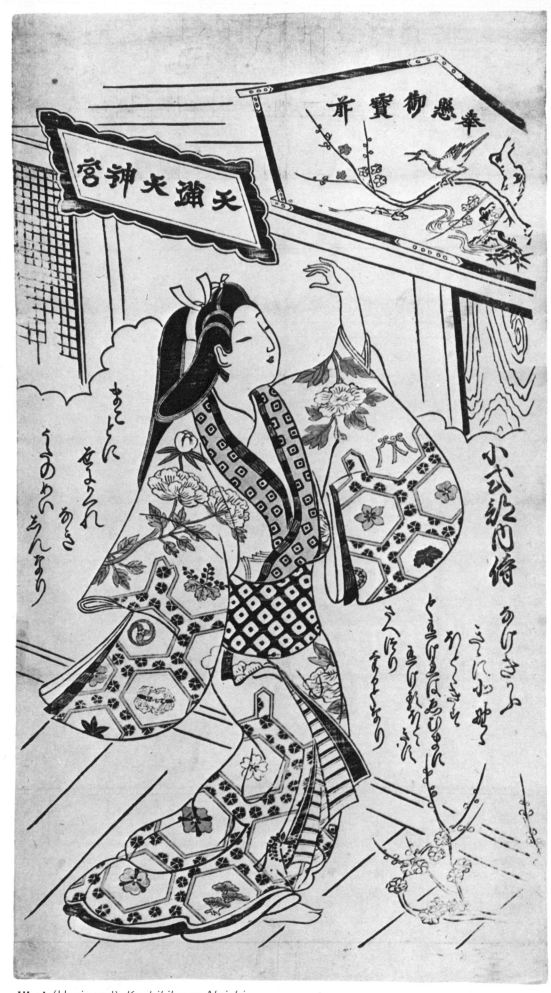

Jihei, (Unsigned) *Koshikibu no Naishi*
Kakemono-e, sumizuri-e, hand-coloured

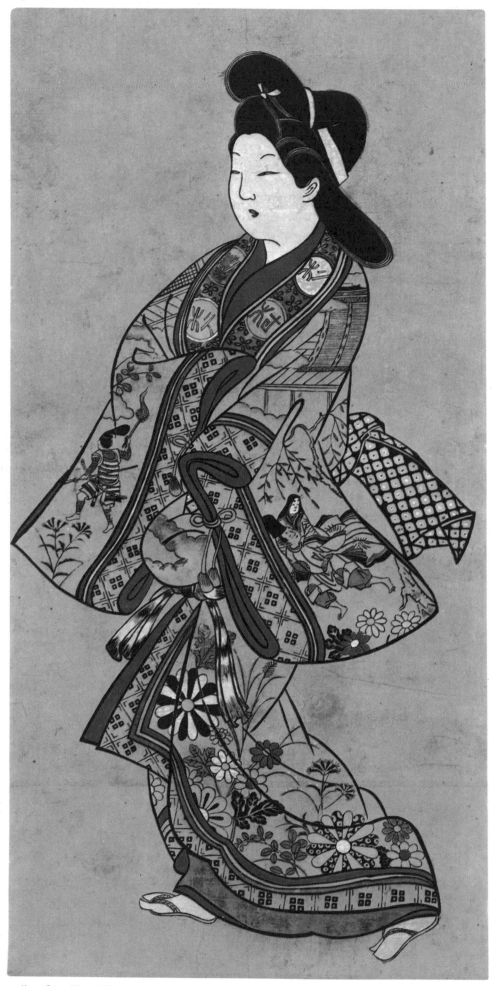

Jihei (Unsigned) *Strolling Woman*
Extra-oban, sumizuri-e, hand coloured, 57 × 28.1 cm
Publisher: unknown. Date: c. 1680's. The Art Institute
of Chicago

The internal signature of Sugimura (Jihei) is seen on
the courtesan's *kimono* whose design contains a
scene from the *Ise Monogatari* (*Tales of Ise*).

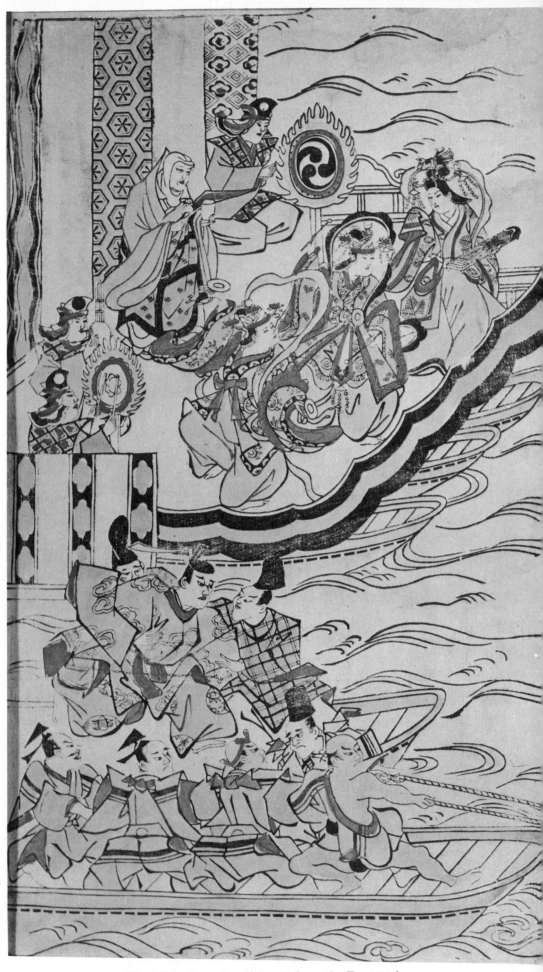

Jihei (Unsigned) *Episode from the Tamatori Monogatari*
Extra-oban, tan-e, Diptych, 52.7 × 30.2 cm each
Publisher: unknown. Date: c. mid 1680's. Worcester
Art Museum, Massachusetts

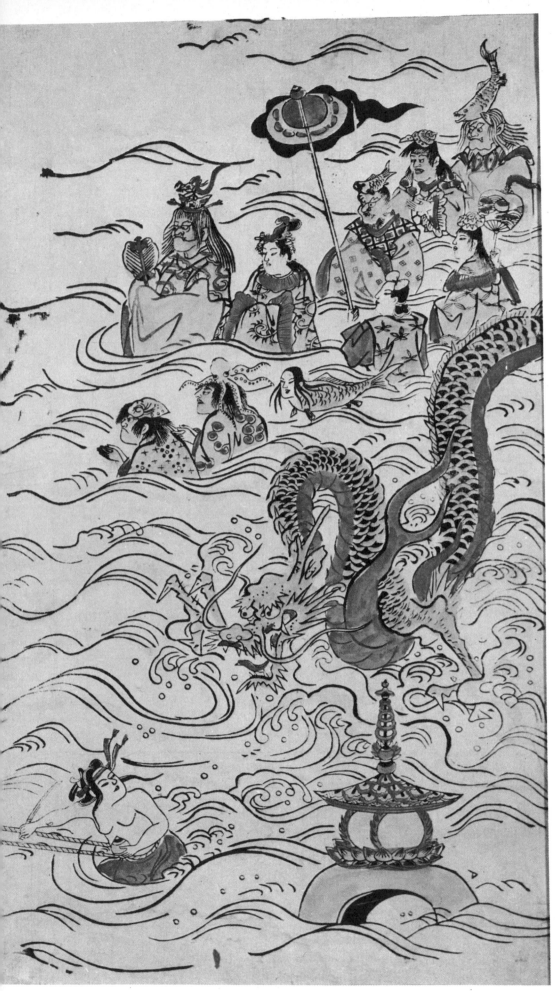

Explanatory pictures of the legend of a woman diver
stealing the hidden treasure of the dragon god. From
the ballad-drama then in vogue.

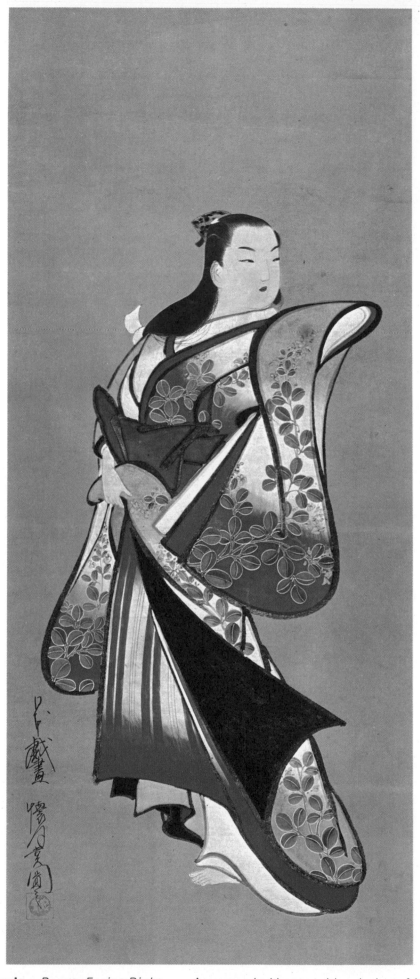

Kaigetsudo Ando *Beauty Facing Right*
Painting on paper, 105 × 44 cm
Date: c. early 1700's

A woman in *kimono* with a design of *hagi* (Japanese bush clover).

66

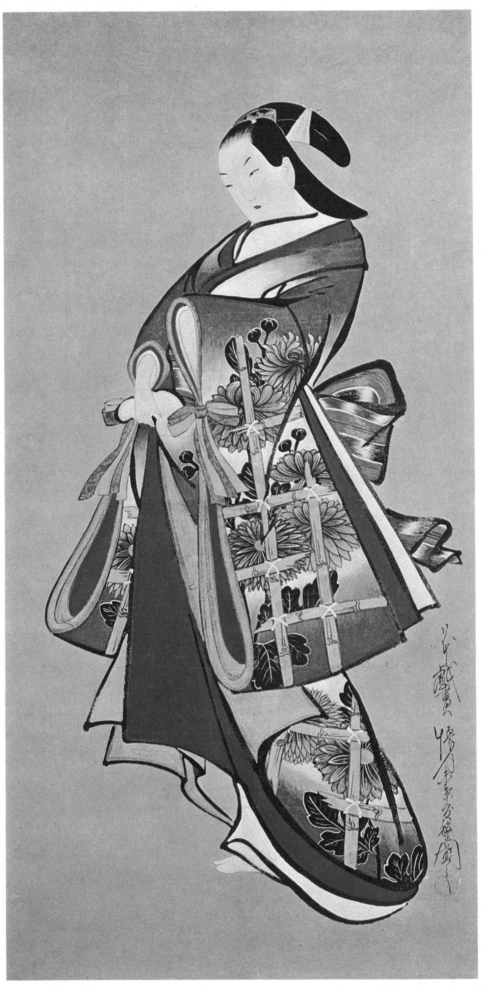

Kaigetsudo Dohan *Beauty Facing Left*
Painting on paper, 93.7 × 45.6 cm
Date: c. 1710's. Idemitsu Art Gallery, Japan

A courtesan walking with her hand tucking up the skirt of her *kimono* with a design of large chrysanthemums at a bamboo fence.

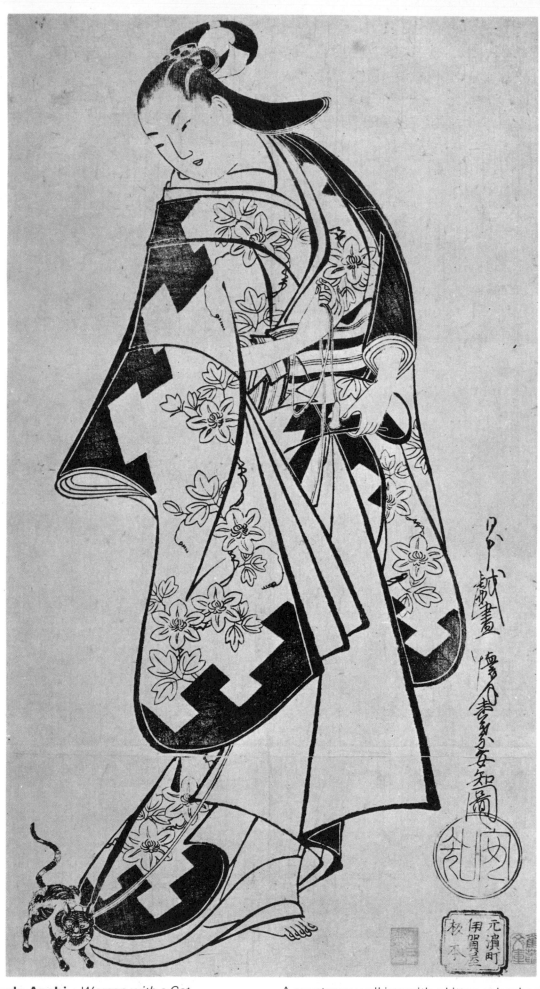

Kaigetsudo Anchi *Woman with a Cat*
Extra-oban, sumizuri-e, 56 × 30.5 cm
Publisher: Iga-ya Kan-emon. Date: c. 1710's. Musée
Guimet, France

A courtesan walking with a kitten at her heels. The
two red seals at the bottom right-hand corner of the
print are both the former owner's.

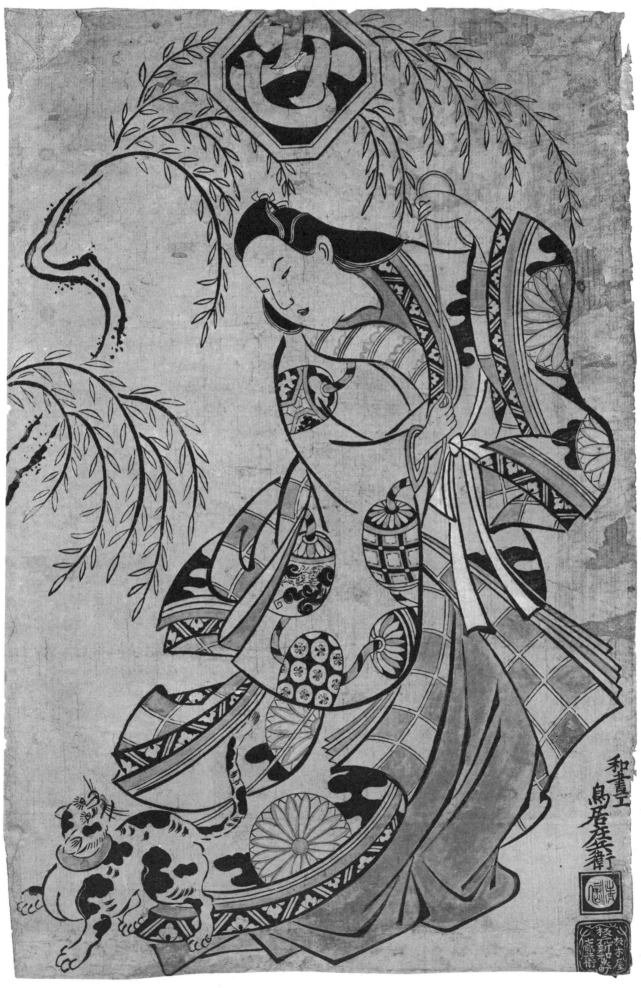

Kiyonobu *The Actor Uemura Kichisaburo as Nyosan no Miya (Third Princess)*
Extra-oban, tan-e, 48.6 × 31.5 cm
Publisher: Itagiya Shichirobei. Date: c. 1700's.
The Art Institute of Chicago

Kichisaburo acting the role of one of the heroines in *The Genji Monogatari (Tales of Genji)*.

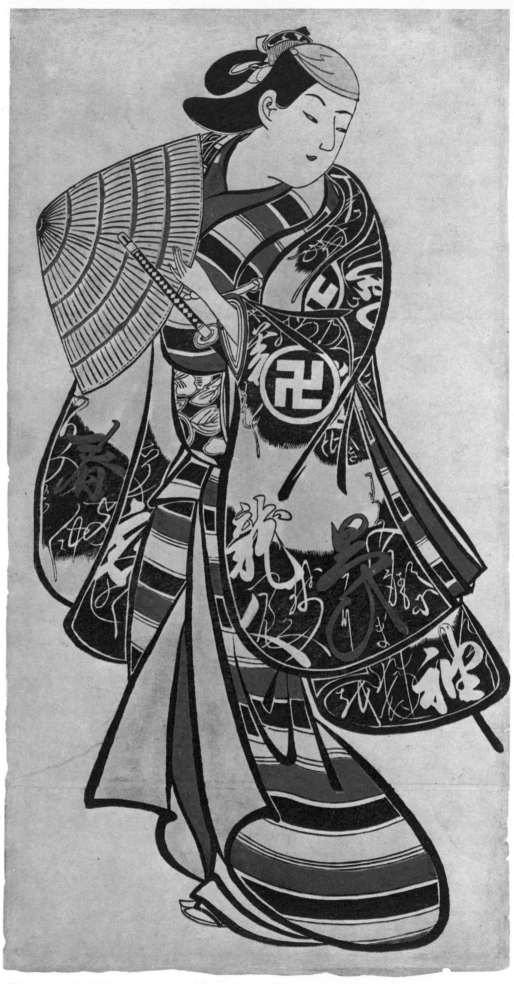

Kiyonobu *The Actor Takii Hannosuke as a Young Samurai*
Extra-oban, tan-e, 56.6 × 29.3 cm
Publisher: unknown. Date: c. 1707. The Art Institute of Chicago

Hannosuke acting as a young *samurai*, with a braided hat in his hand. The letters on his *kimono* are Japanese characters.

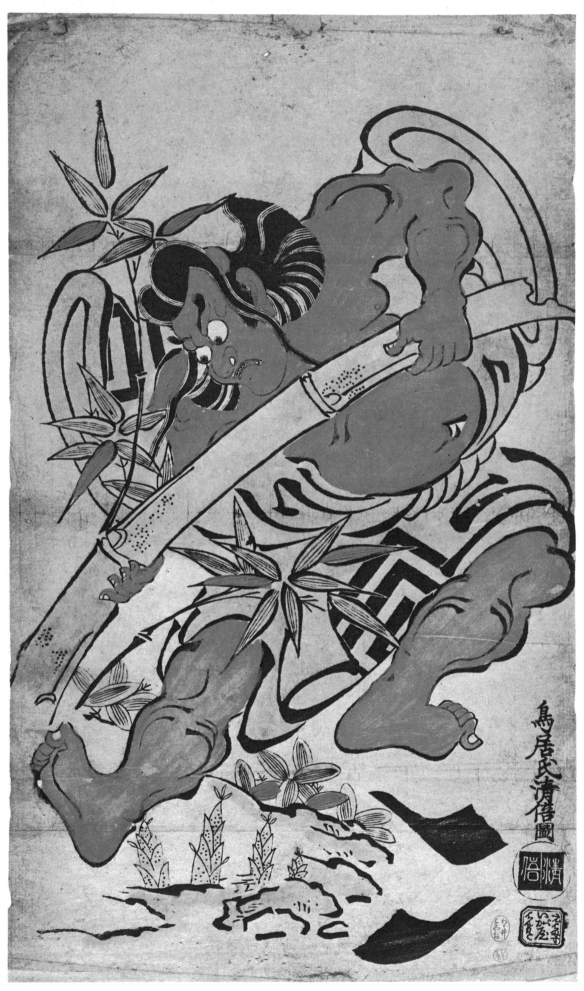

Kiyomasu *The Actor Ichikawa Danjuro as Goro Uprooting a Bamboo*
Extra-oban, tan-e, 54.2 × 32.2 cm
Publisher: Iga-ya Kan-emon. Date: c. 1710's. Tokyo National Museum

An exaggerated and stylized representation of the superhuman strength of Goro uprooting a bamboo for use in a fight with a tiger. A typical *aragoto* style of acting in *Kabuki*.

71

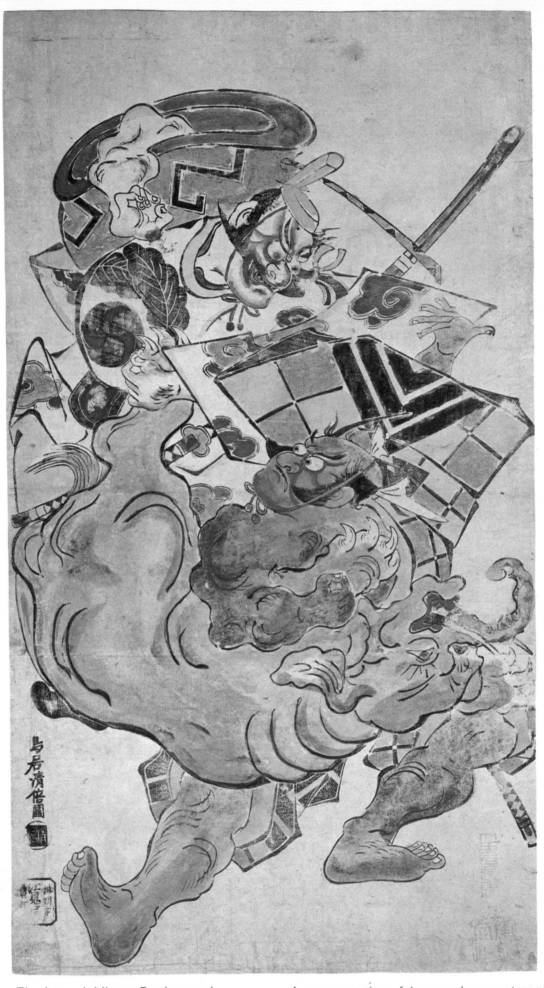

Kiyomasu *The Actors Ichikawa Danjuro and Nakayama Heikuro in "Zobiki"*
Extra-oban, sumizuri-e, hand-coloured,
59.1 × 32.4 cm
Publisher: Emi-ya Kichi-emon. Date: c. 1710's
Nelson-Atkins Gallery of Art, Kansas City

A representation of the superhuman strength to throw down an elephant with a twist. A scene in *Zobiki*, one of the "18 Favourites" of the *Kabuki* plays.

72

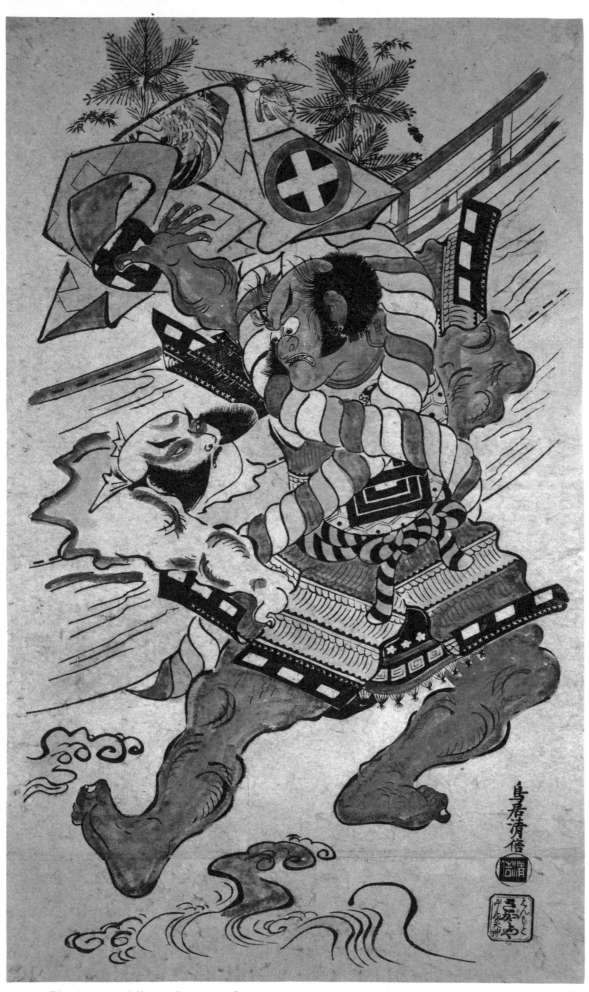

Kiyomasu *The Actors Ichikawa Danzo as Soga Goro and Otani Hiroji as Asahina*
Extra-oban, tan-e, 53.4 × 32.2 cm
Publisher: Sagami-ya. Date- c. 1717. British Museum, London

A scene in a play dealing with the Brothers Soga's vendetta, one of the most popular plays in *Kabuki*. Asahina is grasping Goro's armour to keep him back. The Torii school's typical style of portraying *Kabuki* actors.

73

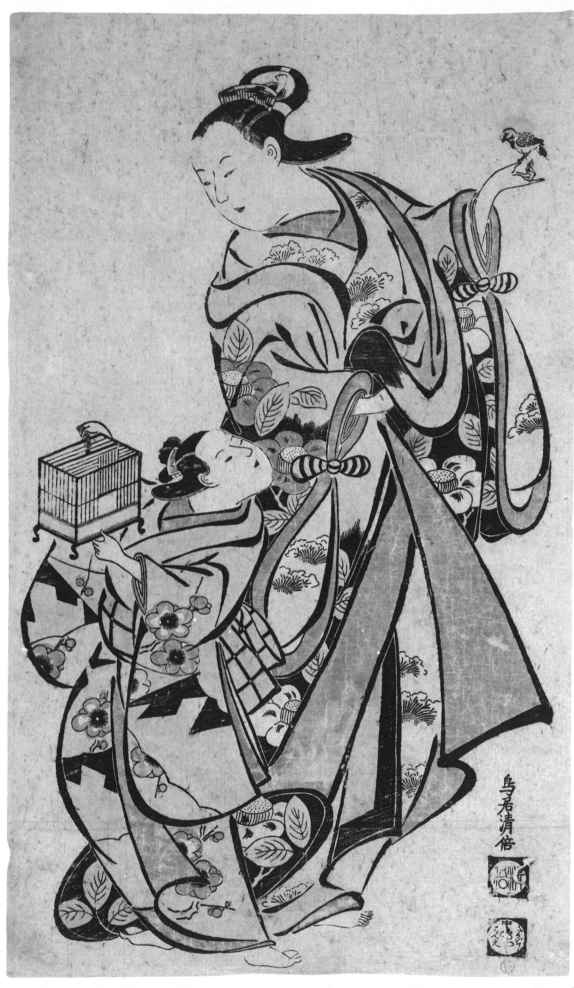

Kiyomasu *Woman with a Bird, and Kamuro*
Extra-oban, tan-e, 54 × 31.6 cm
Publisher: Nakajima-ya. Date: c. 1710's. Tokyo
National Museum

A courtesan with a Java sparrow in the palm of her
hand and her little attendant *kamuro* holding a
birdcage.

74

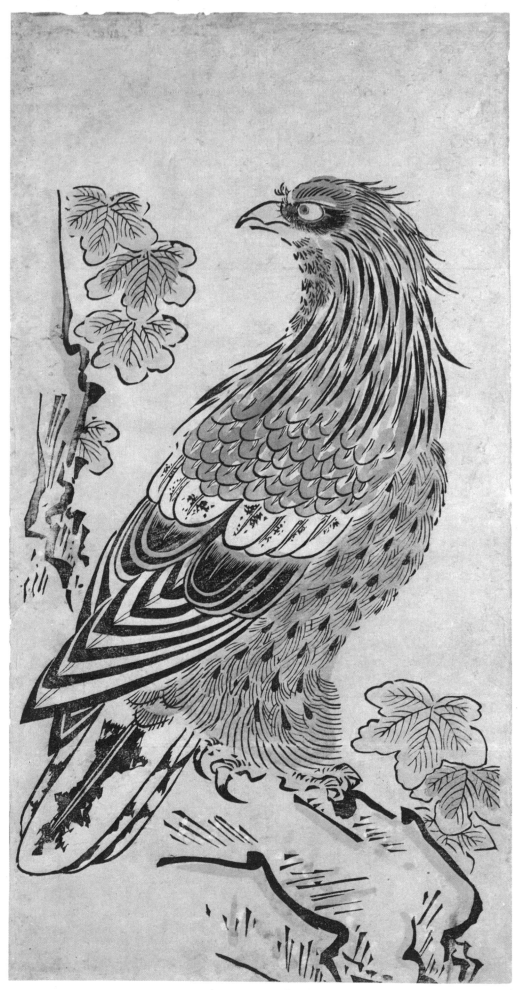

Kiyomasu (Unsigned) *Hawk on Oak Tree*
Extra-oban, sumizuri-e, hand-coloured,
55.7 × 28.8 cm
Publisher: unknown. Date: c. 1710's
The Art Institute of Chicago

Hawks, symbol of a strong *samurai* spirit, were raised
for use in hunting.

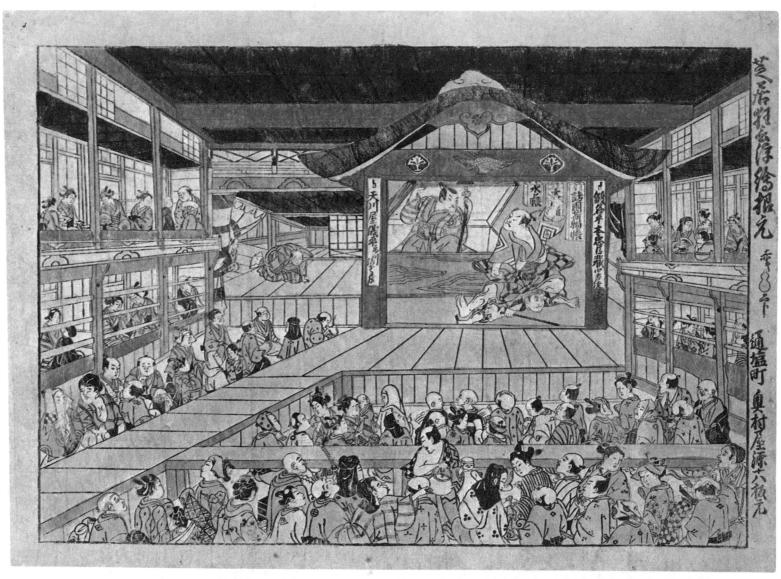

Masanobu (Unsigned) *Interior View of the Nakamura-za Theatre*
Extra-oban, Urushi-e, 32.5 × 45 cm
Publisher: Okumura-ya Genroku. Date: c. 1740's
Sakai Collection, Japan

Stage devices of the Edo period such as a *hanamichi* (passage-way) and the roof of a stage, and boxes crowded with spectators. The play being performed is the famous vendetta story *Chushin-gura*.

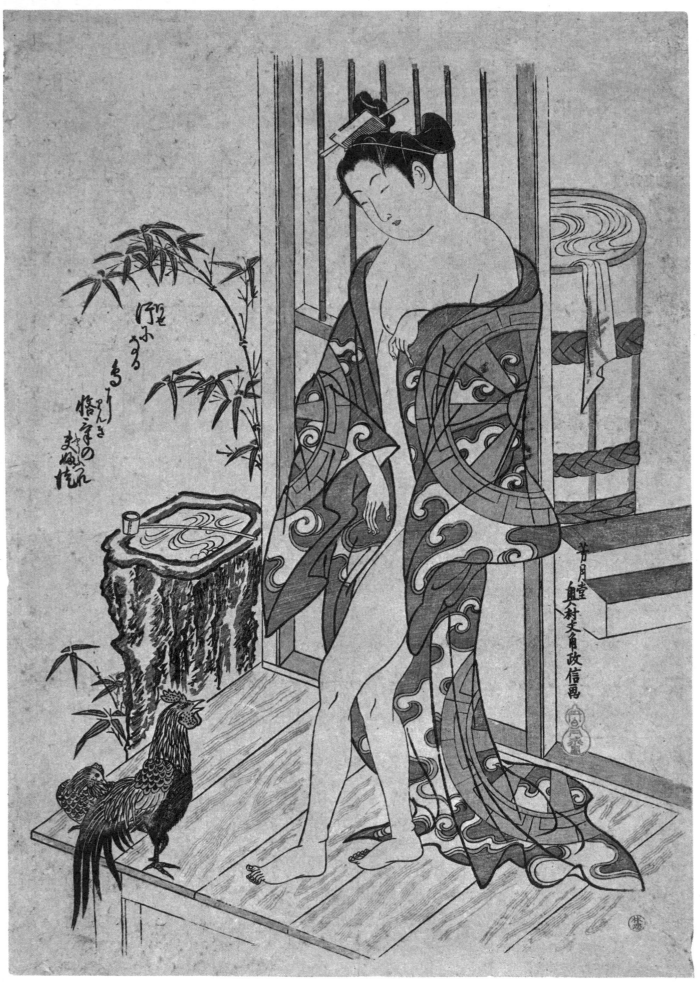

Masanobu *Beauty after Bath*
Extra-oban, benizuri-e, 43.8 × 30.9 cm
Publisher: unknown. Date: c. 1750's. Tokyo National
Museum

A risqué picture of a woman just out of her bath on a
summer day. The poem written on the print tells how
the hen is jealous of the cock gazing in rapture at the
beautiful woman.

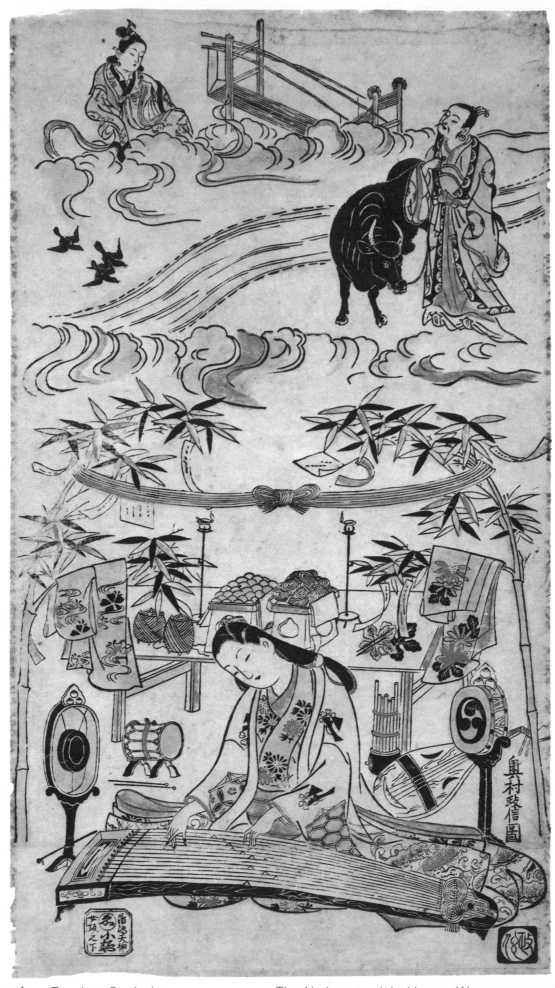

Masanobu *Tanabata Festival*
Extra-oban, tan-e, 55.3 × 29.8 cm
Publisher: Komatsu-ya Denbei. Date: c. 1710's
Kyusei Atami Art Museum, Japan

The Altair star and the Vega or Weaver star are about to have their once-yearly meeting on the bank of the Milky Way, and a young girl is playing the *koto* before the offerings made to the two stars. The festival is based on a Chinese legend.

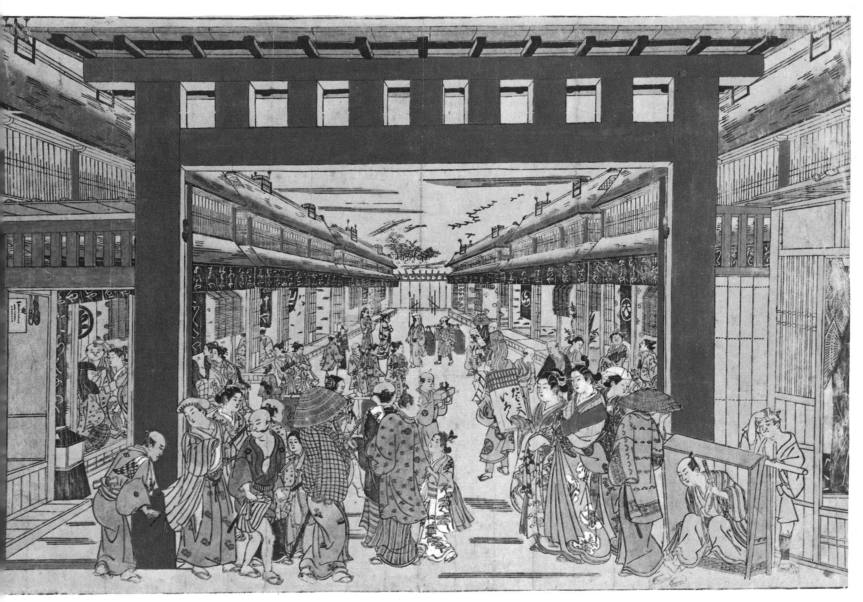

Masanobu (Unsigned) *Entrance to Yoshiwara Gay Quarters*
Extra-oban, beni-e, 43.2 × 64 cm
Publisher: unknown. Date: c. 1740's. The Art Institute of Chicago

The great outer gate and the rows of tea houses lining the broad street of the gay quarters at Yoshiwara. Some courtesans are greeting customers at the gate. An example of *ukiyo-e* (pictures with perspective) of the early period.

Toshinobu *Horned Owl and Sparrows*
Hosoban, urushi-e, 33.3 × 15.6 cm
Publisher: Emi-ya Kichi-emon. Date: c. 1730's. Japan
Monopoly Corporation

Probably the horned owl is a caricature of a person
suggested by a tobacco pouch, hoe, and sedge hat.

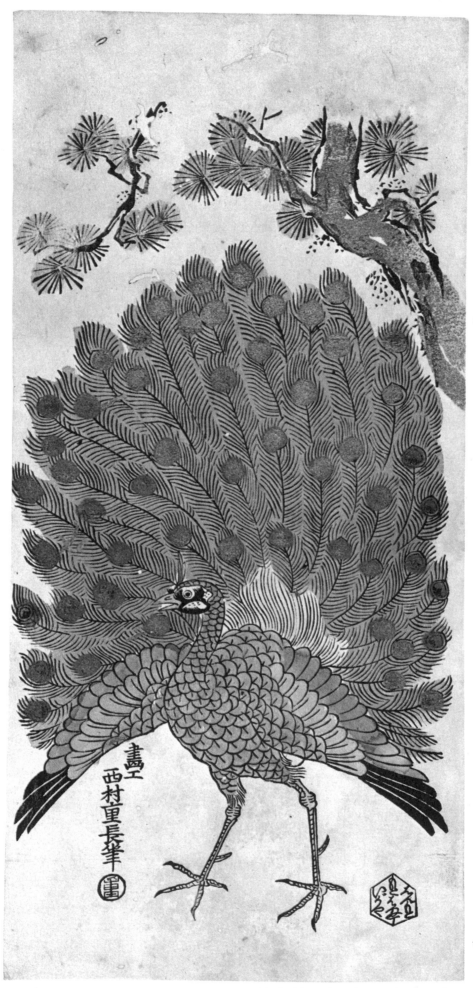

Shigenaga *Peacock*
Hosoban, urushi-e, 34.5 × 16.3 cm
Publisher: Iga-ya Kan-emon. Date: c. 1730's. Riccar
Art Museum, Japan

Probably painted as a picture of a strange bird brought
from abroad. Animals such as camels and elephants
were also imported for exhibition.

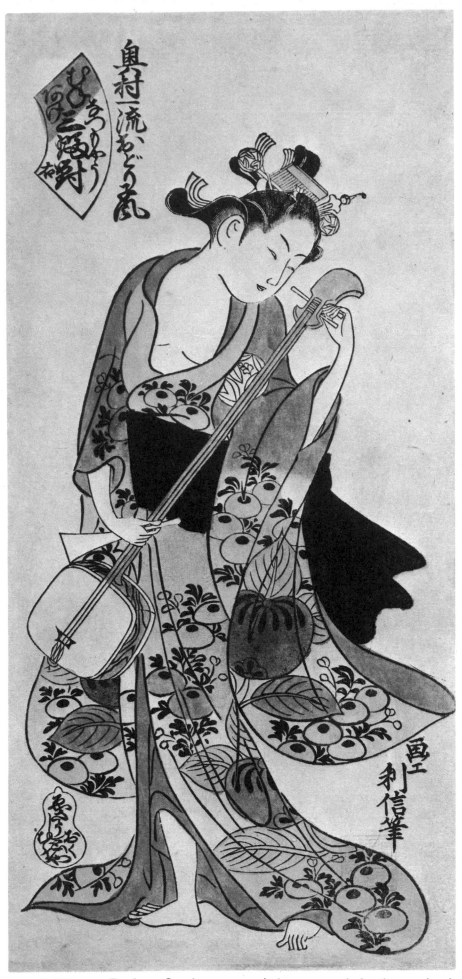

Toshinobu *A Beautiful Woman Tuning a Samisen (Natsu Moyo Muneake Sanpuku-tsui Migi)*
Hosoban, urushi-e, 30.5 × 14 cm
Publisher: Okumura-ya Genroku. Date: c. 1730's

A dancer nonchalantly opening her *kimono* at the breast and holding a *samisen* in her hands. One of the triptych depicting scenes in summer.

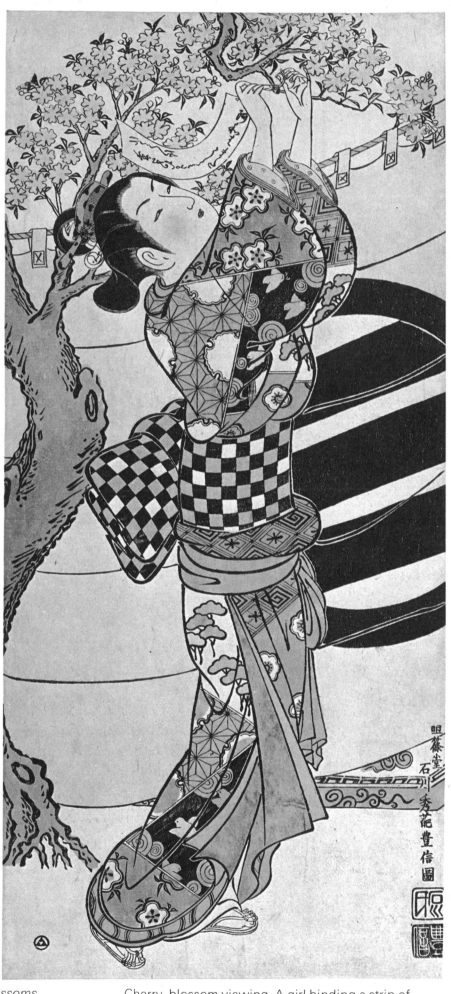

Toyonobu *Beauty under Cherry Blossoms*
Wide-hashiraeban, beni-e, 50.9 × 23.2 cm
Publisher: Urokogata-ya Magobei. Date: c. 1740's
Riccar Art Museum, Japan

Cherry-blossom viewing. A girl binding a strip of
fancy paper bearing a poem to branches of a cherry
tree. A curtain, under which a carpet is seen, is hung
up for a banquet under the cherry blossoms.

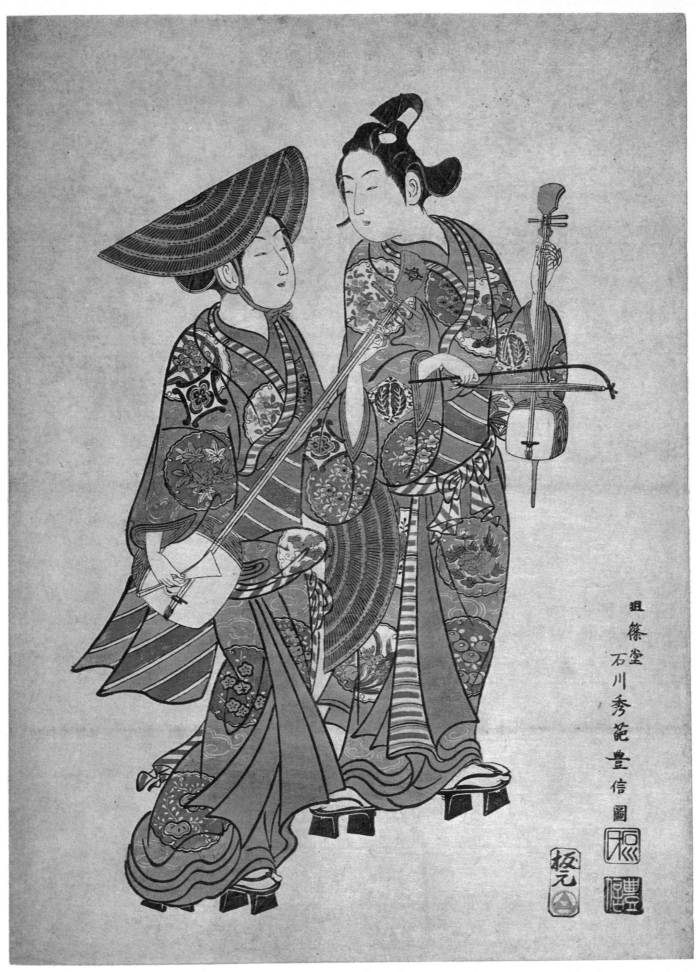

Toyonobu *Strolling Minstrels: The Actors Onoe Kikugoro and Nakamura Kiyosaburo*
Extra-oban benizuri-e, 44.8 × 31.9 cm
Publisher: Urokogata-ya Magobei. Date: c. 1750
Riccar Art Museum, Japan

Based on a story of a woman searching for her missing husband. The actors, performing as a young man and woman, are singing the elegy *Strolling Minstrels* while playing the Chinese fiddle and the *samisen*. Depicted in the style of pictures of beautiful women, not of actors.

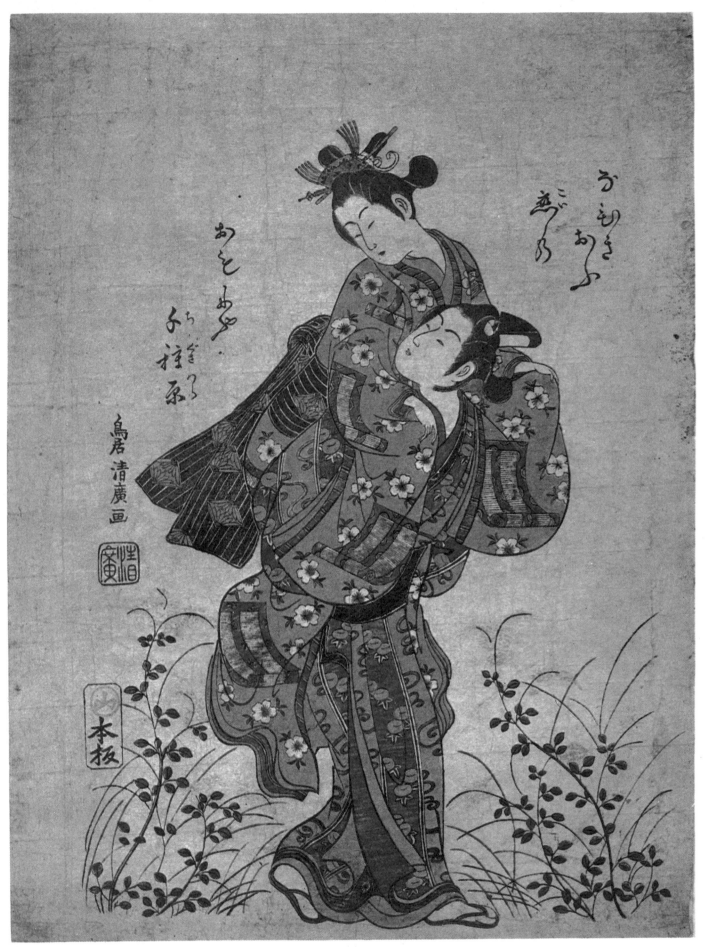

Kiyohiro *Fleeing Lovers, Elopement Scene from the*
Ise Monogatari (*Tales of Ise*)
Extra-oban, benizuri-e, 43.7 × 32 cm
Publisher: Maru-ya Yamamoto Kohei. Date: c. 1750's

A young man fleeing with his sweetheart on his back
across the fields spread with autumnal flowers.

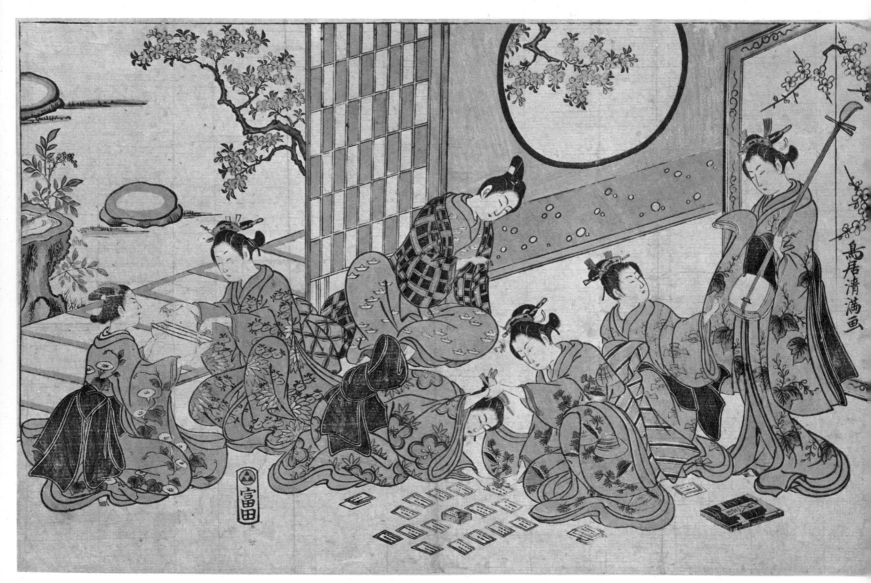

Kiyomitsu *Interior Pastime*
Extra-oban, benizuri-e, 28.2 × 43.8 cm
Publisher: Tomita-ya. Date: c. 1760's

Young girls playing cards and cat's cradle.

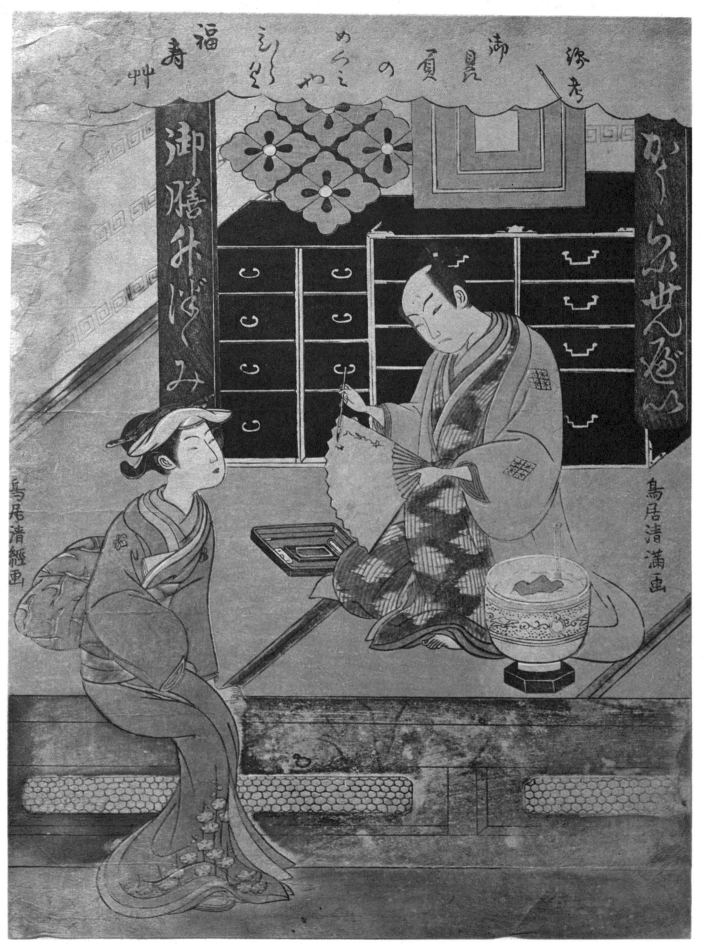

Kiyomitsu and **Kiyotsune** *Korai Sembei*
Chuban Nishiki-e, 27.6 × 20.4 cm
Publisher: unknown. Date: c. early 1770's. Tokyo
National Museum

Naming stores after actors was then in fashion. This is a *sembei* (rice cracker) store named after the actor Matsumoto Koshiro with the house name of Korai-ya. The man, Ichikawa Komazo (later Matsumoto Koshiro IV) was depicted by Kiyomitsu, and the beautiful women sitting at the storefront by Kiyotsune. Behind them is a confectionery cabinet. At the top of the print is a poem written by Segawa Kikunojo II.

The romantic world of fantasy

The creation of full-colour wood-block prints

In the latter half of the 1760's the exchange of "pictorial calendars" was very much in vogue among intellectuals in Edo (modern Tokyo).

According to the then lunar calendar, there were two kinds of month: a long one of 30 days and a short one of 29 days. Although they generally alternated to make a year of 12 lunar months, some adjustment was necessary each year so as to minimize the discrepancy between the calendar and the seasons. Among intellectuals the hobby spread rapidly in which the participants met and vied for the superiority of their works: calendars depicted in pictures instead of characters. This involved both *samurai* (warriors) and *chonin* (literally, townspeople, i.e. merchants and craftsmen).

In any case, because they were all highly-cultivated persons with a keen connoiseurship of literature and the fine arts, their competitions resulted in elevating the level of the conventional wood-block prints to a full-colour work of art. Suzuki Harunobu was one of the most outstanding of the artists who displayed their talent in the designing of such wood-block prints.

Suzuki Harunobu (1725–1770)

In his early years, Harunobu, too, produced actor portraits in *benizuri-e* (pink-printed pictures) of two or three colours. Most of these works were influenced by the illustrating styles of Nishikawa Sukenobu (about whom more information is to be found in the next chapter), and Torii Kiyomitsu.

In the meantime, the craze for pictorial calendars encouraged the expenditure of greater amounts of money and time in printing as well as in the manufacture of paper. Full-colour multi-printing was also developed, creating a new world of rich colour and beauty utterly unlike the old one.

This became possible only with the development of a fine, thick paper durable enough to withstand printing several times, and also to the development of a technique called *Kento*, which avoids shear in making successive impressions from blocks in different colours.

Polychrome wood-block prints produced in this way came to be called *nishiki-e* (brocade pictures), chiefly because of their dazzling splendour similar to Chinese brocade, and partly because they were so expensive to buy. Thus, *ukiyo-e* prints entered a new and fantastic world of resplendent colour. Thenceforth, these full-colour *nishiki-e* came to mean *ukiyo-e* in the mind of the public.

It must be noted here, however, that *nishiki-e* were not invented by Harunobu, but were the result of co-operation with many other people. Harunobu has come to be regarded as the inventor and pioneer of *nishiki-e* because his work was so outstanding.

The main characteristics of *nishiki-e*, which were brought to full flower by Harunobu, can be summarized as follows.

A literary romanticism

Classical epic and poems had sometimes been chosen as subjects for *ukiyo-e* in the early period, but this trend was even more evident in the works of Harunobu. The intellectuals who contributed to the creation of *nishiki-e* were all people endowed with a literary romanticism. Harunobu himself, however, did his best to impart even more of a literary flavour than his patrons demanded. His tactful depiction of people and customs and above all his lyricism probably served to make these works based on classic poetry so successful.

The expression of human figures

The men and women portrayed in the early period of *ukiyo-e* have a suggestion of healthy and artless beauty. For example, the people shown in works of the Kaigetsudo school were often of large build and imposing proportions. Persons in Harunobu's works, however, were all pretty and small-statured with miniaturized limbs. This painting style might seem to have been influenced by Chinese wood-block prints, but these lovely figures of men and women are nothing but an outward reflection of the idealized and fantasized beauty enshrined in his innermost heart, rather than a mere expression of outward reality. Even his scenes of sexual love rise far above vulgarity and seem to allude to the realm of pure love rather than carnal lust.

A world of beautiful colour

Completion of full-colour printing techniques meant more than a mere richness in colouring. For instance, besides colouring the background in accordance with seasonal changes, there are some works in which all the vacant space is filled with one colour. Such happened quite rarely in the primitive stage of wood-block prints.

Besides the primary colours, *gofun* (a white pigment made of powdered chalk or shells) used to be mixed with paints to make the most of neutral tints, adding a note of refinement to the print. Harunobu's sense of colour was quite wonderful in this respect, too.

New printing devices

Wood-block prints in full-colour would be impossible without a close co-operation between excellent engravers and printers. In Harunobu's case, many a skilled artisan co-operated with him, always keeping pace with the progress of the new technology. There was for example, the new technique of blind-printing or gauffrage. For a pure white costume or fallen snow, white paper was embossed by a uneven and uninked wood-block, making possible the more vivid expression of cubic space. Many technical innovations like gauffrage originated in Harunobu's works and most later ones were built on this foundation. In fact, the appearance of Harunobu's *nishiki-e* had such an influence on the development of *ukiyo-e*, that even today painters strive to emulate the beauty of Harunobu.

These *nishiki-e* masterpieces by Harunobu number 800-odd, produced in the short space of five years, a very brief period, similar perhaps to Van Gogh's, his genius burnt out once he had discovered his own style.

Suzuki Harushige (Shiba Kokan, 1747–1818)

Though Harushige did not study directly under Harunobu, he produced works in a very similar style. Harushige was his artistic pseudonym, but he recorded in his autobiography that prints illustrated by him under the feigned signature of Harunobu had passed for true works of Harunobu. When the scenery in the background is designed in an extreme perspective, we may safely assume that we are looking at one of Harushige's works.

Later, under the name of Shiba Kokan, he was the first artist in Japan to make his own copper prints.

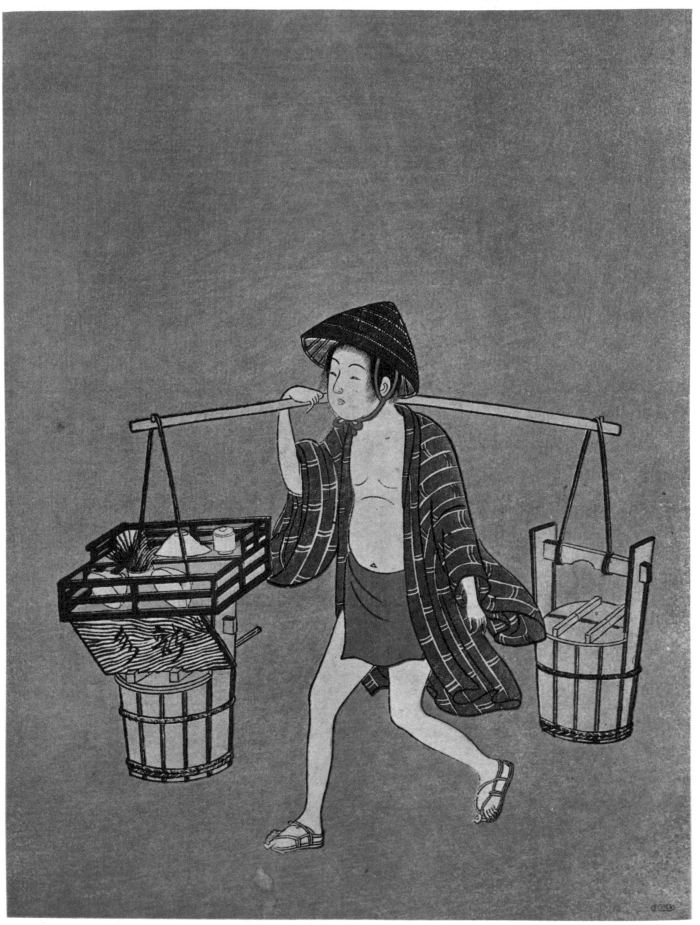

Harunobu *Water Vendor*
Chuban, Nishiki-e, 25.5 × 19.3 cm
Publisher: unknown. Date: c. 1765. Tokyo National
Museum

A young man vending fresh cold water in the streets in
summer. Depicted here as a boy.

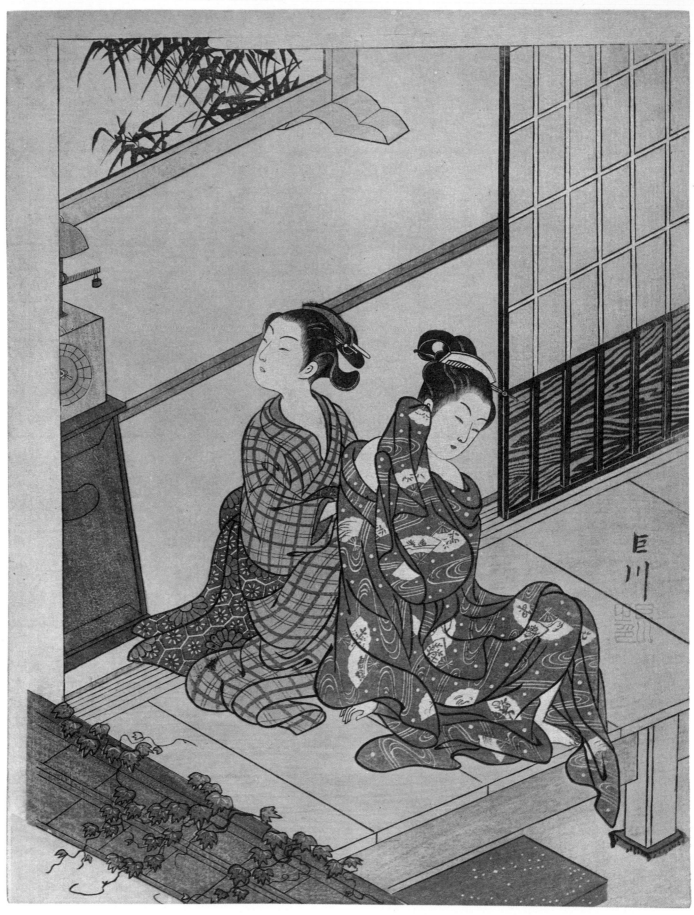

Harunobu *Evening Bell of the Clock*, from the
series *Eight Indoor Views (Zashiki Hakkei)*
Chuban, Nishiki-e, 28.5 × 21.7 cm
Publisher: unknown. Date: c. 1765. The Art Institute
of Chicago

Emulating *The Eight Views of Lake Tung-Tin* in China,
eight indoor views were made, of which the evening
bell was replaced by the chime of a Japanese clock
with spring. Two women sitting on a veranda.

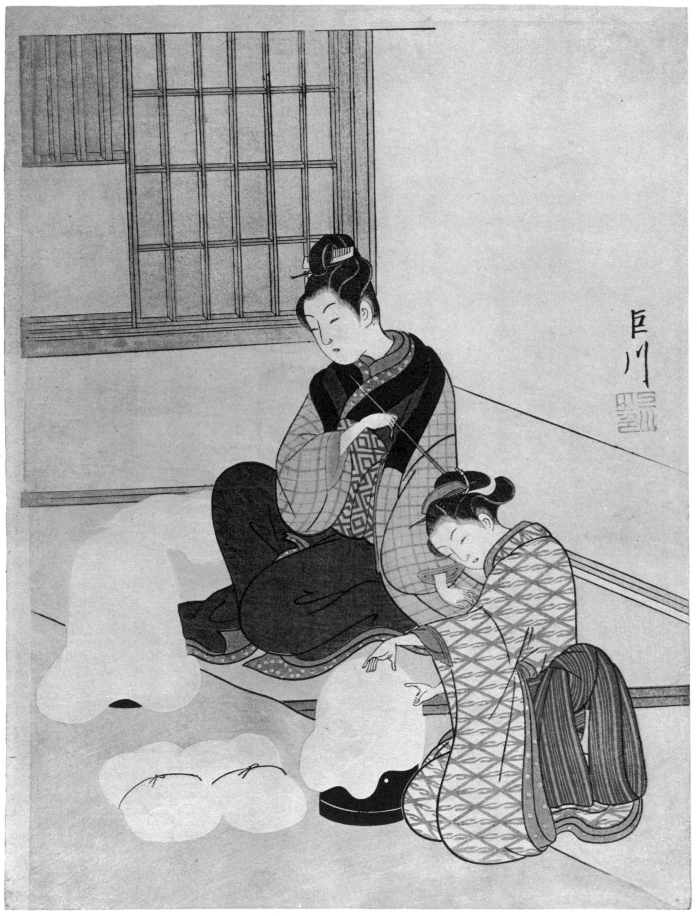

Harunobu *Lingering Snow on a Lacquered Pail,* from the series *Eight Indoor Views (Zashiki Hakkei)* Chuban, Nishiki-e, 28.5 × 21.6 cm Publisher: unknown. Date: c. 1765. The Art Institute of Chicago

This is the same idea as page 92. One of the Eight Views is a snowscape. Floss silk is likened here to snow. A middle-aged woman holding a long pipe and her daughter spinning yarn from floss.

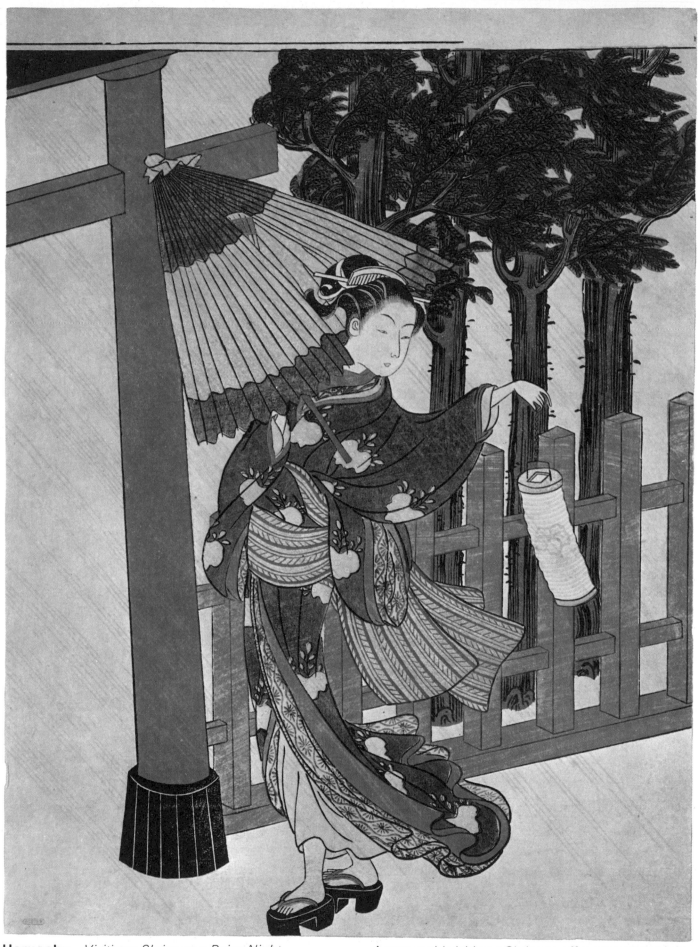

Harunobu *Visiting a Shrine on a Rainy Night*
Chuban, Nishiki-e, 27.7 × 20.5 cm
Publisher: unknown. Date: c. late 1760's. Tokyo
National Museum

A young girl visiting a Shrine to offer a prayer at night in the teeth of a severe storm. She seems to be worried that the lantern light may be blown out.

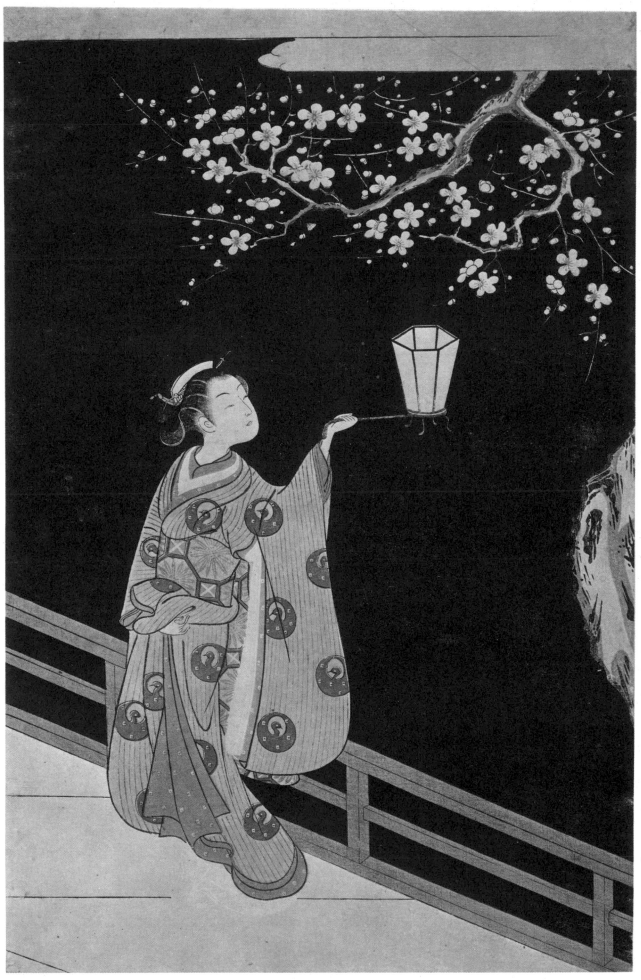

Harunobu *Plum-Blossom Viewing at Night*
Chuban, Nishiki-e, 32.4 × 20.9 cm
Publisher: unknown. Date: c. late 1760's. The
Metropolitan Museum of Art, New York

A little girl waiting upon a courtesan. She is holding a
portable candle high in the air and viewing plum
blossoms.

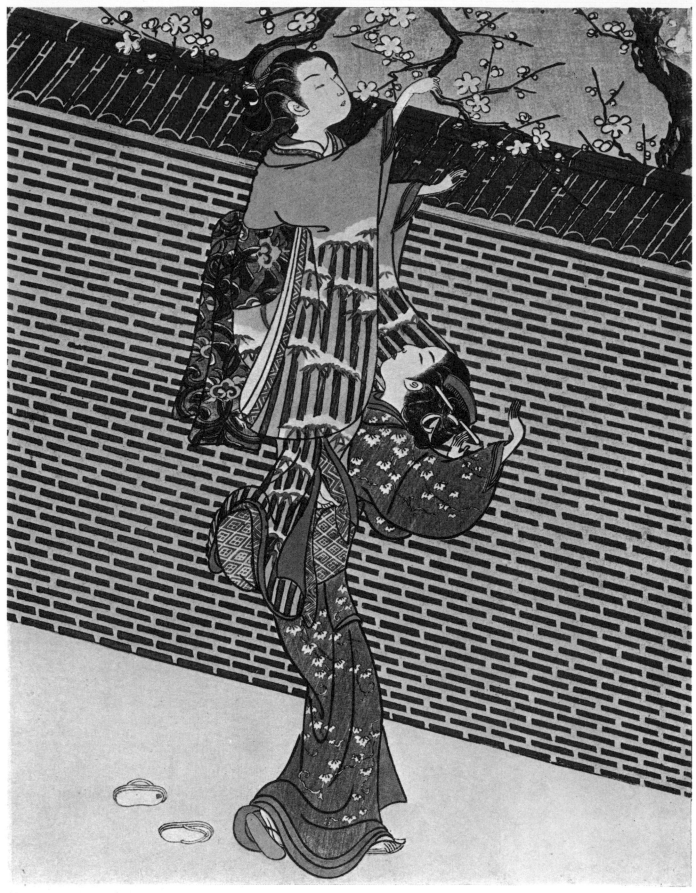

Harunobu *Girl Breaking a Plum Branch*
Chuban, Nishiki-e, 26.9 × 20.9 cm
Publisher: unknown. Date: c. late 1760's. Yamatane
Museum of Art, Japan

A girl standing on the shoulders of her maidservant
and breaking a plum branch which is peeping over the
wall. The wall is tiled on the top and built of mud,
probably a temple wall.

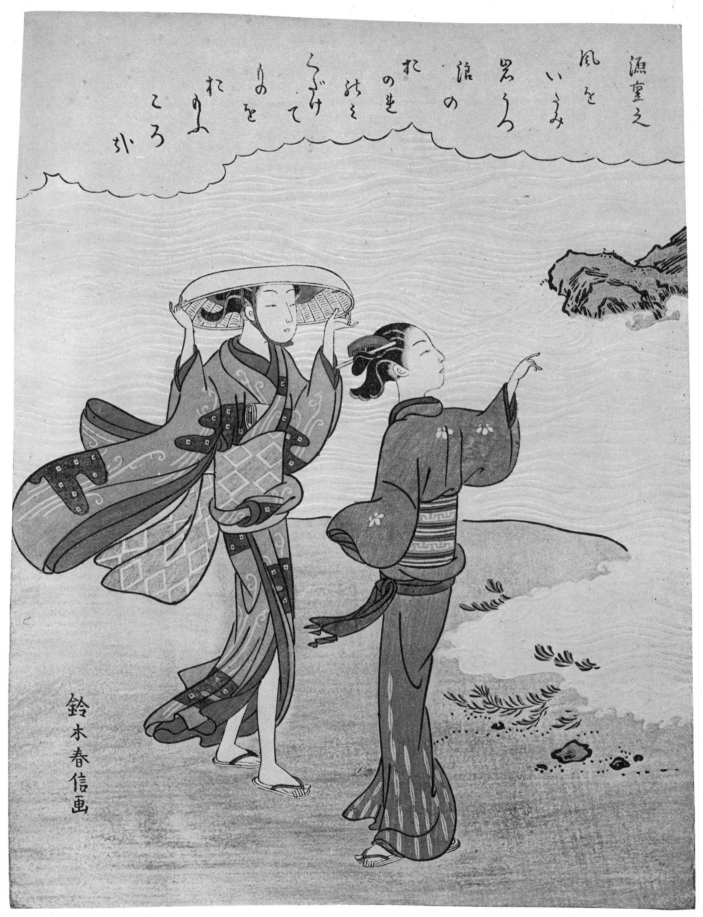

Harunobu *Two Beauties on the Seashore* (An analogue of a poem by Minamoto no Shigeyuki) Chuban, Nishiki-e, 28.4×21.4 cm Publisher: unknown. Date: c. late 1760's

One of a genre picture series whose motif was taken from the *One Hundred Poems by One Hundred Poets*. The poem itself is ancient, but the attire and hairstyle are modified in the contemporary fashion. Waves are made by the *kimekomi* technique – a part of the picture is rugged so as to provide a three-dimensional effect.

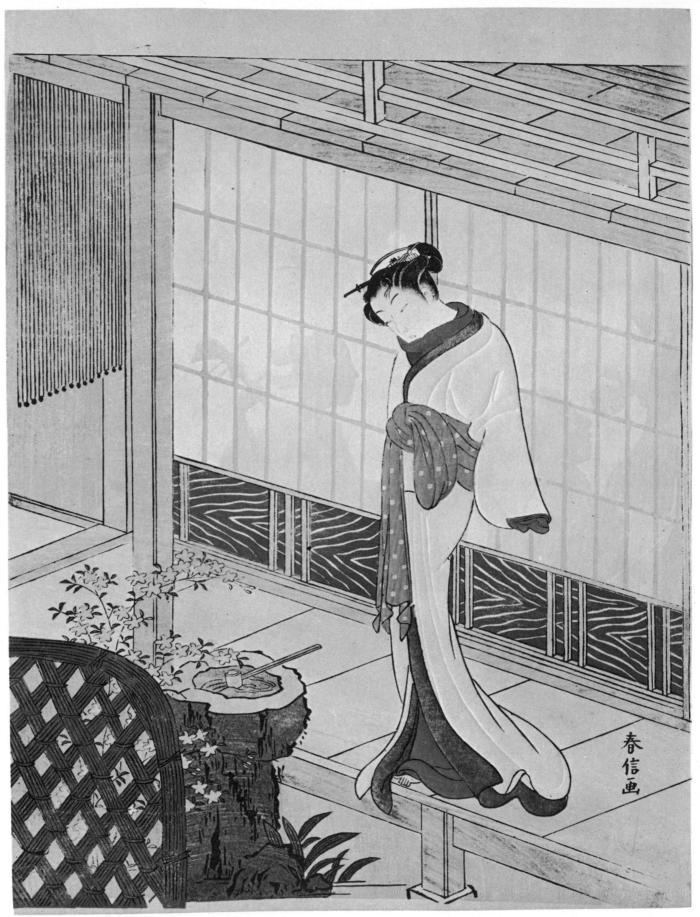

Harunobu *Courtesan on the Veranda*
Chuban, Nishiki-e, 28.7 × 21.6 cm
Publisher: unknown. Date: c. late 1760's

A tipsy courtesan coming to the veranda to get sober. On the paper screen are projected some silhouettes of people who are enjoying the banquet in the room.

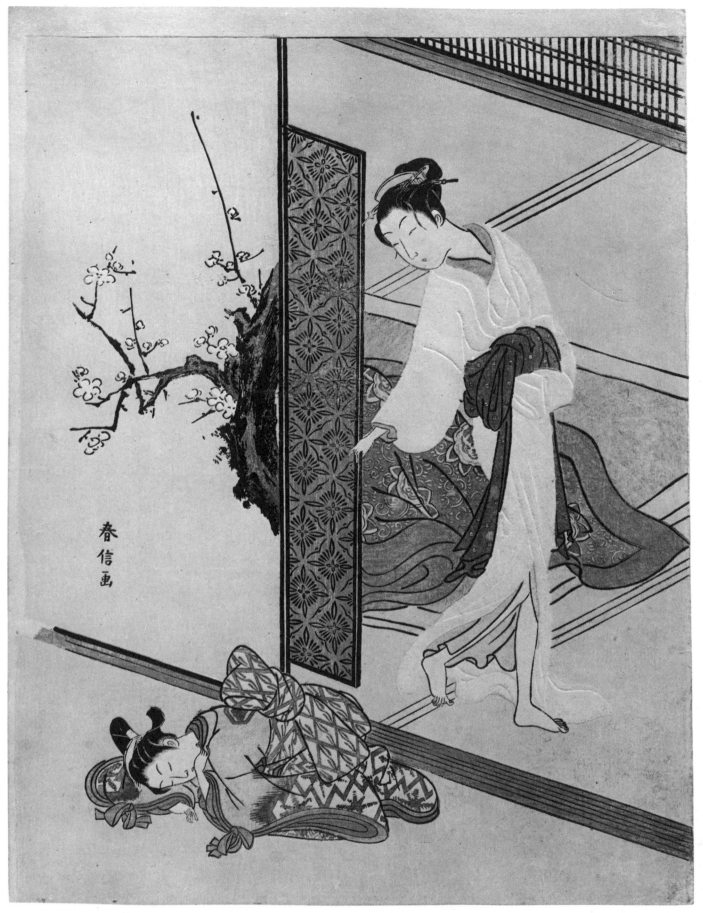

Harunobu *Scene at Midnight*
Chuban, Nishiki-e, 28.7 × 22.2 cm
Publisher: unknown. Date: c. late 1760's

A night scene in the gay quarters. A girl attendant (*kamuro*) drops her head and dozes. A *futon* (quilted coverlet) is seen behind the courtesan.

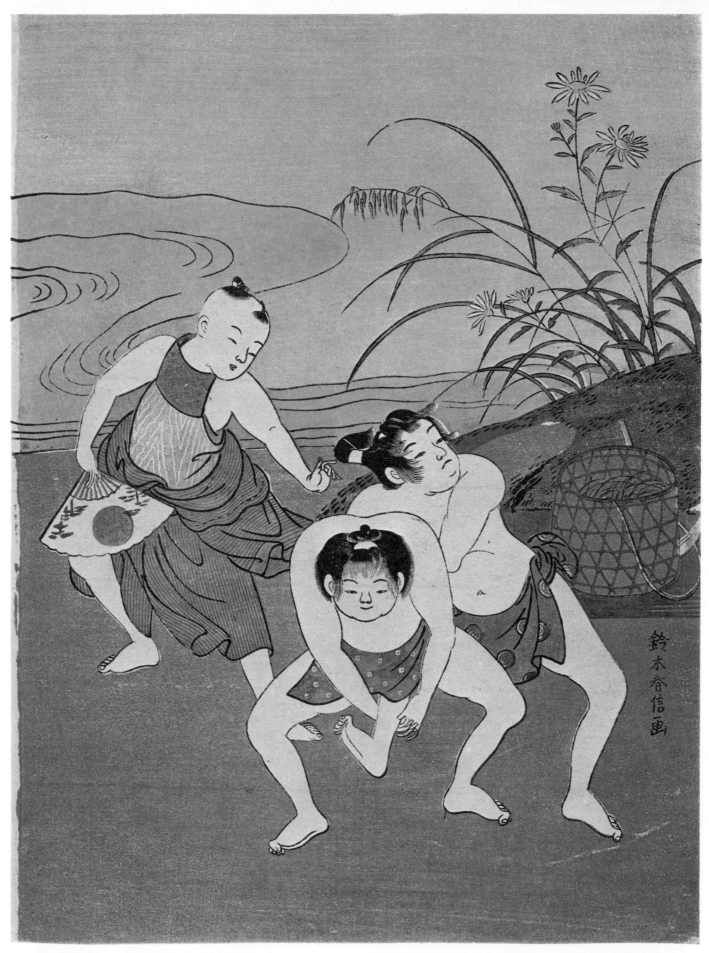

Harunobu *Children's Sumo Wrestling*
Chuban, Nishiki-e, 27.8 × 20.5 cm
Publisher: unknown. Date: c. late 1760's. Takahashi
Collection, Japan

Children are also one of the favourite subjects of
ukiyo-e. Forgetful of their stint of grass-cutting, the
children are playing at wrestling by the riverside. The
child holding a folding fan is the referee.

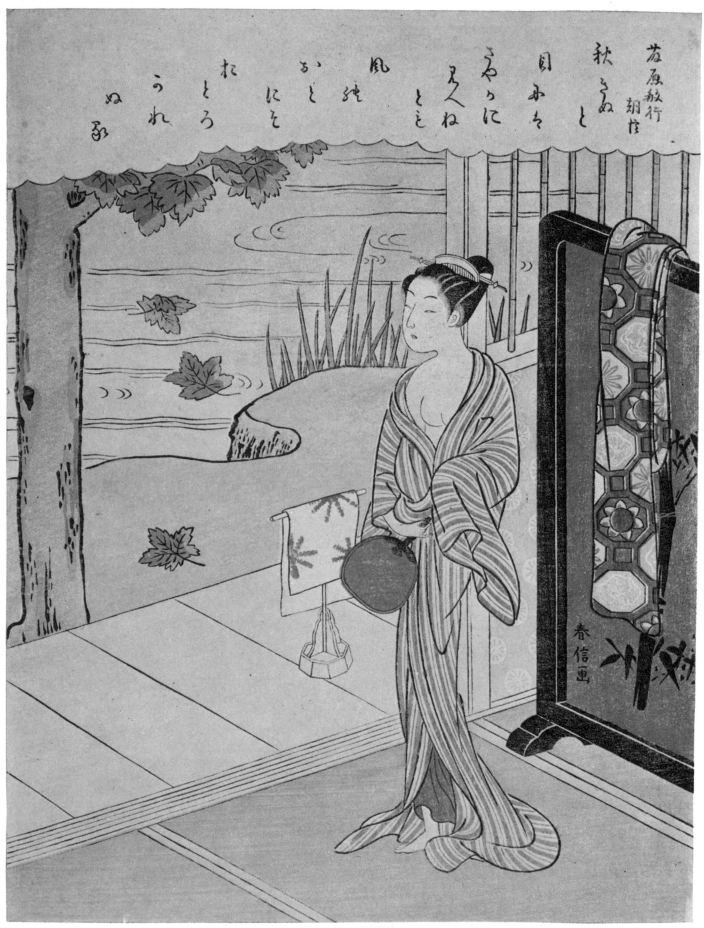

Harunobu *Beauty after the Bath* (An analogue of a poem by Fujiwara no Toshiyuki, a courtier)
Chuban, Nishiki-e, 28.2 × 21.2 cm
Publisher: unknown. Date: c. late 1760's. Kyusei Atami Art Museum, Japan

A picture from a genre picture series based on the *One Hundred Poems* by *One Hundred Poets*. The season is the end of summer. A towel rack on the veranda. A few leaves of paulownia reveal that autumn is coming.

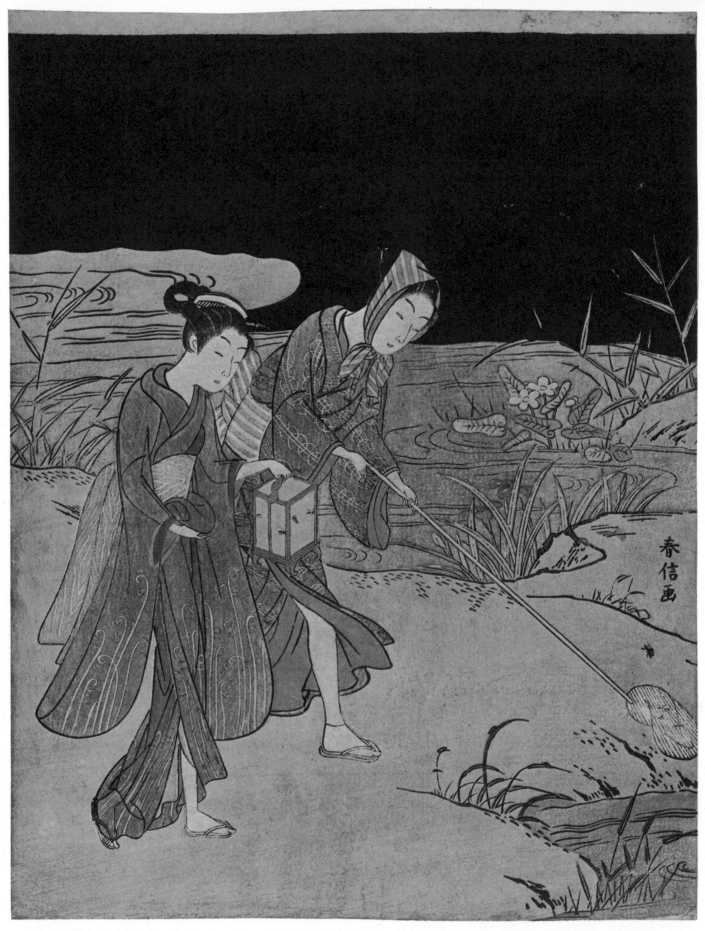

Harunobu *Firefly Catching*
Chuban, Nishiki-e, 27.9 × 21 cm
Publisher: unknown. Date: c. late 1760's. Riccar Art
Museum, Japan

A young couple catching fireflies.

102

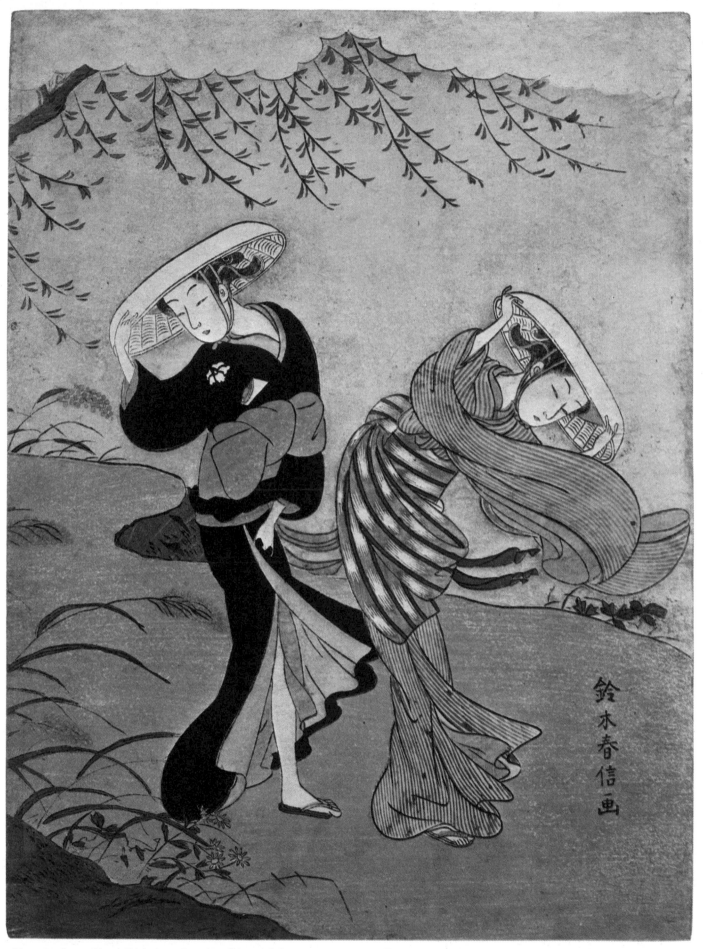

Harunobu *Two Girls in a Searing Blast of Autumn*
Chuban, Nishiki-e, 27.3 × 20 cm
Publisher: unknown. Date: c. late 1760's. The
Minneapolis Institute of Art

Two girls being troubled with strong autumn wind.
They are perhaps out on a picnic.

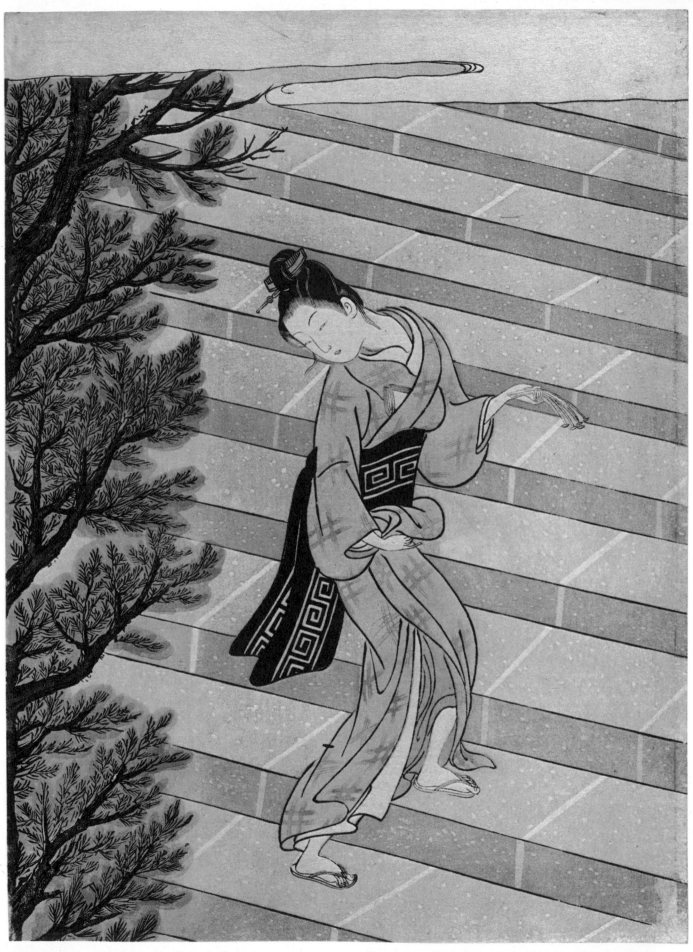

Harunobu *Climbing the Temple Steps*
Chuban, Nishiki-e, 27.4 × 20 cm
Publisher: unknown. Date: c. 1765. The Art Institute
of Chicago

A one-hundred-times worship. A woman walking
back and forth a hundred times before a temple (or
shrine), offering a prayer each time. Her hair is wound
round a comb in a fashionable hairstyle. In her left
hand she holds twisted-paper strings to help her
count how many prayers she has offered.

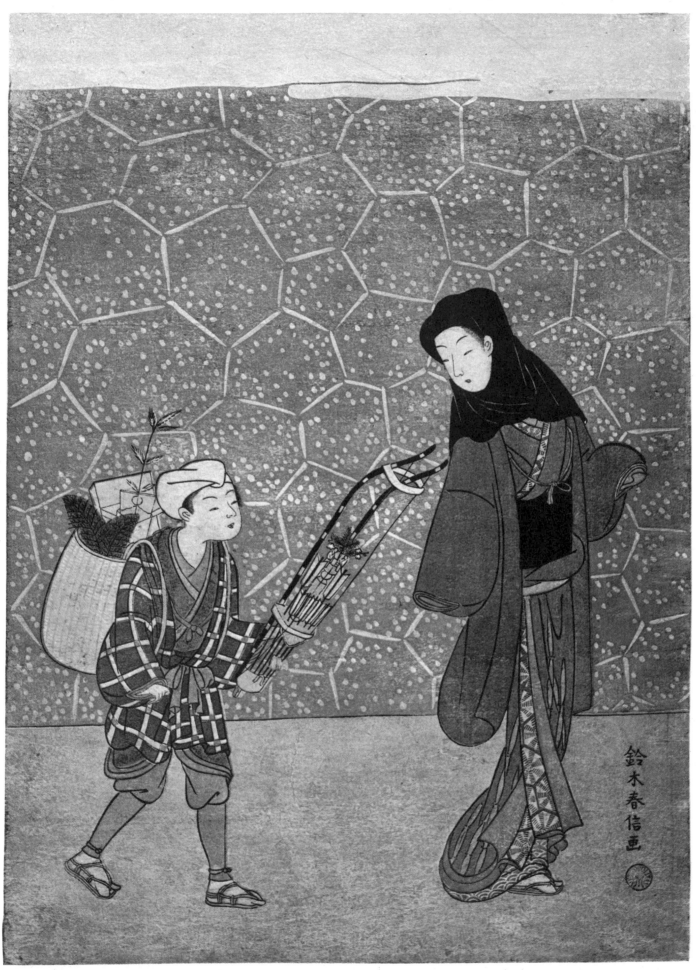

Harunobu *New Year's Toy Bows and Arrows for Exorcism (Hamaya)*
Chuban, Nishiki-e, 29.6 × 21.2 cm
Publisher: unknown. Date: c. late 1760's. The
Metropolitan Museum of Art, New York

A *hamaya*-vendor is trying to persuade a woman to
buy a set of *hamaya*. The woman wears a hood to
protect her against the cold. A stone wall is in the
background.

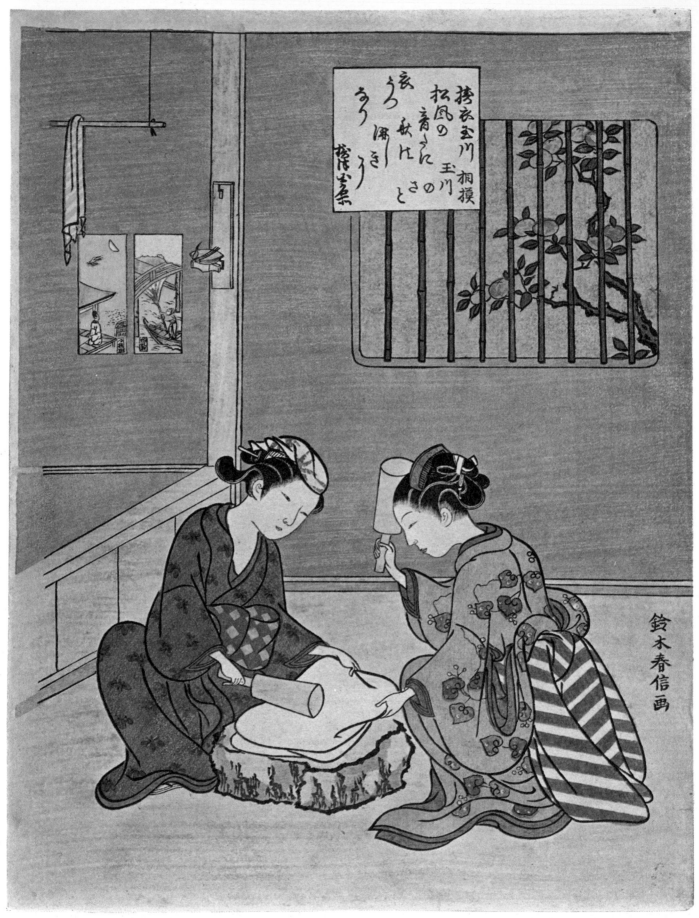

Harunobu *Toi no Tamagawa,* from the series *Six Crystal Rivers (Mu-Tamagawa)*
Chuban, Nishiki-e, 27.8 × 21 cm
Publisher: unknown. Date: c. late 1760's

Mother and daughter beating cloth for bleaching. The tree outside the window is a persimmon. Two *ukiyo-e* prints are pasted on the wall. On the pillar is a light in a dish which contains rapeseed oil.

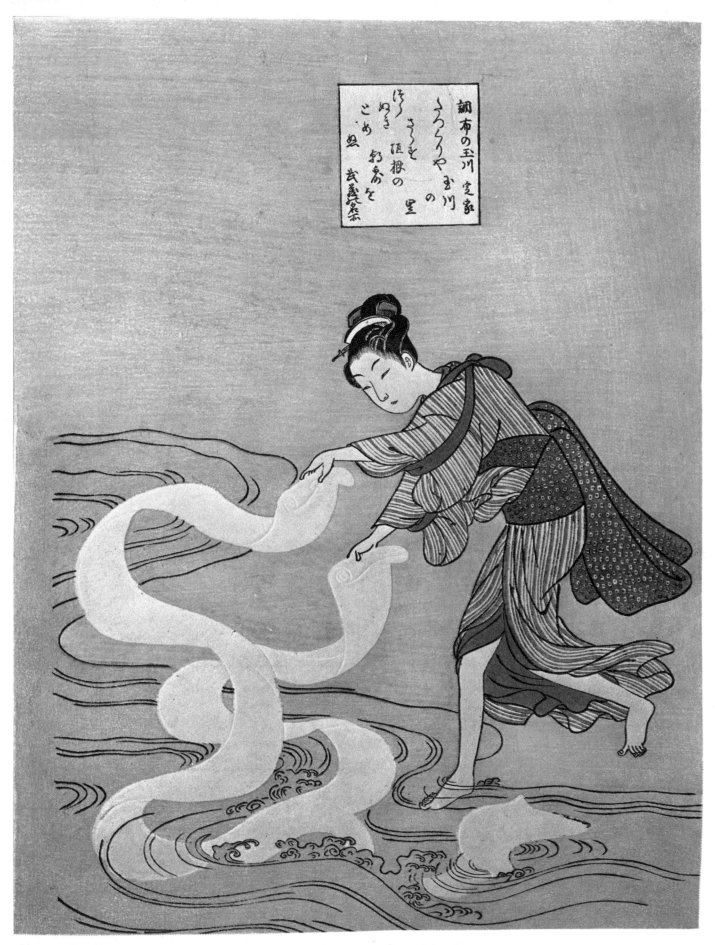

Harunobu (Unsigned) *Chofu no Tamagawa*, from the series *Six Crystal Rivers (Mu-Tamagawa)*
Chuban, Nishiki-e, 27.8 × 20.9 cm
Publisher: unknown. Date: c. late 1760's

One of the six-print series of six rivers with the name of Tamagawa. A girl bleaching cloth in the stream. (*Chofu* is literally "bleaching cloth".)

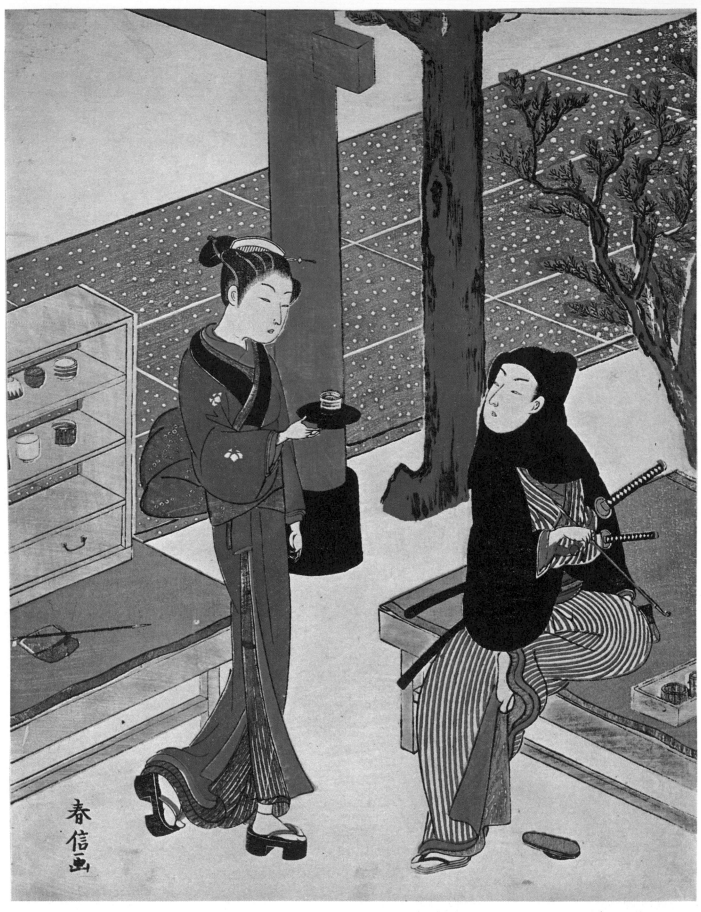

Harunobu *Tea-stall of Osen*
Chuban, Nishiki-e, 26.7 × 20.3 cm
Publisher: unknown. Date: c. late 1760's. Tokyo
National Museum

A young *samurai* (warrior) taking rest at a tea-stall of
Osen, a famous beauty of Edo at that time. A *tori-i* and
a stone pavement can be seen.

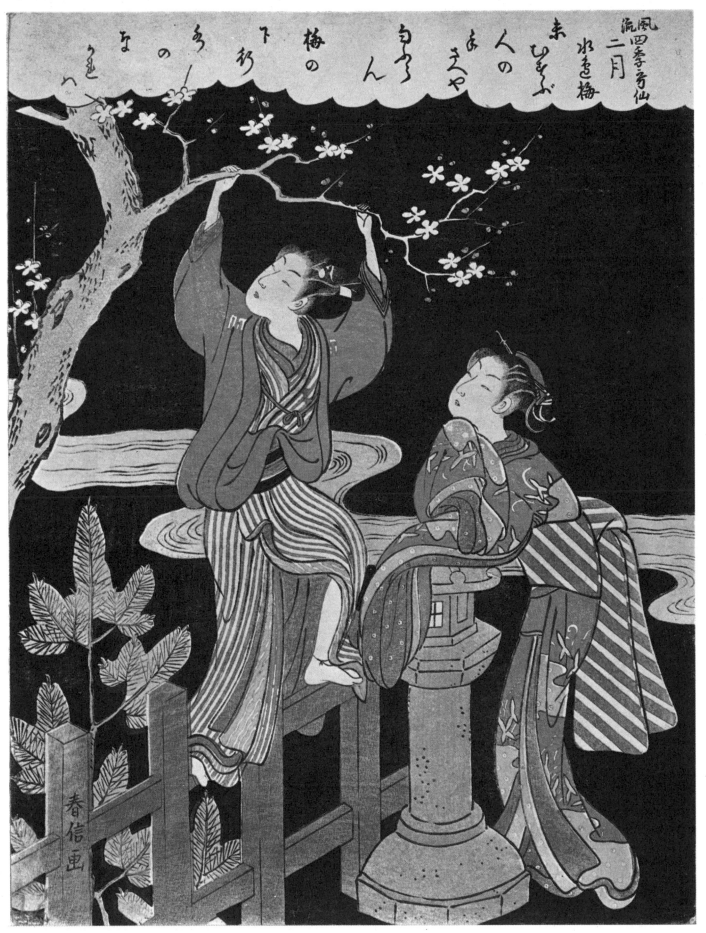

Harunobu *Plum-blossoms by the Riverside in February,* from the series *Celebrated Poems on the Four Seasons (Furyu Shiki Kasen)*
Chuban, Nishiki-e, 28 × 20.8 cm
Publisher: unknown. Date: c. late 1760's. Takahashi Collection, Japan

A young man breaking a plum branch for a girl. She rests her arms on a stone lantern.

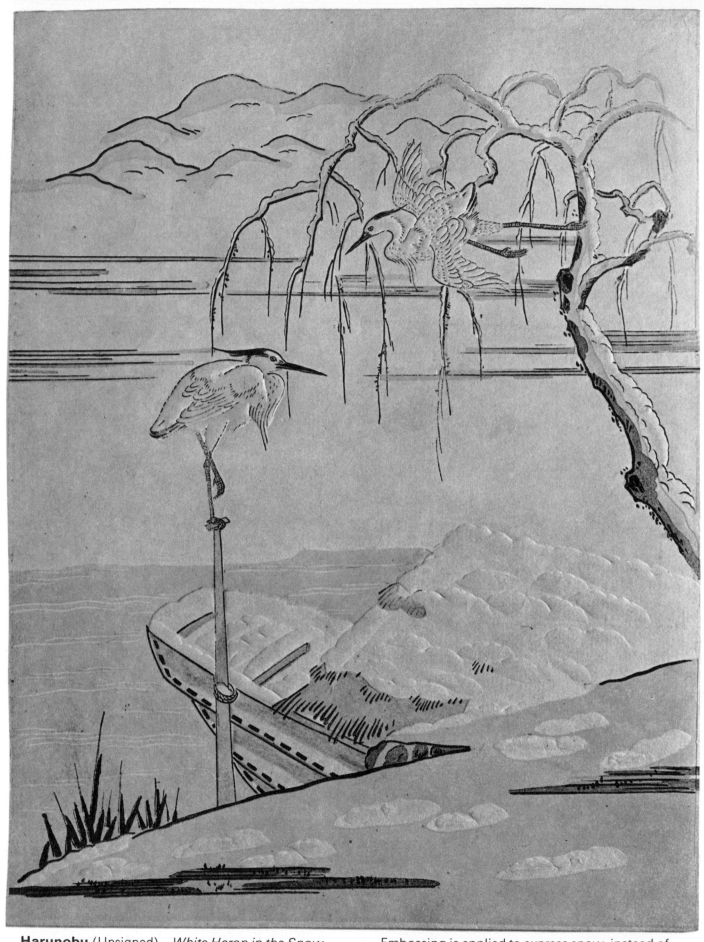

Harunobu (Unsigned) *White Heron in the Snow*
Chuban, Nishiki-e, 27.8 × 20.5 cm
Publisher: unknown. Date: c. late 1760's. The Art
Institute of Chicago

Embossing is applied to express snow, instead of
colouring with white paint, stressing the three-
dimensional sense. A boat is moored by the riverside.
Mountains are seen in the distance.

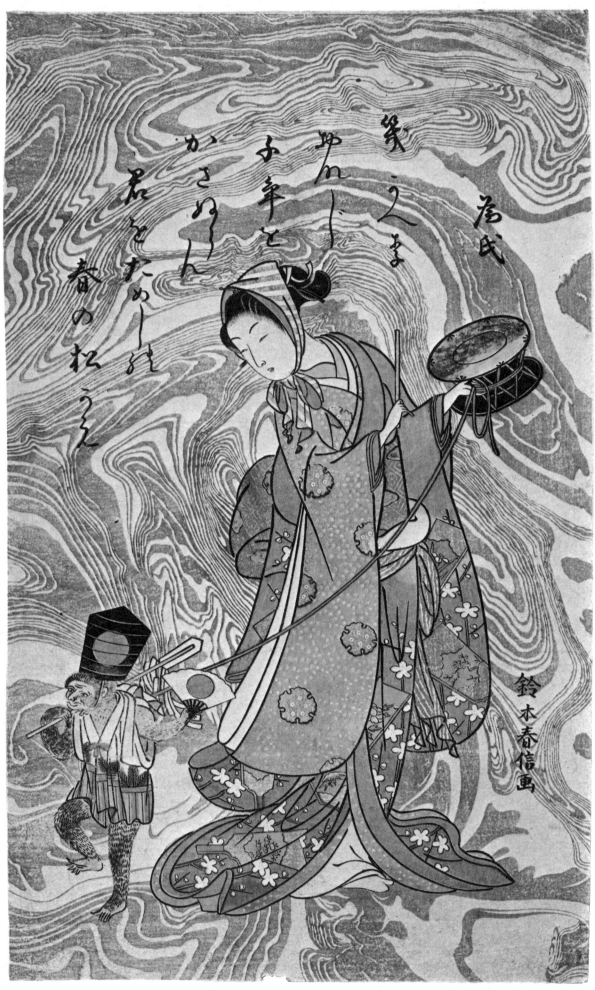

Harunobu *Monkey Show*
Aiban, Nishiki-e, 35.3 × 21 cm
Publisher: unknown. Date: c. late 1760's

The background is achieved by the method of spilling black ink on water. A girl making a monkey dance. A burlesque depicting one of the New Year's regular events.

111

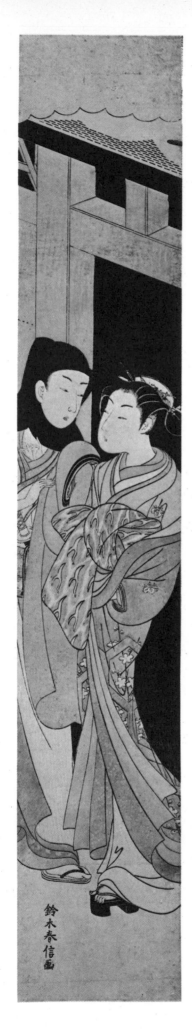

Harunobu *Main Entrance of Yoshiwara*
Hashiraeban, Nishiki-e,
71.2 × 12.2 cm
Publisher : unknown. Date : c. late 1760's. Takahashi Collection, Japan

A scene at the main gate of the Yoshiwara gay quarters. A courtesan regretfully parting with her customer.

Harunobu *Ryogoku Bridge*
Hashiraeban, Nishiki-e,
68.6 × 11.9 cm
Publisher : unknown. Date : c. late 1760's. Tokyo National Museum

A courtesan gazing at Ryogoku bridge from the window of a restaurant by the River Sumida.

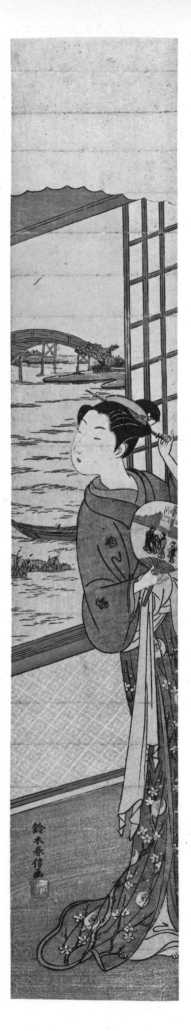

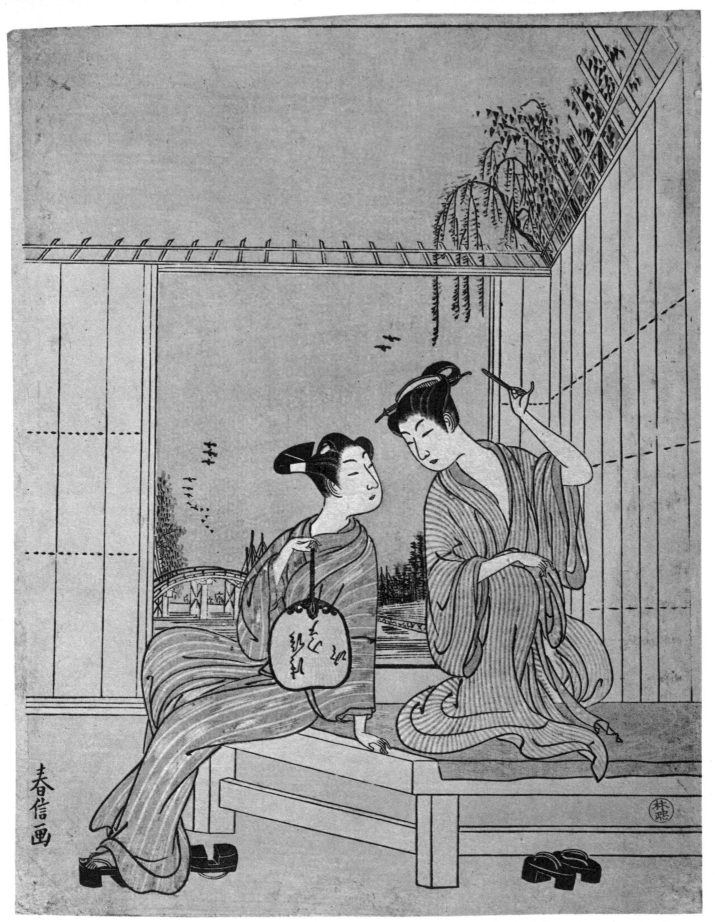

Harushige (feigned signature of Harunobu) *Enjoying the Cool Air on a Bench*
Chuban, Nishiki-e, 28.2 × 21.5 cm
Publisher: unknown. Date: c. 1770. Tokyo National Museum

Two people (a man on the left, and a woman on the right), enjoying the cool evening breeze in a restaurant by the river side. Though this print has the signature of Harunobu, it is really a fake by Harushige. The exaggerated perspective is a hall-mark of Harushige.

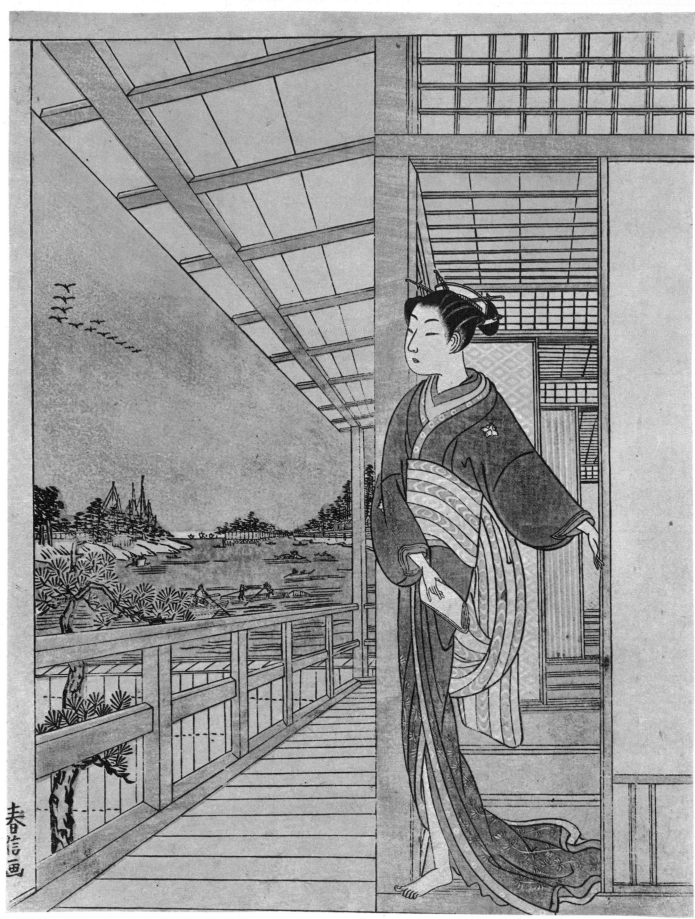

Harushige (feigned signature of Harunobu) *Beauty on the Veranda Upstairs*
Chuban, Nishiki-e, 27.2 × 20.7 cm
Publisher: unknown. Date: c. 1770. Tokyo National Museum

A woman standing near the veranda of a restaurant. Though this print bears Harunobu's signature, this is believed to be a spurious work by Harushige, judging from its exaggerated perspective.

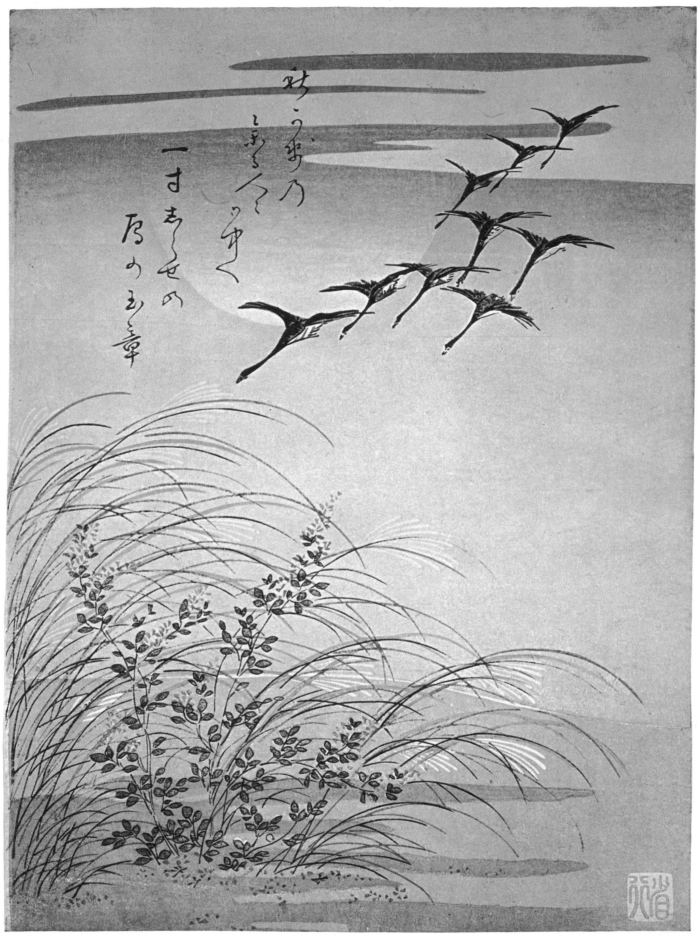

Hyakki *Wild Geese Flying in the Moonlight*
Chuban, Nishiki-e, 26.5 × 18.9 cm
Publisher: unknown. Date: c. mid-1760's. The Art
Institute of Chicago

A full moon is in the night sky. Moon and geese are
one of the favourite combinations to express autumn.
On the lower half of the picture is depicted a bush of
eulalia and *hagi* (Japanese bush clover).

The road to realism

New style of portraying actor and beauty, leading to realism – Choshun and Shunsho

With the appearance of the *nishiki-e* (polychrome prints, literally "brocade pictures") of Suzuki Harunobu, a marvellous world of colour was brought into being. The atmosphere of the time was ripe for Harunobu's exploitation of this technique, although the credit for his accomplishment lies, as well, both with his predecessors and those earlier masters whose work influenced him. Nishikawa Sukenobu (1671–1750), whose name has already been mentioned, was one of them. Sukenobu, born in Kyoto, the ancient city of culture, can be placed among the group of master artists of that city who uninterruptedly, from the earliest days of *ukiyo-e*, exercised a considerable influence on their counterparts in Edo.

Sukenobu first studied the traditional painting styles of both the Kano and Tosa schools. Later he became interested in *ukiyo-e* and Moronobu and created his own style. The majority of works he drew during his career are illustrations for *ehon* ("picture-books").

A richer, more splendid variety of picture-books began to appear along with Sukenobu's production, which contributed at once to a significant rise in the level of quality of *ehon* (picture-books) and their illustrations. He also excelled in his brush-paintings of beautiful women.

Miyakawa Choshun (1683–1753)

Having never produced a wood-block print, Choshun is known solely for his brush-painted *ukiyo-e*. He was born in Owari (now Aichi Prefecture) and later moved to Edo. Like Sukenobu, he also first studied the Kano and Tosa styles of painting and turned eventually to *ukiyo-e*. For his *bijin-ga* (pictures of beautiful women or courtesans) he drew great inspiration from models by Moronobu and Kaigetsudo artists in particular, whose work he surpassed in polished grace and elegance. He set the stage for the new age of *ukiyo-e*.

Katsukawa Shunsho (1726–1792)

Shunsho was a master artist who was producing original works throughout a career spanning a period that witnessed a succession of master artists – from when Harunobu was active, followed by Kiyonaga at his height, and extending into the age when Utamaro was beginning to display his genius.

Distinguishing himself among the great masters of the day by his wood-block-printed *yakusha-e* (actor portraits) and brush-painted *bijin-ga*, Shunsho demonstrated his originality through styles so dissimilar as to appear unlikely to be from the same hand. In actor prints, the style of the Torii school had become stereotyped, while Shunsho's new, more realistic presentation, treated in a skilful and lively manner, led to his establishing of the Katsukawa school.

Shunsho was first the pupil of Miyakawa Shunsui, and later, under the tutelage of Ko Sukoku (1730–1804), studied the genre painting of Hanabusa Itcho (1652–1724), whose fluent style of brushwork he adopted. Though he made some prints of beautiful women, it was his portrayals of especially masculine actors, expressive of his interest in the *Kabuki* theatre, that mark his distinctive achievement.

Further, in his theatre prints, Shunsho aimed at presenting realistic views of stage settings and even went not only behind the scenes to depict actors, as they would never be observed by their audience, but also out of the theatre, where he showed them in everyday life.

Shunsho's ability in brush-paintings of beautiful women is shown in such masterpieces as his *Activities of Women in the Twelve Months* and *Triptych of Snow, Moon, and Flower*.

Katsukawa Shunko (1743–1812) and his rival Shun-ei were the distinguished pupils of Katsukawa Shunsho. Shunko's depiction of *Kabuki* actors in diptychs or triptychs even excelled his master. In the 1780s he was afflicted with a paralysis and was forced to work only with his left hand.

Like his master, Shunsho produced a number of *sumo-e*, depicting a contest of strength in which two wrestlers vie with bare hands within a circular arena, and practised since ancient times as the national sport of Japan, *Sumo* reached a peak of popularity in the Edo era. The giant-statured wrestlers fill all the space as in a close-up picture. Every artist in the Katsukawa school, from Shunsho onwards, found a fruitful motif in *sumo* wrestling.

Possibly conscious of a rivalry with Sharaku, Shunko was more adventurous than his master Shunsho in the *okubi-e* (half-length portrait).

Katsukawa Shun-ei (1762–1819) excelled, like his master Shunsho, in portraying actors. Like Sharaku and Shunko, he won universal recognition with his *okubi-e* (of *Kabuki* actors). He was distinguished in his treatment not only of actors and sumo-wrestlers but of *musha* (warriors) and courtesans, as well.

Representing the Katsukawa school, he remained active after his master's death and had a considerable influence on the *ukiyo-e* tradition.

The work of Ippitsusai Buncho (active around the 1770's) unmistakably exhibits the influence of Harunobu, but exhibits a pronounced originality nonetheless. We know little, however, about the artist. Reflecting a delicate sense of beauty and a refined feeling for colour, his portrayal of actors and courtesans is distinctive. His extant works are comparatively few, but lack nothing in quality.

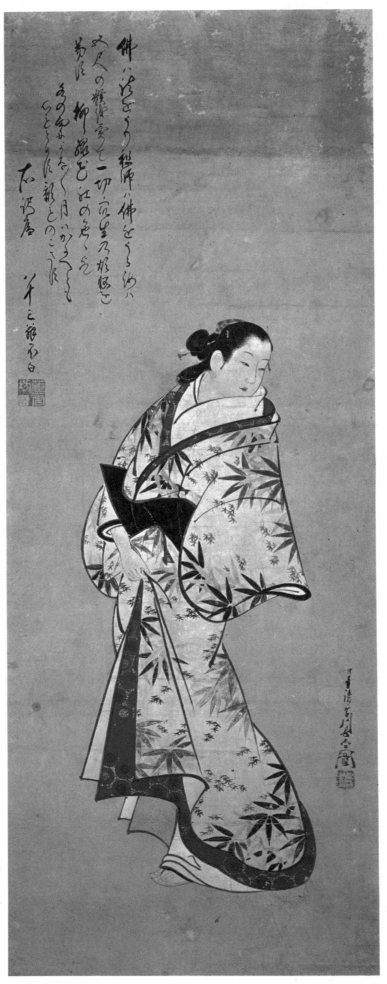

Choshun *Standing Beauty*
Painting on paper, 90.5 × 35 cm
Date: c. 1720's. Yamato Bunka-kan Museum, Japan

A work of the middle period of Choshun's activity. A courtesan wearing a *kimono* with a pattern of bamboo-grass and maple leaves.

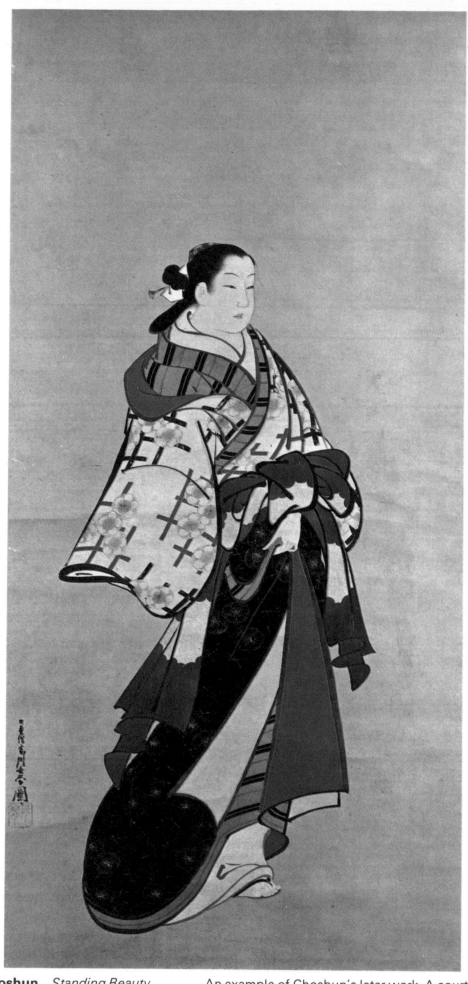

Choshun *Standing Beauty*
Painting on silk, 112.2 × 53.5 cm
Date: c. 1740's

An example of Choshun's later work. A courtesan wearing a *kimono* with a pattern of cherry blossoms.

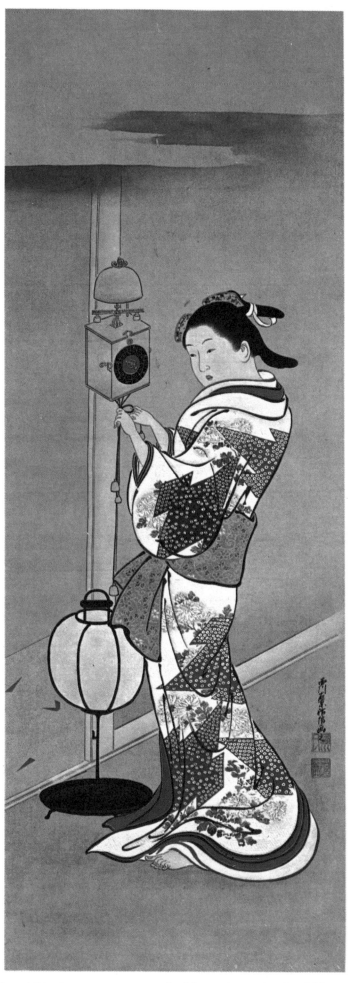

Sukenobu *Girl and Clock*
Painting on silk, 88.4 × 31.3 cm
Date: c. 1740's. Tokyo National Museum

A girl wearing a tie-dyed *kimono*. The clock works on
a spring. The clock face is divided into the twelve parts
of one day.

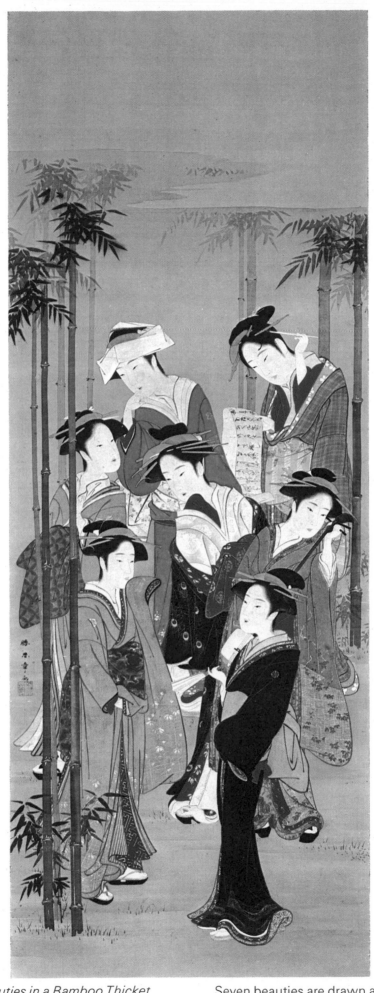

Shunsho *Seven Beauties in a Bamboo Thicket*
Paintings on silk, 94.2 × 34.7 cm
Date: c. 1780's. Tokyo University of Arts

Seven beauties are drawn after the seven wise men in China. Each woman belongs to a different social class.

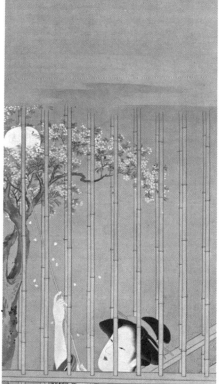

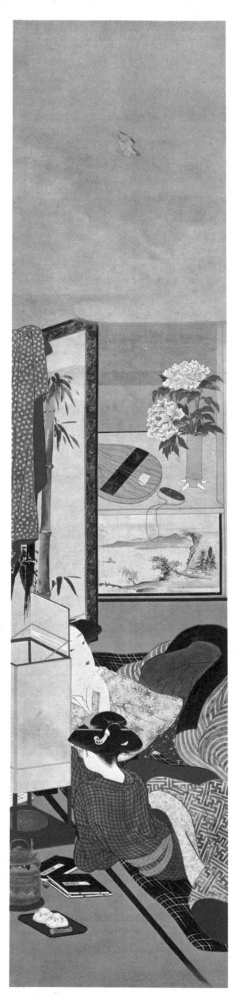

Shunsho *Activities of Women in the Twelve Months*
Paintings on silk, 115 × 25.7 cm each
Date: c. 1780's. Kyusei Atami Art Museum, Japan

A series of 12 pictures depicting seasonal and customary events of the common people including courtesans in segregated districts. Other scenes on pages 124–126. (The first two months have been lost.)

March: Trying to retrieve a ball caught in a tree.

April: Listening to a cuckoo in the bedroom.

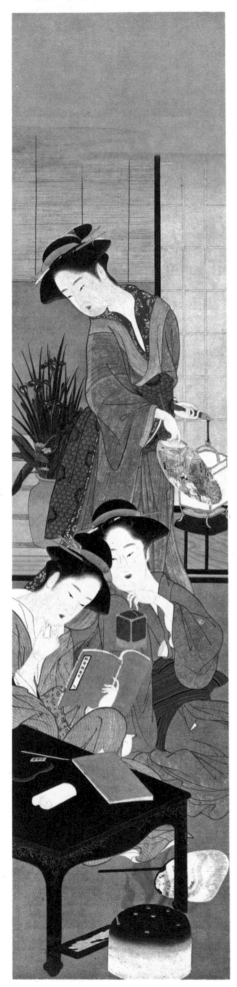

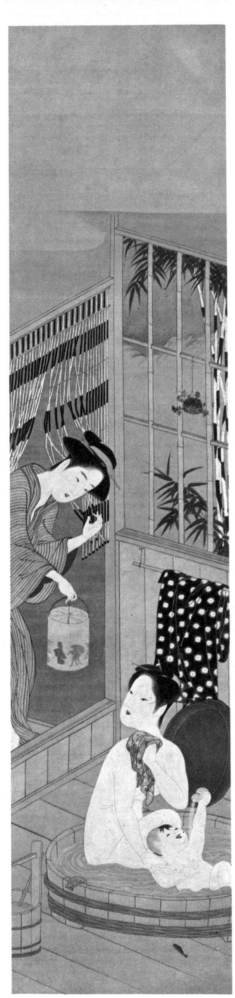

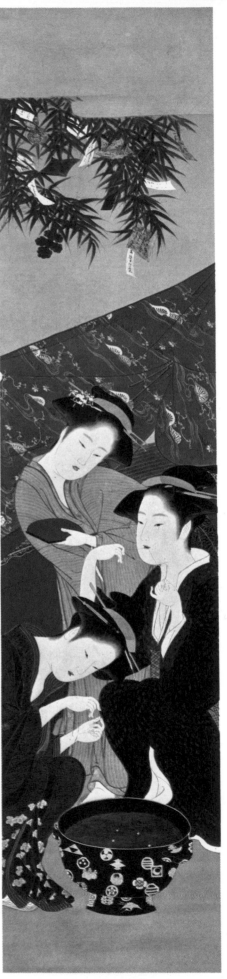

May: The woman in the centre of the group is holding a cage filled with fireflies for the other woman to read a book; this scene comes from a Chinese source.

June: Mother and child taking a tub-bath. The woman at the door holds a revolving lantern.

July: Strips of paper with wishes and poems written on them are tied on a bamboo. It is said that, if you can thread a needle while stars are reflected in the water, you will become good at sewing.

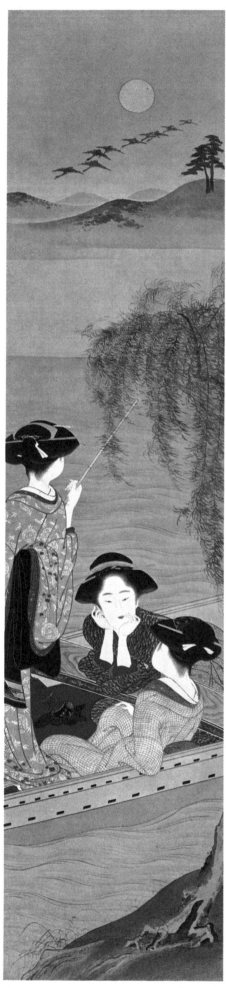

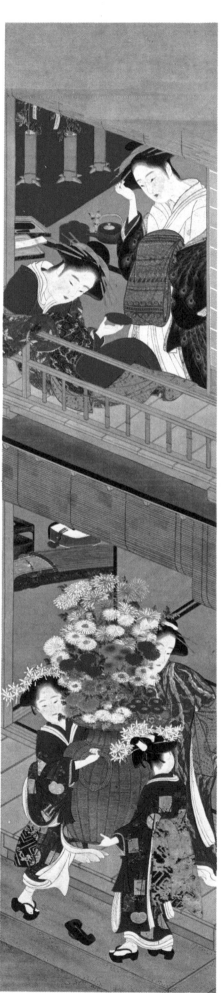

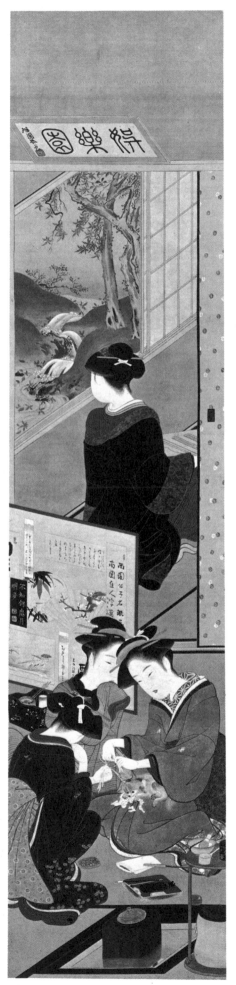

August: Women enjoying the cool
air on a boat.

September: The Feast of the
Chrysanthemum.
Little girls are
carrying a basket
of chrysanthemums.

October: A middle-aged woman
looking out at coloured
leaves. Girls in forefront
playing with paper
strings.

125

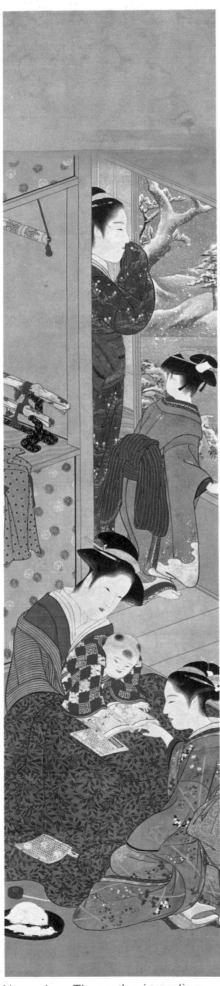

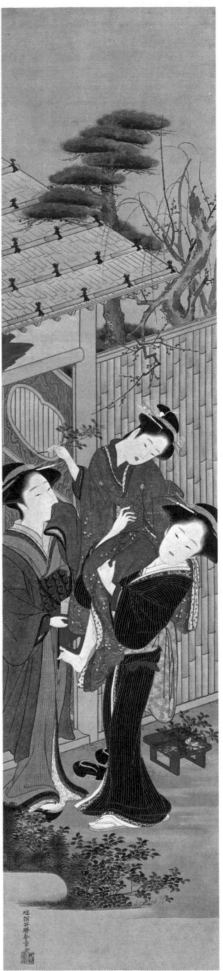

November: The mother is reading a picture book, sitting at a foot-warmer (*kotatsu*). A snow rabbit is on a tray.

December: Three women decorating a gate with twigs of holly on the day before the setting-in of spring.

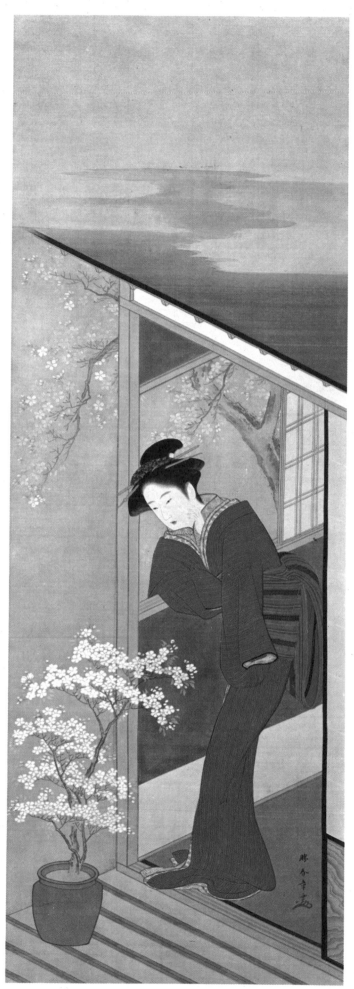

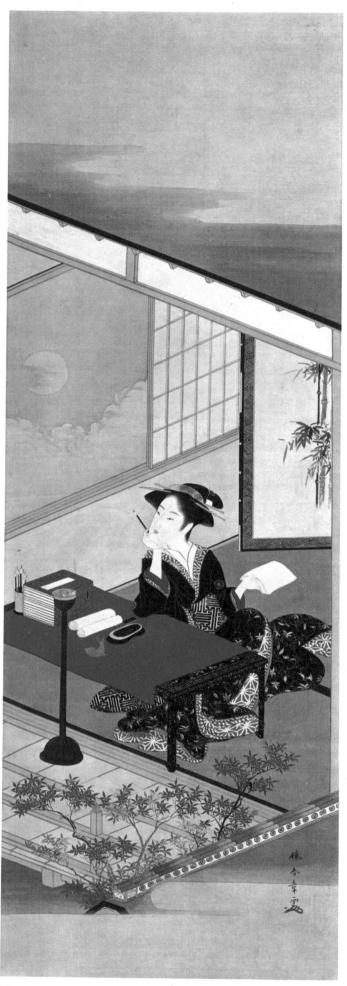

Shunsho *Triptych of Snow, Moon, and Flower*
Paintings on silk, 93 × 32.2 cm each
Date: c. 1780's. Kyusei Atami Art Museum, Japan

Manners of contemporary women depicted after the
famed women of letters in ancient times: Lady
Murasaki (with moon), and Onono Komachi (with
flowers).

127

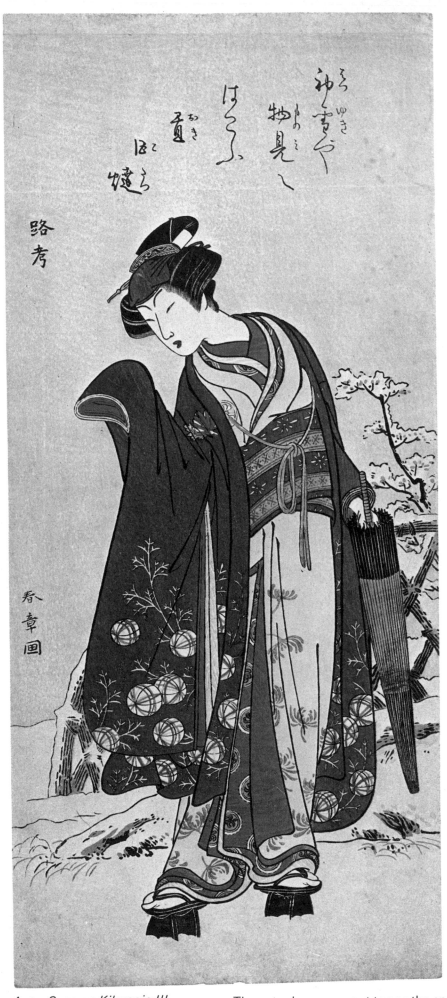

Shunsho *The Actor Segawa Kikunojo III*
Hosoban, Nishiki-e, 34 × 15.3 cm
Publisher: unknown. Date: c. 1770's. Sakai
Collection, Japan

128

The actor has come out to see the snow. The purple
cloth on his forehead indicates he is a female
impersonator. Above is a poem by Kikunojo.

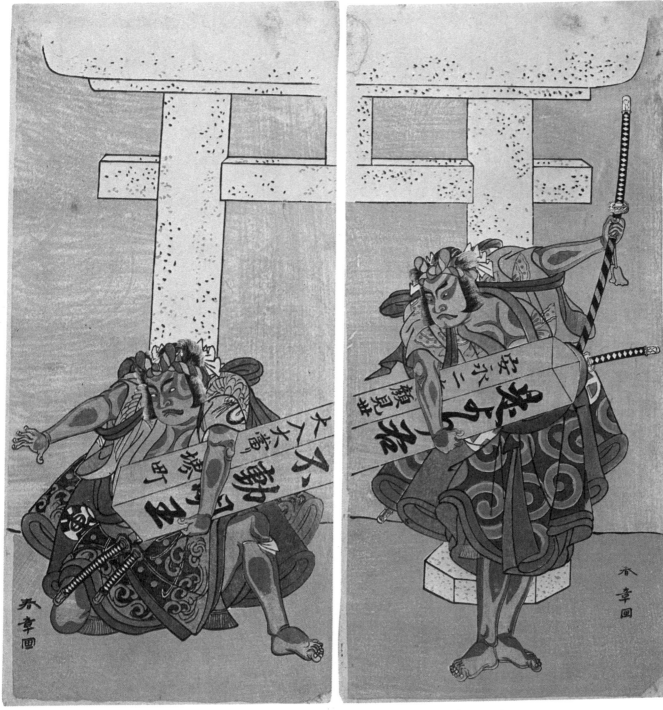

Shunsho *The Actors Ohtani Hirotsugu III as Naoe Sa-emon and Bando Matataro IV as Bando Taro* Hosoban, Nishiki-e, Diptych: left: 32.8 × 15.4 cm, right: 32.9 × 15.4 cm
Publisher: unknown. Date: 1773. Sakai Collection, Japan

A dynamic scene of two men struggling, in a popular *Kabuki* play.

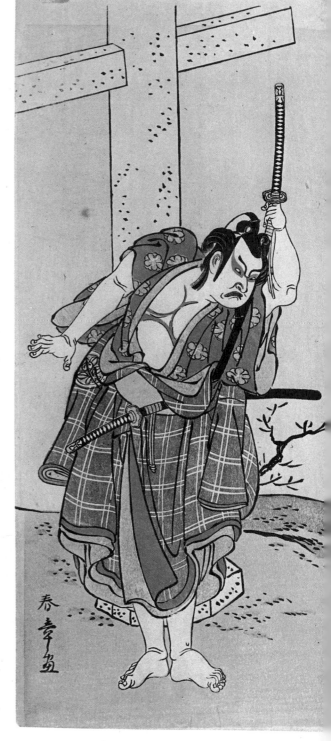

Shunsho *The Actors Ichikawa Yaozo II as Sakura-*
maru, Nakajima Miho-emon II as Lord Shihei,
Ichikawa Ebizo III as Matsuo-maru, and Ichimura
Uzaemon X as Umeo-maru
Hosoban, Nishiki-e, Triptych: from left to right:
33 × 14.8cm, 32.9 × 15.1 cm, 32.8 × 14.8 cm
Publisher: unknown. Date: 1776. Sakai Collection,
Japan

A dynamic, compelling portrayal of three brothers in
conflict with each other because of a villain, Lord
Shihei. A famous scene in the one of the most popular
Kabuki plays.

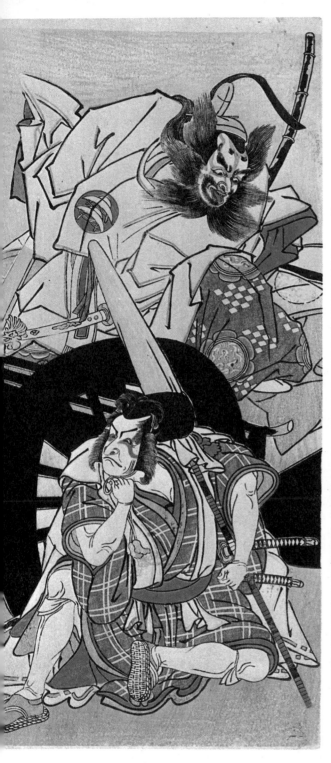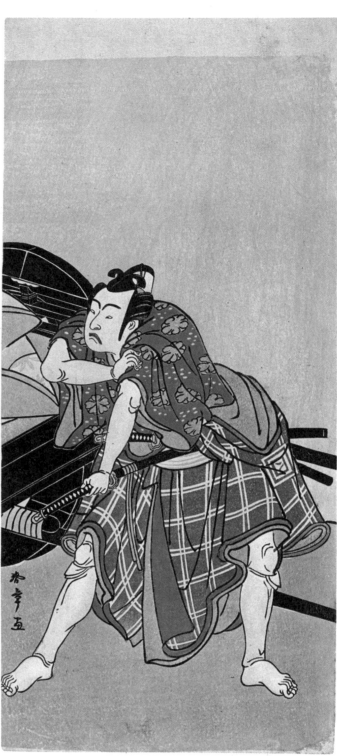

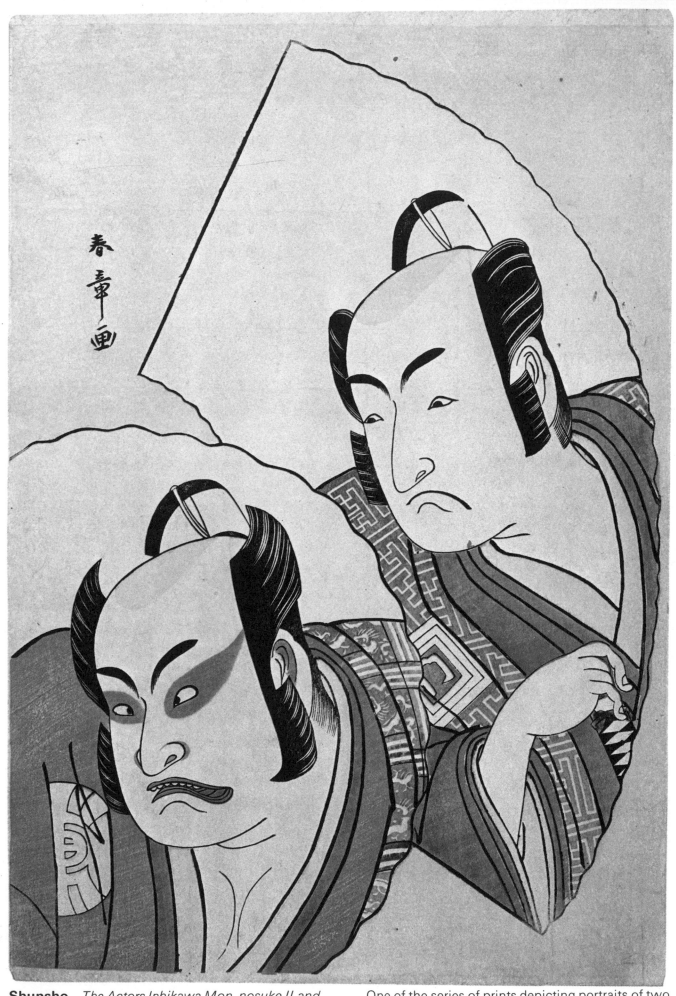

Shunsho *The Actors Ichikawa Mon-nosuke II and Bando Matataro IV*
Aiban, Nishiki-e, 33 × 22 cm
Publisher: unknown. Date: c. 1880's. Sakai Collection, Japan

One of the series of prints depicting portraits of two actors in fan-shaped frames.

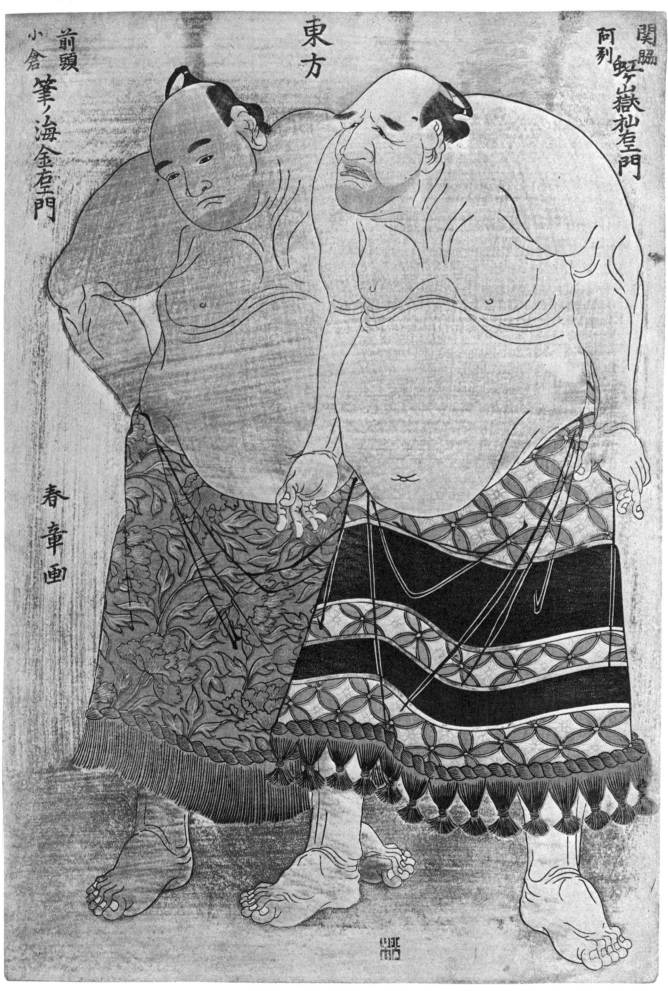

Shunsho *The Sumo wrestlers Nijigatake Soma-emon and Fudenoumi Kin-emon*
Oban, Nishiki-e, 37.6 × 25.5 cm
Publisher: unknown. Date: c. 1790's. Takahashi
Collection, Japan

Popular *sumo* wrestlers represented as gallant figures in the ring.

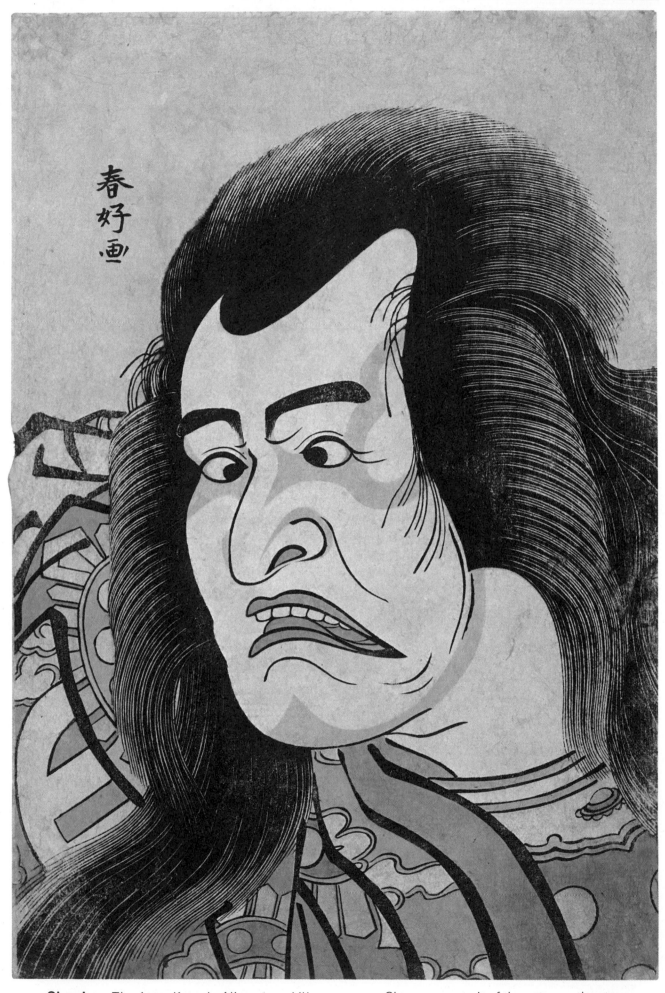

春好画

Shunko *The Actor Kataoka Niza-emon VII*
Oban, Nishiki-e, 38.4 × 25.5 cm
Publisher: unknown. Date: c. 1790's. Takahashi
Collection, Japan

Close-up portrait of the actor on the stage.

134

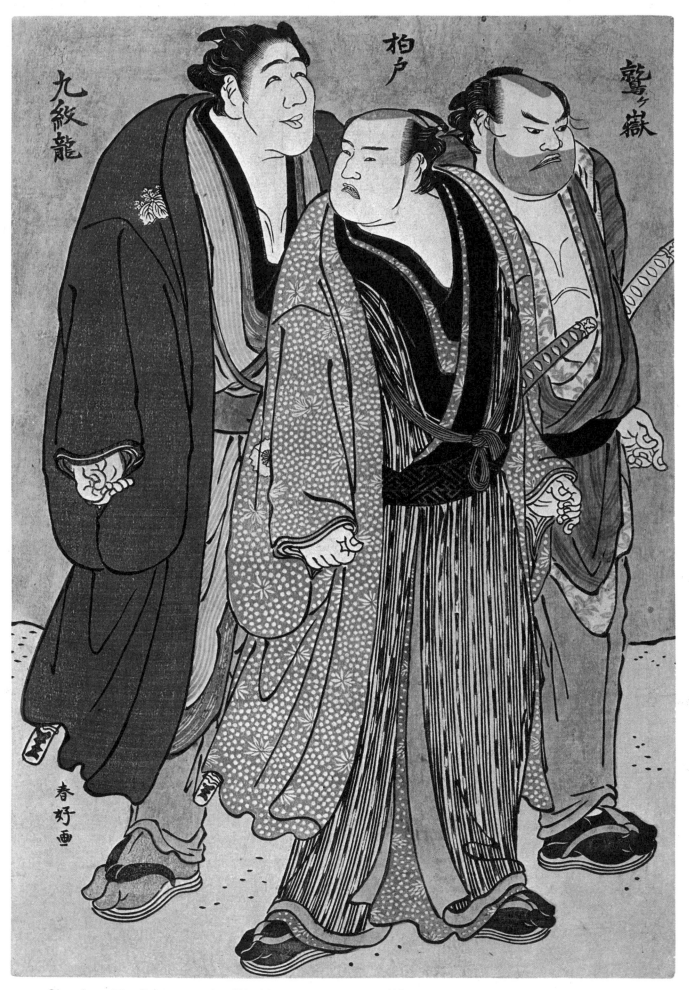

Shunko *The Sumo wrestlers Washigatake,
Kashiwado and Kumonryu*
Aiban, Nishiki-e, 31.4 × 21.6 cm
Publisher: unknown. Date: c. late 1780's. Takahashi
Collection, Japan

Wrestlers strolling in town.

135

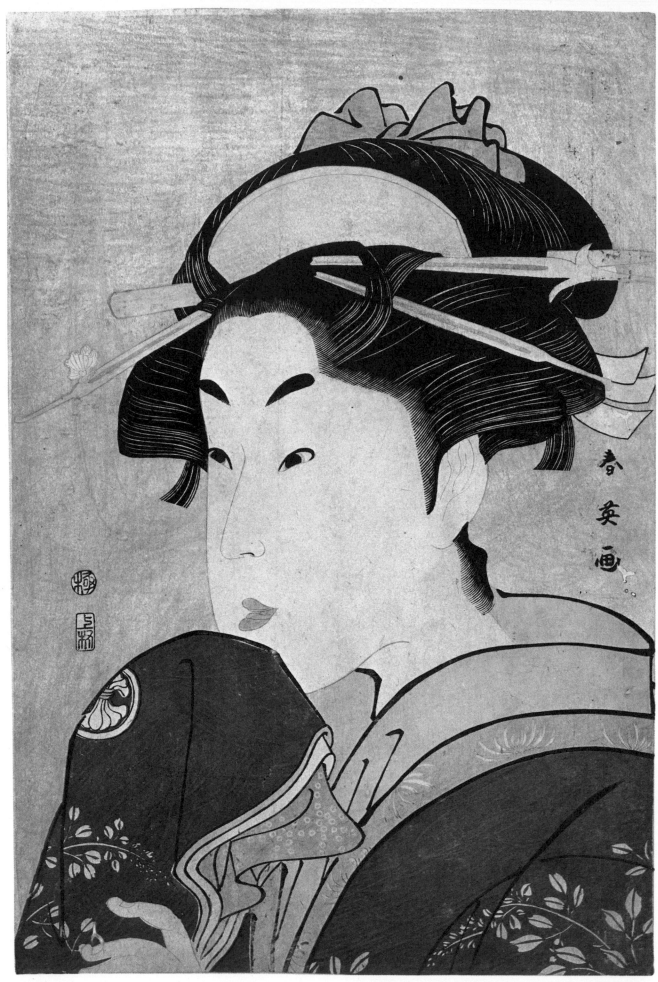

Shun-ei *The Actor Segawa Kikunojo III as Abura-ya Osome*
Oban, Nishiki-e, 38.3 × 25.3 cm
Publisher: Uemura Yohei. Date: c. 1796

136

Osome, daughter of the proprietor of a pawn-shop, who died together with Hisamatsu, an apprentice. Kikunojo was successful in acting the part of this lovely girl.

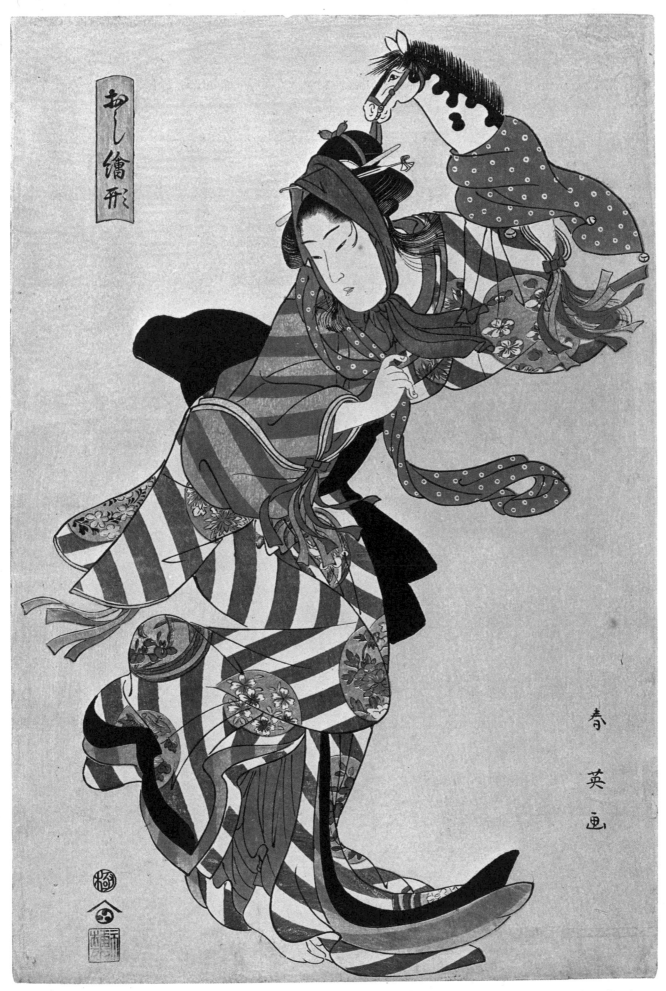

Shun-ei *Harukoma*, from the *Oshi-egata* series
Oban, Nishiki-e, 38.5 × 25.8 cm
Publisher: Nishimura-ya Yohachi. Date: c. early
1790's. Sakai Collection, Japan

Oshi-egata (raised-picture) is made with quilted
cloths pasted on a board. Every one of the series
depicts a *Kabuki* dance. *Harukoma* is a dance
performed with a toy-horse in one hand.

137

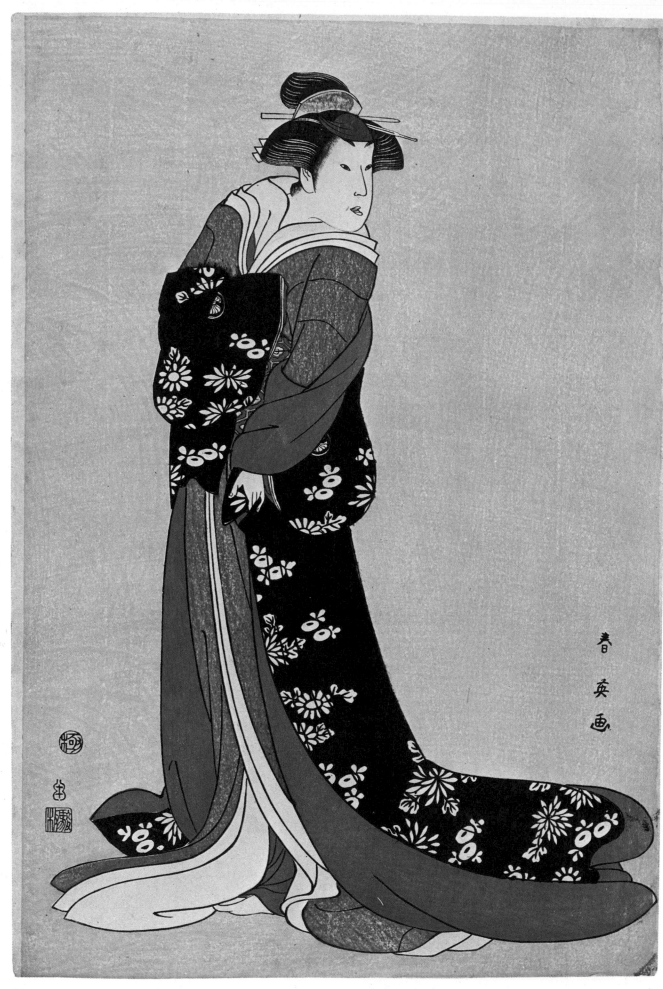

Shun-ei *The Actor Segawa Kikunojo III*
Oban, Nishiki-e, 39.1 × 26.3 cm
Publisher: unknown. Date: c. 1796. Sakai Collection, Japan

A portrait of Kikunojo, an excellent female impersonator.

138

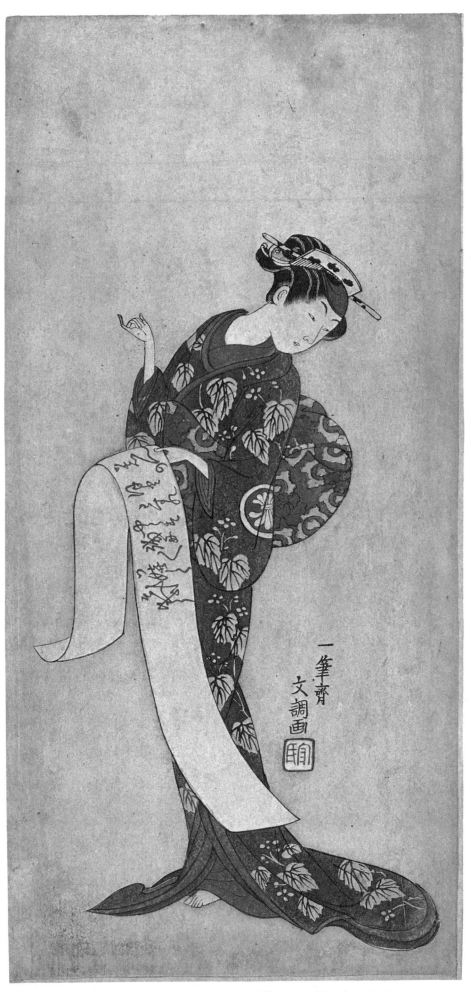

Buncho *The Actor Segawa Kikunojo II as Owata*
Hosoban, Nishiki-e, 30.3 × 14.3 cm
Publisher : unknown. Date : c. 1767. Waseda
University Theatrical Museum, Japan

Kikunojo II, a female impersonator, acting the part of
Owata reading a letter.

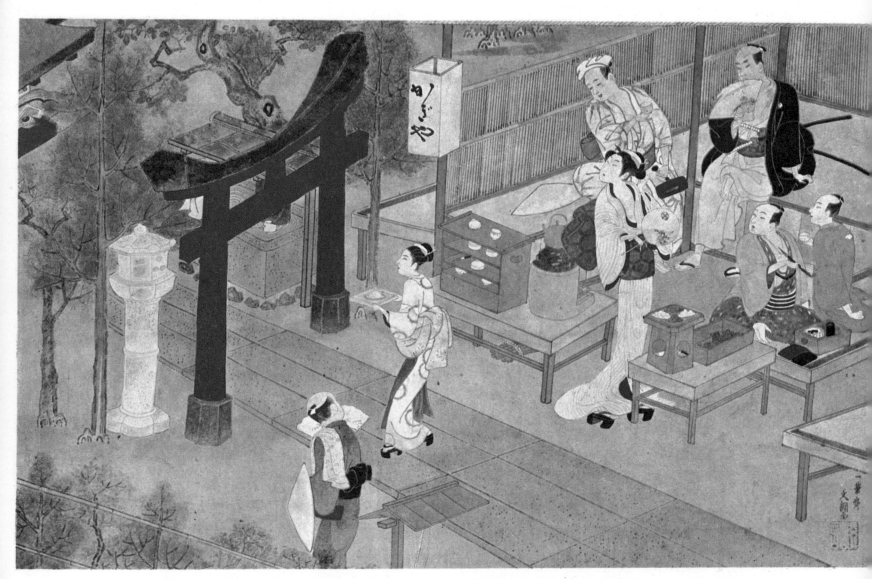

Buncho *Kagiya Osen at Kasamori Inari*
Painting on paper, 35.8 × 56.3 cm
Date: c. 1770. Idemitsu Art Gallery, Japan

Depicting a famed beauty, Osen, in the city of Edo.
This is one of the few brush-paintings by Buncho.

140

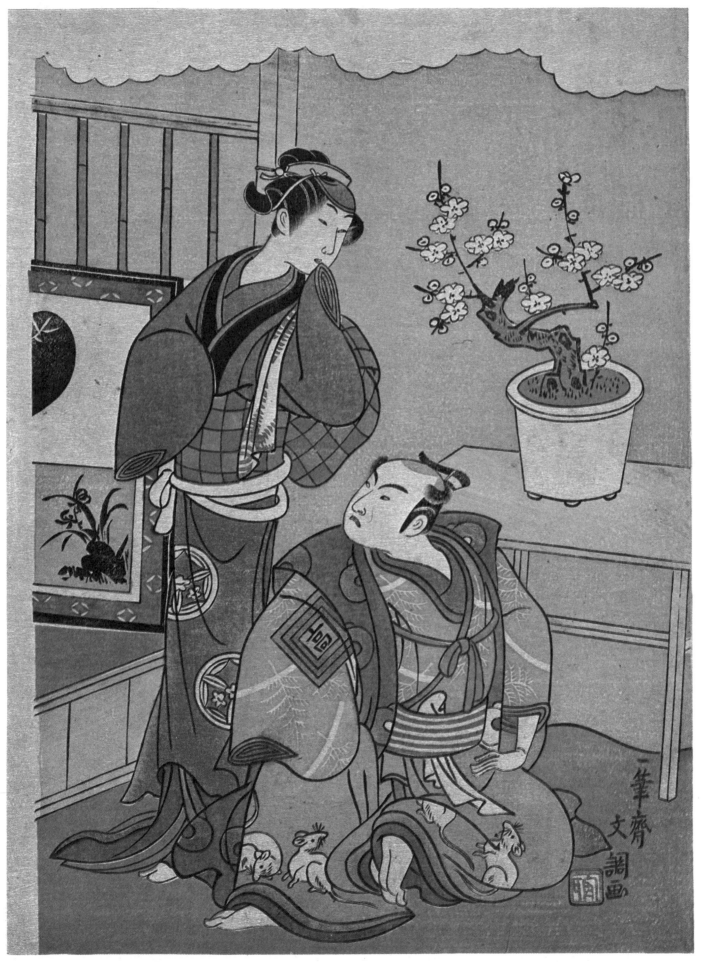

Buncho *The actors Ichikawa Komazo as Hanamori Kisaku and Yamashita Kinsaku II as Oume, Kisaku's wife*
Chuban, Nishiki-e, 25.6 × 18.6 cm
Publisher: unknown. Date: c. 1660. Tokyo National Museum

A scene from *Kabuki*. The potted tree in the back is a plum tree. (*Oume* means "plum blossom".)

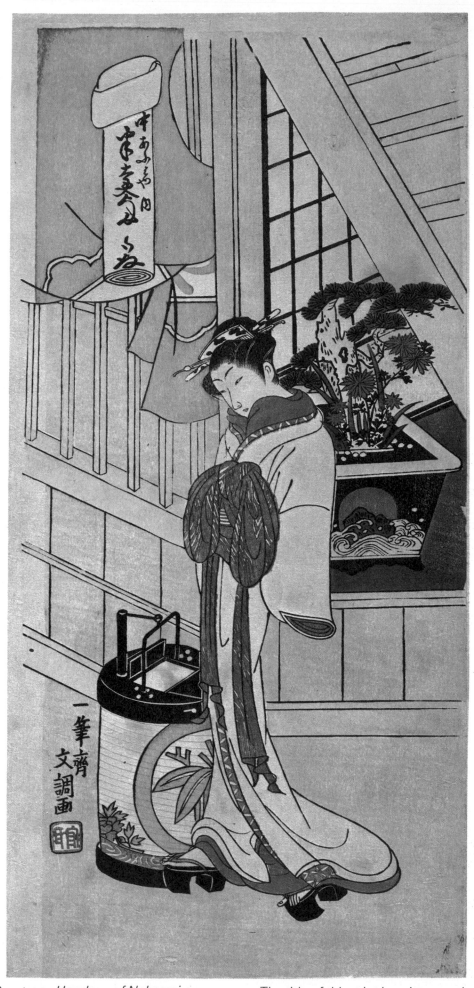

Buncho *The Courtesan Handayu of Nakaomi-ya (Nakaomi-ya uchi Handayu)*
Hosoban, Nishiki-e, 32.4 × 15.5 cm
Publisher: unknown. Date: c. late 1760's. The Metropolitan Museum of Art, New York

The title of this print is written on the letter folded in a knot. The lantern at her feet bears a crest of the house of pleasure.

142

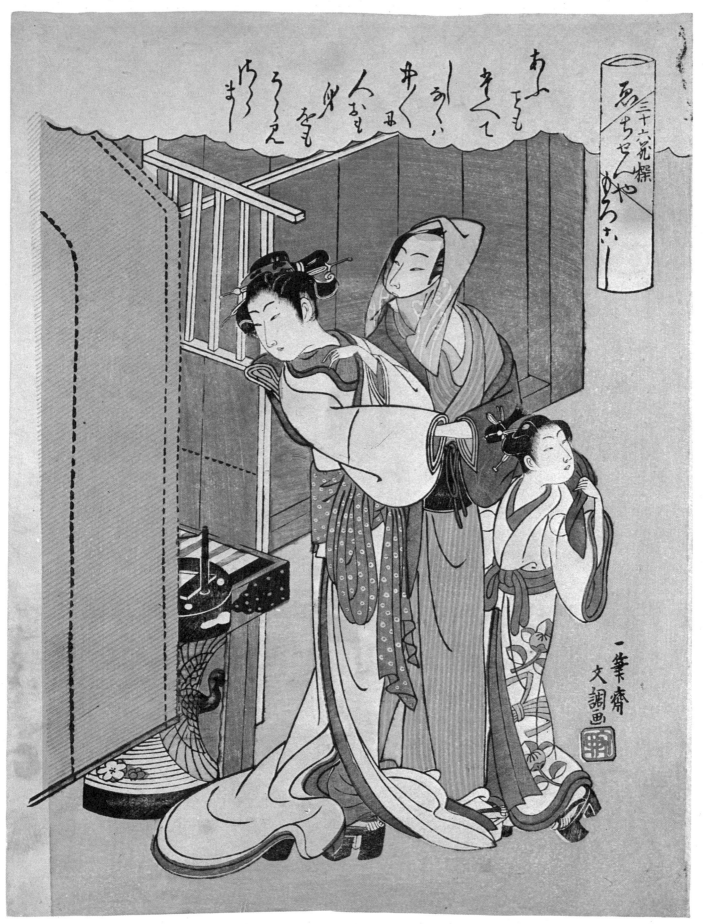

Buncho *The Courtesan Morokoshi of Echizenya,* from the series *Thirty-six Courtesans* (Sanju-rokkasen)
Chuban, Nishiki-e, 26.5 × 20.1 cm
Publisher: unknown. Date: c. early 1770's. Riccar Art Museum, Japan

A series of prints depicting 36 courtesans after the 36 classical poets. A man flirting with a courtesan in front of the tea-house. The poem written above is the theme of this piece.

The golden age of ukiyo-e

The golden age of *ukiyo-e*

During a long, tranquil period without any wars at home or abroad, the population of Edo steadily increased and the city experienced some of the most brilliant times in its history, culminating in the Genroku period (1688–1703). However, in the background of this peace and prosperity were deepening economic contradictions brought about by the feudal system based on trade within the country and on agricultural production, especially rice. The gulf between rich and poor rapidly widened in this period; in the countryside there was a small minority of wealthy families but most became poorer, while with the increase of the power of the tradesmen, the *samurai* were reduced to poverty.

Soon after the death of Harunobu, the powerful Tanuma Okitsugu (1719–1788) became a senior official in the Tokugawa Shogunate. Tanuma, who attained his position through merit and sagacity rather than hereditary succession, adopted mercantile policies one after another, shaking off traditional practices. He tried to stimulate and re-establish the domestic economy through these positive policies, but he could not stem the increase in the lower class population.

In addition, an extended period of cold weather caused a bad crop and about 130,000 to 200,000 people are thought to have died of starvation in the north-east of Japan. The city of Edo as well suffered the effects of a disastrous flood and an eruption of Mount Asama (1783), the volcanic ashes of which fell on the city and darkened the sky as if it were night. The people were increasingly anxious and uneasy and before long Tanuma's policies ended in failure and his dismissal.

Nevertheless, the world of *ukiyo-e* continued to flourish and reach the dawning of its golden age despite these social conditions. A direct representation of the dark side of actual life had been forbidden at any time in the Edo period. Besides this, it may also be said that Tanuma's rigorous policies encouraged the development of *ukiyo-e*.

The following were the major artists in this golden age of *ukiyo-e*.

Isoda Koryusai (active 1765–1780s)

Koryusai is said to have been born of a *samurai* family, but the details of his life are unknown. Although at first he used the art-name Haruhiro, there is no decisive proof that he was a pupil of Harunobu. Koryusai, however, is one of the most important artists who followed and further developed the techniques of *nishiki-e* or "brocade pictures", to which Harunobu had devoted so much effort.

Koryusai's style in depicting *bijin* (beautiful women) is more realistic than that of Harunobu and in his later series of close on 100 prints, *Hinagata Wakana-no-Hatsumoyo* (*Courtesans in New Year Fashion Dresses*), the figures are larger and more decorative than those of Harunobu. Furthermore, he did excellent *hashira-e* (pillar-pictures, long and narrow prints to be hung on pillars), in which he made skilful use of the space available, and took Harunobu's techniques one step further. Koryusi also took a great interest in *kacho-ga* (bird-and-flower pictures) and produced many lovely works. His later years were devoted to brush-work painting.

Torii Kiyonaga (1752–1815)

Ukiyo-e prints in the early period had been *oban* (large size) and *sumizuri* (black-printed), but after the employment of colour printing, the *ukiyo-e* wood-block became a little smaller in size. This may have been due to a desire to economize on paper and wood-blocks and also because of the difficulty in making successive impressions from blocks in different colours. With the emergence of Harunobu's polychrome *nishiki-e* ("brocade pictures"), however, the demand for *ukiyo-e* prints increased greatly.

Kiyonaga was not the first to produce large-size *nishiki-e*, but he took full advantage of this format to depict tall, statuesque women on a large sheet. Moreover, Kiyonaga produced diptychs and triptychs, enlarging the space of his *nishiki-e* rather like the Cinemascope wide screen. In this respect alone, Kiyonaga was a great master who marked the opening of the golden age of *ukiyo-e*.

Kiyonaga was the adopted son of a book dealer whose shop was near a theatre, and therefore he had the opportunity to look at a variety of *ehon* (picture-books). He soon became a pupil of Kiyomitsu, the third titular head of the Torii school which specialized in theatrical signboards. Kiyonaga at first made portraits of actors, but under the influence of Koryusai and Kitao Shigemasa (mentioned below), he gradually shifted to *bijin-ga* (pictures of beautiful women) in their style.

Kiyonaga's early works had already shown a voluptous beauty and refined taste as seen in his excellent large-size series, *Tosei Yuri-Bijin-awase* (*Contemporary Beauties of the Gay Quarters*). His genius soon reached full bloom and he produced fine works in rapid succession such as *Fuzoku Azuma-no Nishiki* (*Customs of the East*) and *Minami Juni-ko* (*Twelve Months in the South*), in which he

portrayed a number of tall, well-proportioned beauties. These tall figures show the idealized proportions of his time; the proportions of the human body varied throughout the Edo era and much later some artists portrayed extremely short figures.

Afterwards, Kiyonaga began to produce triptychs of tall beauties. In the backgrounds of these works are landscapes depicted spaciously and realistically, laying the foundation for landscape painting, which later became an independent field of *ukiyo-e*. Kiyonaga's works of theatrical performances also reveal his tendency to realistic depiction. He was probably the first illustrator to show not only dressing rooms, but also the musicians and singers present on the stage.

Kiyonaga succeeded to the leadership of the Torii school and became Torii the Fourth. It is said that he put up a descendent of the main family for the fifth-generation succession and forced his own son to give up painting, an episode reflecting his loyal and upright personality.

Torii Kiyomine (1787–1868)

Kiyomine was a blood member of the Torii family who studied under Kiyonaga. He at first used the art-name Kiyomine but after the death of Kiyonaga (Torii the Fourth), he became the fifth titular head of the Torii school under the name Kiyomitsu II. Although he studied under Kiyonaga, his style does not show a strong Kiyonaga influence; most of his works are *bijin-ga* in the manner of Utagawa Toyokuni (mentioned in the next chapter).

The school of Shunsho (active during the same period as Kiyonaga) produced another distinguished artist in Katsukawa Shuncho.

Katsukawa Shuncho (active between c. 1770's–1790's)

Shuncho was a pupil of Shunsho, but he produced few *yahasha-e*. Instead, he depicted, under Kiyonaga's influence, tall beautiful women like Kiyonaga's. He also made some masterpieces in triptyches. His *okubi-e* works have dignity like those by Eishi. However, he abandoned *nishiki-e* production in his early years, and devoted himself to literature, especially *kyoka*.

The illustrators of the Kitao school should also be mentioned here.

Kitao Shigemasa (1739–1820)

Shigemasa, the eldest son of the leading Edo book publisher Suhara-ya, was a largely self-taught artist who studied book illustrations and picture-books. He produced a number of book illustrations, and his original style in the depiction of beauties influenced Kiyonaga and many other illustrators.

Kitao Masanobu (1761–1816)

Masanobu at first studied under Shigemasa and started to draw illustrations, but later he began to write fiction. After 1782 he became famous as a writer under the pseudonym of Santo Kyoden. As he became busy with writing, he almost abandoned painting and therefore most of his *nishiki-e* prints belong to his early years.

Kitao Masayoshi (1764–1824)

Masayoshi, a pupil of Shigemasa, produced pictures of *uki-e* warriors, beauties, and bird-and-flower prints. In 1794, when he became a painter in the service of a *daimyo* (feudal lord), he changed his name to Kuwagata Keisai and started to study anew the traditional pictures of the Kano school. He also depicted the daily life of craftsmen as seen in *Kinsei Shokunin Zukushi E-kotoba* (*Collection of Modern Workmen*).

Kubo Shunman (1757–1820)

Shunman at first studied painting and calligraphy under Katori Nahiko (1723–1782) and later became a pupil of Kitao Shigemasa and produced *bijin-ga*. His style, however, was more influenced by that of Kiyonaga than that of his teacher Shigemasa and his works show a delicate beauty. He also made prints by a colour scheme called *beni-girai* (pink-avoiding; prints using purple together with yellow and grey).

The artists of the Kitao school, in general, had a good knowledge of literature and were well-educated: for instance, Masanobu, one of the group, left painting for literary work. Shunman was also a versatile artist and created much craftwork. In his later years he made *kyoka*-related *surimono* (literally "printed things"; specifically, small rectangular or square prints commissioned for gifts, announcements and other such purposes) and illustrated books of *kyoka* (humorous verses of thirty-one syllables, often satirical).

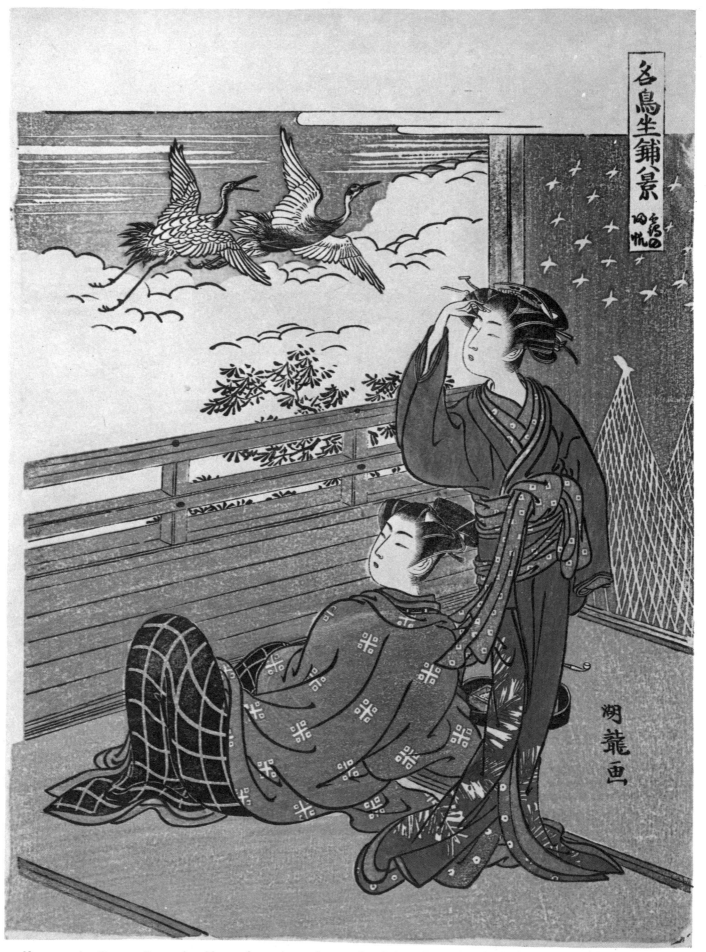

Koryusai *Cranes Returning Home*, from the series *Eight Indoor Views with Famous Birds (Meicho Zashiki Hakkei)*
Chuban, Nishiki-e, 26.8 × 19.5 cm
Publisher: unknown. Date: c. 1770. Riccar Art Museum, Japan

An eight-print series depicting a man and woman in a room and birds. A work produced in the period when Koryusai made pictures in Harunobu's style.

147

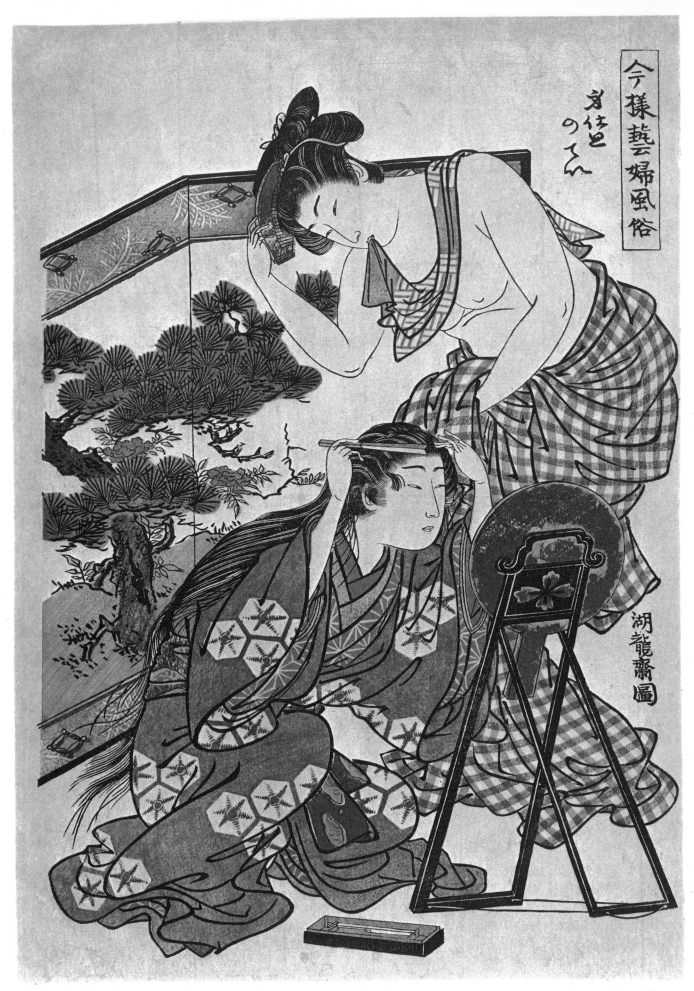

Koryusai *Women Dressing*, from the series *Contemporary Courtesans (Imayo Geifu Fuzoku)* Aiban, Nishiki-e, 33 × 22.7 cm

Publisher: unknown. Date: c. 1770's. Sakai Collection, Japan

Courtesans dressing: one shaving downy hair off her forehead before the mirror and the other putting on a comb.

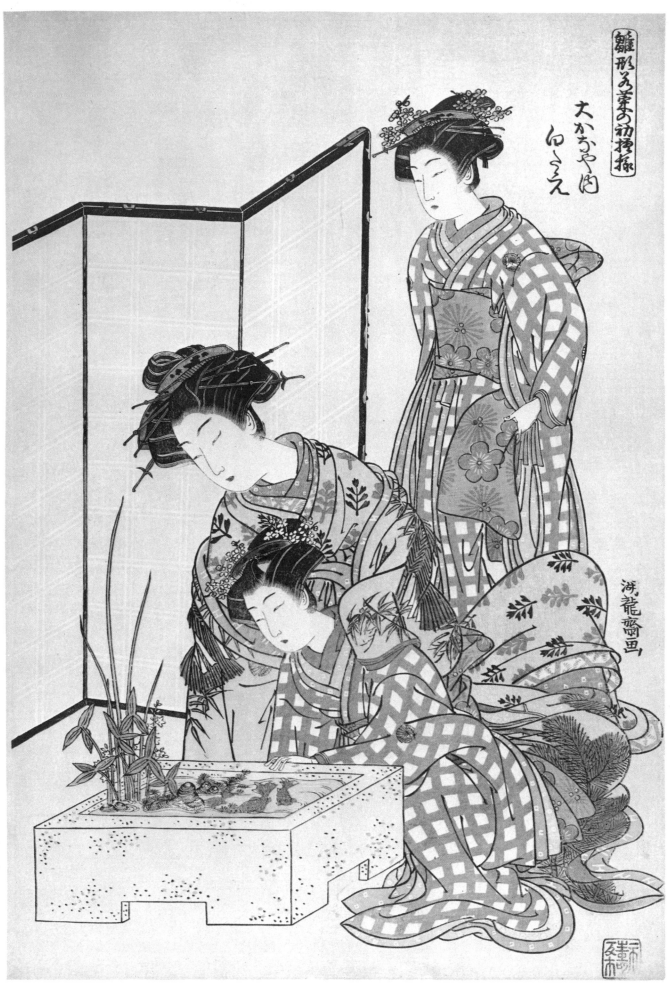

Koryusai *The Courtesan Shirotae of Okana-ya, from the series Courtesans in the New Year's Fashion Dresses (Hinagata Wakana-no-Hatsumoyo)* Oban, Nishiki-e, 37.9 × 26 cm Publisher: Nishimura-ya Yohachi. Date: c. late 1770's. The Art Institute of Chicago

A series of large-size prints showing fashion dresses for the young, together with the names of a tea house and its famous courtesan. Keeping goldfishes was popular in the Edo era.

149

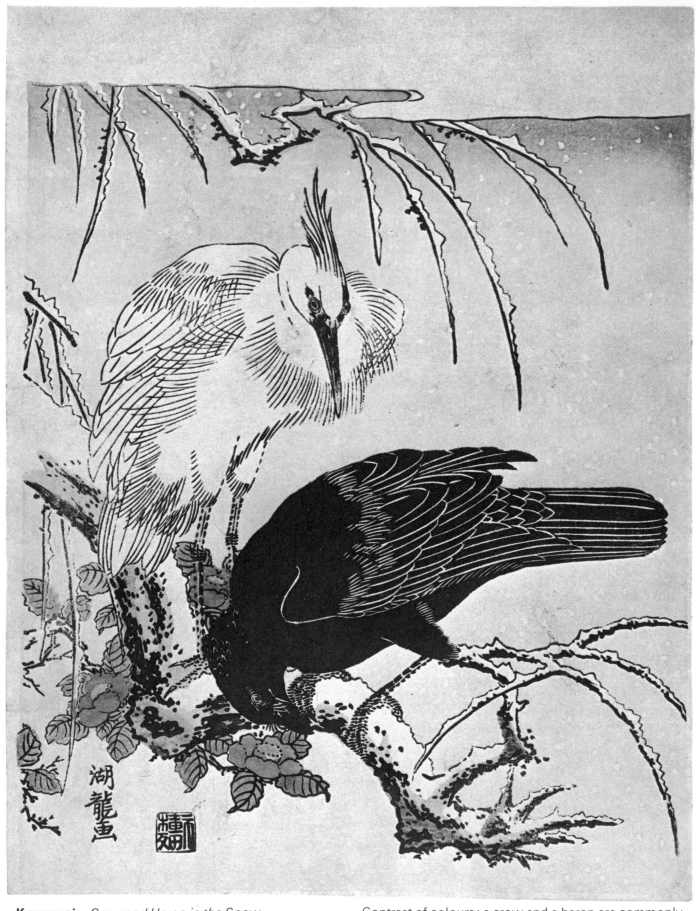

Koryusai *Crow and Heron in the Snow*
Chuban, Nishiki-e, 25.6 × 19.6 cm
Publisher: unknown. Date: c. 1770's. Riccar Art
Museum, Japan

Contrast of colours: a crow and a heron are commonly used to show the contrast between black and white.

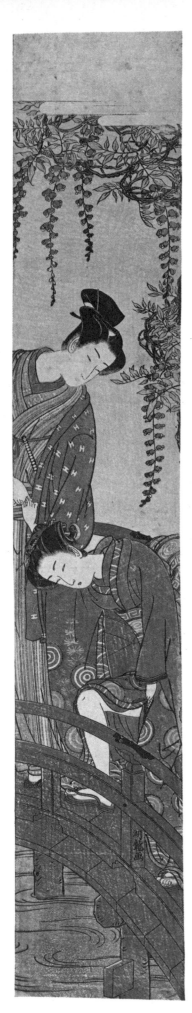

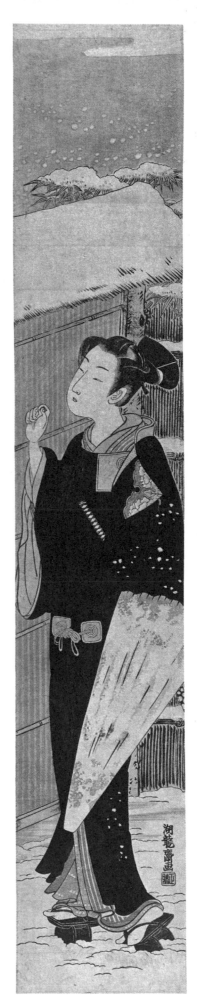

Koryusai Left : *Arched Bridge at Kameido Shrine*
Hashiraeban, Nishiki-e,
69.8 × 11.8 cm
Publisher : unknown. Date : c. 1770's. Tokyo National Museum

The Kameido Shrine in the city of Edo was famous for its wistaria flowers. The noted steep-arched bridge is seen.

Koryusai Right : *Knocking at the Gate*
Hashiraeban, Nishiki-e,
66.6 × 11.7 cm
Publisher : unknown. Date : c. 1770's. The Art Institute of Chicago

A young *samurai* knocking at the gate, probably calling on his beloved.

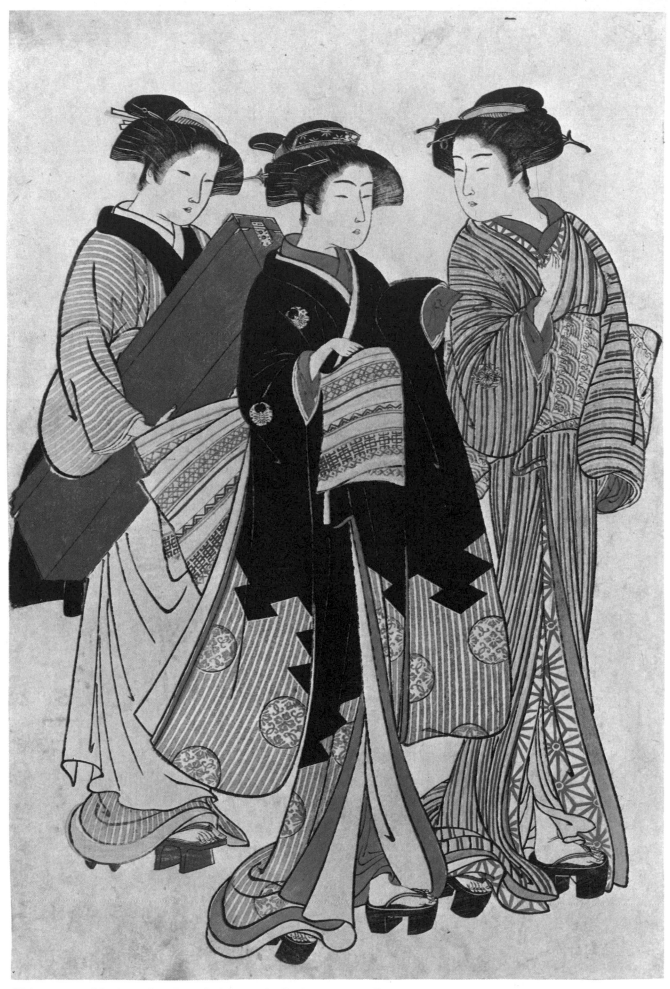

Shigemasa (Unsigned) *Two Geisha and a Tea-House Maid*
Oban, Nishiki-e, 38.2 × 26.2 cm
Publisher: unknown. Date: c. 1780's. Honolulu
Academy of Arts

Two geisha attended by a maidservant holding a *samisen* (three-stringed guitar) case in her hands.

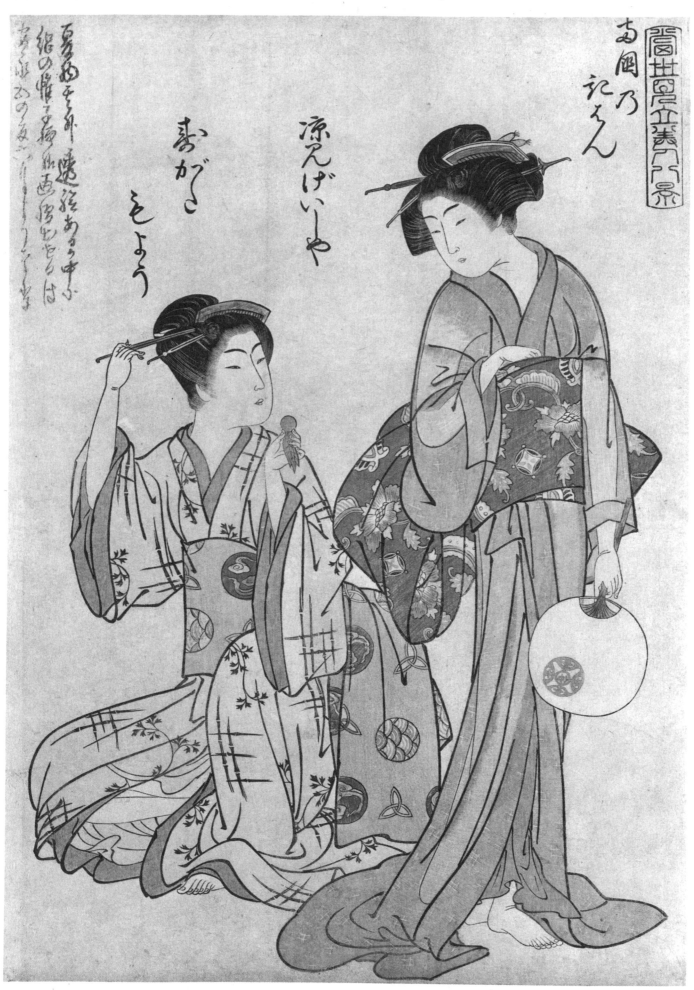

Shigemasa (Unsigned) *Two Geisha of Ryogoku,* from the series *Eight Scenes of Contemporary Beauties (Tosei Mitate Bijin Hakkei)* Oban, Nishiki-e, 36 × 25.7 cm Publisher: unknown. Date: c. 1780's. The Art Institute of Chicago

A series of eight pictures of beauties depicted in association with eight views. An *uchiwa* (fan) and a ground cherry held in women's hands symbolize summer. The arms of the woman on the right are visible through her *kimono* made of gauze.

153

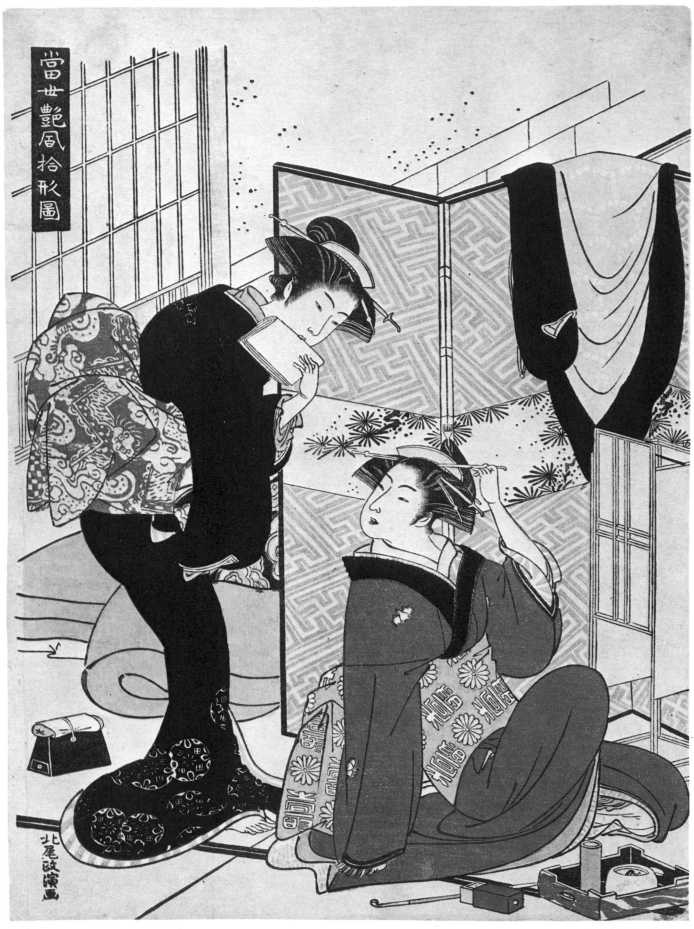

Masanobu *Two Courtesans*, from the series *Ten Scenes of Contemporary Courtesans (Tosei Enpu Jukkei-zu)*
Chuban, Nishiki-e, 25.8 × 14.1 cm
Publisher: unknown. Date: c. 1780's. Sakai Collection, Japan

A pillow, a smoking-set and a paper-covered lamp are seen, and a *futon* (quilted coverlet) is laid behind a folding screen.

154

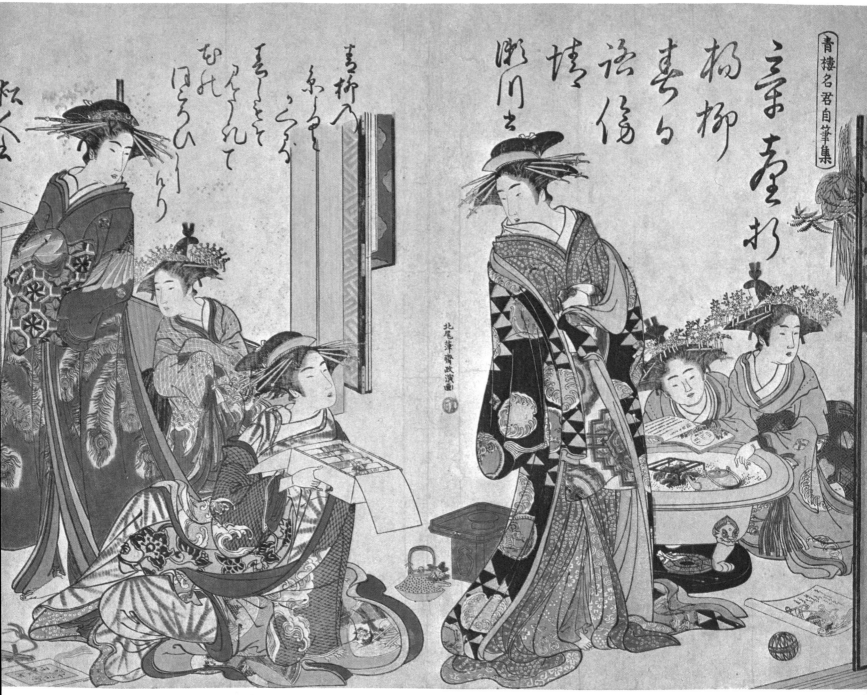

Masanobu *Segawa and Matsuhito*, from the album *Famous Courtesans with Poems in Their Own Hands (Seiro Meikun Jihitsu-shu)*
Extra-oban, Nishiki-e, 36.4 × 48.8 cm
Publisher: Tsuta-ya Juzaburo. Date: c. 1784

A work also famous for courtesans' poems written by themselves. The attraction of this picture lies in the gorgeous *kimono* and furnishings.

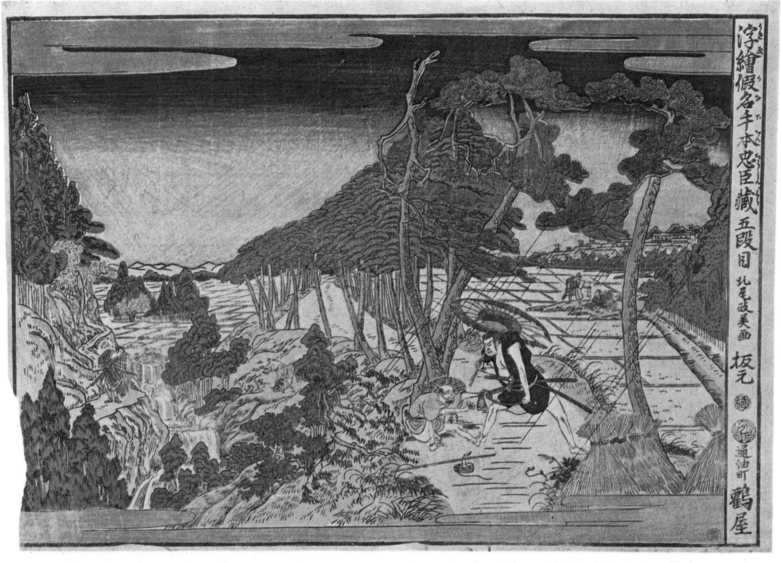

Masayoshi *Scene from Act V of Kana-dehon
Chusingura* (a *Kabuki* drama)
Extra-oban, Nishiki-e, 32.6 × 44.5 cm
Publisher: Tsuru-ya Ki-emon. Date: c. 1780's. Tokyo
National Museum

A perspective picture. A highway is depicted in
perspective, so that the space appears like a landscape
rather than a stage scene.

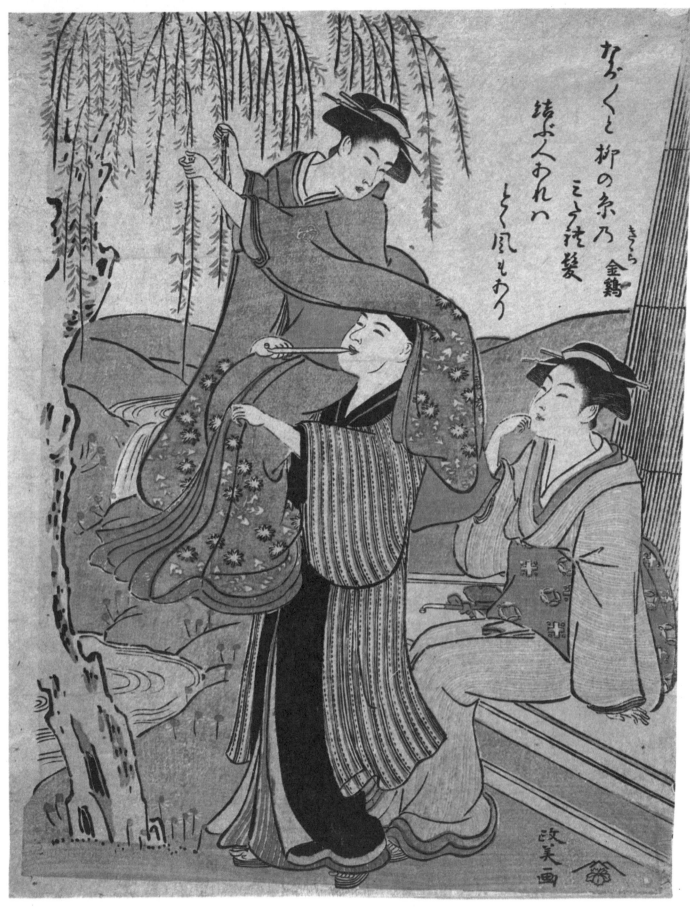

なぐくと柳の糸乃 金鶏
きくら
結ぶ人あれハ
三ヶ花髪
とく風もあり

政美画

Masayoshi *Long Drooping Branches of a Willow Tree*
Chuban, Nishiki-e, 25.7 × 19.2 cm
Publisher: Tsuta-ya Juzaburo. Date: c. late 1780's
Tokyo National Museum

A girl riding on a man's shoulder. The poem says metaphorically that some men bind women's hair and some dishevel it and let it down.

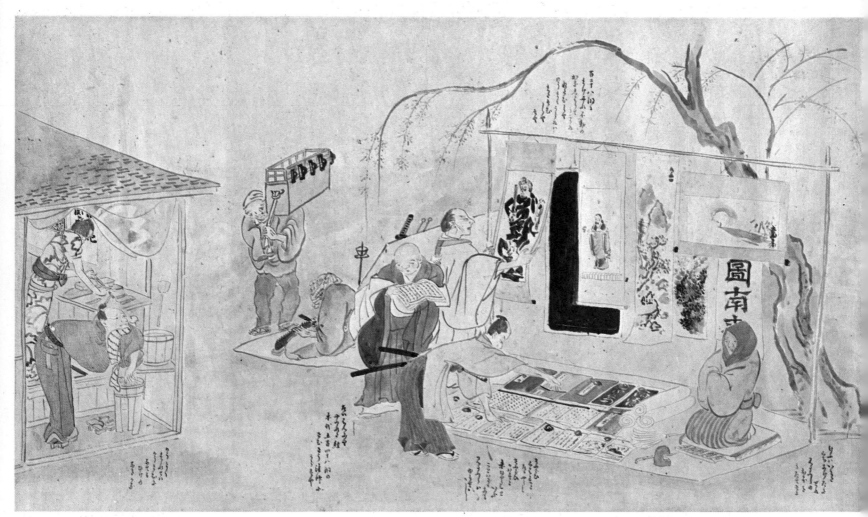

Keisai (Masayoshi) *Dealer in Pictures and Writings*, detail of the second scroll of *Collection of Modern Workmen (Kinsei Shokunin Zukushi E-kotoba)*
Paintings on paper, one of the three scrolls, 36.4 × 1039.3 cm
Date: 1805. Tokyo National Museum

A street trader selling writings and paintings. This work in three scrolls includes interesting pictures similar to caricatures and sketches depicting members of all classes, from feudal lords to ordinary people, namely warriors, farmers, artisans and tradesmen, priests and so on. This is one of the most famous works in the history of Japanese painting.

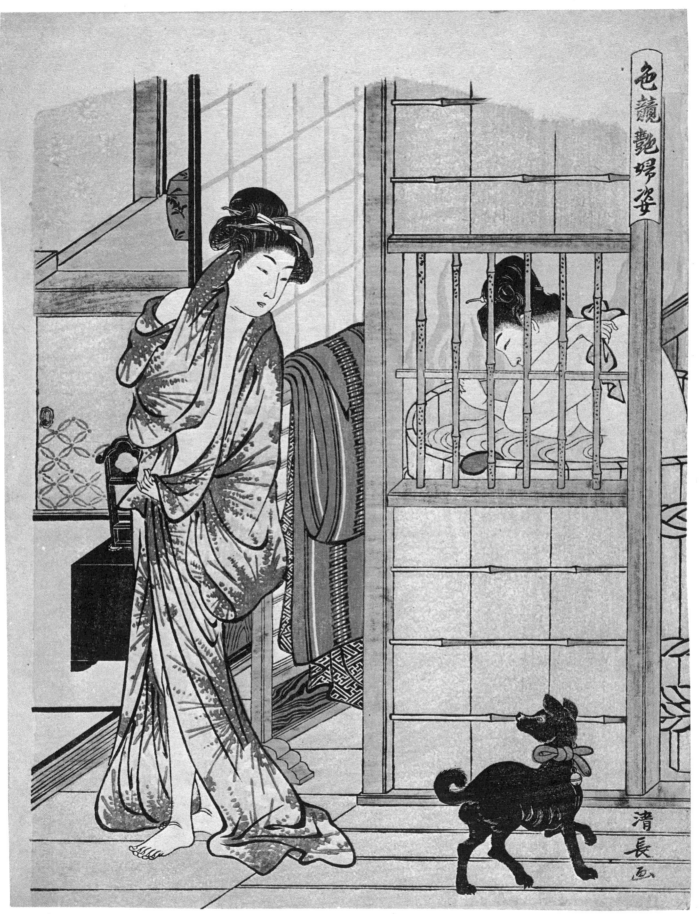

色競艶婦姿

清長画

Kiyonaga *In the Bathroom,* from the series
Comparison of Feminine Charms (Irokurabe Empu no Sugata)
Chuban, Nishiki-e, 26.5 × 19.8 cm
Publisher : unknown. Date : c. late 1770's. Takahashi
Collection

A woman taking a bath is seen through the window.
The bathtub is wooden and oval. *Kimono* and *obi*
(sash) are hung on a screen in front of her.

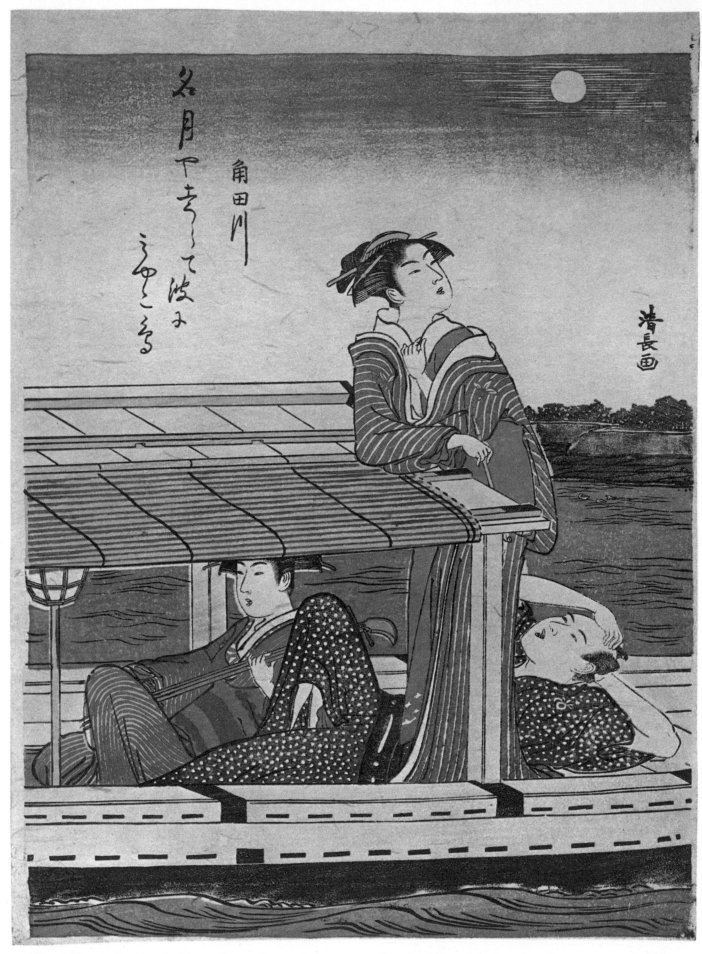

Kiyonaga *Viewing the Moon from a Boat on the Sumida River*
Chuban, Nishiki-e, 26.6 × 19.6 cm
Publisher: unknown. Date: c. 1780's

Courtesans and their customer on a summer pleasure boat with a roof and a bamboo blind.

160

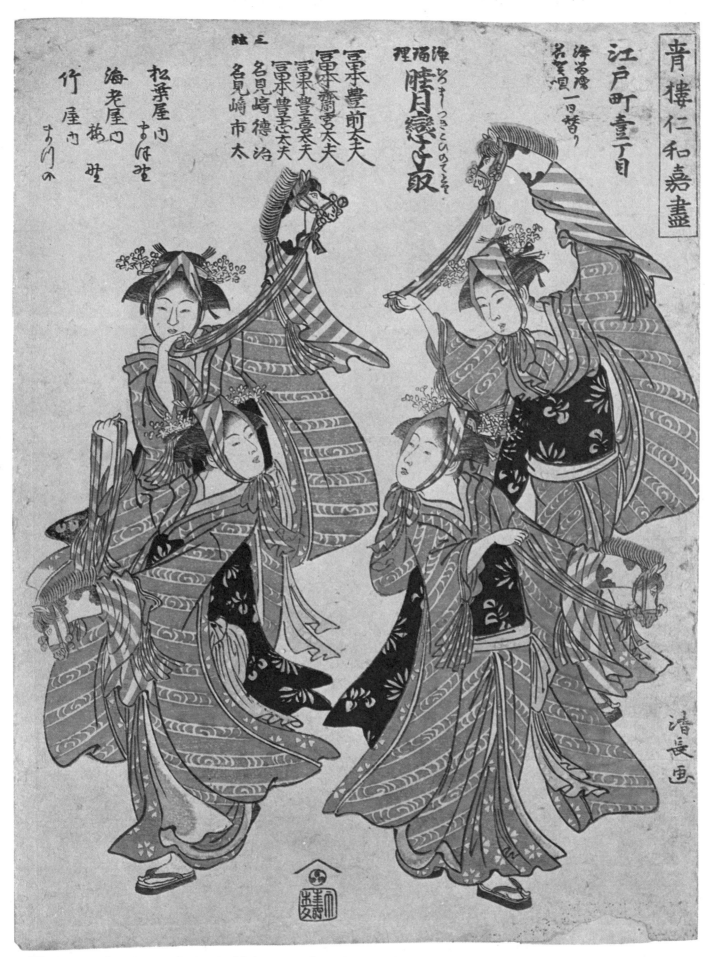

青樓仁和嘉盡

江戸町壹丁目

三ツ紐

Kiyonaga *Impromptu Dances of Courtesans*, from the series *Niwaka Dance Contest at the Gay Quarters (Seiro Niwaka Zukushi)*
Chuban, Nishiki-e, 26 × 19 cm
Publisher: Nishimura-ya Yohachi. Date: c. 1780's

Annual festival early in August at the gay quarters of Yoshiwara. Leading courtesans of each tea house competed with one another in dancing.

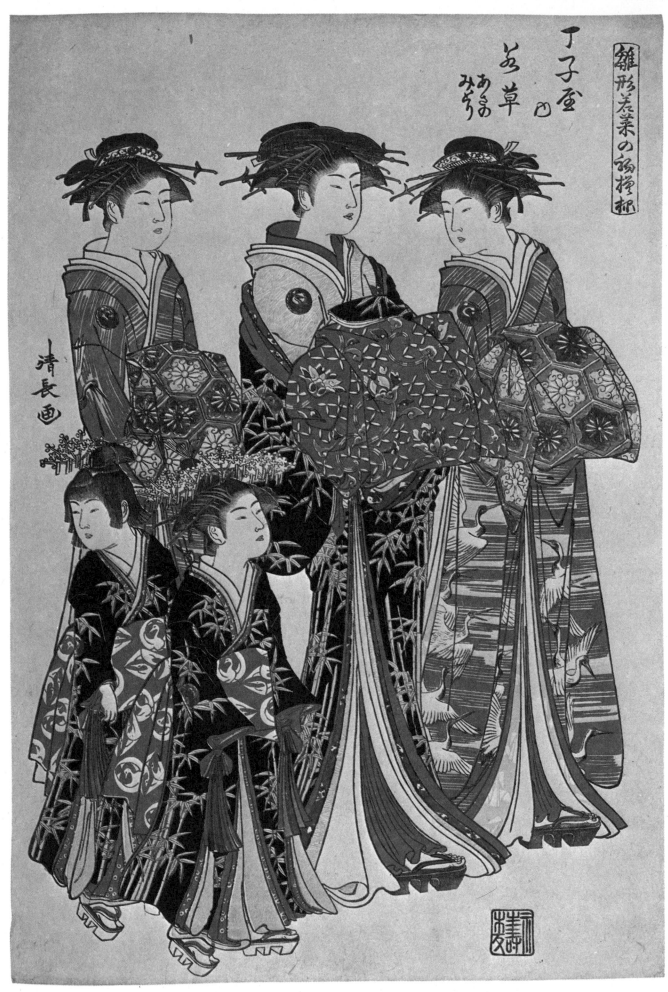

Kiyonaga *The Courtesan Wakakusa of Choji-ya,* from the series *Courtesans in the New Year's Fashion Dresses (Hinagata Wakana no Hatsumoyo)* Oban, Nishiki-e, 39 × 26.5 cm Publisher: Nishimura-ya Yohachi. Date: c. mid 1780's

A leading courtesan of a tea house at Yoshiwara. A print serving as advertisement both for the house and the fashion dresses. Kiyonaga continued this series which Koryusai had originated.

162

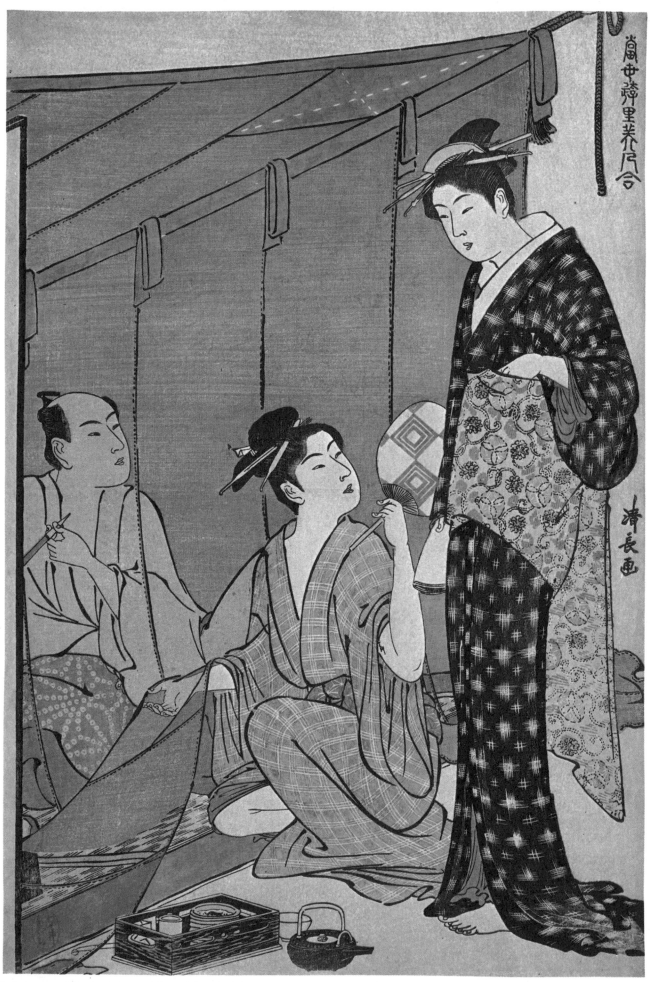

Kiyonaga *The Inside and Outside of a Mosquito Net*, from the series *Contemporary Beauties of the Gay Quarters (Tosei Yuri Bijin Awase)*
Oban, Nishiki-e, 37 × 24.7 cm
Publisher: unknown. Date: c. early 1780's

A woman entering under a mosquito net in summer. The sitting woman is wearing a *kimono* with a striped design, while the standing woman's *kimono* has splashed patterns. A smoking set is in front of them.

163

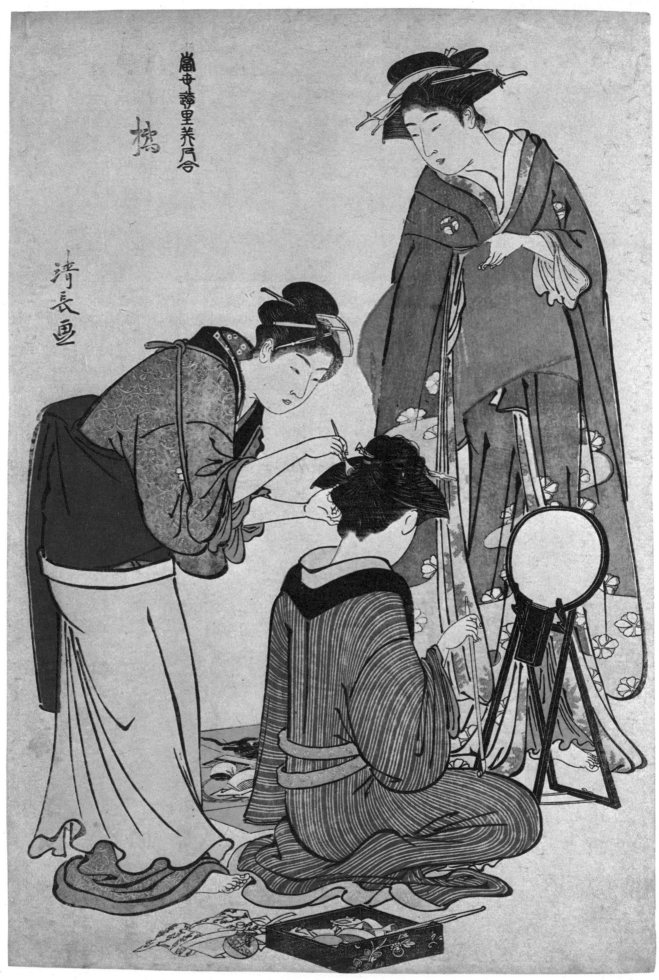

Kiyonaga *Tachibana*, from the series *Contemporary Beauties of the Gay Quarters (Tosei Yuri Bijin Awase)* Oban, Nishiki-e, 39.7 × 26.3 cm
Publisher: unknown. Date: c. Early 1780's.
The Art Institute of Chicago

A woman having a hairdresser do up her hair. A mirror made of polished metal is on a stand and hairdressing utensils are in a box in front.

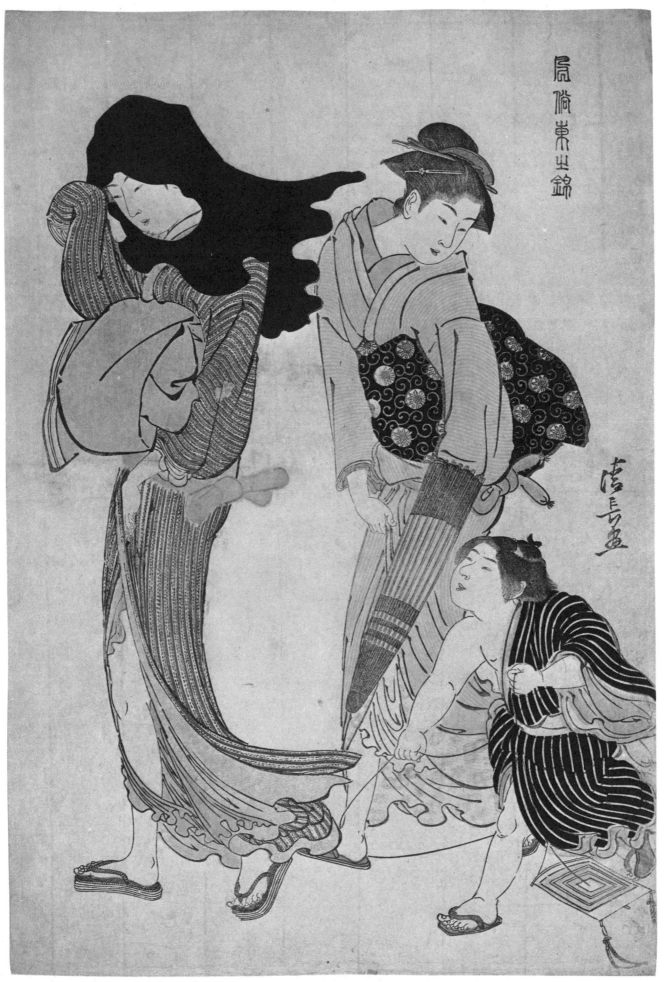

Kiyonaga *The Entangled Kite-string*, from the series *Customs of the East (Fuzoku Azuma no Nishiki)* Oban, Nishiki-e, 39.3 × 26.2 cm Publisher: unknown. Date: c. mid 1780's

The string of a kite flown by a child catches on a girl's foot.

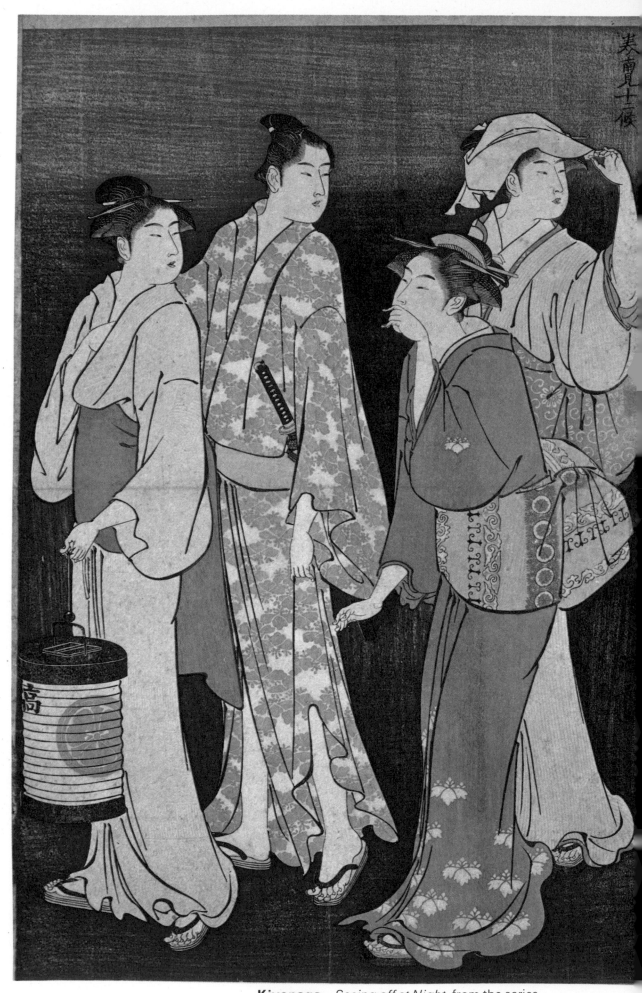

美南見十二候

Kiyonaga *Seeing off at Night*, from the series
Twelve Months in the South (Minami Juni-ko)
Oban, Nishiki-e, Diptych, 38.1 × 25.4 cm each
Publisher: unknown. Date: c. mid 1780's. Honolulu
Academy of Arts

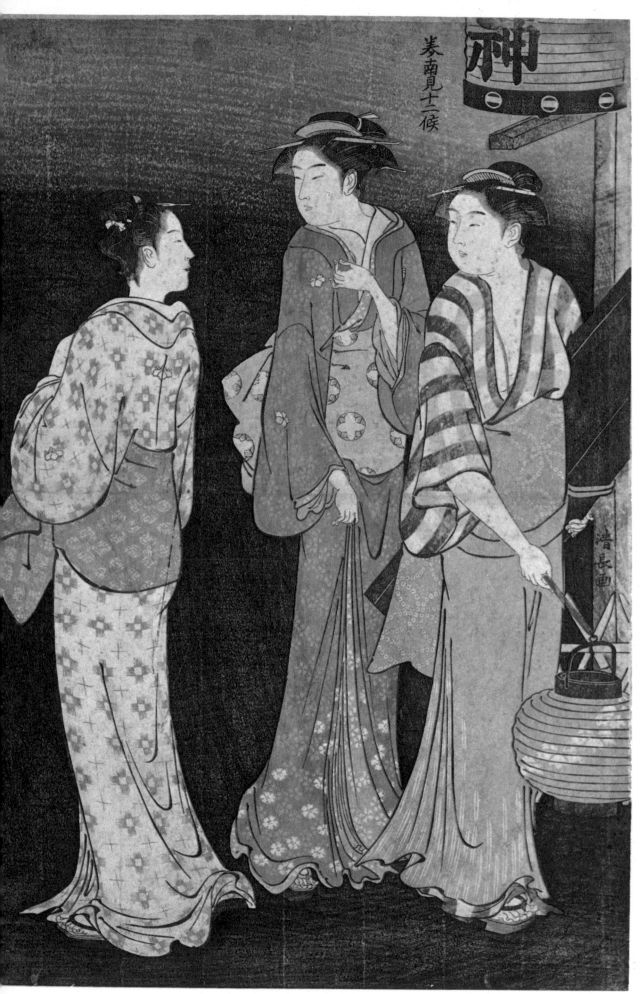

Minami was the pleasure quarter of Shinagawa in southern Edo. Courtesans seeing their customers off. Lanterns have the family crest of tea houses.

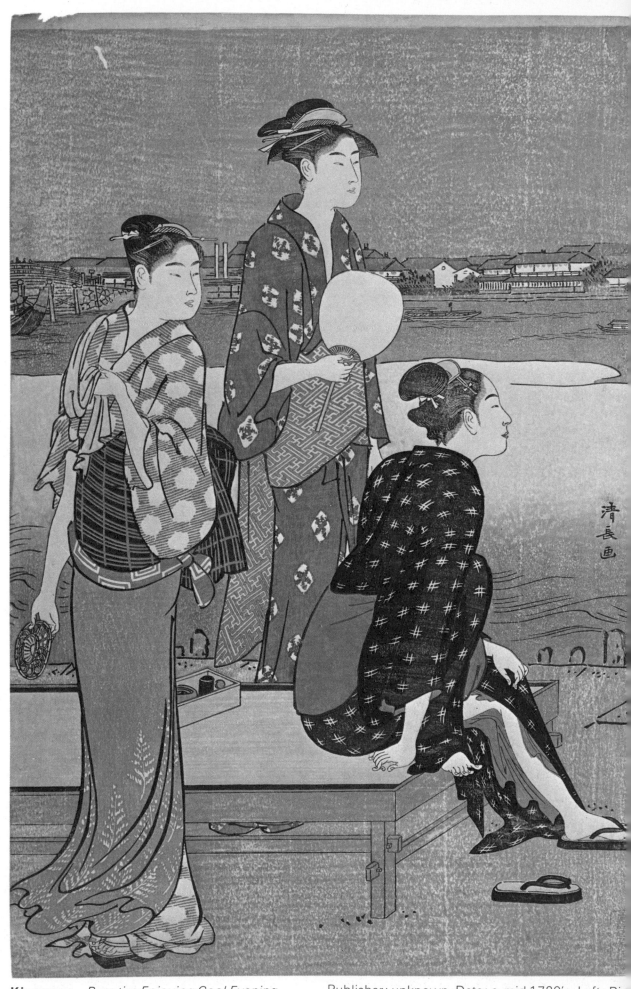

Kiyonaga *Beauties Enjoying Cool Evening*
Oban, Nishiki-e, Diptych, left: 39 × 25.6 cm, right:
37.2 × 25.8 cm

Publisher: unknown. Date: c. mid 1780's. Left: Ric
Art Museum, Japan; right: The Metropolitan Muse
of Art, New York

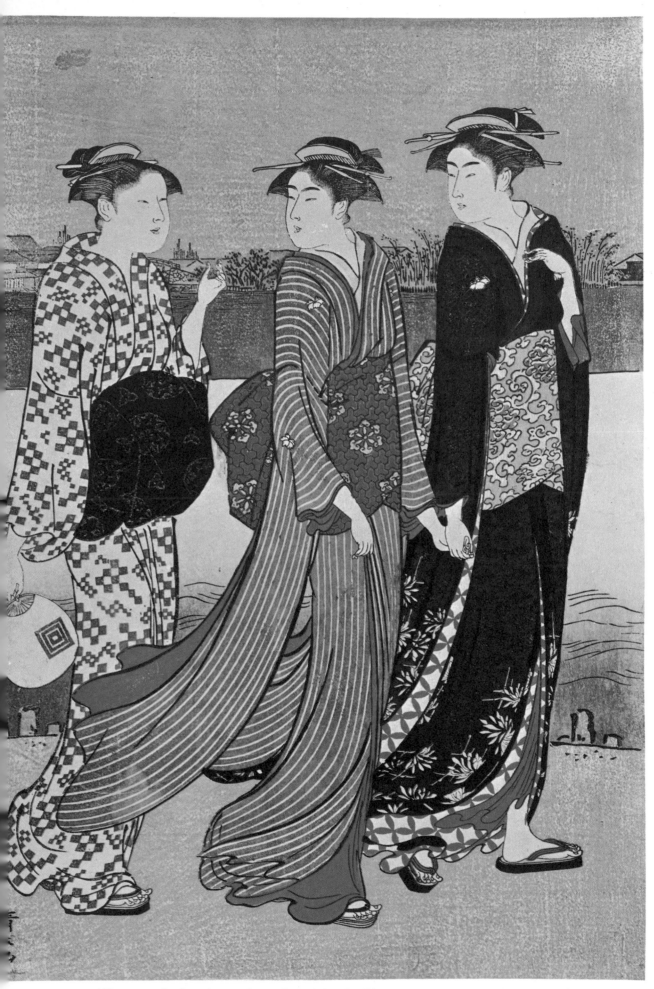

Women enjoying the cool evening air by the River
Sumida in Edo. The woman with no eyebrows is
married.

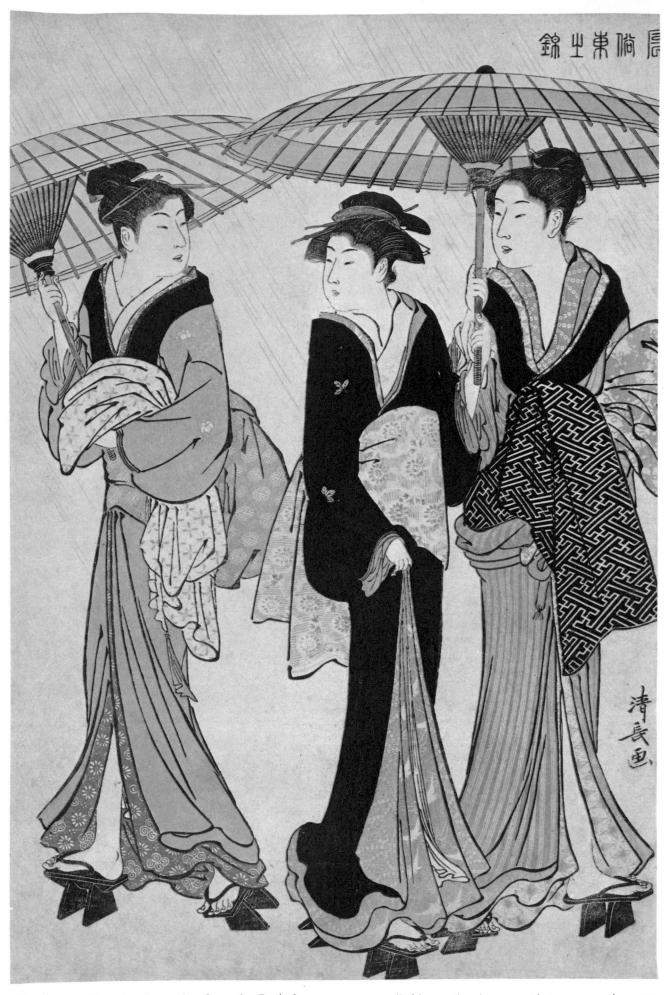

Kiyonaga *Beauties Returning from the Bath*, from the series *Customs of the East (Fuzoku Azuma no Nishiki)*
Oban, Nishiki-e, 37.4 × 24.8 cm
Publisher: unknown. Date: c. mid 1780's. Sakai Collection, Japan

A woman (left) meeting her acquaintances on the way back from a public bath.

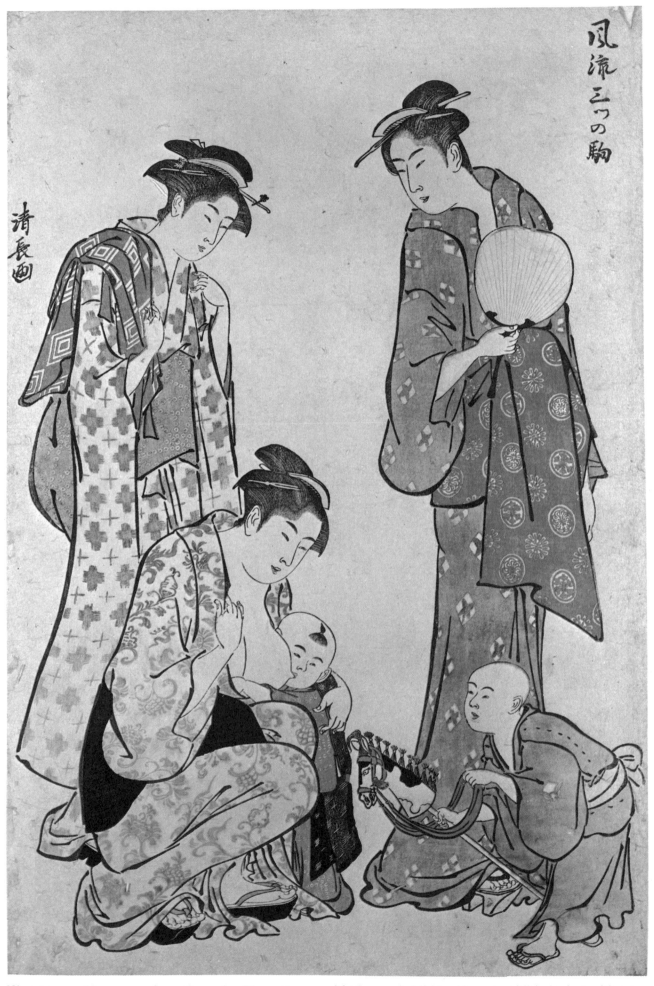

Kiyonaga *Harugoma*, from the series *Three Horses* (*Furyu Mittsu-no-koma*)
Oban, Nishiki-e, 38.4 × 25.7 cm
Publisher: unknown. Date: c. mid 1780's. Musées
Royaux d'Art et d'Histoire, Brussels

Mother and child looking at a child playing with a toy horse (*Harugoma*)

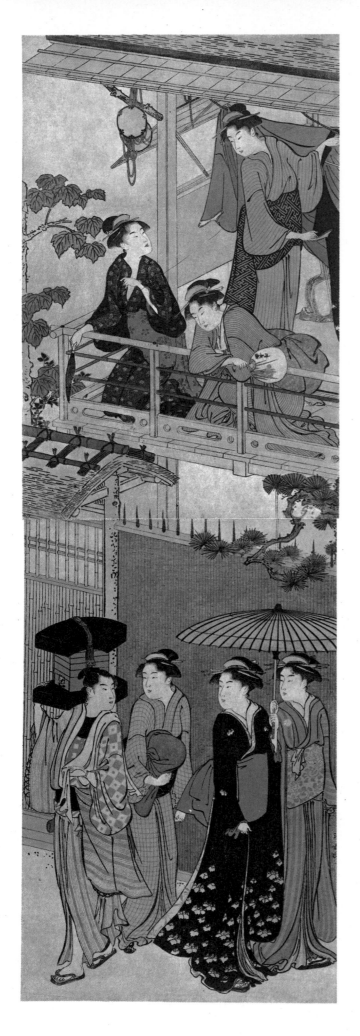

Kiyonaga *Fan Seller and Beauties*
Oban, Nishiki-e, Vertical Diptych : above :
37.5 × 24.9 cm, below : 37.9 × 24.9 cm
Publisher : unknown. Date : c. mid 1780's.

Women watching a handsome fan-seller passing by.

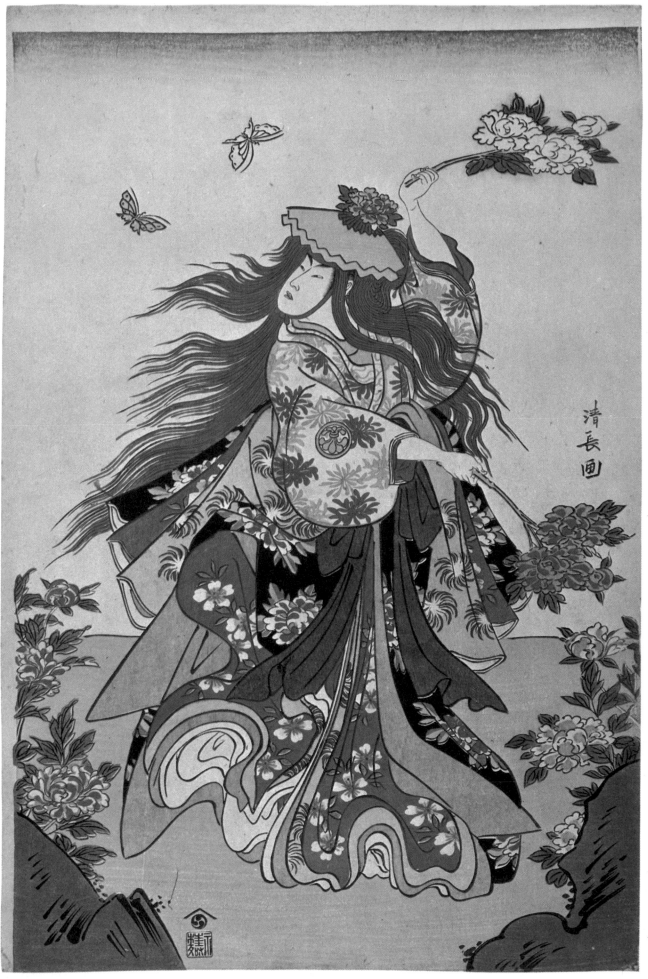

Kiyonaga *The Actor Segawa Kikunojo III in the Dance "Shakkyo"*
Oban, Nishiki-e, 39.7 × 25.8 cm
Publisher: Nishimura-ya Yohachi. Date: 1789
Honolulu Academy of Arts

A famous dance in the *kabuki* performance based upon a No play written by Ze-ami, in which the spirit of the lion dances madly.

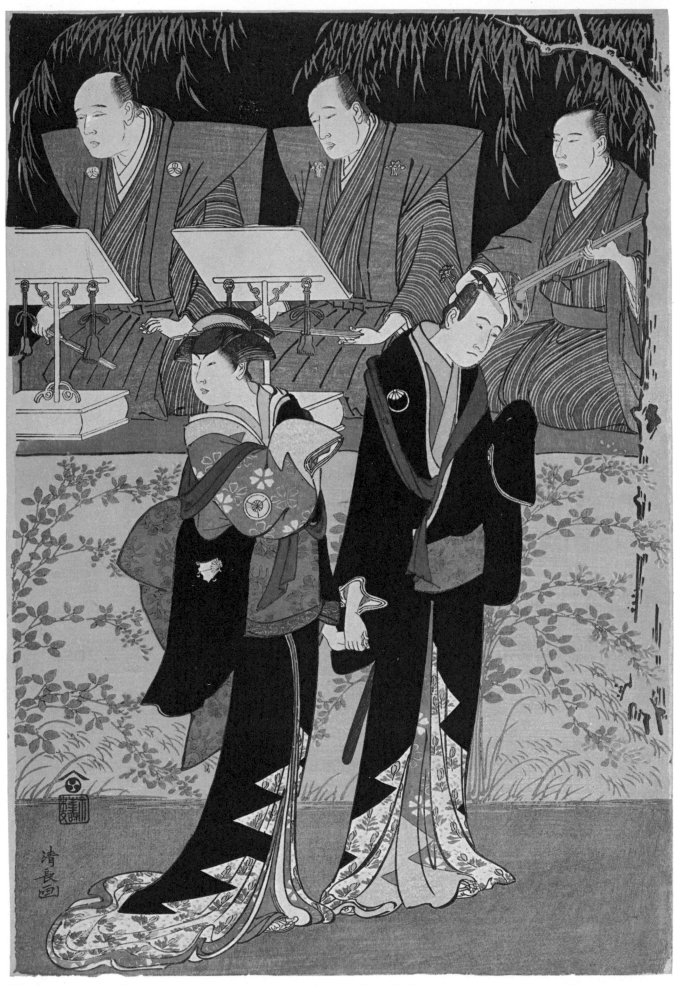

Kiyonaga *Stage Scene: The Actors Sawamura Sojuro III as Jihei and Iwai Hanshiro IV as Koharu*
Oban, Nishiki-e, 39 × 26.6 cm

Publisher: Nishimura-ya, Yohachi. Date: 1784. Sakai Collection, Japan

A realistic stage scene with story-tellers and an accompanist for a background. A famous account of lovers' suicide: a couple eloping to commit suicide.

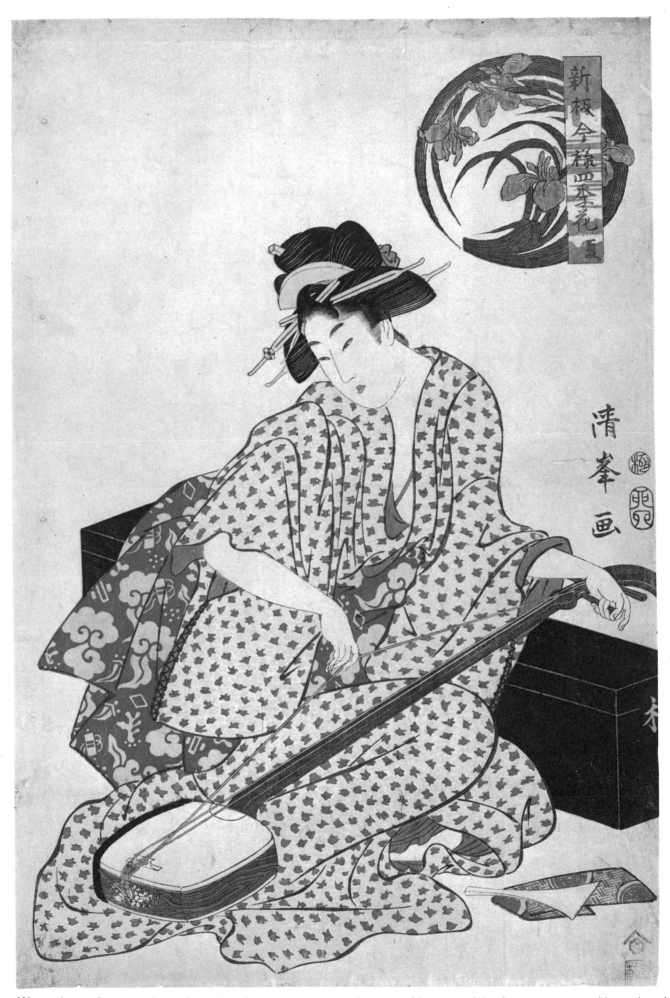

新板今様四季の花 夏

清峯画

Kiyomine *Summer*, from the series *Contemporary Flowers of the Four Seasons (Shinpan Imayo Shiki no Hana)*
Oban, Nishiki-e, 38.7 × 25.9 cm
Publisher: Nishimura-ya Yohachi. Date: 1809

A series of flowers of the four seasons and beauties. A woman tightening the strings of her *samisen*.

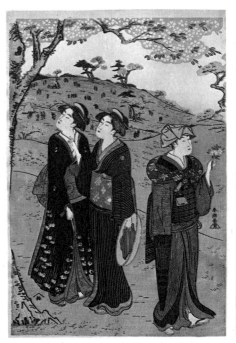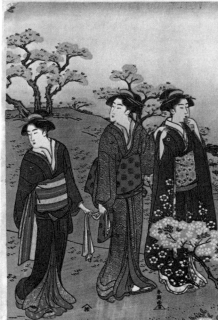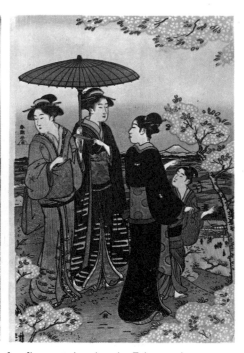

Shuncho *Cherry Blossom Viewing at Asukayama*
Oban, Nishiki-e, Triptych: left: 39.2 × 26.3 cm, centre:
39.2 × 26.5 cm, right: 39.2 × 26.3 cm
Publisher: Chichibu-ya. Date: c. late 1780's

A place famous for flower viewing in Edo, and
viewers. A monument inscribed with the history of this
place can be seen on a distant hill.

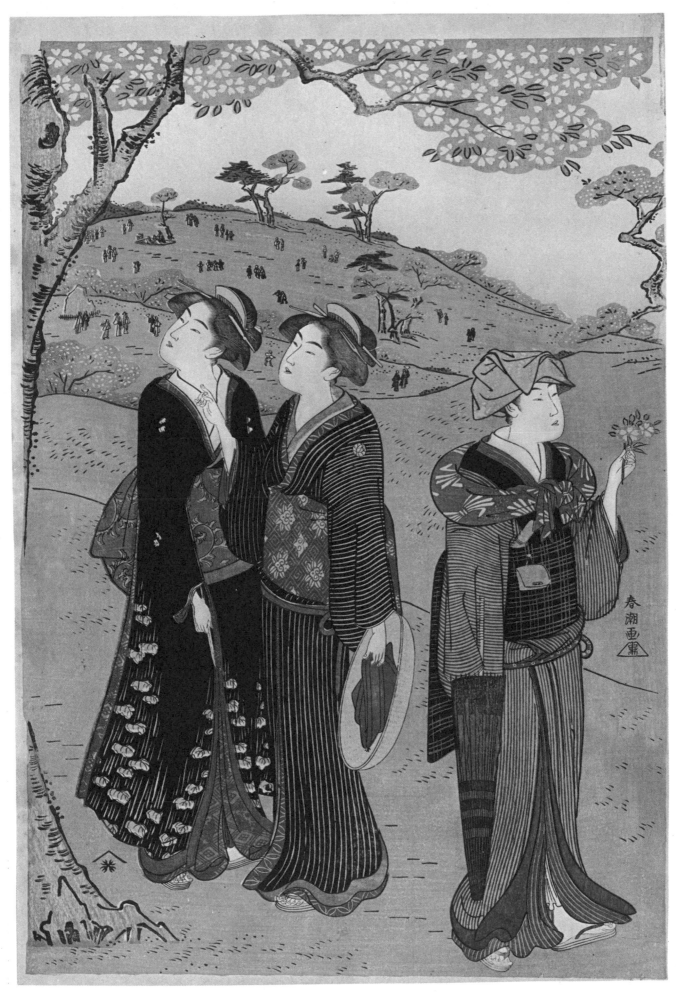

Shuncho *Cherry Blossom Viewing at Asukayama*
Left panel of the triptych.

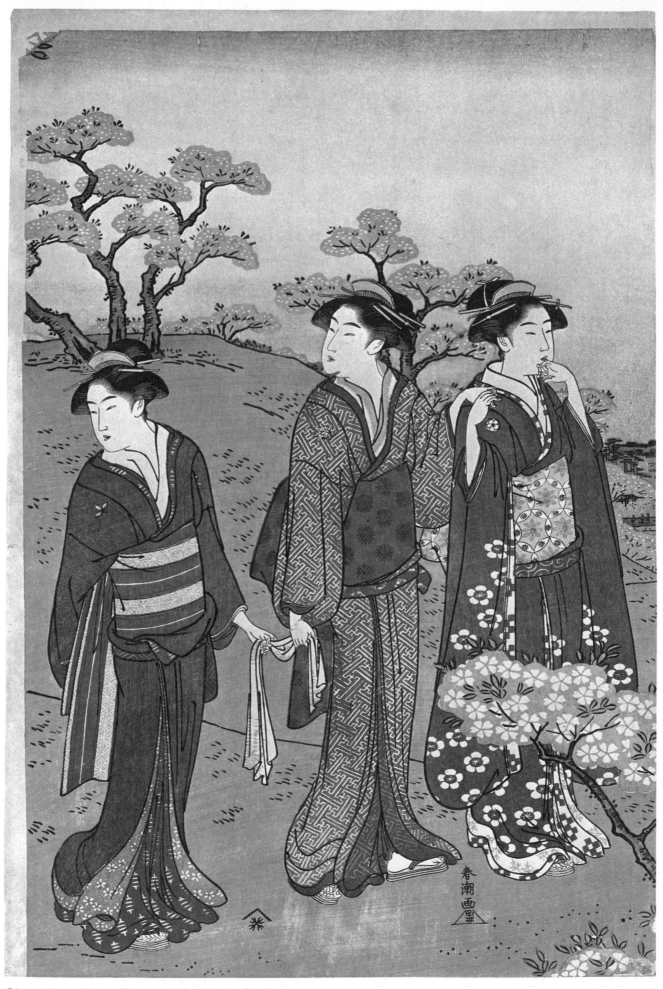

Shuncho *Cherry Blossom Viewing at Asukayama*
Central panel of the triptych.

178

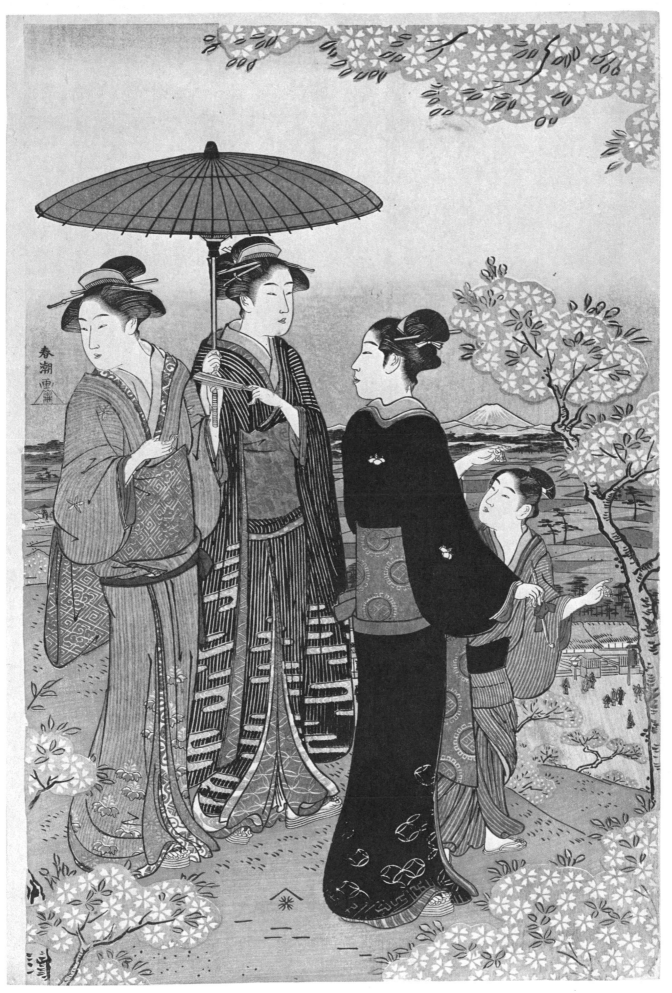

Shuncho *Cherry Blossom Viewing at Asukayama*
Right panel of the triptych.

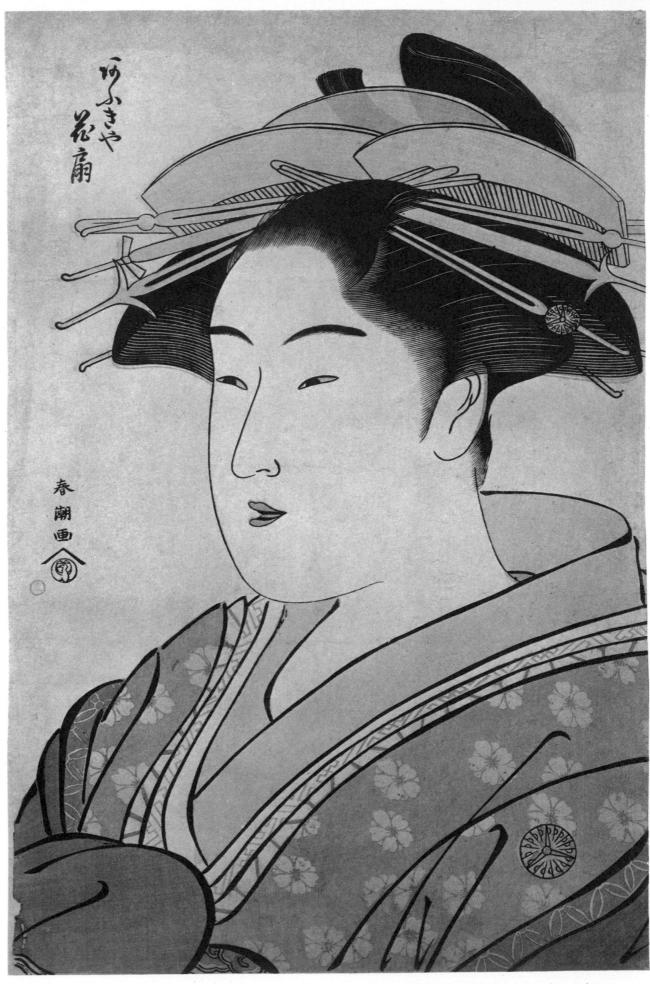

Shuncho *The Courtesan Hanaogi of Ogi-ya*
Oban, 39.4 × 26 cm
Publisher: Tsuru-ya Ki-emon. Date: c. late 1780's
Victoria and Albert Museum, London

Luxurious hair-style with three combs and six ornamental hairpins. Projecting hair on both sides of the head is dressed with *binzashi* hairpins.

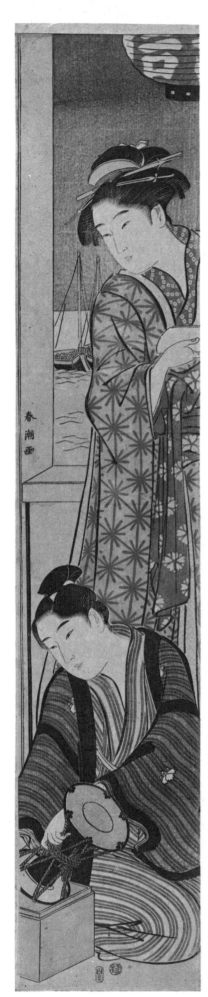

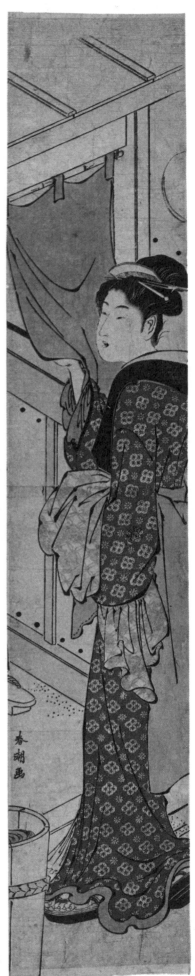

Shuncho Left: *A Seaside Restaurant*
Hashiraeban, Nishiki-e,
75.5 × 14.5 cm
Publisher: Yamada-ya Sanshiro.
Date: c. early 1790's

A man tightening the strap of a *tsuzumi* (hand-drum); behind him is a courtesan.

Shuncho Right: *Curtain*
Hashiraeban, Nishiki-e, 63.5 × 11.9 cm
Publisher: unknown. Date: c. late 1780's

A woman raising the curtain of a bath.

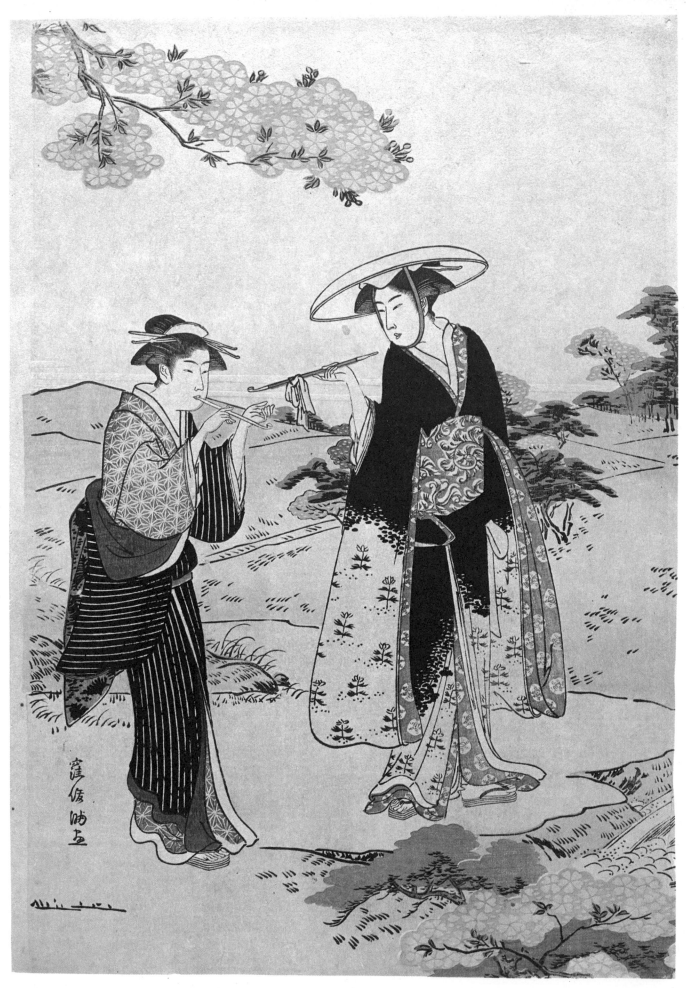

Shunman *Smoking under a Cherry-tree*
Aiban, 32.4 × 22.3 cm
Publisher: unknown. Date: c. late 1780's. Tokyo
National Museum

A scene of flower viewing. A woman lighting her pipe.

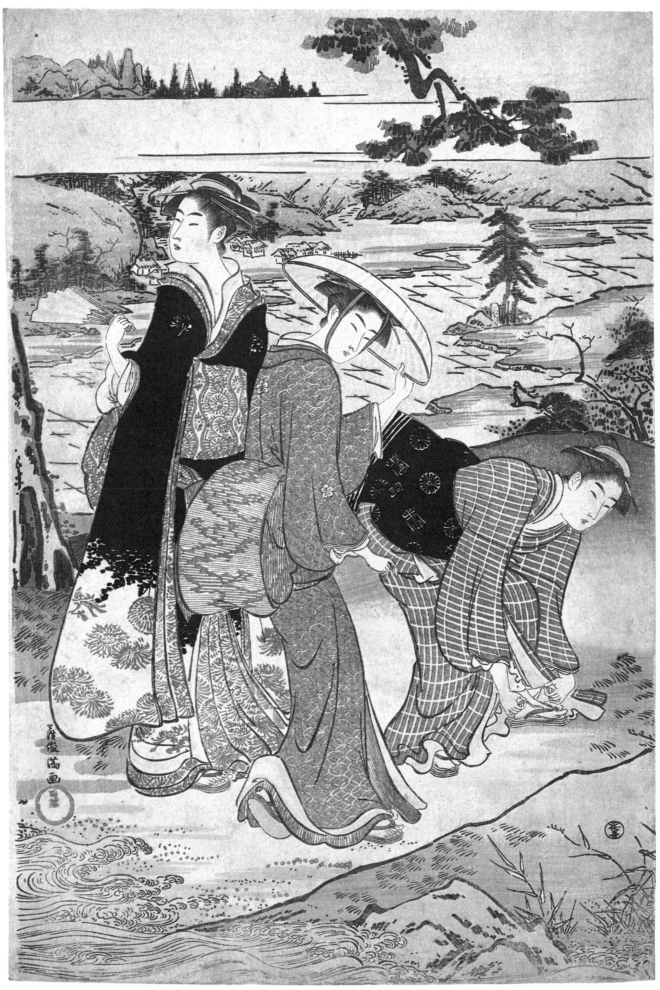

Shunman *Koya no Tamagawa*, from the series *Six Crystal Rivers (Mu-Tamagawa)*
Oban, Nishiki-e, 38.7 × 26 cm
Publisher: Fushimi-ya Zenroku. Date: c. late 1780's

A six-print series based on an ancient poem. A woman fixing a strap on her straw sandals on a pilgrimage to the Kongobuji Temple on Mount Koya. An example of *beni-girai*, avoiding showy colours.

Feminine beauty

An artist who devoted his life to the beauty of women

One of the dominant themes in fine arts everywhere in the world has been womanly beauty. Utamaro is particularly prominent in that he devoted his whole life to the pursuit of this beauty. He specialized in the depiction of feminine carriage, character, and softness of skin as well as gracefulness, taking full advantage of the characteristic of woodcut prints to capture the essence of woman. In the genre of *okubi-e* (close-up portraits), he repeatedly experimented with the suggestion of an entire female figure by close-up portrayals of only a bust or face. He attempted to depict women's life and psychology intuitively, by expression of their hair styles, hair-pieces, make-up, facial appearance, moderately depicted costumes, patterns, and finger tips. Thus, Utamaro has become a world-famous *ukiyo-e* artist, especially in the area of *bijin-ga*.

Kitagawa Utamaro (1753–1806)

Utamaro's active period is said to correspond to the golden age in the history of *ukiyo-e* in Japan. Closer observation, however, reveals that at that time, the *ukiyo-e* world was suffering from various strict controls imposed upon the activities of the artists by the *samurai*, the then declining military class.

Although Utamaro was one of the hardest hit among the *ukiyo-e* artists of the time, he knew how to cope with the situation, and somehow managed to survive as an *ukiyo-e* artist, producing many excellent works, in spite of the difficult circumstances.

He also left many erotic works despite the severe censorship and controls. Here lie his strength and genius as a civilian artist, and these were works unmatched by the other artists of his time. However, Utamaro did not start out as a *bijin-ga* artist. Like many others, he began his artistic career illustrating theatre playbills, collections of poems or other books, and even did portrait prints of actors. In this work his genius had not yet come to the fore. It was Tsuta-ya Juzaburo (1750–1797), a publisher, that discovered and helped develop Utamaro's then hidden talent.

As is the case with many other *ukiyo-e* artists, little is known of Utamaro's childhood; even his birthplace is not definitely traceable, and there are many differing opinions. The only thing known of his early life is that he was taught by a certain artist named Toriyama Sekien (1714–1788), who, although not originally an *ukiyo-e* artist, was an orthodox painter, and one of the great literati of the time. At the beginning of his career, Utamaro used the name Toyoaki, but he began to use the name Utamaro for the first time in 1781. Soon afterwards he took up residence in Tsuta-ya's home.

During the 1780's, he cooperated with the publisher in producing collections of *kyoka*, humourous verse made up of thirty-one syllables.

Although the books contain many verses by famous *kyoka* poets, their main feature is Utamaro's excellent illustrations, with large pictures appearing on every page. The most interesting example in this genre is the *Mushi Erami* (*Insect Book*) (1788), which deals with insects, frogs and snakes as well as flowers. In the *Momo Chidori Kyoka Awase* (*Book of Birds*) (1789), many birds are illustrated. Utamaro's keen observation of nature is clearly demonstrated in these works of subjects with which he was intimately familiar.

His skill in eroticism is exemplified by the album *Uta Makura* (*Pillow Poems*) (1788), which, together with the *Mushi Erami* and others, brought him a certain amount of fame. Thereafter, Utamaro developed his world of *bijin-ga* with the smoothness of a sailing boat before a favourable wind.

In the early 1790's Utamaro began to publish his *okubi-e* series. Utamaro was not the first to depict close-ups of the human torso. However, there is no doubt that he brought *bijin-ga* to its full maturity by concentrating on close-ups of his subject, as well as expressing feminine beauty with a new sensibility.

Many of Utamaro's masterpieces are among the *okubi-e* series. The main themes are the then popular courtesans and famous beauties of old Edo (now Tokyo). They were sometimes depicted yearning for and suffering in love, and sometimes reading letters with great emotion. Their costumes and fans and other small articles always correspond to the seasons of the year. All of these themes were popular among the citizens of Edo, and were idealized in their representation.

Utamaro also produced some triptychs of groups of beauties, showing their entire figures. He painted the wives and daughters of merchants, and even children, besides the courtesans, in the course of his search for beauty within the daily life of women. Drunken prostitutes of the lower class were also depicted for the first time. Utamaro was not limited to the idealized feminity of the well-known beauties, but was sensitive to the reality and harshness of the everyday world. Worthy of note in Utamaro's artistic technique are the simplicity, reserve, and strength with which themes are represented. Very often the backgrounds are eliminated, or expressed in a simple tone, as seen in the *okubi-e* and various other prints. Utamaro devoted himself only to the representation of what he genuinely wished to depict. This aim contrasts with those of his predecessors, such as Kiyonaga, who aimed at an atmospheric effect by setting his subjects against realistic backgrounds.

Utamaro devised various artistic methods and techniques: he designed the backgrounds deliberately in monochrome to highlight the figures, or at times changed the colours of the outlines of figures and faces, or eliminated the outlines altogether and instead represented his subjects with areas of colour and *kimono* patterns.

With all his technical inventiveness, Utamaro was so arrogant towards his imitators that he even wrote on his prints how confident he was in his abilities.

During this period, the ruling military class was gradually declining economically under the prolonged feudalistic system. However, the merchant class was steadily strengthening its economic power. The political situation of the time inevitably had an effect on the artistic world. Without finding any really effective counter-measures, the ruling military class tried to improve public and social morals by laws and regulations, held to strict economic policies, and forced people to live simple and frugal lives in order to rehabilitate the feudalistic system.

They increased the censorship of artistic works, placing more and more restrictions on the subject matter, and putting a stop to polychromatic printing.

In 1804, many black-listed publishers and illustrators were arrested and punished, including Tsuta-ya and Utamaro. After this incident Utamaro rapidly declined, both in health and spirit. He died at the age of 54. Utamaro was another *ukiyo-e* master who developed his genius to its fullest potential.

Utamaro II (active between c. 1800–c. 1820)

At first Utamaro II was a disciple of Koikawa Harumachi (1744–1789), a writer and illustrator, and was named Koikawa Yukimachi. He made his debut as a writer. Later he became an apprentice to Utamaro, and called himself Utamaro II after his master's death.

The idiom of Utamaro II resembles that of his master in the later years. In this respect, it is worth noting that all the works after 1806 bearing Utamaro's signature were produced by Utamaro II.

Among the students of Utamaro, besides Utamaro II, were Fujimaro and Tsukimaro (Kikumaro). Under Tsukimaro were Yukimaro and Shikimaro. However, they were neither energetic nor inventive, and inferior by far to Utamaro.

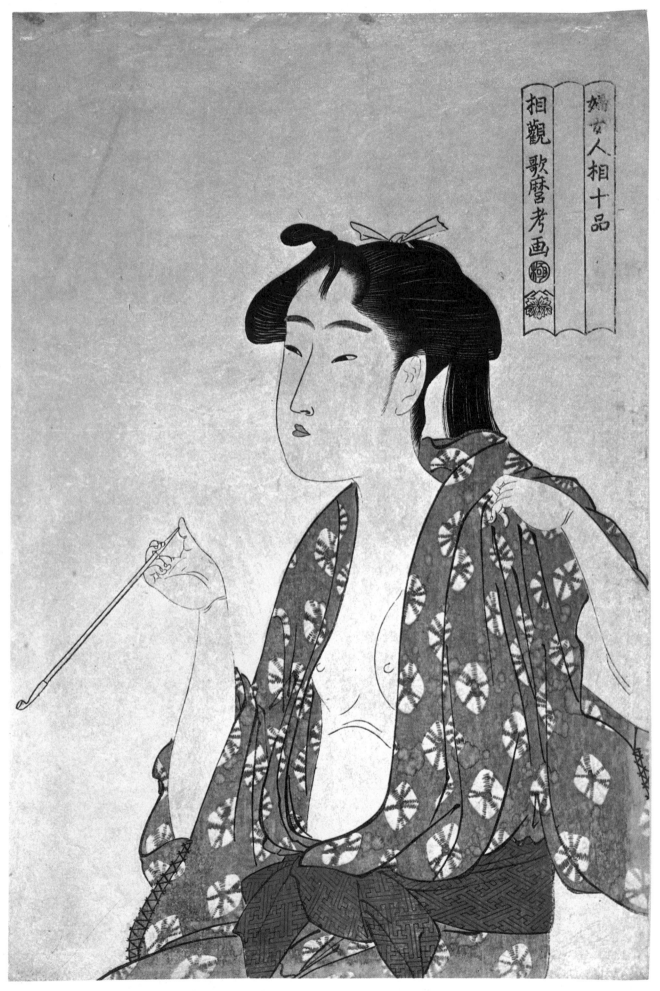

婦女人相十品

相觀 歌麿考画

Utamaro *Woman Smoking*, from the series *Ten Physiognomatic Aspects of Woman (Fujo Ninso Jippon)*
Oban, Nishiki-e, 37.3 × 25.2 cm
Publisher: Tsuta-ya Juzaburo. Date: c. early 1790's

A woman in a *yukata* (cotton bathrobe) smoking, probably after taking a bath.

187

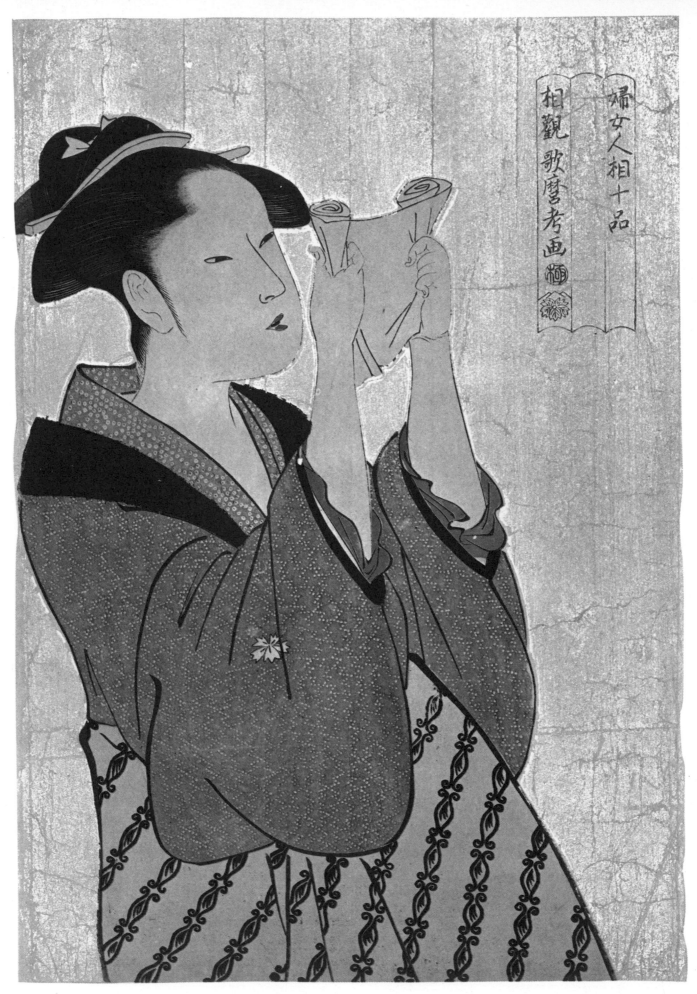

Utamaro *Woman Reading a Letter,* from the series
*Ten Physiognomatic Aspects of Woman (Fuju Ninso
Jippon)*
Oban, Nishiki-e, 36.1 × 24.9 cm
Publisher : Tsuta-ya Juzaburo. Date : c early 1790's
Tokyo National Museum

A middle-aged woman reading a billet-doux. Her
shaved eyebrows and dyed black teeth indicate that
she is married.

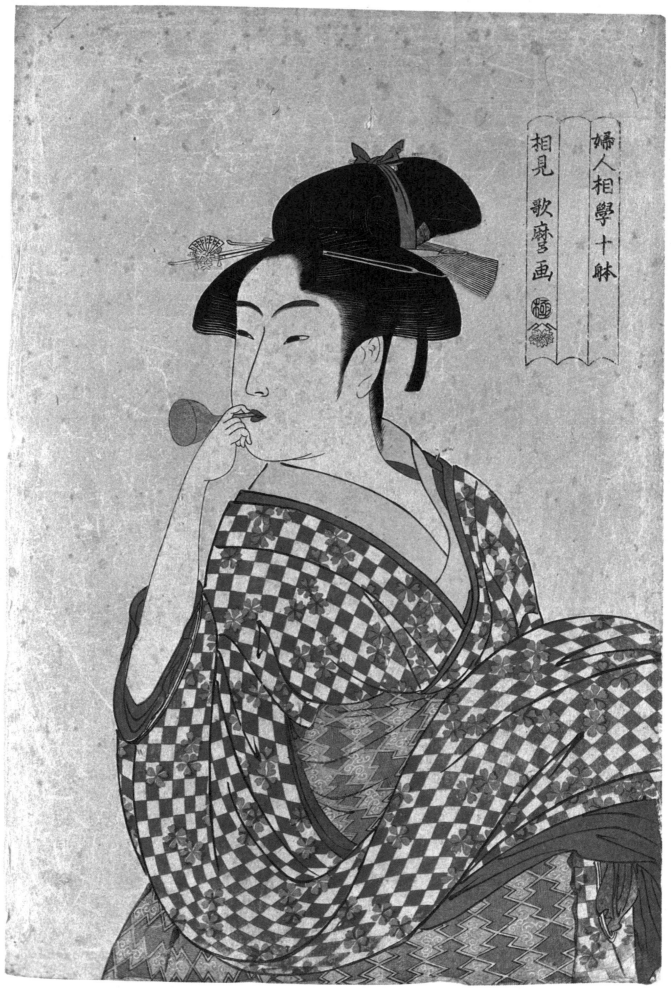

婦人相學十躰

相見 歌麿画

Utamaro *Girl Blowing Poppin, a Glass Toy*, from
the series *Ten Physiognomatic Aspects of Woman
(Fujo Ninso Jippon)*
Oban, Nishiki-e 38.7 × 25.7 cm
Publisher: Tsuta-ya Juzaburo. Date: c. early 1790's
Honolulu Academy of Arts

A young girl making a sound, blowing a *poppin*,
which was first introduced to Nagasaki and then
spread all over Japan.

189

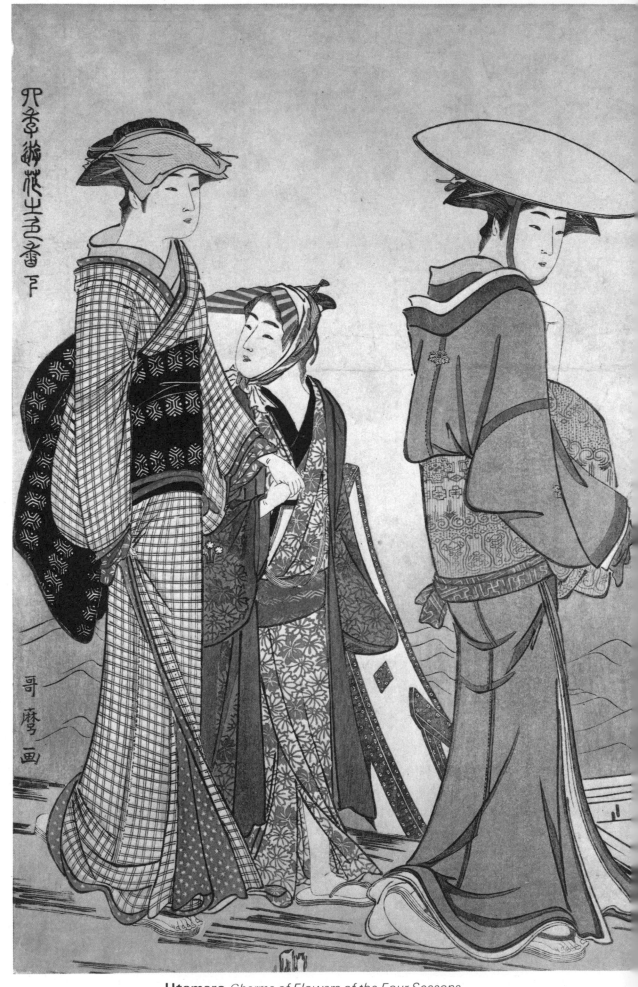

Utamaro *Charms of Flowers of the Four Seasons*
(Shiki Asobi Hana no Iroka)
Oban, Nishiki-e, Diptych: left: 37.1 × 24.3 cm, right:
37.1 × 24.5 cm
Publisher: unkown. Date: c. early 1780's. British
Museum, London

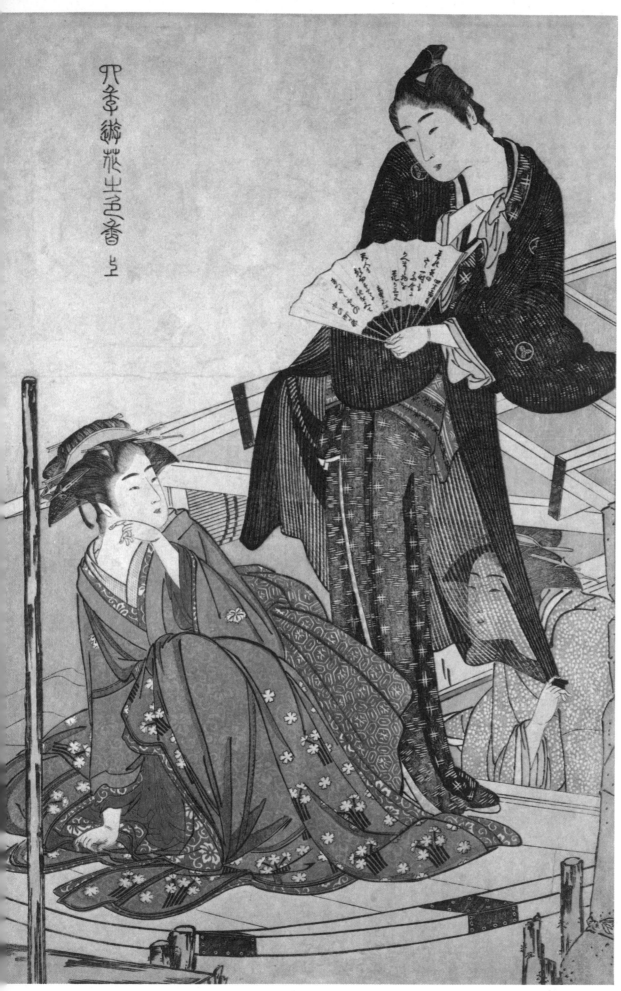

Townspeople enjoying life on a pleasure boat.

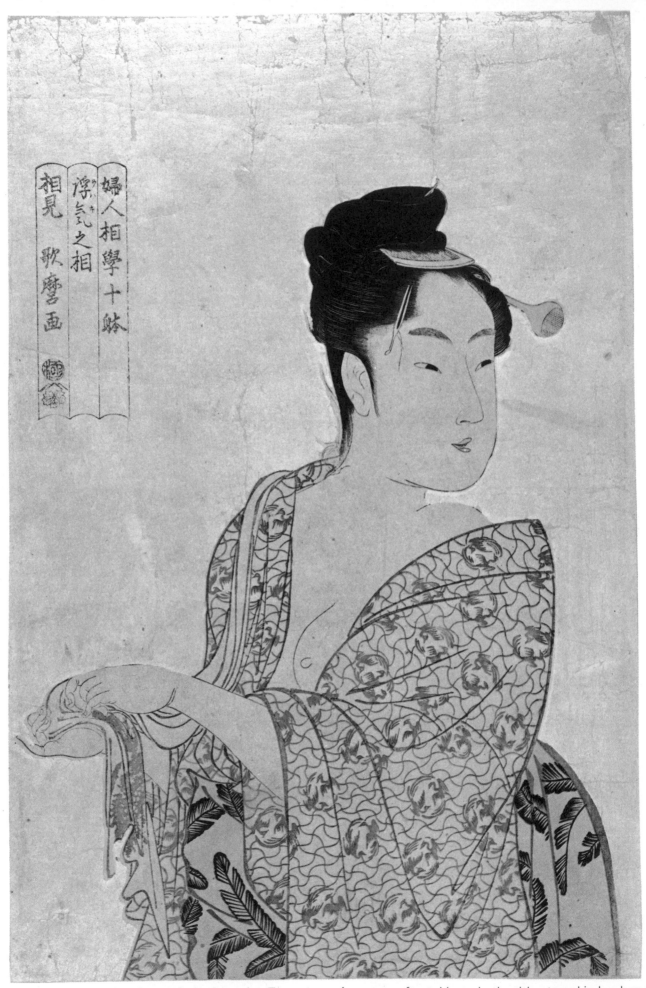

婦人相學十躰
浮気之相
相見 歌麿画

Utamaro *Flirtatious Woman*, from the series *Ten Physiognomatic Aspects of Woman (Fuju Ninso Jippon)*

Oban, Nishiki-e, 37.9 × 24.4 cm
Publisher: Tsuta-ya Juzaburo. Date: c. early 1790's
Tokyo National Museum

A woman after taking a bath with a towel in her hands, and her newly-washed hair wound up round a comb.

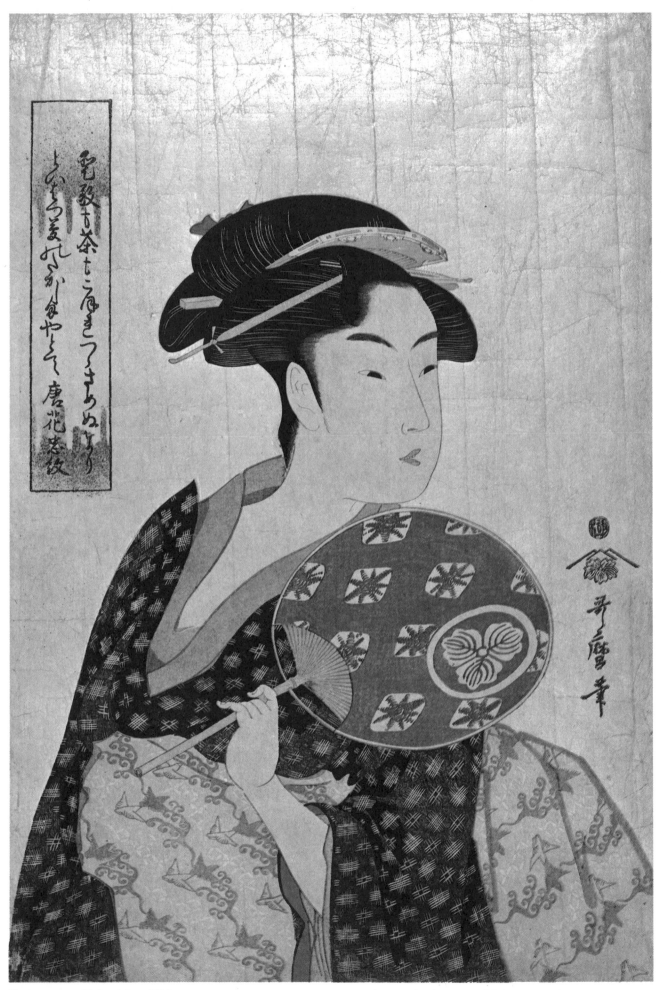

Utamaro *Takashima Ohisa*
Oban, Nishiki-e, 38.4 × 25.6 cm
Publisher: Tsuta-ya Juzaburo. Date: c. early 1790's

A popular beauty of Edo with a fan in her hands.

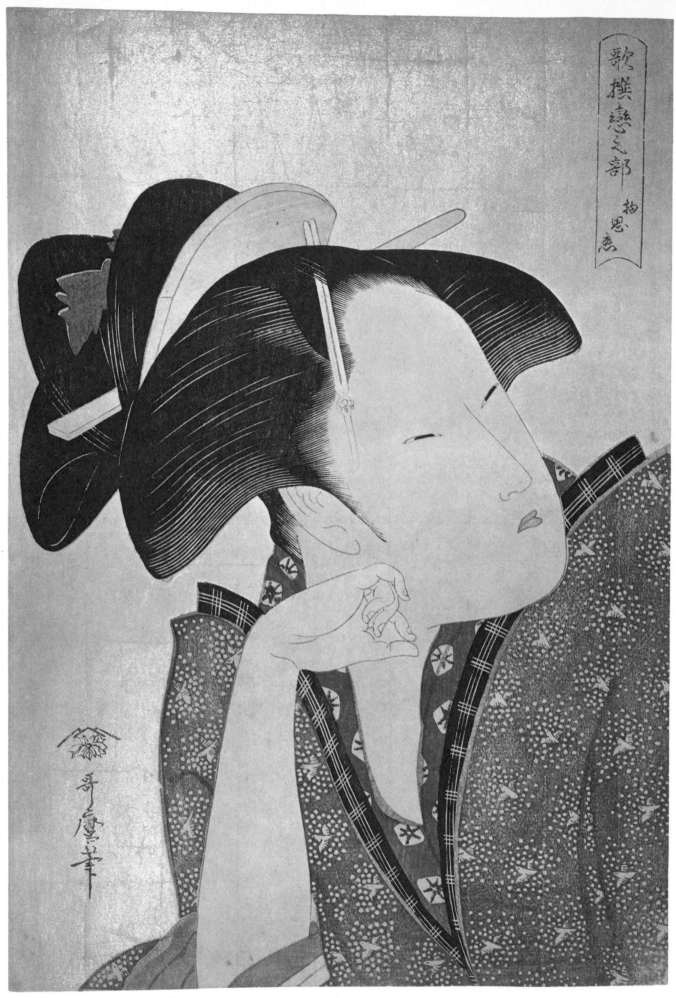

Utamaro *Pensive Love*, from the series *Selected Poems on Love (Kasen Koi no Bu)*

A middle-aged woman pining from love.

194

Oban, Nishiki-e, 38.6 × 26.1 cm
Publisher: Tsuta-ya Juzaburo. Date: c. early 1790's
Riccar Art Museum, Japan

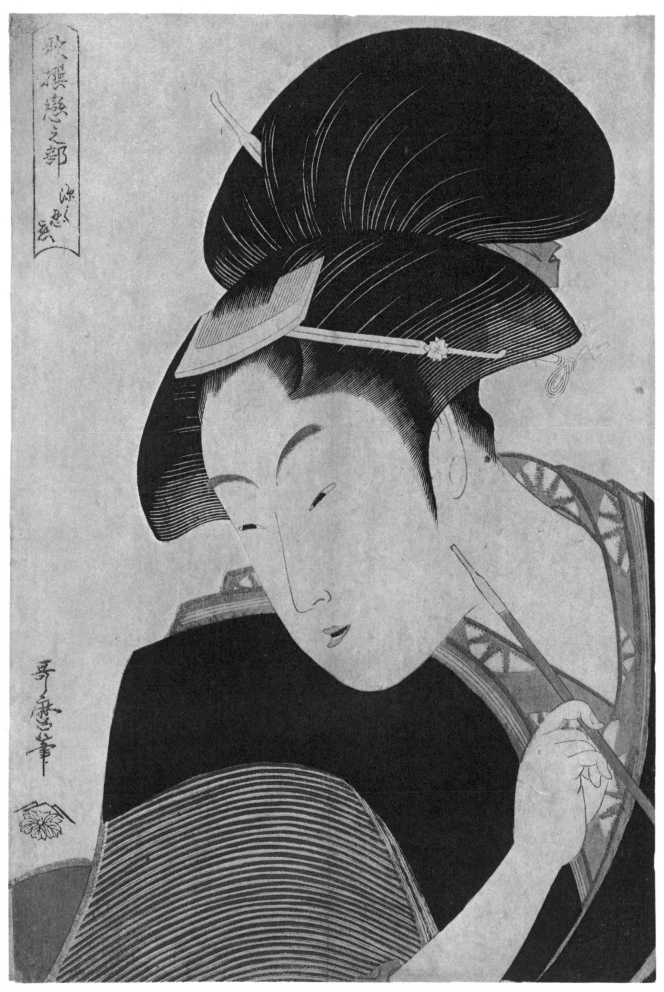

Utamaro *Secret Love,* from the series *Selected Poems on Love (Kasen Koi No Bu)*
Oban, Nishiki-e, 38.2 × 25.4 cm
Publisher: Tsuta-ya Juzaburo. Date: c. early 1790's
Tokyo National Museum

A married woman pining from love. Her dyed black teeth are slightly visible.

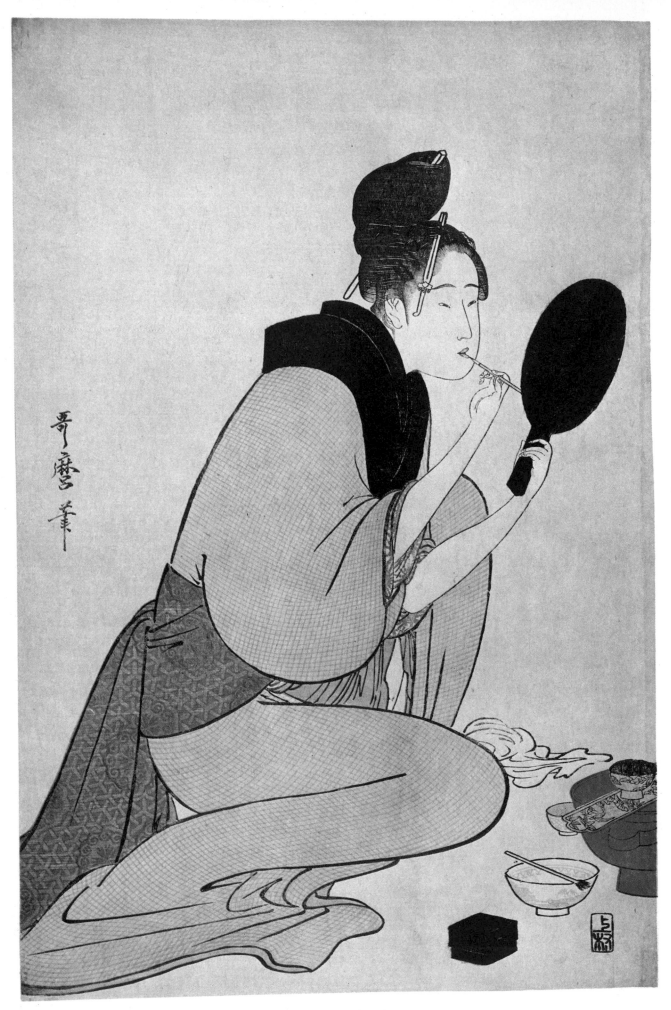

Utamaro *Beauty Putting On Rouge*
Oban, Nishiki-e, 38.2 × 25.4 cm
Publisher: Uemura Yohei. Date: c. mid 1790's. Riccar
Art Museum, Japan

A woman, looking into a mirror in her hand with one
knee drawn up, is putting rouge on her lips after
dyeing her teeth black. In front of her is a teeth-
blackening device.

196

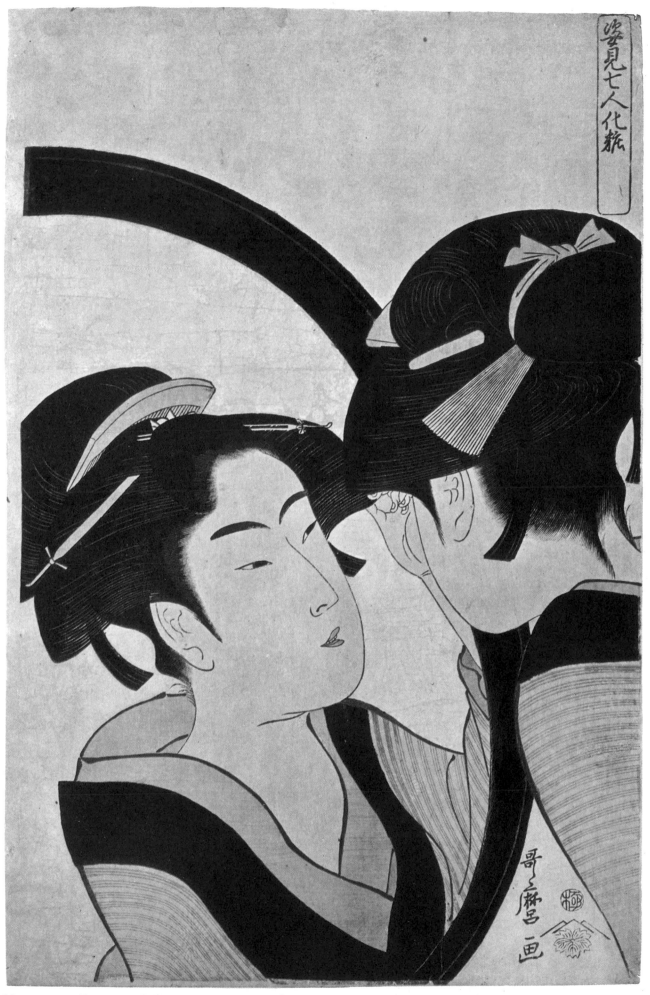

Utamaro *Beauty at Toilet,* from the series *Seven Beauties Making-up (Sugatami Shichinin Kesho)* Oban, Nishiki-e, 38.3 × 26.4 cm Publisher: Tsuta-ya Juzaburo. Date: c. mid 1790's

A young woman dressing her hair before a mirror, showing her nape as well as her face. A beautiful nape was essential to female beauty.

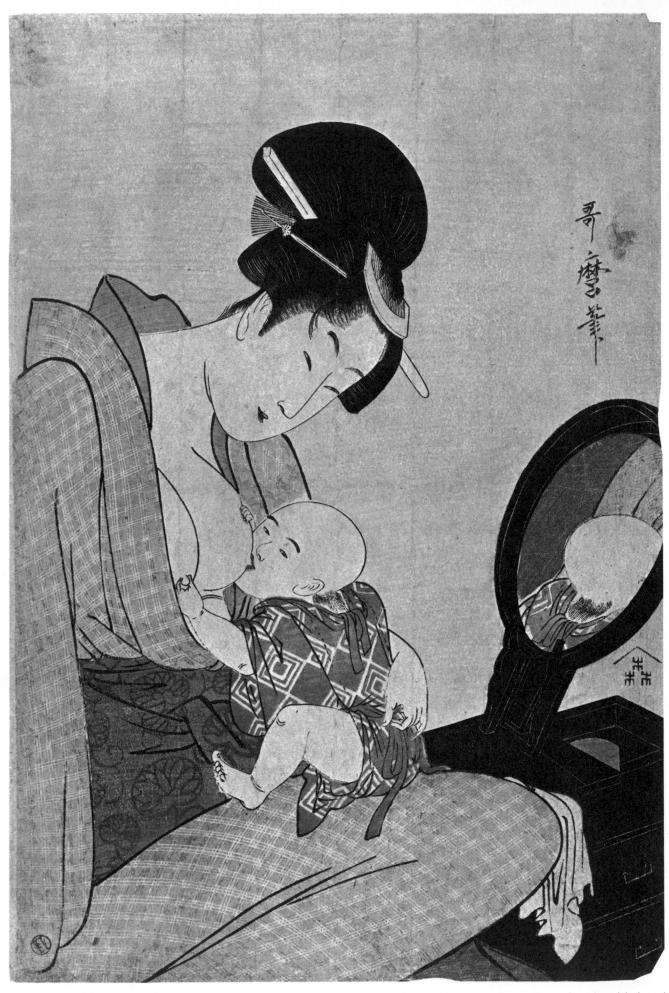

Utamaro *Mother and Infant*
Oban, Nishiki-e, 38 × 25.5 cm
Publisher: Mori-ya Jihei. Date: c. late 1790's. Tokyo
National Museum

A mother feeding an infant. The infant has his head
shaved all over except for the back, as seen in the
mirror.

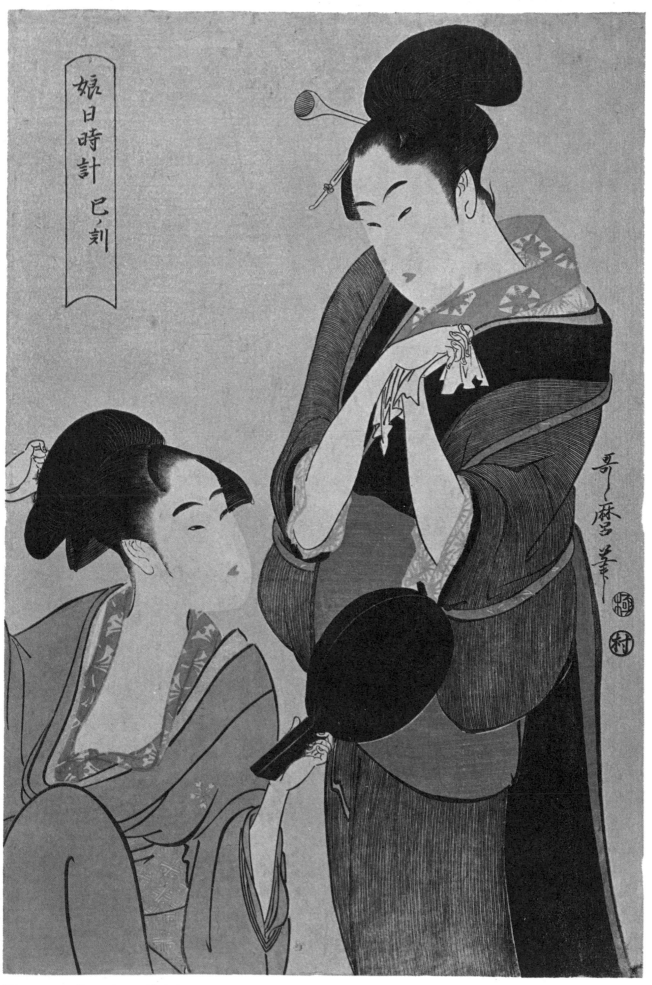

Utamaro *Beauties at Hairdressing,* from the series
Sundial of Girls (Musume Hidokei)
Oban, Nishiki-e, 38 × 25.1 cm
Publisher: Murata-ya Jirobei. Date: c. mid 1790's
Tokyo National Museum

From a series depicting various female countenances
at various times of the day. A girl engaged in make-up
and another in hairdressing.

199

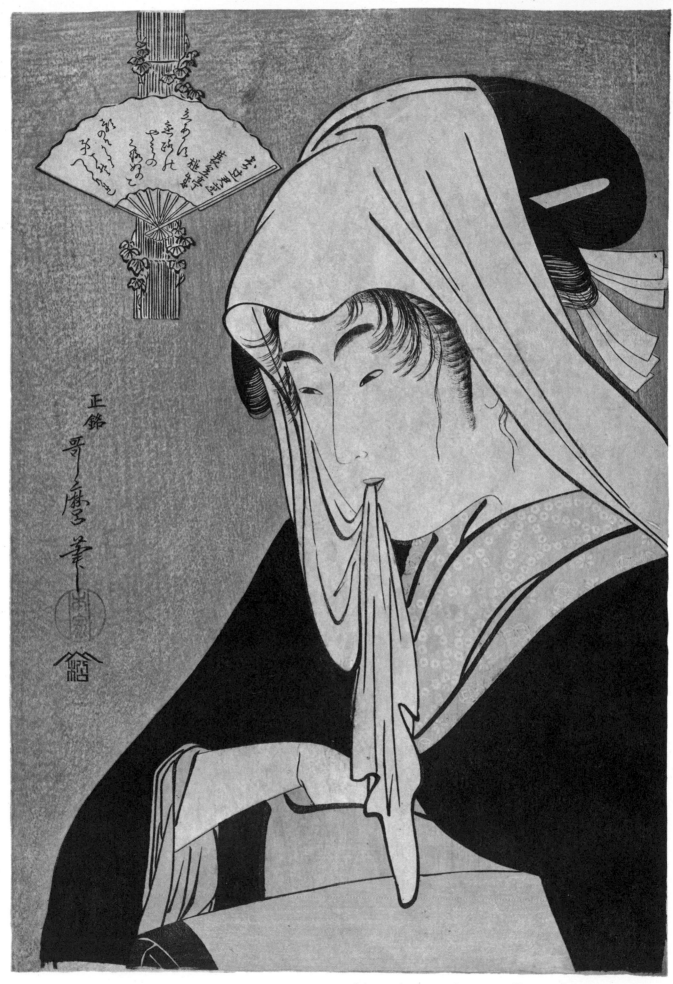

Utamaro *A Streetwalker*
Oban, Nishiki-e, 38.7 × 26.4 cm
Publisher: Matsumura Yahei. Date: c. late 1790's
Tokyo National Museum

A low-class prostitute standing on the street corner at night. Utamaro's signature, ''Genuinely Utamaro's'', proudly indicates this to be his own work.

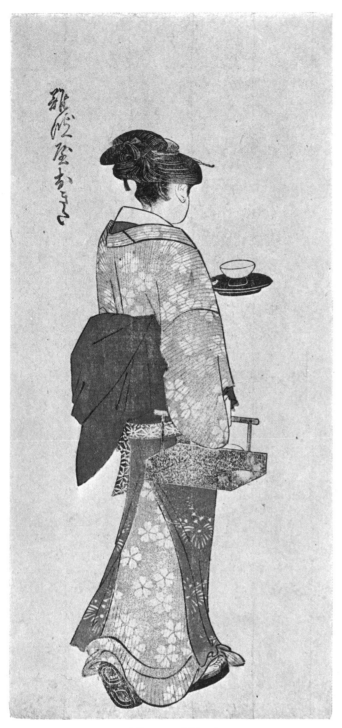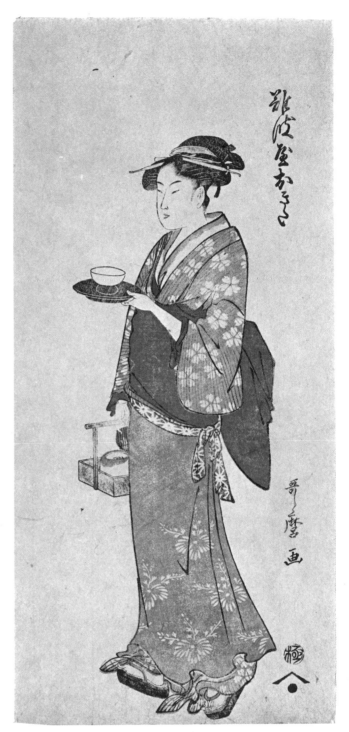

Utamaro *Okita of Tea-stall Naniwaya*
Hosoban, Nishiki-e, paired prints (on both sides of a
paper), 33.2×15.2 cm
Publisher: unknown. Date: c. early 1790's

A popular beauty of Edo with a tobacco tray in her
right hand and a cup in her left. The same character is
depicted on both the front and the back side of the
same paper.

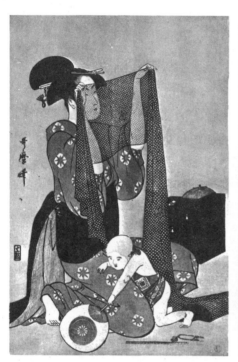 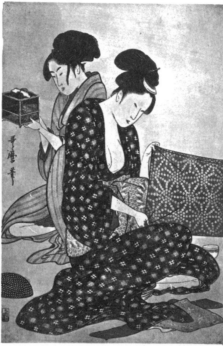 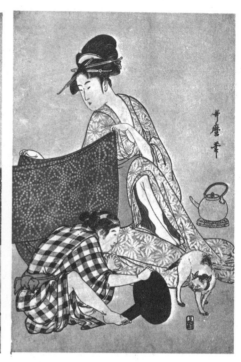

Utamaro *Women Making Dresses*
Oban, Nishiki-e, Triptych: left: 38.6 × 25.4 cm
centre: 38.1 × 25.5 cm, right: 38.2 × 25.3 cm
Publisher: Uemura Yohei. Date: c. mid 1790's. Tokyo
National Museum

Housewives and daughters of tradesmen-class
making dresses. A child is seen teasing a cat with a
mirror.

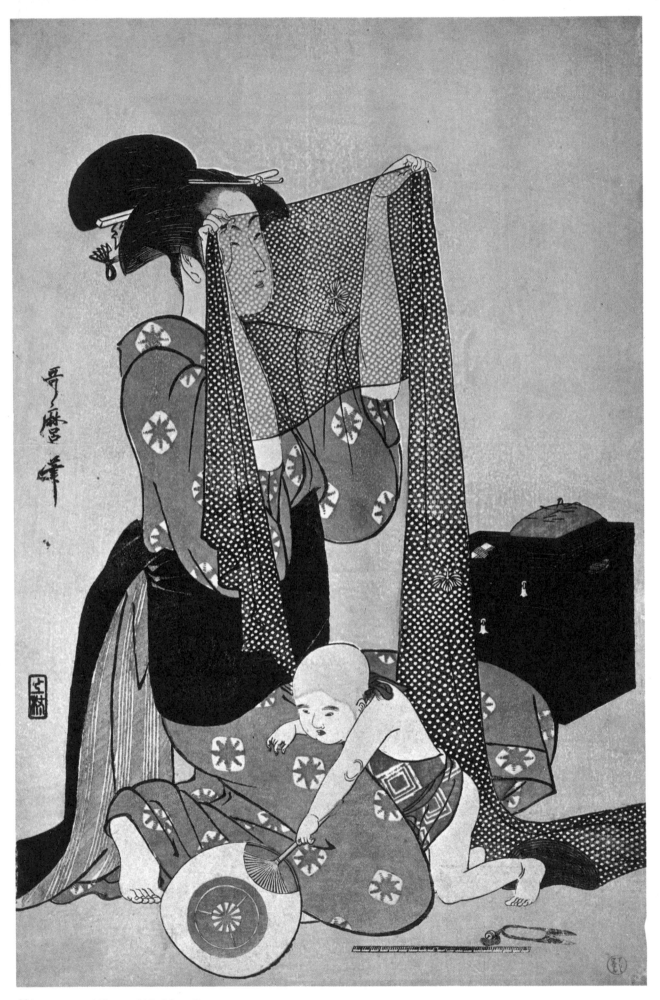

Utamaro *Women Making Dresses*
Left panel of the triptych.

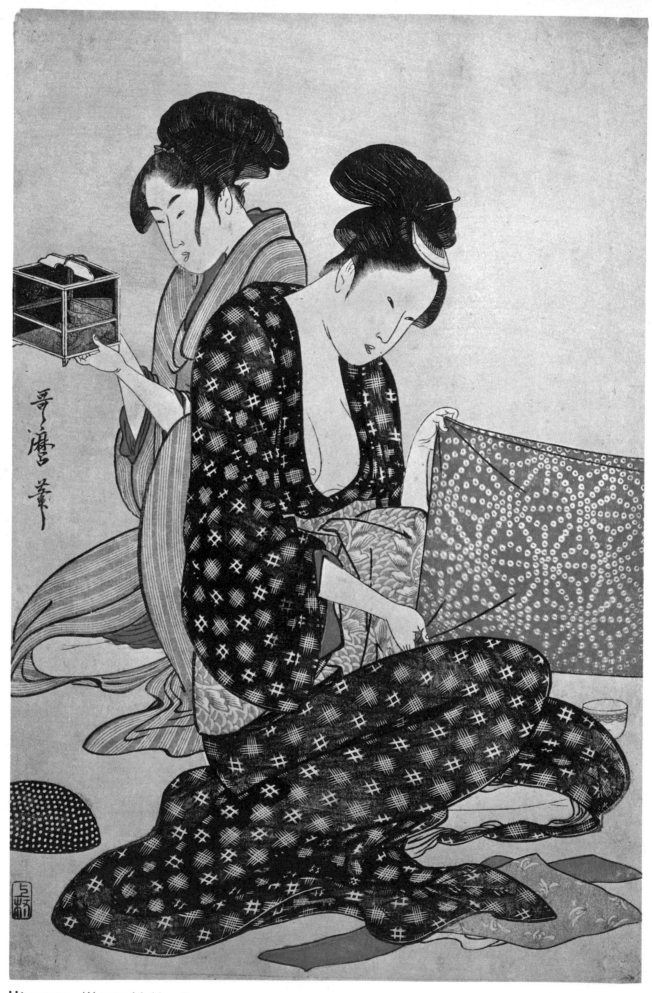

Utamaro *Women Making Dresses*
Central panel of the triptych.

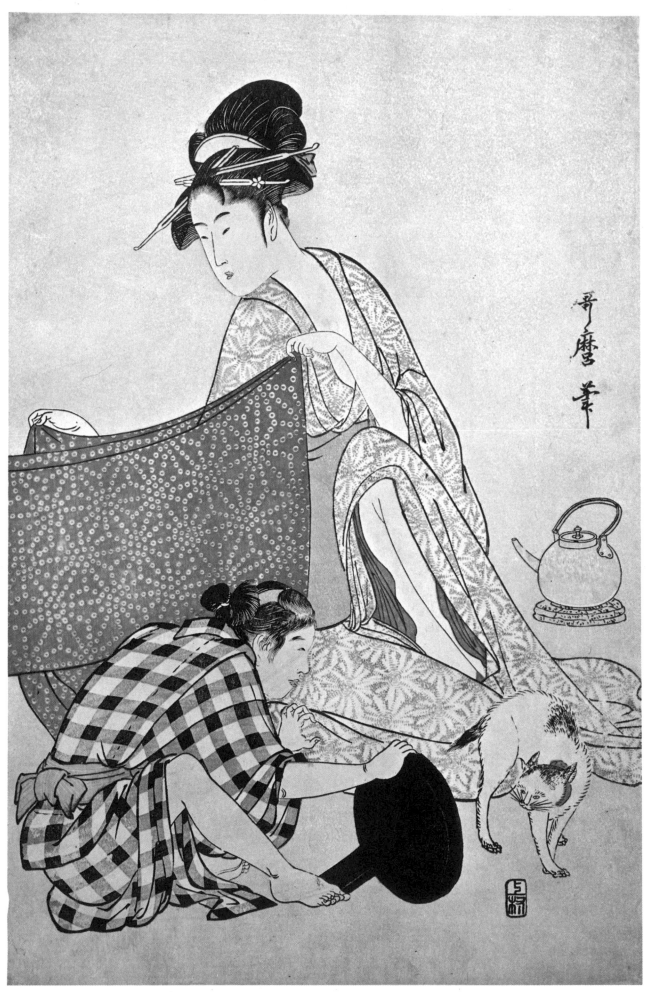

Utamaro *Women Making Dresses*
Right panel of the triptych.

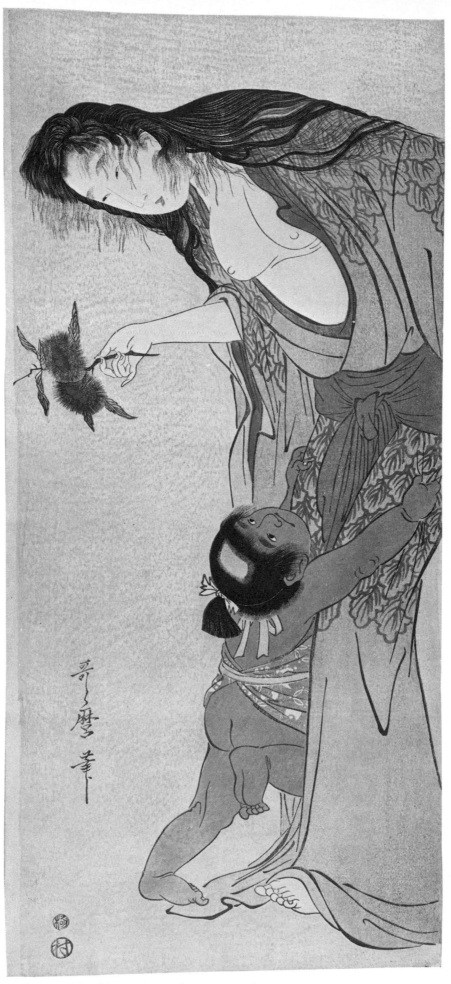

Utamaro *Chestnut*, from a series *Yamauba and Kintaro*
Long oban, Nishiki-e, 52.1 × 23.7 cm
Publisher: Marata -ya Jirobei. Date: c. late 1790's
Riccar Art Museum, Japan

A legendary *Yamauba* (a woman of the mountain) is depicted raising Kintaro, who will later become a legendary hero.

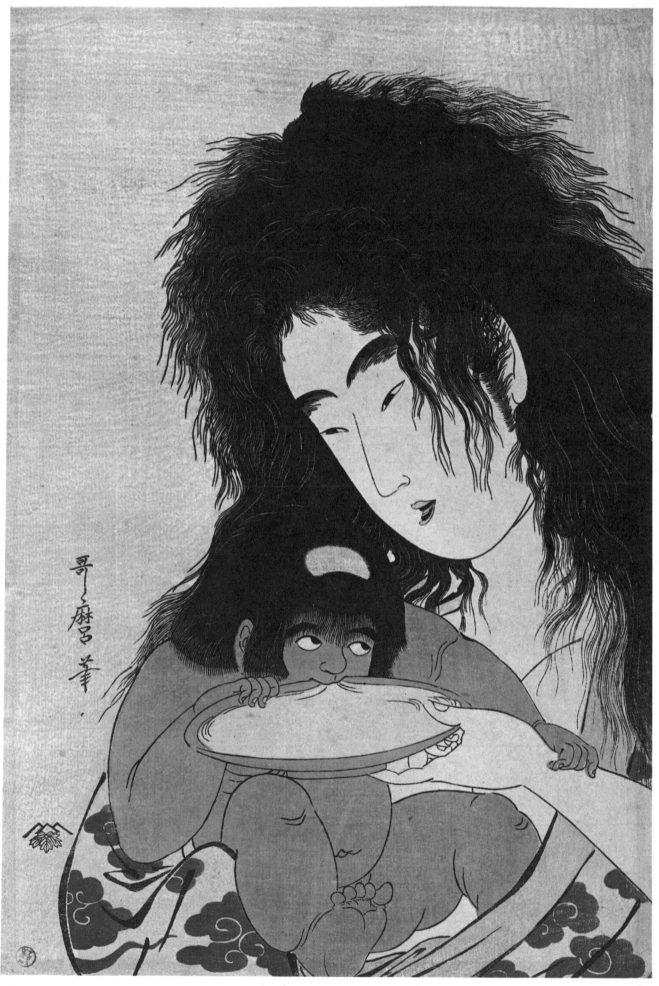

Utamaro *Sake Cup,* from the series *Yamauba and*
Kintaro
Oban, Nishiki-e, 38.3×25.5 cm
Publisher: Tsuta-ya Juzaburo. Date: c. late 1790's
Tokyo National Museum

Kintaro drinking *sake.*

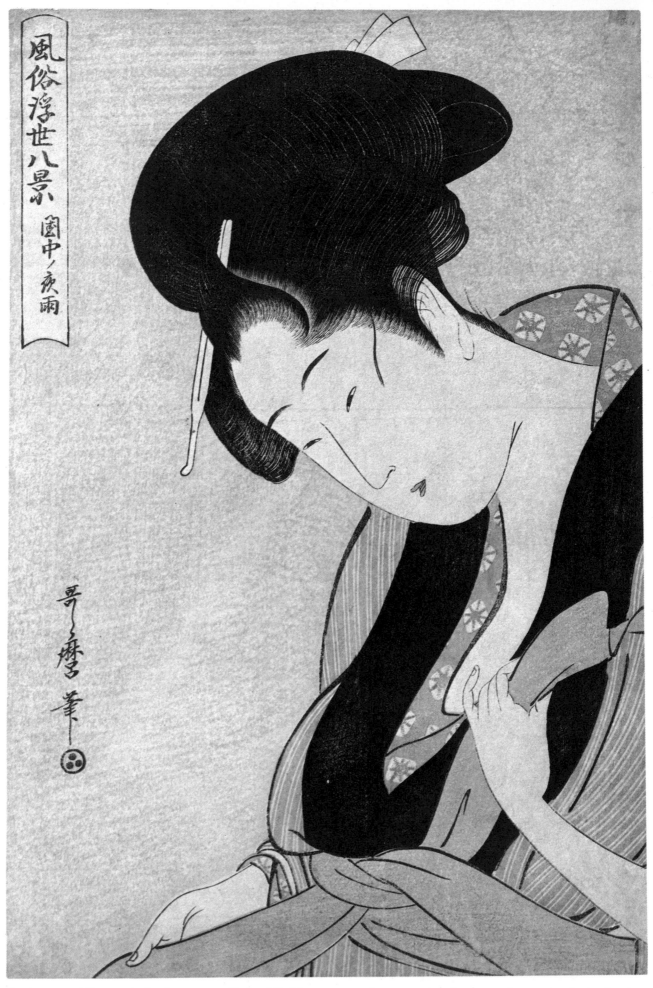

Utamaro *Woman in Bedroom on a Rainy Night,*
from the series *The Eight Genre Scenes from Transient
World (Fuzoku Ukiyo Hakkei)*
Oban, Nishiki-e, 38.2 × 25 cm
Publisher: Ise-ya Sanjiro. Date: c. mid 1790's

A woman in a bedroom is seen re-fastening her
loosened *obi* (belt).

208

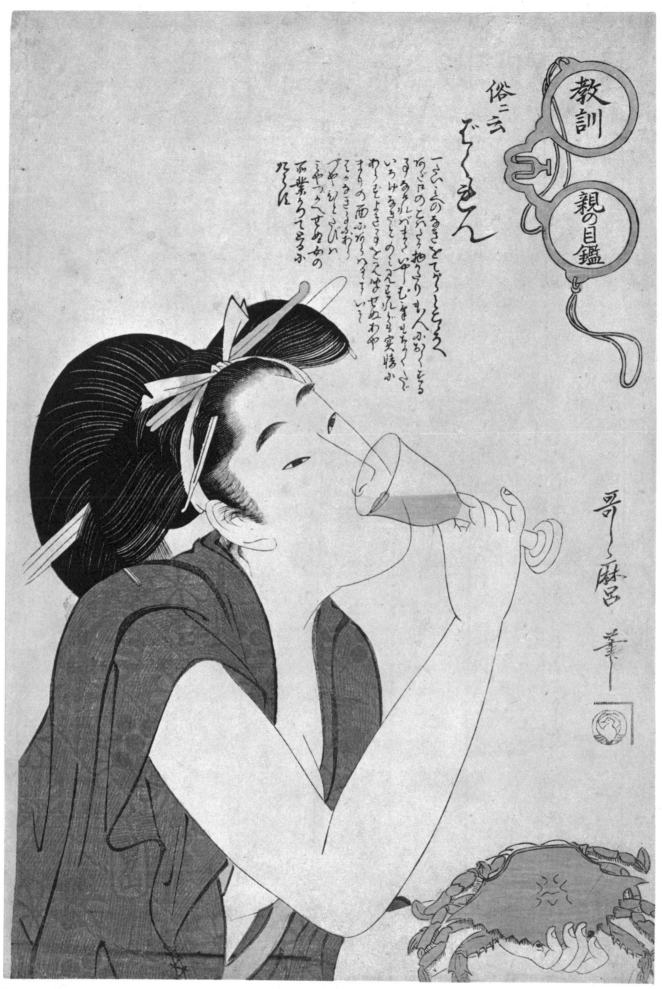

俗ニ云
どくをん

Utamaro *The Hussy,* from the series *Through the Parents' Moralizing Spectacles (Kyokun Oya no Mekagami)*
Oban, Nishiki-e, 38.4 × 25.6 cm
Publisher: Tsuru-ya Kinsuke. Date: c. early 1800's
Takahashi Collection, Japan

One of moralizing picture series depicting a woman. A low-class hussy is seen drinking a glass of *sake* with a crab in her left hand.

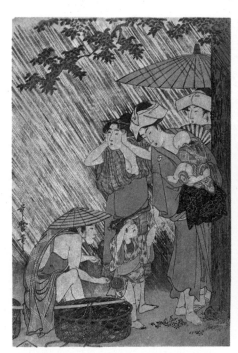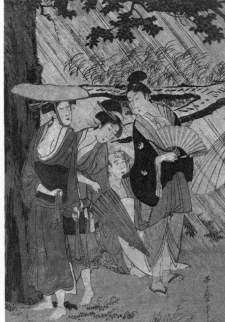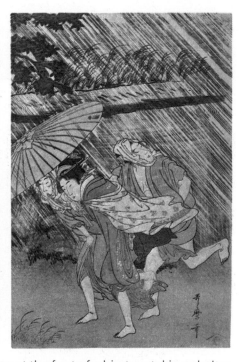

Utamaro *Shower*
Oban, Nishiki-e, Triptych: left: 37.2 × 24.7 cm, centre: 37.2 × 25 cm, right: 37.3 × 24.3 cm
Publisher: Tsuru-ya Kihemon. Date: c. early 1800's.

Men and women at the foot of a big tree taking shelter from the rain. On the left is a vegetable peddler and on the right are lovers rushing to escape the downpour.

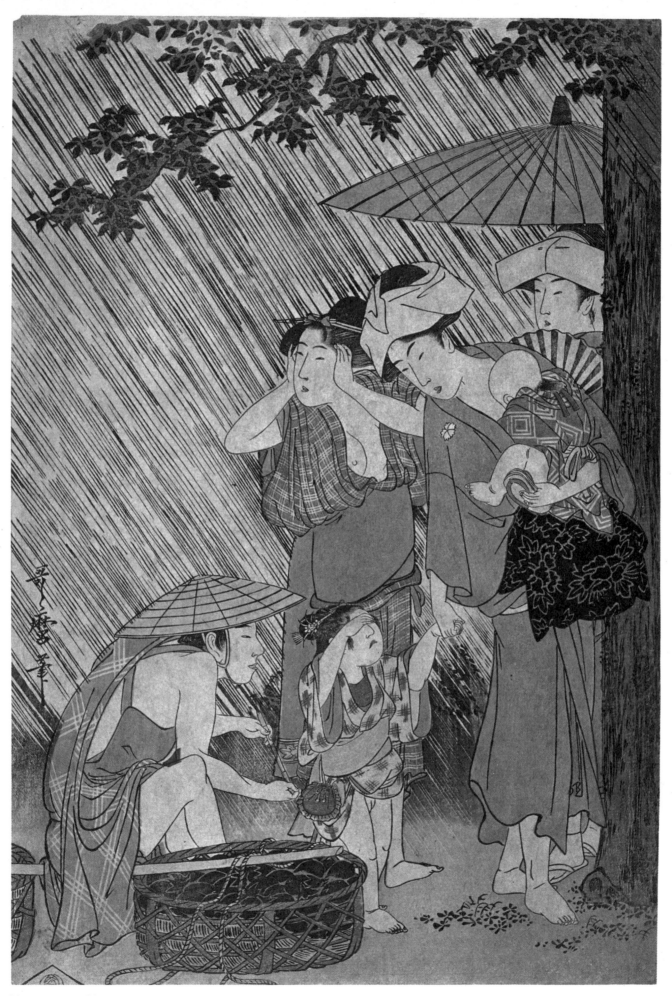

Utamaro *Shower*
Left panel of the triptych.

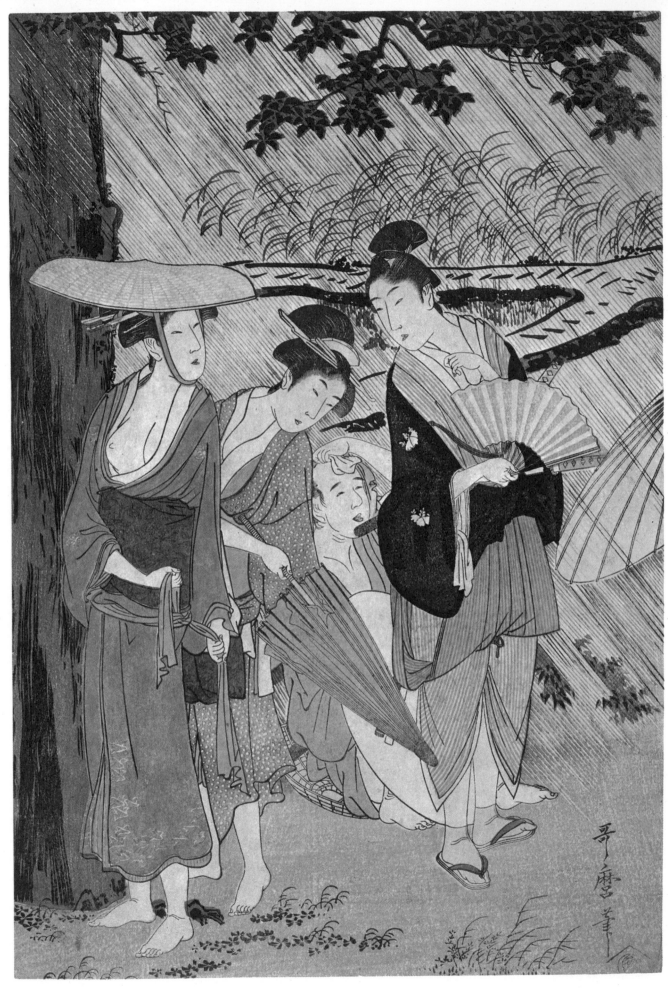

Utamaro *Shower*
Central panel of the triptych.

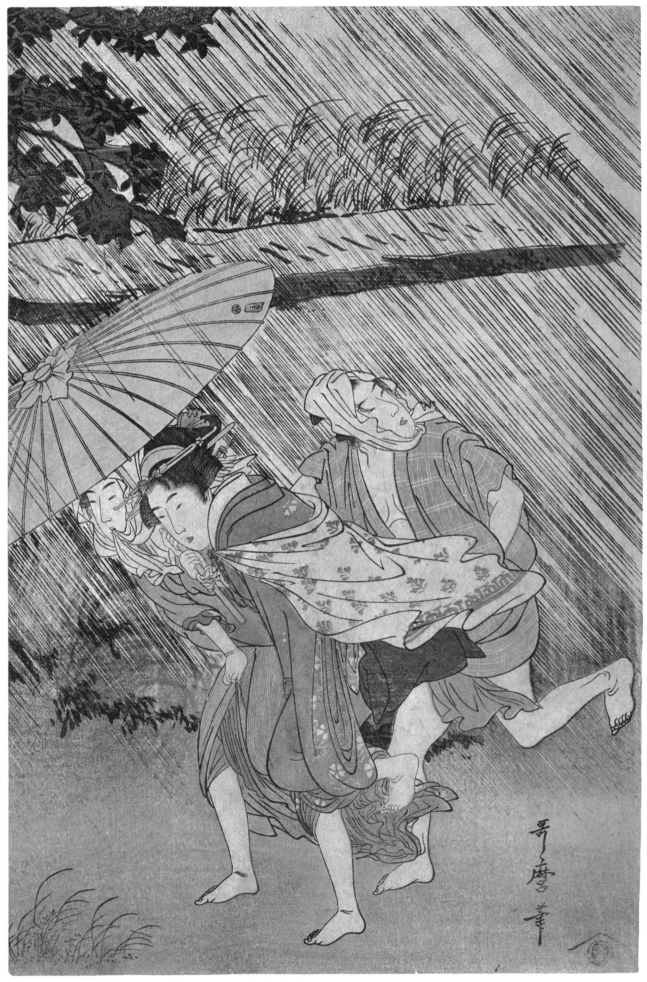

Utamaro *Shower*
Right panel of the triptych.

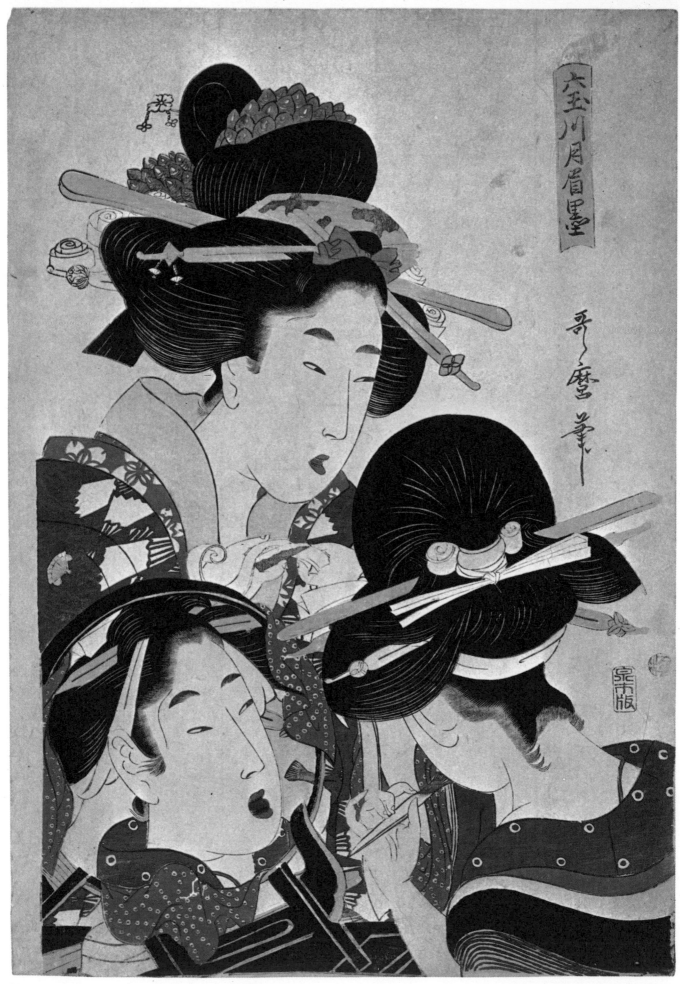

Utamaro II *Make-up,* from the series *Beauties as the Six Crystal Rivers (Mu-Tamagawa Tsuki no Mayuzumi)*
Oban, Nishiki-e, 38 × 26.8 cm
Publisher: Izumi-ya Ichibei. Date: c. late 1800's
Takahashi Collection, Japan

One of a series of six beauties. Women are depicted while making-up. (Dyeing their teeth black.)

214

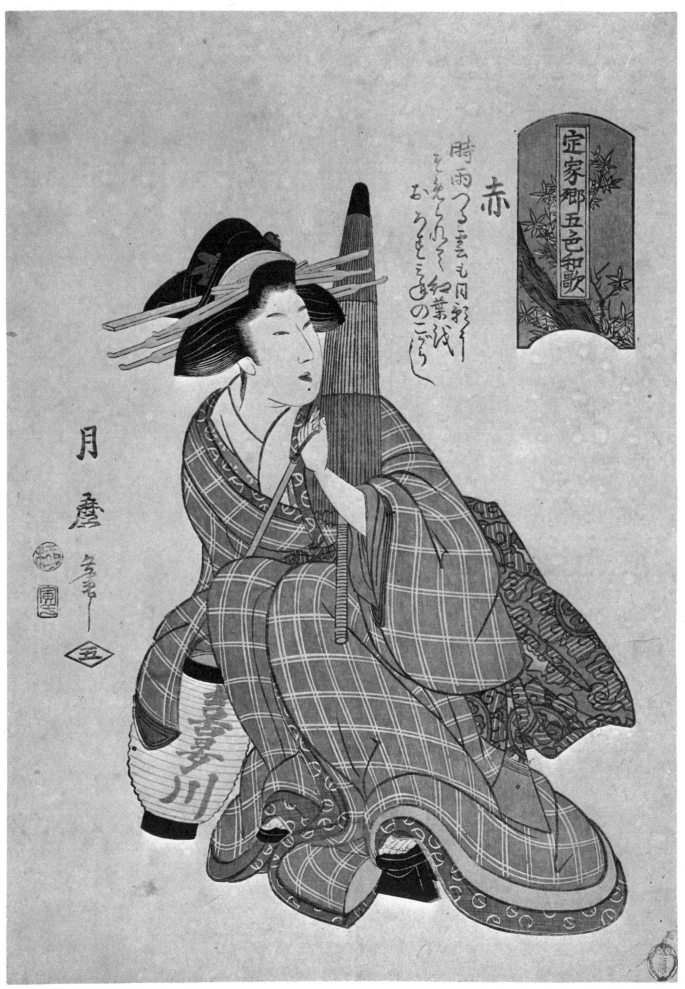

Tsukimaro　*Red*, from the series *Five Colour Poems by Teika (Teika Kyo Goshiki Waka)*
Aiban, Nishiki-e, 32.9 × 22.6 cm
Publisher: unknown. Date: 1806. Riccar Art Museum, Japan

One of the series for five famous poems by Teika, a famous classic poet. The letters on the lantern beside her foot are Tsukimaro's surname.

215

The rivals of Utamaro

The rivals of Utamaro

Ukiyo-e was an art created and enjoyed by the merchants of Edo. They had their own "stars" – courtesans, *Kabuki* actors, and *sumo* wrestlers – and their likenesses were reproduced in *ukiyo-e*. The *chonin*, merchant class, was very free in its appreciation of womanly beauty, while the *samurai*, the ruling class, was rigid and strict. The ethics of the *samurai* were based on Confucianism, which denies the beauty of woman and preaches that men should be ashamed if they were attracted by their charm. Thus it was unthinkable that a man of that rank should enjoy the *ukiyo-e* prints of courtesans or actors, much less produce them. Under these circumstances, the ethics and aesthetics of the Edo period were divided into two contrasting ideologies.

The Edo period was also an age when merchants grew wealthier and consequently more powerful. And as they became more influential, they began to contact and mix with the *samurai* of lower rank. This was the social condition in which *nishiki-e* ("brocade pictures") came into existence. At this time, some *samurai* began to find it more attractive to lead a freer life in the enjoyment of writing or of *ukiyo-e* painting of *bijin* (beauties) and actors.

It was in such circumstances that an ex-*samurai* of ancient lineage and good standing began to create wood-block prints of portraits of courtesans. Chobunsai Eishi (1756–1829) was his name. His grandfather had been the *kanjo-bugyo*, Treasury Minister, in the *Shogun* government (it was also his business to govern the areas which were under direct control of the *Shogun*). He was a statesman of great influence. Eishi transferred the leadership of the family to his successor and resigned his government post on the grounds that he had fallen ill and was not well enough to continue working. One reason may have been the death of the *Shogun* whom he had served. Whatever the reason, he abandoned his *samurai* rank to devote himself to painting. He had studied the traditional painting of the *Kano* school, and began producing *ukiyo-e* even before he resigned his position.

During Eishi's early career, he published a series of *nishiki-e* prints whose themes were literary classics such as *The Tale of Genji*. They were wood-block prints of quiet colours devoid of *beni* (pink), in other words, loud colour, probably in consideration of the rigid policy of the time. The government prohibited any kind of luxury, in contrast to the policy of Tanuma Okitsugu, who had been the most influential member of the *Shogun*'s Council of State and known for his liking of bribes and luxuries.

Presently, Eishi began to produce *ukiyo-e* representing *yujo* (courtesans). They reflect the influence of Kiyonaga, but show a free, easy and original touch. Then came a period of compositions of solitary sitting women. He seems most confident of himself in the depiction of the daily activities of full-bodied women, seen letter-writing or reading books, with backgrounds of brighter tones. The bearing of the women and the few suggestions of furniture also indicate their way of living.

The next period finds works representing standing figures of women (also single figures), but this time without any explanatory backgrounds. The background is in a subdued monotone, which makes the slender figure of the standing woman more conspicuous in contrast.

Eishi then began to represent women taller and taller, and at the last stage the women he depicted were so tall that their heads were only one twelfth of their height (taller even than the women in Kiyonaga's works). It is interesting to note that representation of women in these proportions is also found in the Greek sculptures, and that Eishi had an aesthetic sense like the ancient Greeks but independent of them. This aethetic sense influenced Utamaro in his later years. Conversely, Utamaro's influence on Eishi is shown in the latter's few *okubi-e*.

Eishi almost stopped his production of wood-block prints in his last years, to devote himself to brush-painting of courtesans.

His works are generally characterized by his elegant, aristocratic touch and have unique atmosphere among the great works in the golden age of *ukiyo-e*.

Eishi is also known as a mentor of many artists – Eisho, Eiri, Eisui, and Eishin, to name a few. They were active mainly during the 1790's. Every one of them created excellent series of *okubi-e*, showing the good sense of their master Eishi. It is also notable that Eiri illustrated realistic portraits of Santo Kyoden, a celebrated author of the day, and other people. However, records of the lives of these artists are scarce.

Eishosai Choki (active c. 1780–early 1800's)

Contemporary with Eishi was a unique master, Eishosai Choki. He studied under Toriyama Sekien, the teacher of Utamaro. He excelled in the combination of colours, composition, and expression of atmosphere. Although some of his *bijin-ga* have monotone backgrounds like Eishi's, in most cases he paid greater attention to more realistic backgrounds, as in his depiction of falling snow in *A Girl with Umbrella and a Servant*.

His life is disputable: some say he signed "Shiko" in one period and "Choki" in another; some argue that "Shiko" and "Choki" are two different artists.

Tamagawa Shucho (active c. 1780–1800)

Tamagawa Shucho's life is even more obscure than Choki's. Some scholars classify him as a member of the Utamaro school, and others as a pupil of Buncho. His works are few, and they seem to suggest the influence of Utamaro's later prints, rather than a style developed from Buncho.

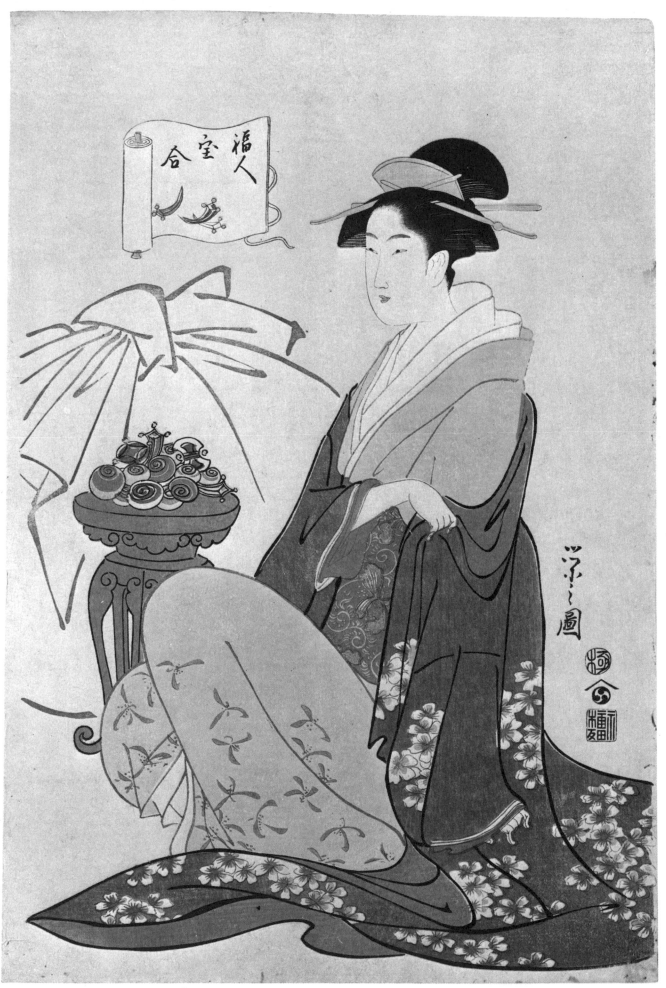

Eishi *Daikoku*, from the series *Selected Treasures of Good Fortune (Fukujin Takara Awase)*
Oban, Nishiki-e, 38.4 × 25.7 cm
Publisher: Nishimura-ya Yohachi. Date: c. late 1780's
The Art Institute of Chicago

One of the series in which courtesans are likened to the Seven Deities of Good Fortune. On the side table are sweets made in the shapes of treasures. She is sitting in the way contemporary courtesans used to, with one knee raised.

219

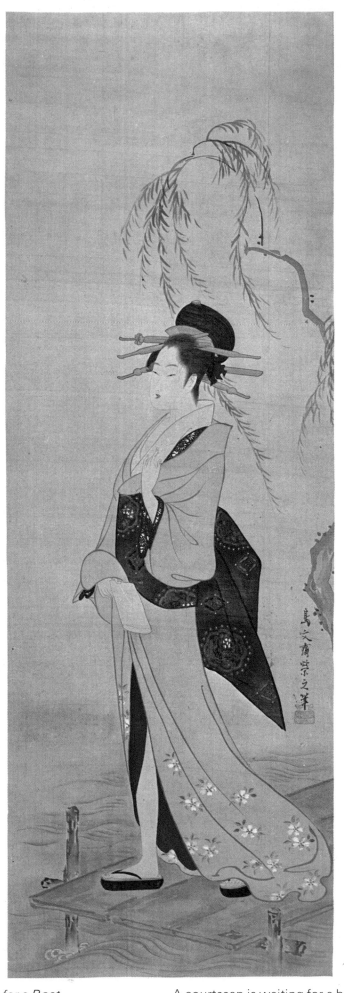

Eishi *Beauty Waiting for a Boat*
Painting on silk, 84.7 × 28.4 cm
Date: c. 1790's. Takahashi Collection, Japan

A courtesan is waiting for a boat at the ferry. A willow is in the background.

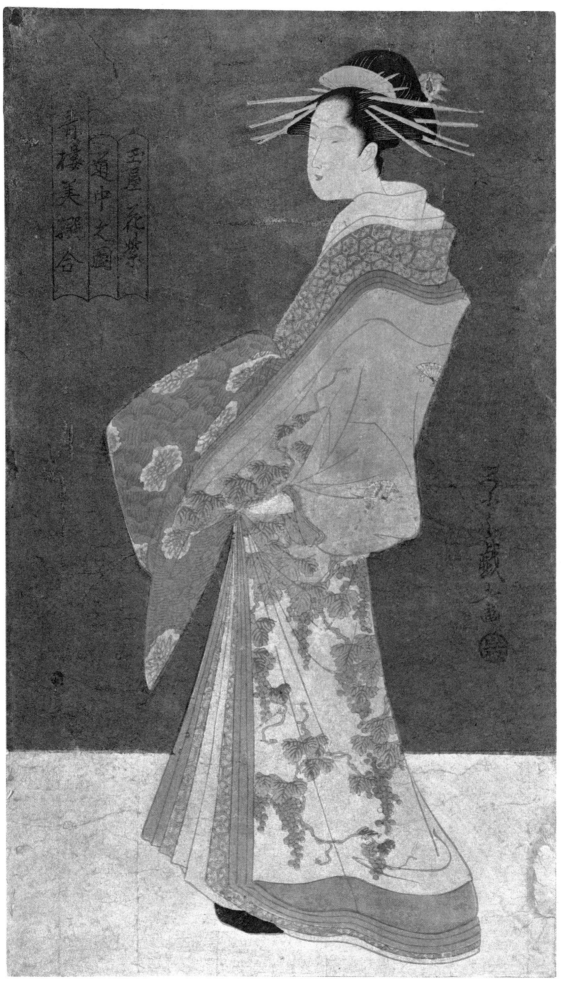

Eishi *The Courtesan Hanamurasaki of Tama-ya,* from the series *Beauties in the Gay Quarters (Seiro-bi Erabi Awase)*
Oban, Nishiki-e, 37.8 × 21.6 cm
Publisher: Iwato-ya Kisaburo. Date: c. mid 1790's
The Art Institute of Chicago

One of the series in which celebrated courtesans of the day are depicted. A courtesan in promenade.

221

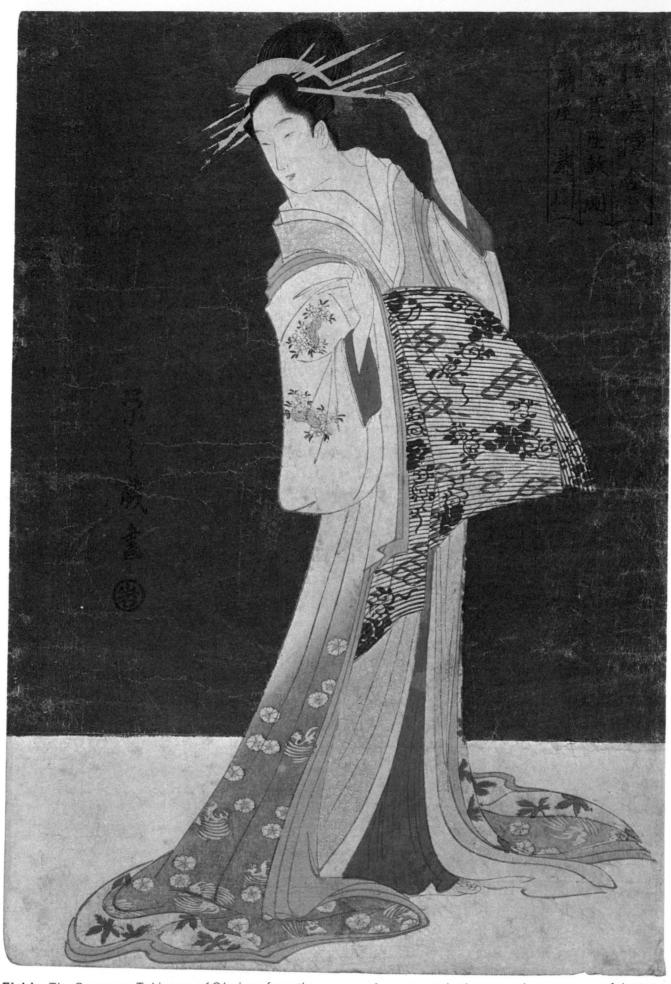

Eishi *The Courtesan Takigawa of Ohgi-ya*, from the
series *Selected Beauties in the Gay Quarters (Seiro-bi
Erabi Awase)*

Oban, Nishiki-e, 36.3 × 24.9 cm
Publisher: Iwato-ya Kisaburo. Date: c. mid 1790's
Tokyo National Museum, Japan

A courtesan in the entertainment room of the tea-
house.

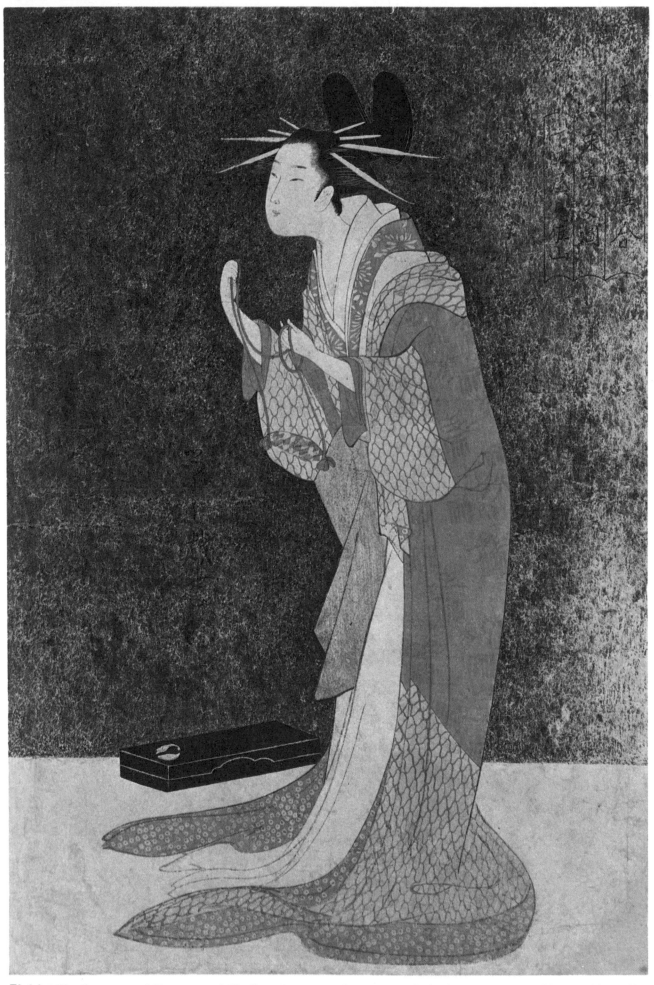

Eishi *The Courtesan Misayama of Choji-ya*, from the series *Selected Beauties in the Gay Quarters (Seiro-bi Erabi Awase)*
Oban, Nishiki-e, 37.7 × 25 cm
Publisher: Iwato-ya Kisaburo. Date: c. mid 1790's
Honolulu Academy of Arts

A courtesan in bedroom garment. She is taking off a scent bag.

223

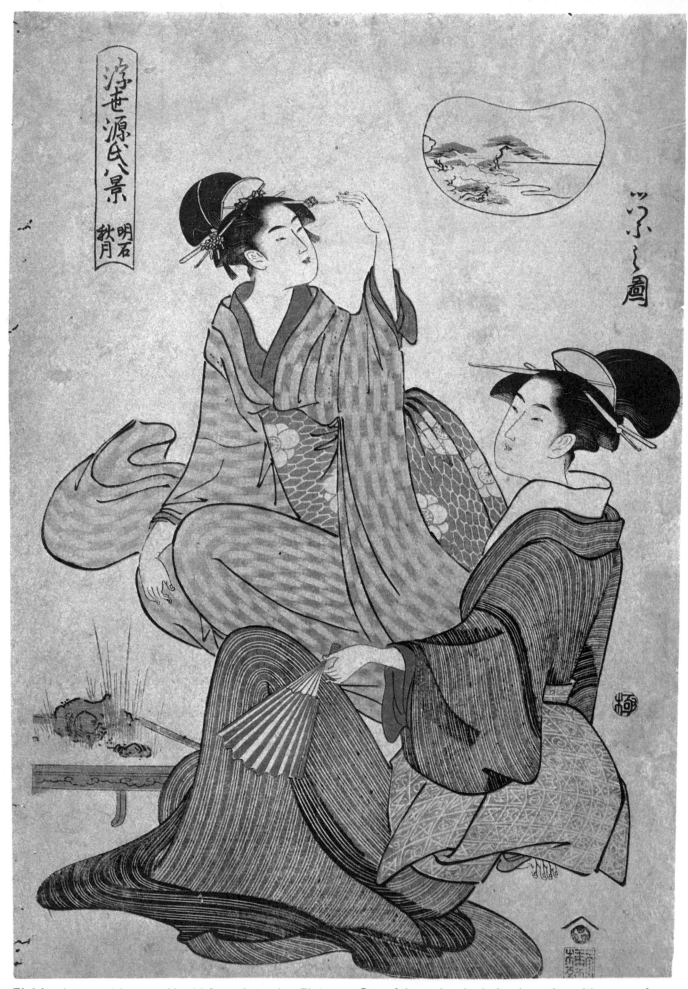

Eishi *Autumn Moon at Akashi,* from the series *Eight Celebrated Sceneries and Beauties (Ukiyo Genji Hakkei)*

Oban, Nishiki-e, 36.7 × 24.8 cm
Publisher: Nishimura-ya Yohachi. Date: c. 1790's

One of the series depicting beauties with scenes from *The Tale of Genji*. The scene at the top is the beach at Akashi. The woman in the foreground holds a *sensu* (folding fan) in one hand.

224

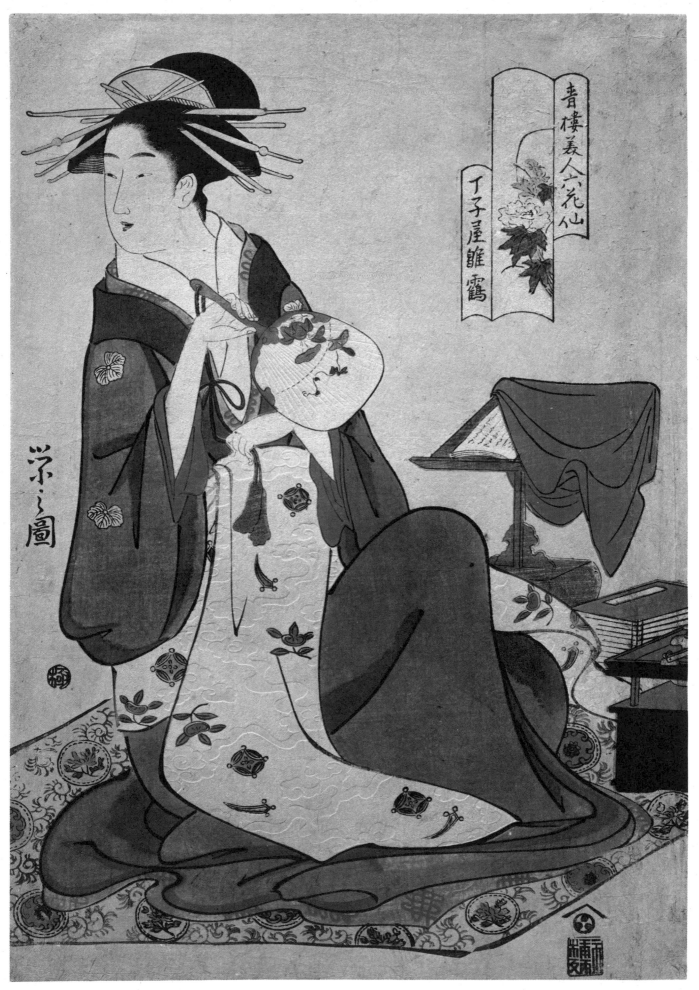

青樓美人六花仙

丁子屋雛鶴

Eishi *The Courtesan Hinazuru of Choji-ya*, from the series *Six Beautiful Flowers of the Gay Quarters (Seiro Bijin Rokkasen)*
Oban, Nishiki-e, 35.2 × 24.5 cm
Publisher: Nishimura-ya Yohachi. Date: c. mid 1790's
The Metropolitan Museum of Art, New York

One of the series in which six courtesans of the Yoshiwara gay quarters are depicted. She has a *uchiwa* (fan) in one hand. On the right are some books and a reading stand.

225

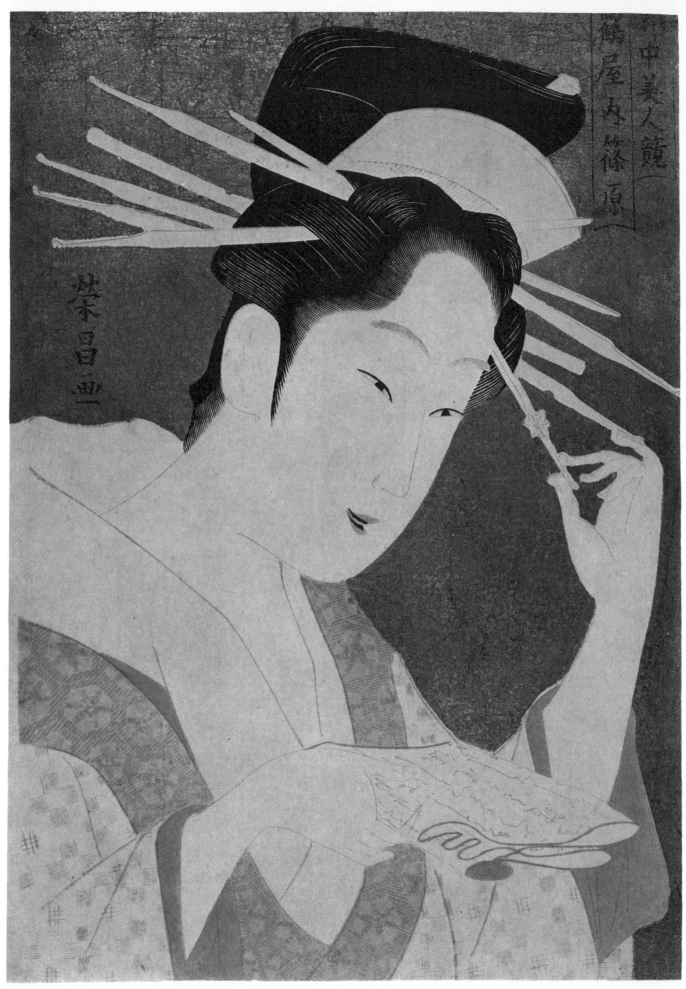

Eisho *The Courtesan Shinohara of Tsuru-ya*, from
the series *Contest of Beauties of the Gay Quarters
(Kakuchu Bijin Kurabe)*

Oban, Nishiki-e, 37.5 × 26.1 cm
Publisher: Yamaguchi-ya Chusuke. Date: c. mid
1790's

A series of courtesans in the Yoshiwara gay quarters.
A courtesan reading a billet-doux.

226

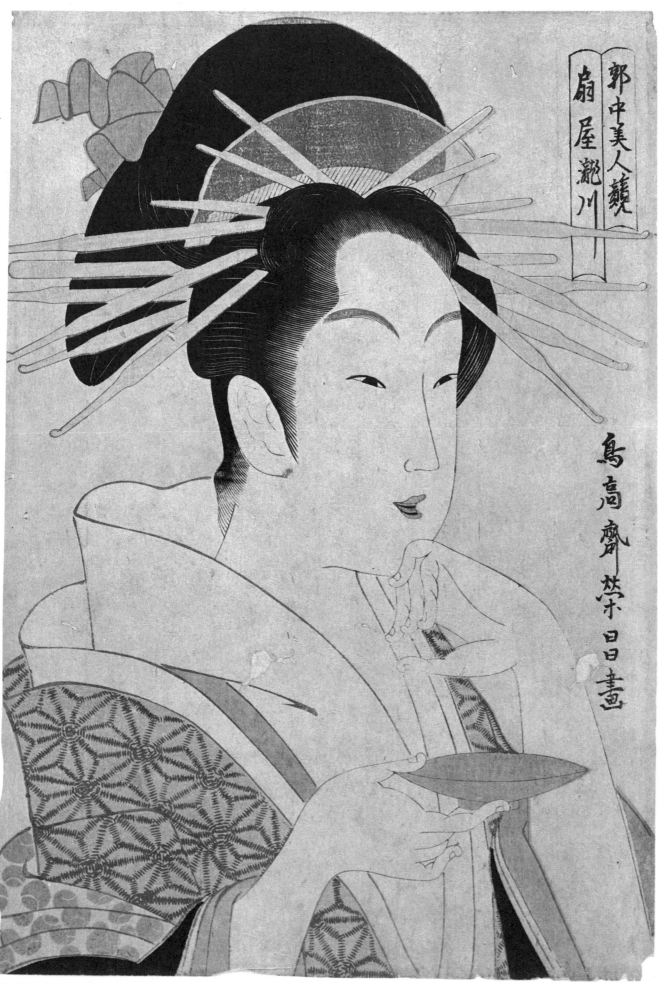

郭中美人競

扇屋瀧川

鳥高齋榮昌日日畫

Eisho *The Courtesan Takigawa of Ogi-ya*, from the series *Contest of Beauties of the Gay Quarters (Kakuchu Bijin Kurabe)*
Oban, Nishiki-e, 38.1 × 25.5 cm
Publisher: Yamaguchi-ya Chusuke. Date: c. mid 1790's. Tokyo National Museum

A courtesan with a *sake* cup in her hand; feeling tipsy. The pattern of her *kimono* is *asanoha* (hemp-leaf).

227

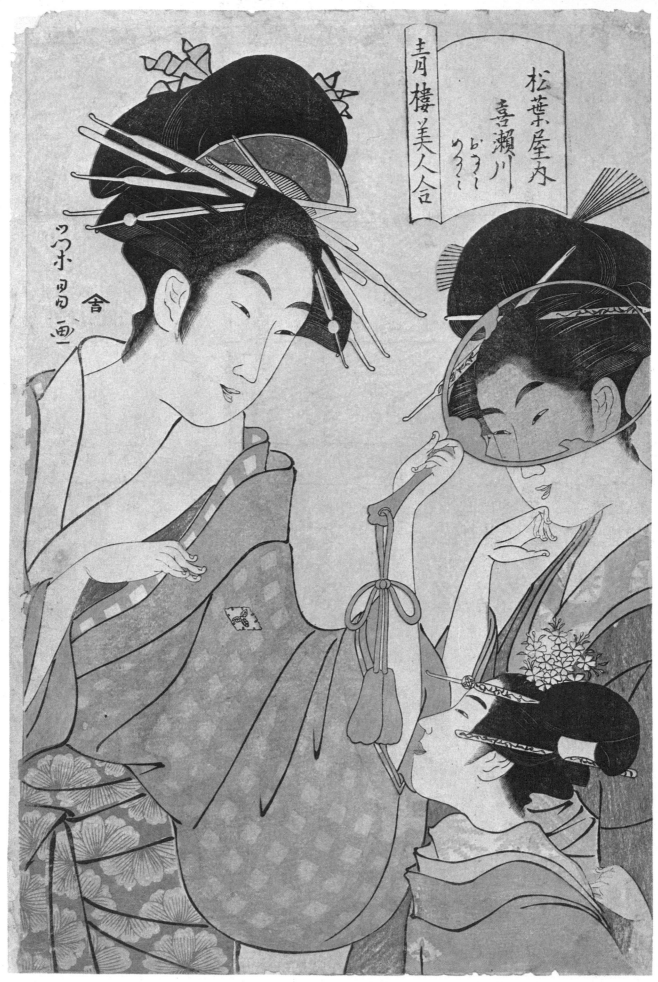

松葉屋内
喜瀬川
おもしろく
青楼美人合

Eisho *The Courtesan Kisegawa of Matsuba-ya,* from the series *Selected Beauties of the Gay Quarters (Seiro Bijin Awase)*
Oban, Nishiki-e, 38.9 × 25.7 cm
Publisher: Izutsu-ya Shokichi. Date: c. mid 1790's
The Art Institute of Chicago

Beautiful courtesans. Kisegawa holds in her hand a fan of *ro* (transparent silk), through which the other woman's expression is seen.

228

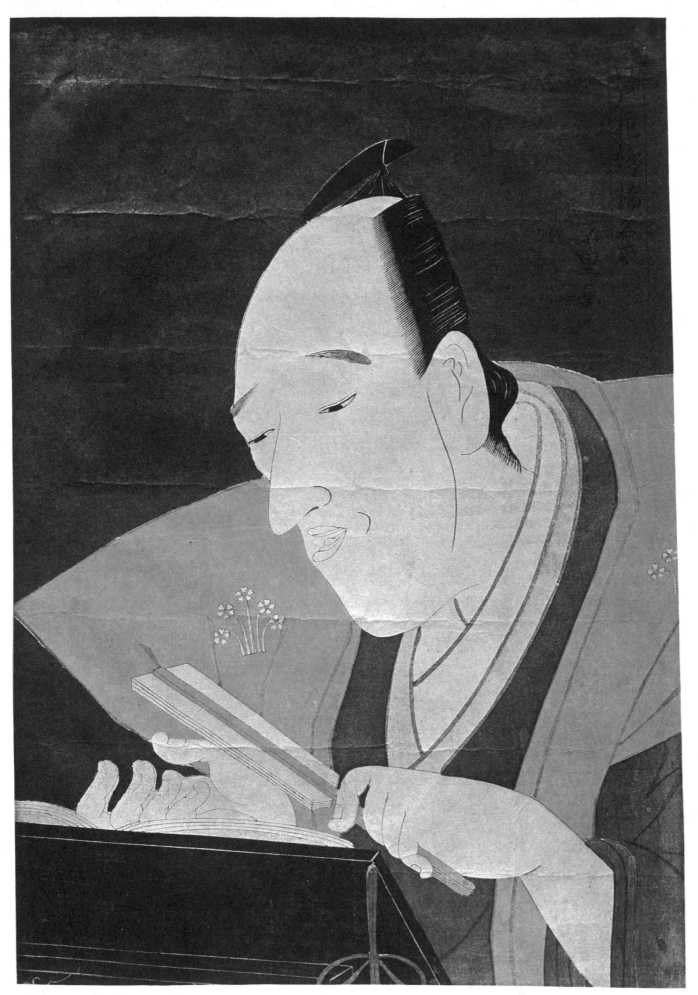

Eiri *Tomimoto Buzen-dayu*
Oban, Nishiki-e, 37 × 25 cm
Publisher: unknown. Date: c. late 1790's. Theodor
Scheiwe Collection, Germany

A portrait of a master singer of Tomimoto-bushi, a
school of Joruri. In the foreground is a score-stand.
He beats out the rhythm with the folded fan in his
hand.

229

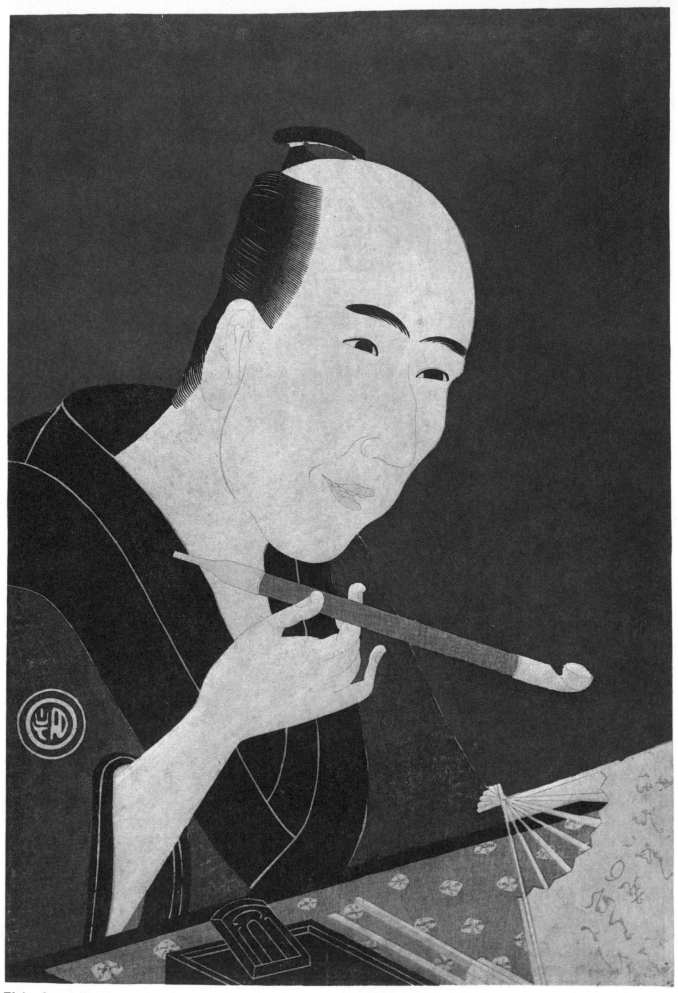

Eiri *Santo Kyoden*
Oban, Nishiki-e, 37.2 × 25.1 cm
Publisher: unknown. Date: c. late 1790's. Tokyo
National Museum

230

A portrait of Santo Kyoden, a popular writer and
ukiyo-e artist whose art-name was Masanobu
(1761–1816). In the foreground are *suzuri*, *sumi* and
some *sensu* (an ink slab, an ink stick and fans). He is
taking a rest, smoking as he writes down *kyo-ka*
(humourous, thirty-one syllable poems).

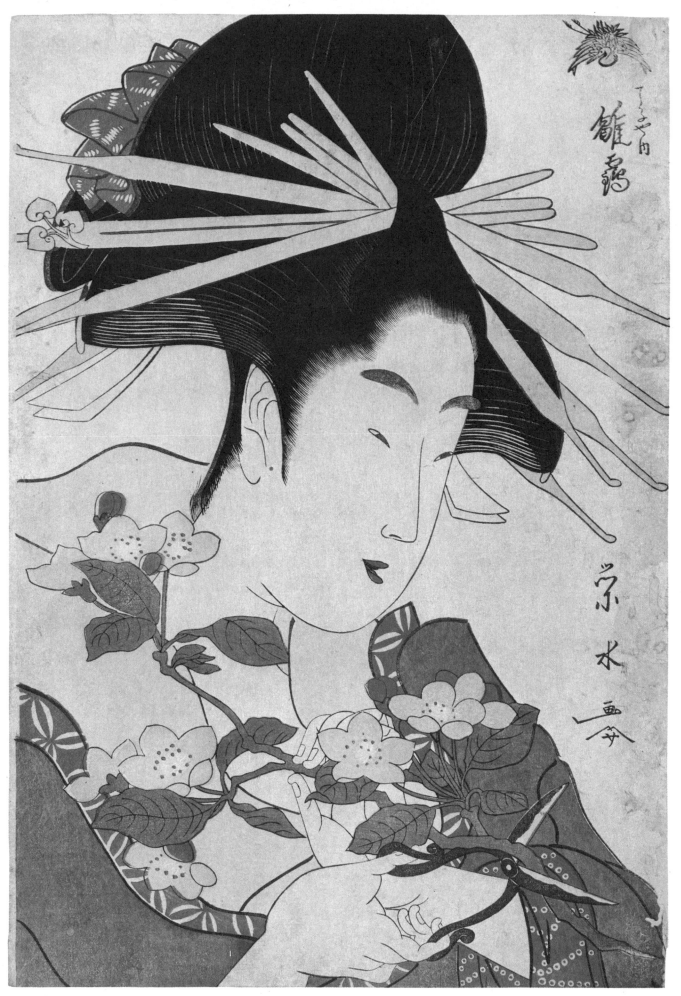

Eisui *The Courtesan Hinazuru of Choji-ya*
Oban, Nishiki-e, 37.3 × 25.2 cm
Publisher: Matsumoto Sahei. Date: c. late 1790's. The
Art Institute of Chicago

A Yoshiwara courtesan arranging flowers.

231

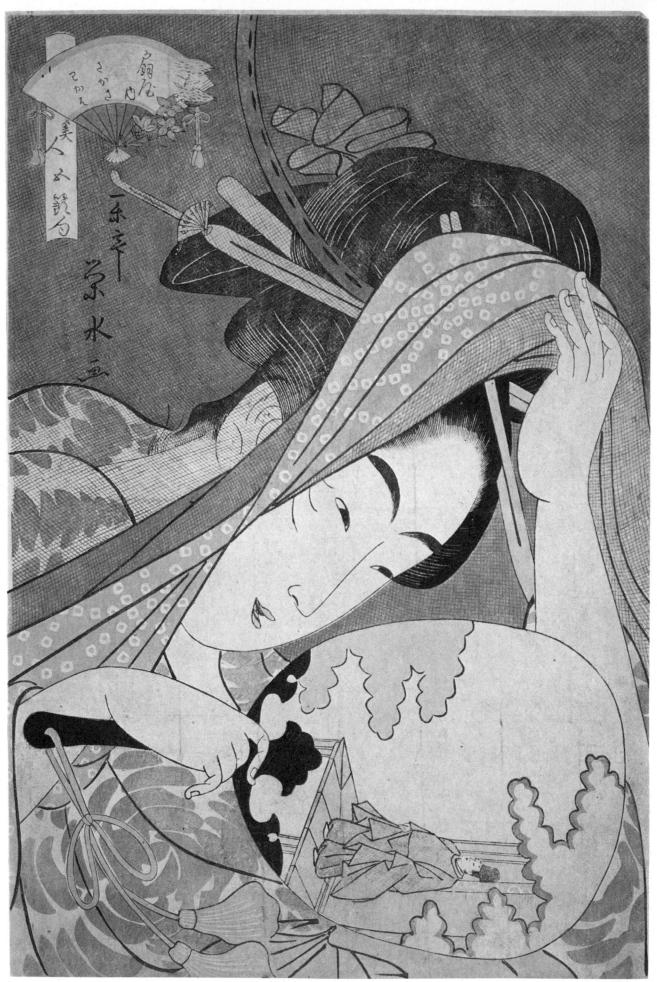

Eisui *The Courtesan Takigawa of Ogi-ya*, from the
series *Beauties in Five Festivals (Bijin Go-sekku)*
Oban, Nishiki-e, 38.4 × 25.3 cm
Publisher: unknown. Date: c. late 1790's. Kanagawa
Prefectural Museum, Japan

232

A series of courtesans in Yoshiwara. A courtesan
holding a mosquito net over her head. On the fan is a
picture from ancient times from *The Tale of Genji*.

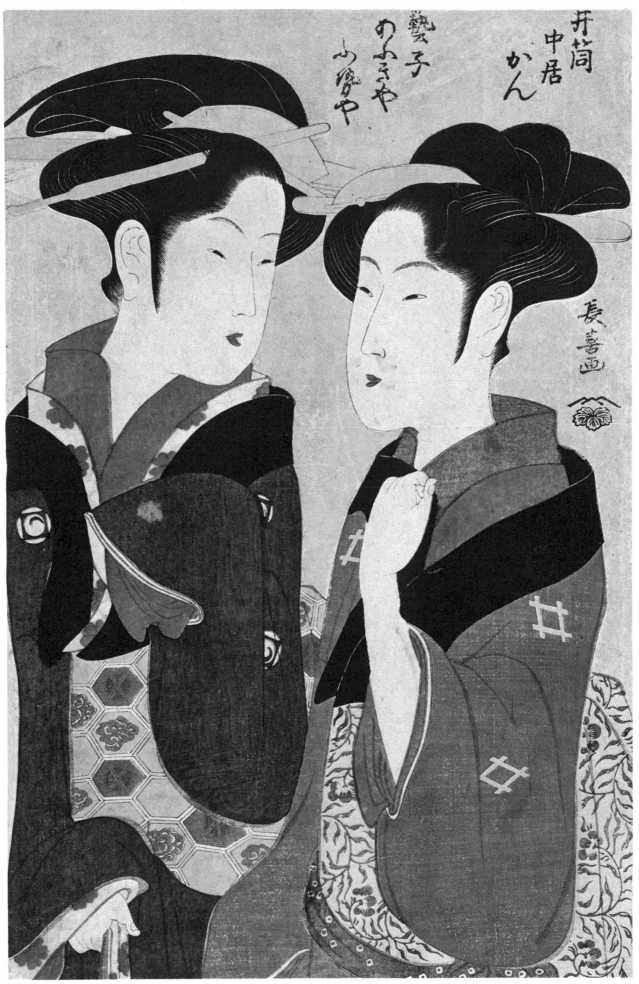

筆筒 中居 かん

藝子 のふきや 小坂や

長善画

Choki *The Maidservant Kan of Izutsu-ya and Junior Courtesan Fuseya of Auki-ya*
Oban, Nishiki-e, 36.7 × 23.7 cm
Publisher: Tsuta-ya Juzaburo. Date: c. mid 1790's
Tokyo National Museum

Women of the gay quarters in Osaka, not in Edo. It is very rare that Osaka women are depicted in *ukiyo-e* published in Edo.

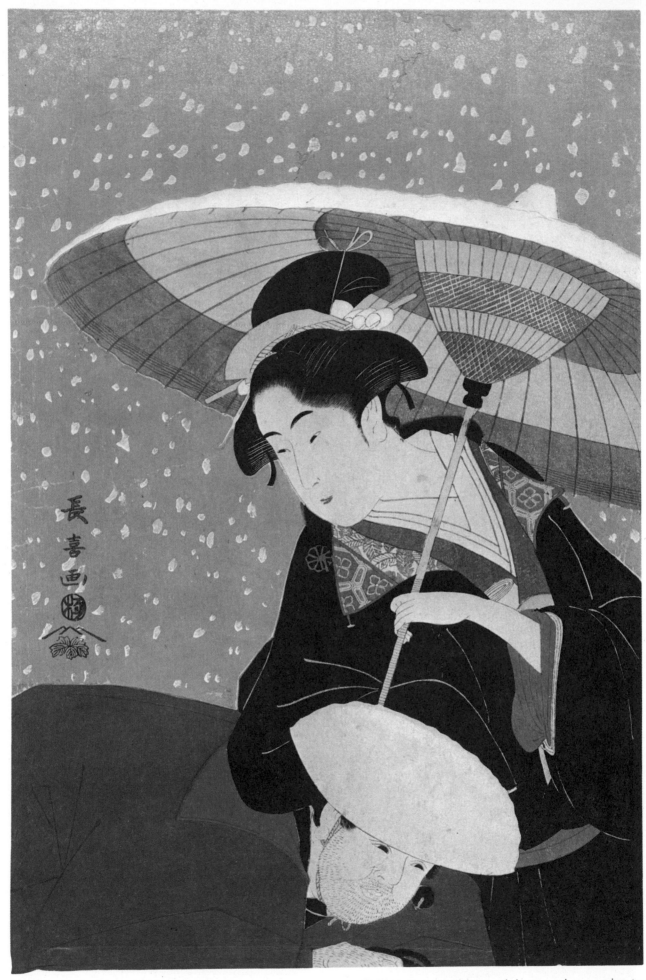

Choki *Girl with an Umbrella and a Servant*
Oban, Nishiki-e, 37.2 × 24.5 cm
Publisher: Tsuta-ya Juzaburo. Date: c. mid 1790's
Tokyo National Museum

Falling snow: whitewash is spread over mica to represent snow. The servant wears a straw hat.

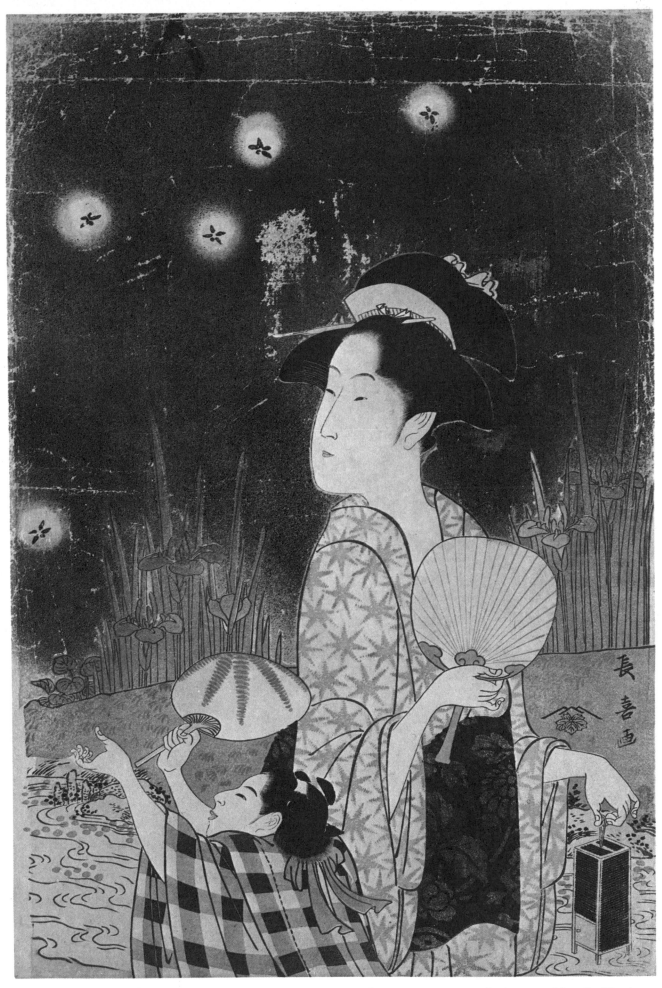

Choki *Firefly Hunting*
Oban, Nishiki-e, 38.3×25.7 cm
Publisher: Tsuta-ya Juzaburo. Date: c. mid 1790's

A young woman and a boy catching fireflies by a pond. The woman holds a fan and a lantern.

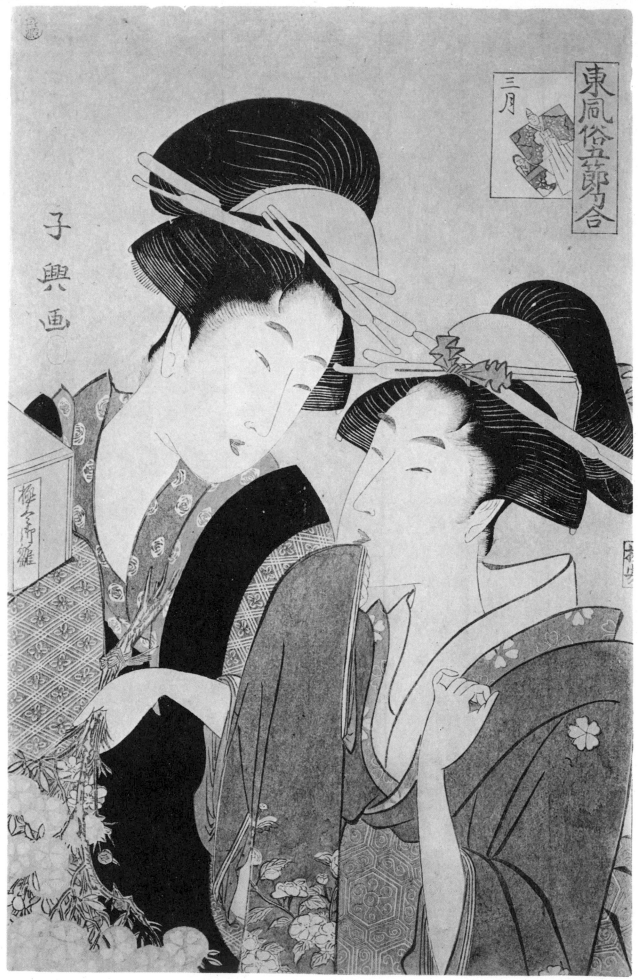

Shiko (Choki ?) *March*, from the series *Edo Women in Five Festivals (Azuma Fuzoku Go-sekku Awase)*

236 Oban, Nishiki-e, 38 × 24.6 cm
Publisher: Matsu-yasu. Date: c. early 1800's
Kanagawa Prefectural Museum, Japan

A series of Five Festivals. On the left there is a box containing dolls for the festival: the third of March is a festival for which girls decorate whole sets of dolls. The woman on the left has flowers to be placed in front of the dolls.

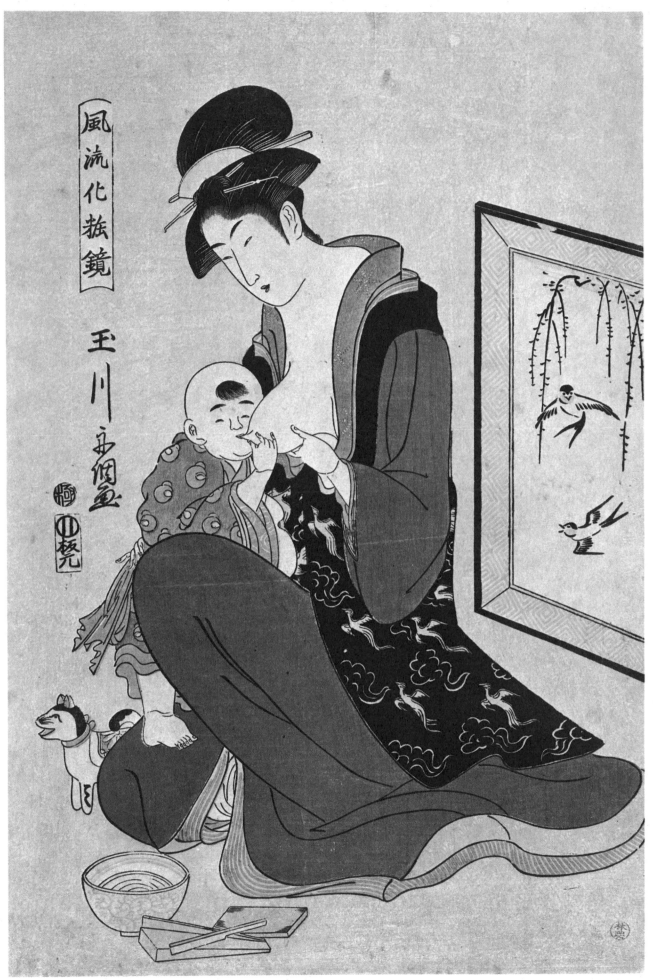

Shucho *A Woman giving the Breast*, from the series
Fashionable Toilets (Furyu Kesho Kagami)
Oban, Nishiki-e, 37.9 × 24.8 cm
Publisher: Ezaki-ya Kichibei. Date: c. early 1800's
Tokyo National Museum

A woman is giving the breast to her son. In the
foreground is a shaving set – a razor, a hone, and a
bowl of water. On the screen on the right are depicted
swallows and a willow.

237

The enigmatic genius

The enigmatic genius

Sharaku made a sudden rise from obscurity, was active as a print designer for a mere ten months, and then vanished from the art world as suddenly as he had appeared – just like a blazing comet. With his unique works and mysterious life, Sharaku is particularly impressive among *ukiyo-e* artists.

In May 1794, Sharaku made his artistic debut with 28 sheets of *okubi-e* (large head-pictures or close-up portraits) of *Kabuki* actors.

They were published by Tsuta-ya Juzaburo, who had introduced Utamaro to the world. Tsuta-ya, who had previously astounded the world with the publication of Utamaro's *okubi-e* of beauties, commissioned the unknown artist Sharaku to produce *okubi-e* of actors and published them in gorgeous prints in *kirazuri* or mica-printing (a method of printing to obtain the effect of silver colour by the application of mica powder to the background). These impressionistic depictions by Sharaku of actors, which exaggerated their facial expressions on stage, created a sensation, gaining both favourable and unfavourable reactions. The hopes of Tsuta-ya were fulfilled.

Four months earlier a rival publisher, Izumi-ya Ichibei, had begun the publication of a series of actor portraits by a rising *ukiyo-e* artist Utagawa Toyokuni (see next chapter). This series was popular but not as shocking as the publication of Sharaku's actor portraits. The two publishers and the two artists were to enter into hot competition with one another.

Some information should be given here about the conditions under which these actor portraits were published.

Tsuta-ya had been punished by the government: his publications had been suspended and half his property confiscated. To overcome this blow, he planned to publish actor portraits and selected for this purpose a totally unknown artist, Sharaku. Further, at that time the three major licensed theatres of Edo were being closed because of debts and the rigid enforcement of regulations, and small theatres were giving performances instead. It was a somewhat sluggish and dull period.

In such a situation, Sharaku's bold, individual close-up portraits of actors must have been refreshing for the public. There were *okubi-e* of actors published before Sharaku, of course, but their expression was milder, as is seen in the works of Shunko. The publication of works by an unknown artist in gorgeous prints and their powerful expression took people by surprise.

The portraits were also unusual in that they treated not only star actors but second-rank ones as well. They were extravagant *kirazuri* portraits, but the number of colours used in them was as limited as possible, probably reflecting the trend of the times. For example, *The Actor Ichikawa Komazo II as Shiga Daishichi* is a print in an extremely small number of colours, but shows Sharaku's strong desire to depict the actor's role and the on-stage atmosphere.

In the second period of his activity, however, Sharaku produced no *okubi-e* but rather full-length portraits of one or two persons. In the third period, his prints were *hosoban* (narrow-size) or *aiban* (medium-size). He also produced some pictures of *sumo* wrestlers. But the power of his brush declined sharply, no longer showing his initial keen zest. This rapid deterioration might have been caused by the worsening of the publishing situation (declining sales, financial problems of the publisher, etc.) or the ill-health of the artist, but this also must remain a mystery.

In this way Sharaku produced over 140 works in only ten months and then suddenly disappeared. The evaluation of his works has been fluctuating for a long time, except for a recognition of their uniqueness. They were then revaluated by European students like Julius Kurth.

Various theories as to the identity of Sharaku have been advanced by scholars. One version says that he was not a professional illustrator but a *No* actor. Another says that Sharaku was the false name of some famous artist like Hokusai. These theories arise from the fact that Sharaku, unlike ordinary *ukiyo-e* artists, appeared suddenly as a master artist with no works of the usual apprentice period when various pictures, including book illustrations, actor portraits, and pictures of beauties would be expected. There are no traces of influence from other artists either.

Most of the *ukiyo-e* artists, who were originally town artists, left only their works behind, and their careers and lives are often unclear. Why Sharaku, who was just one such, should be of such particular interest is that he produced so much unique work and that his active period was extremely short.

After the disappearance of Sharaku, the publisher Tsuta-ya introduced several artists of talent to the world, and died two years later without disclosing anything definite about Sharaku.

There was another figure who attracted public attention temporarily because his works were similar to those of Sharaku and who remained unidentified for a long time. He was called Kabukido Enkyo (1749–1803), and is now identified as Nakamura Jusuke II, a dramatist. Known today are his seven works produced in 1796. He imitated the art of Sharaku, but his works are not as vigorous and expressive as those of Sharaku.

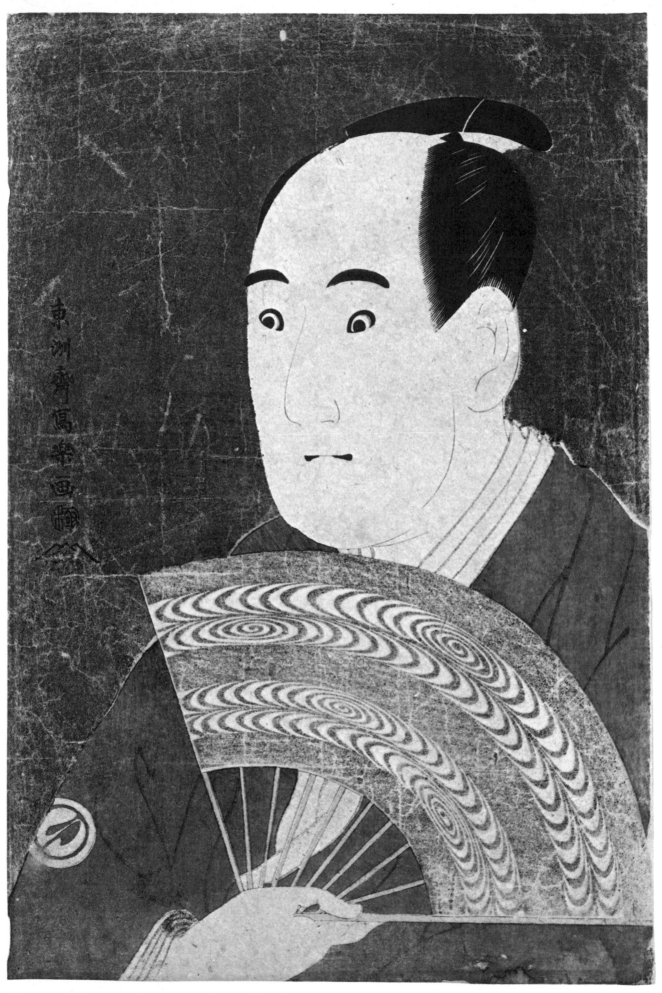

Sharaku *The Actor Sawamura Sojuro III as Ogishi Kurando*
Oban, Nishiki-e, 37.8 × 25.1 cm
Publisher: Tsuta-ya Juzaburo. Date: 1794. Honolulu
Academy of Arts

The actor playing a righteous man who is discreet and knows right from wrong. The pattern on his fan is of stylized waves.

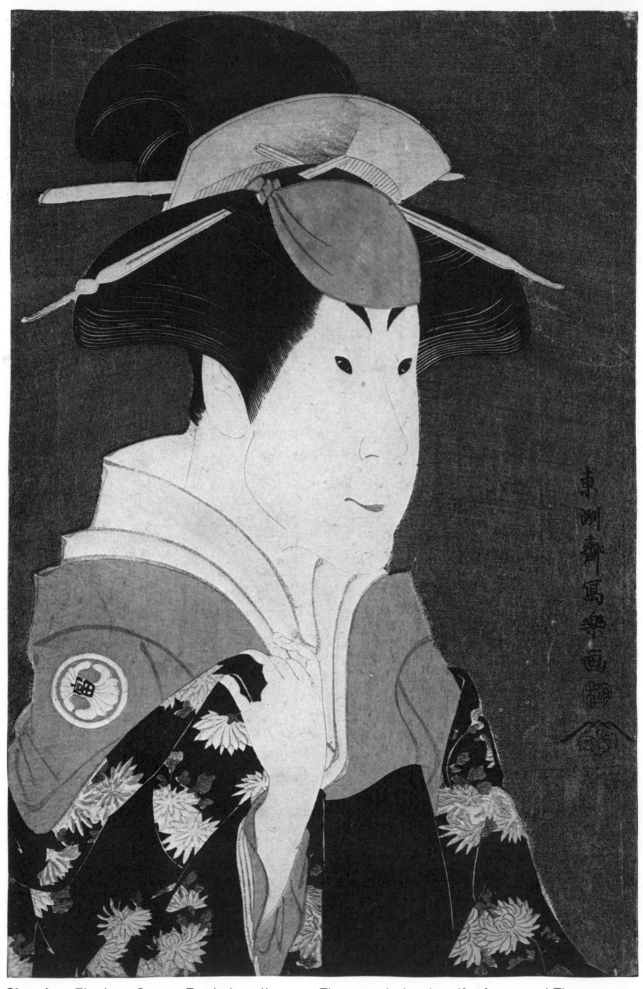

Sharaku *The Actor Segawa Tomisaburo II as Yadorigi, Wife of Ogishi Kurando*
Oban, Nishiki-e, 36.7 × 23.7 cm
Publisher: Tsuta-ya Juzaburo. Date: 1794. Musées
Royaux d'Art et d'Histoire, Brussels

The actor playing the wife of a *samurai*. The pattern on the *kimono* is of chrysanthemums.

242

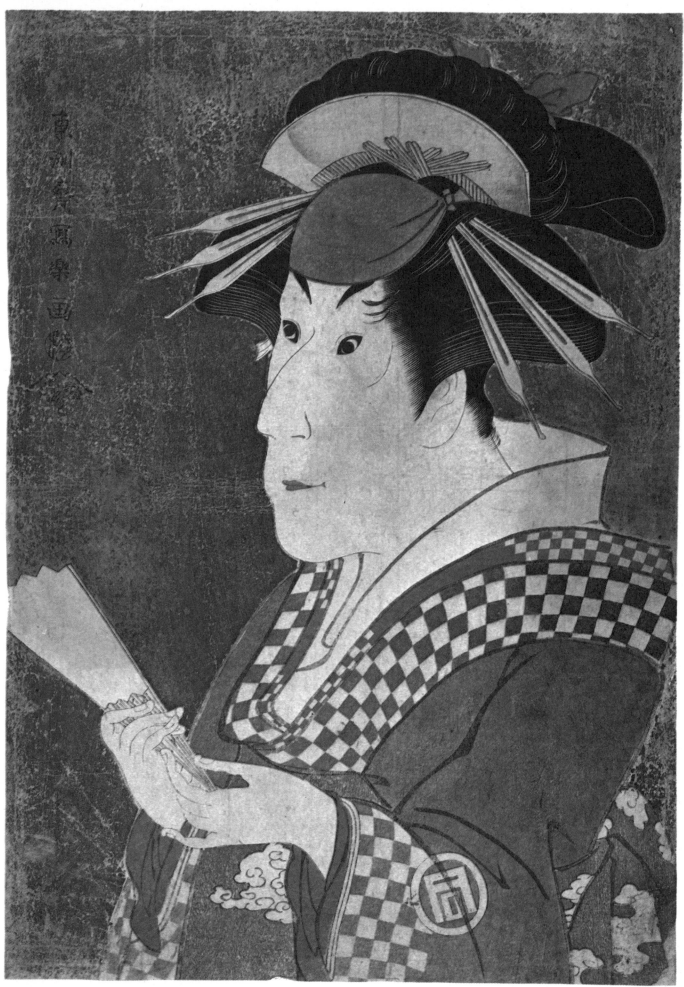

Sharaku *The Actor Sanogawa Ichimatsu III as Onayo, a Courtesan of Gion-machi*
Oban, Nishiki-e, 35.9 × 24.8 cm
Publisher: Tsuta-ya Juzaburo. Date: 1794. Tokyo National Museum

The actor playing a courtesan. The cloth below the ornamental comb worn on the hair was to cover the shaved forelock of the male actor specializing in female roles, because real women did not shave their forelocks.

243

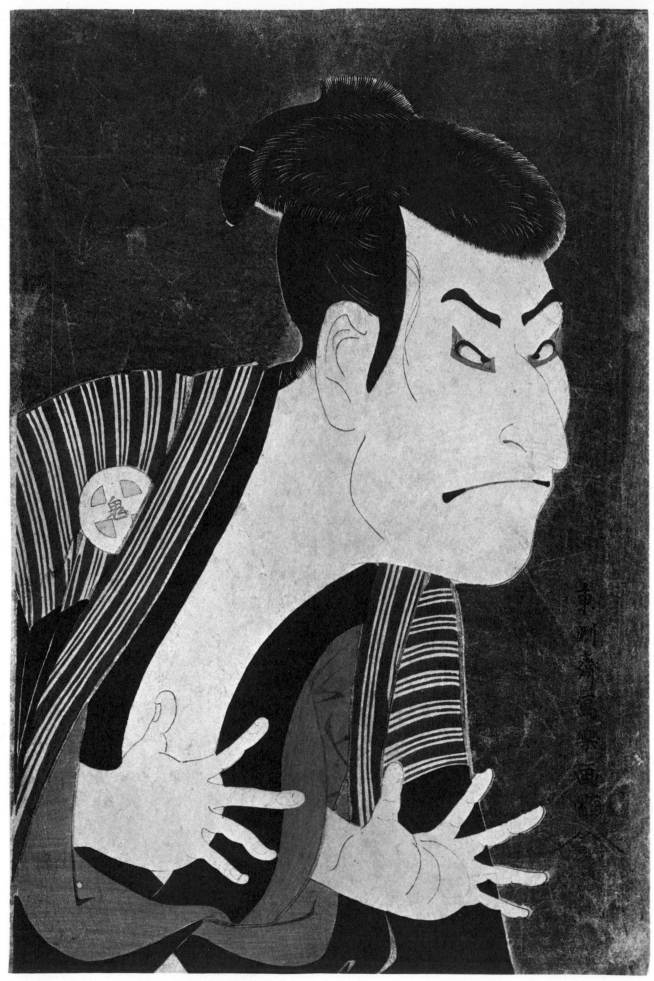

Sharaku *The Actor Otani Oniji II as Edobei, Manservant*
Oban, Nishiki-e, 38.1 × 25.1 cm
Publisher: Tsuta-ya Juzaburo. Date: 1794
The Metropolitan Museum of Art, New York

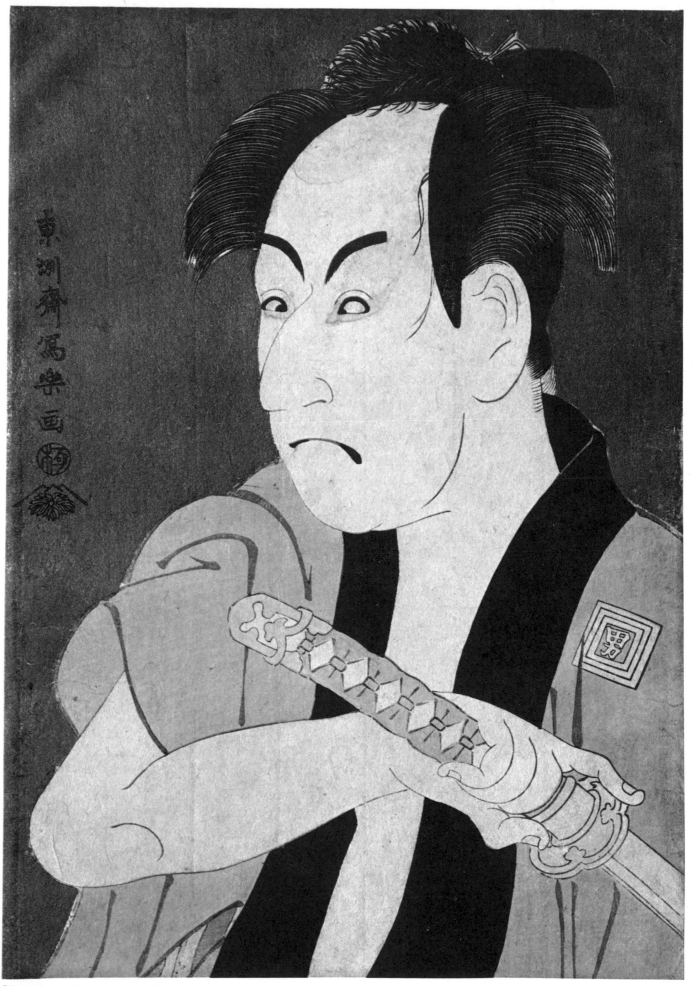

Sharaku *The Actor Ichikawa Omezo I as Ippei,*
Manservant
Oban, Nishiki-e, 35 × 24 cm
Publisher: Tsuta-ya Juzaburo: Date 1794

The actor drawing a sword on his opponent.

245

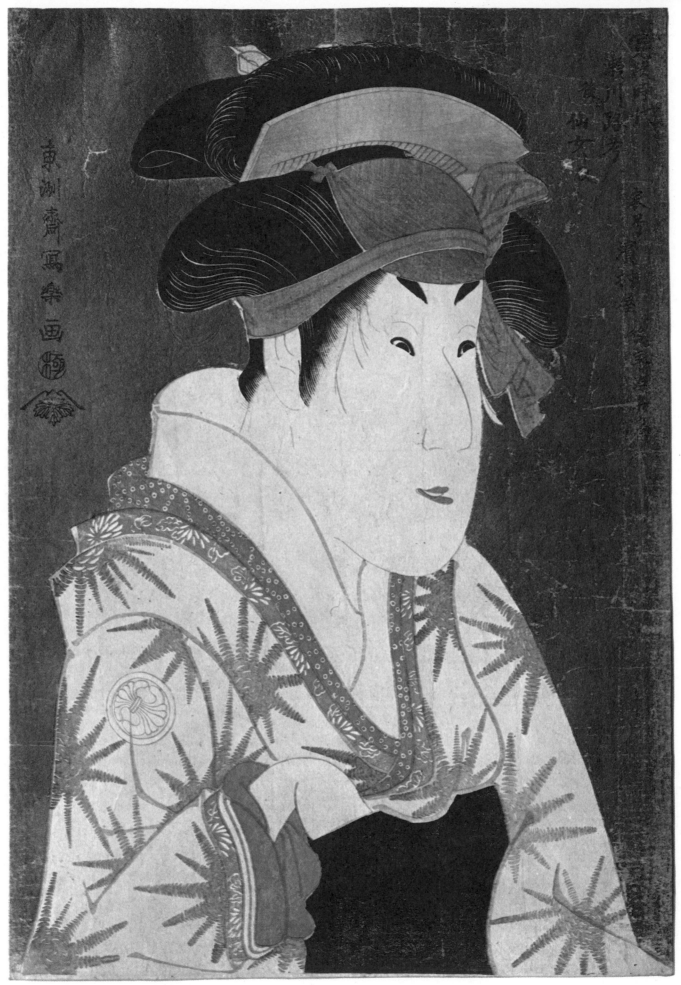

Sharaku *The Actor Segawa Kikunojo III as Oshizu,*
Wife of Tanabe Bunzo
Oban, Nishiki-e, 37.8 × 26.2 cm
246 Publisher: Tsuta-ya Juzaburo. Date: 1794

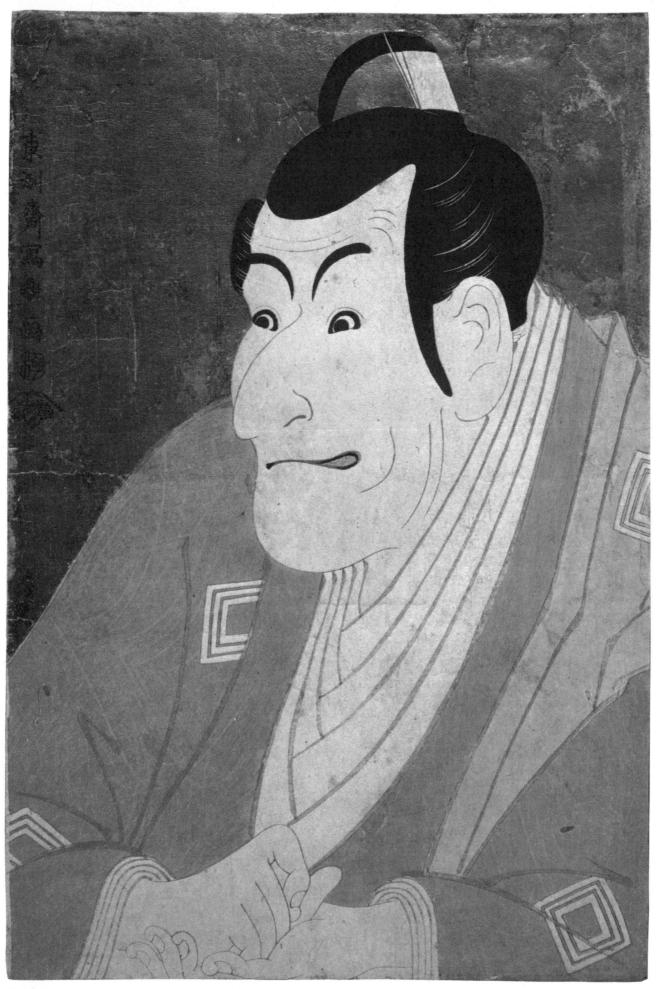

Sharaku *The Actor Ichikawa Ebizo as Takemura Sadanoshin*
Oban, Nishiki-e, 35.9 × 23.5 cm
Publisher: Tsuta-ya Juzaburo. Date: 1794.
The Cleveland Museum of Art, Ohio

Ebizo (Ichikawa Danjuro V) was a leading *Kabuki* actor of his time.

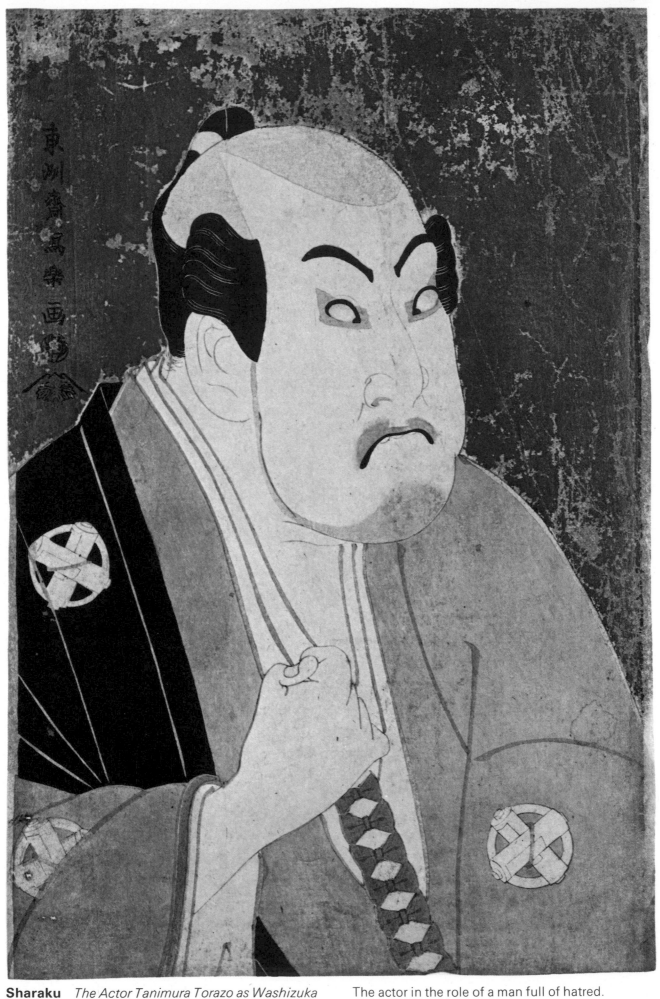

Sharaku *The Actor Tanimura Torazo as Washizuka Yaheiji*
Oban, Nishiki-e, 37.2 × 23.5 cm
Publisher: Tsuta-ya Juzaburo. Date: 1794. Honolulu Academy of Arts

The actor in the role of a man full of hatred.

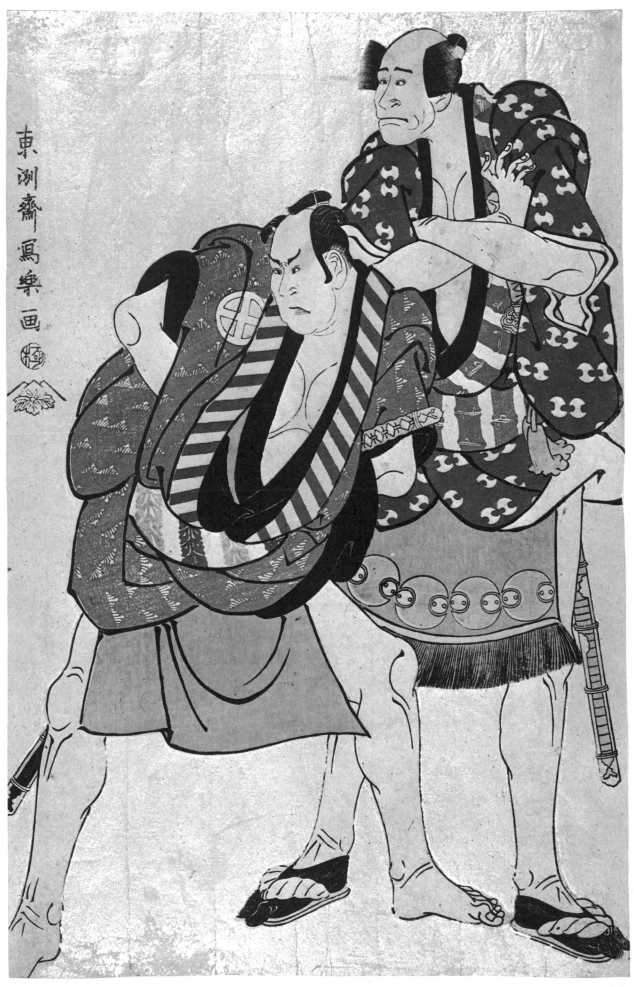

Sharaku *The Actors Arashi Ryuzo as Manservant Ukiyo Matahei and Otani Hiroji III as Manservant Tosa no Matahei*
Oban, Nishiki-e, 36.8 × 23.4 cm
Publisher: Tsuta-ya Juzaburo. Date: 1794. Sakai Collection, Japan

The short *kimono* showing bare legs is a sign of their social rank, as servants to *samurai*.

249

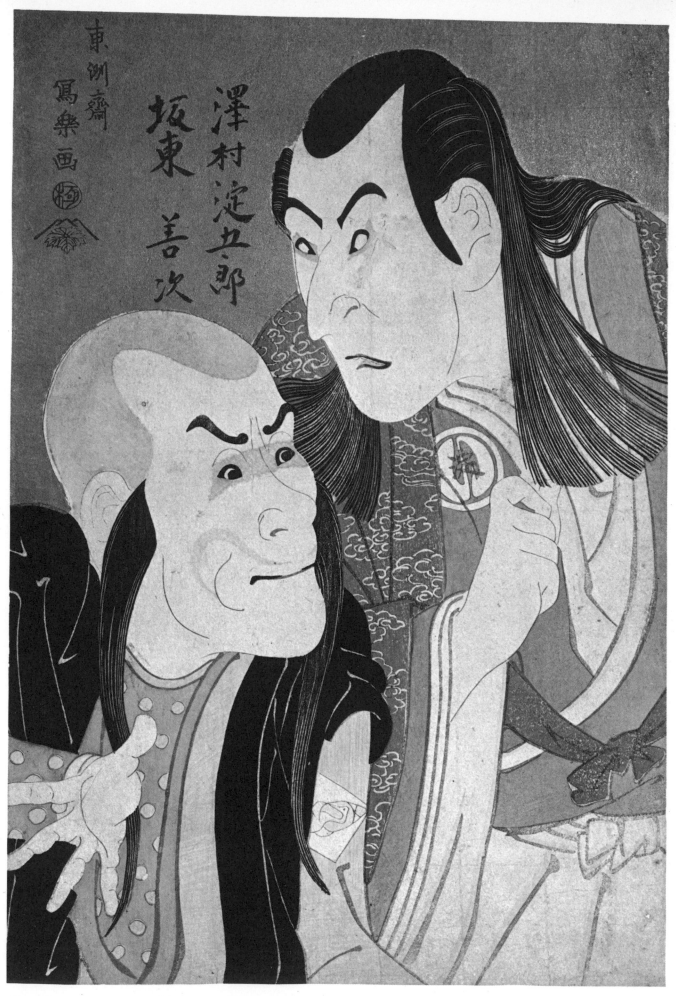

Sharaku *The Actors Sawamura Yodogoro II as Kawatura Hogen and Bando Zenji as Onisado-bo*
Oban, Nishiki-e, 37 × 25 cm
Publisher: Tsuta-ya Juzaburo. Date: 1794
Musée Guimet, Paris

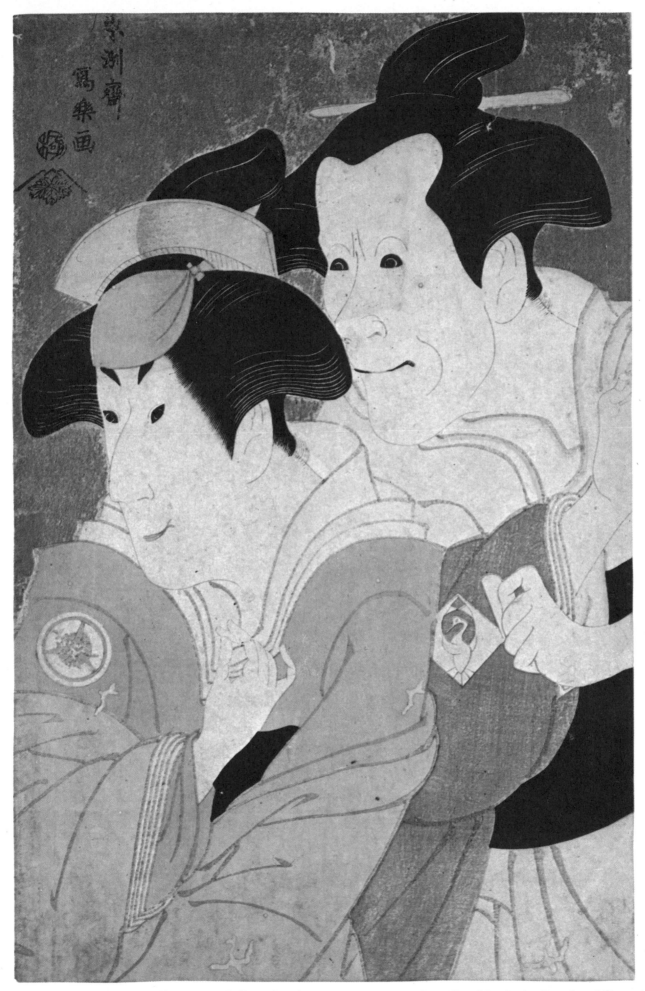

Sharaku *The Actors Iwai Kiyotaro as Fujinami and Bando Zenji as Ozasa*
Oban, Nishiki-e, 36.7 × 23 cm
Publisher: Tsuta-ya Juzaburo. Date: 1794

Fujinami is the wife of Sagisaka Sanai and Ozasa the wife of Washizuka Kandayu.

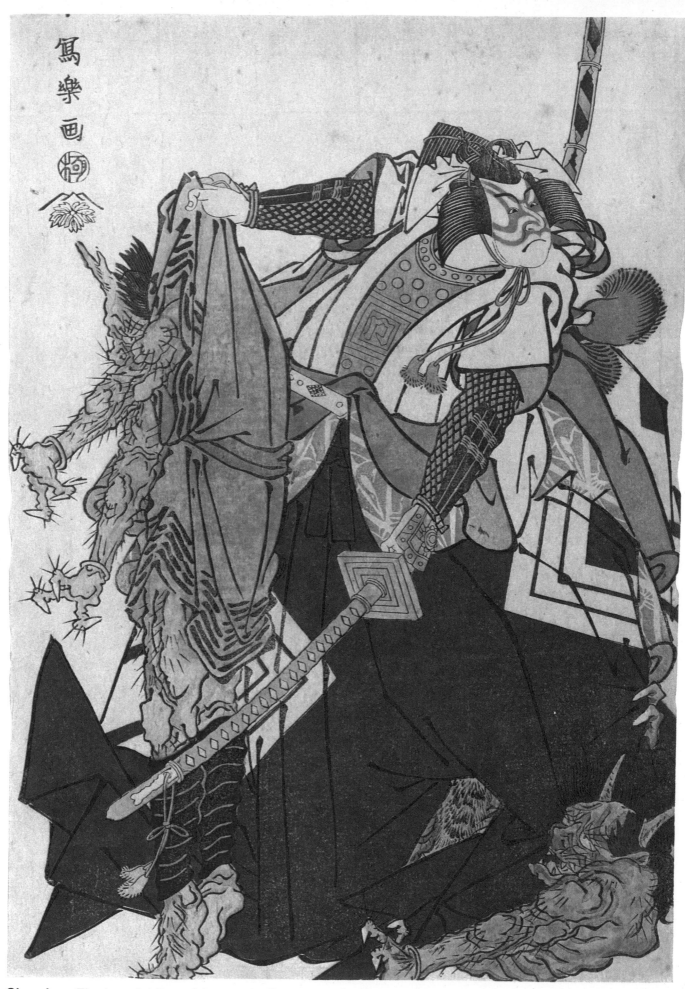

Sharaku *The Actor Ichikawa Monnosuke II*
Aiban, Nishiki-e, 30.5 × 21.1 cm
Publisher: Tsuta-ya Juzaburo. Date: 1794. Tokyo
National Museum

This print was made in memory of Monnosuke, when
he died at the age of 52.

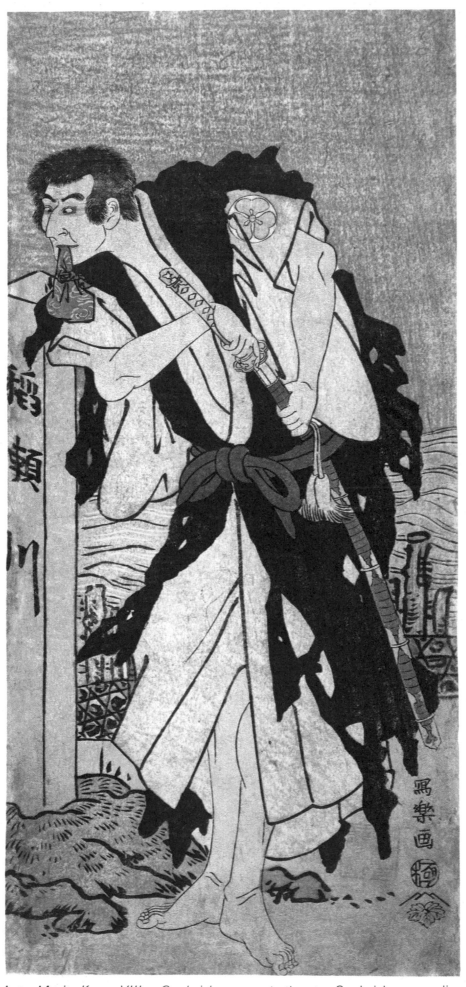

Sharaku *The Actor Morita Kanya VIII as Genkai-bo*
Hosoban, Nishiki-e, 31.4 × 14.6 cm
Publisher: Tsuta-ya Juzaburo. Date: 1794. Musée
Guimet, Paris

In the play Genkai-bo was a disguise of Kawachi
Kanja.

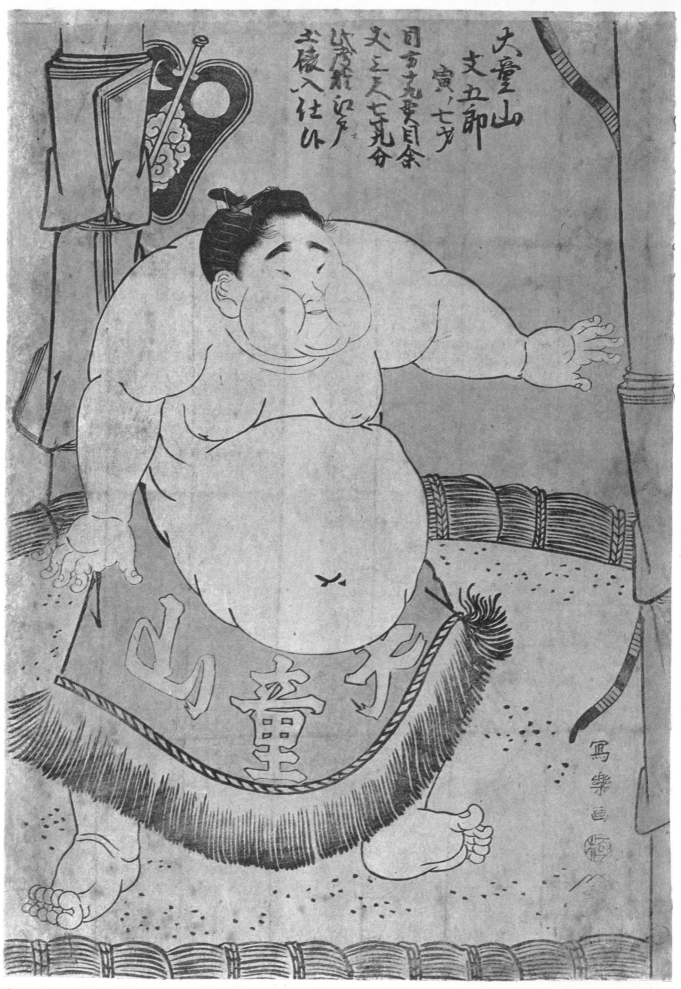

大童山
文五郎
寅ノ七ツ
目方九メ目余
火三尺七寸五分
此度於江戸
土俵入仕候

寫樂画

Sharaku *Dohyoiri Ceremony of Boy Wrestler
Daidozan*
Aiban, Nishiki-e, 33.2 × 22.7 cm
Publisher: Tsuta-ya Juzaburo. Date: 1794. Riccar Art
Museum, Japan

A seven-year-old boy star in the *sumo* world who
appeared on the ring just for the ceremony, as an
attraction. The inscription on the upper right says:
"Daidozan Bungoro is seven years old, weighs not
less than 19 *kan* (71 kg) and is 3 *shaku* 7 *sun* 5 bu
(115 cm tall)."

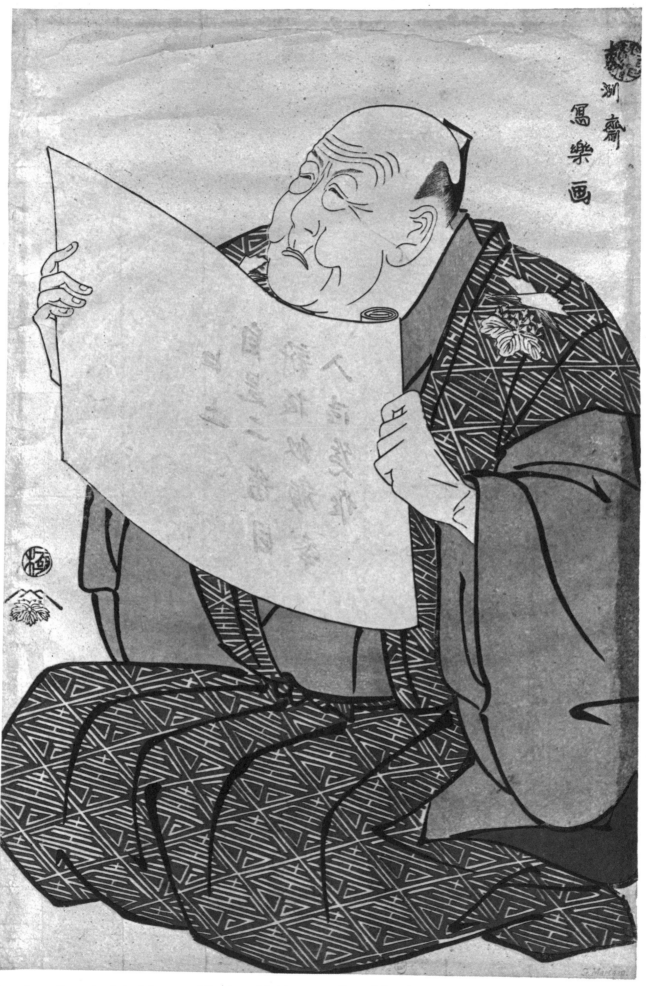

洲齋

寫樂画

Sharaku *Portrait of the Manager Miyakoza Making an Announcement*
Oban, Nishiki-e, 37.3 × 24.4 cm
Publisher: Tsuta-ya Juzaburo. Date: 1794
Bibliothèque Nationale, Paris

Part of the characters written for the announcement
are seen through the paper. He wears a formal *kimono*.

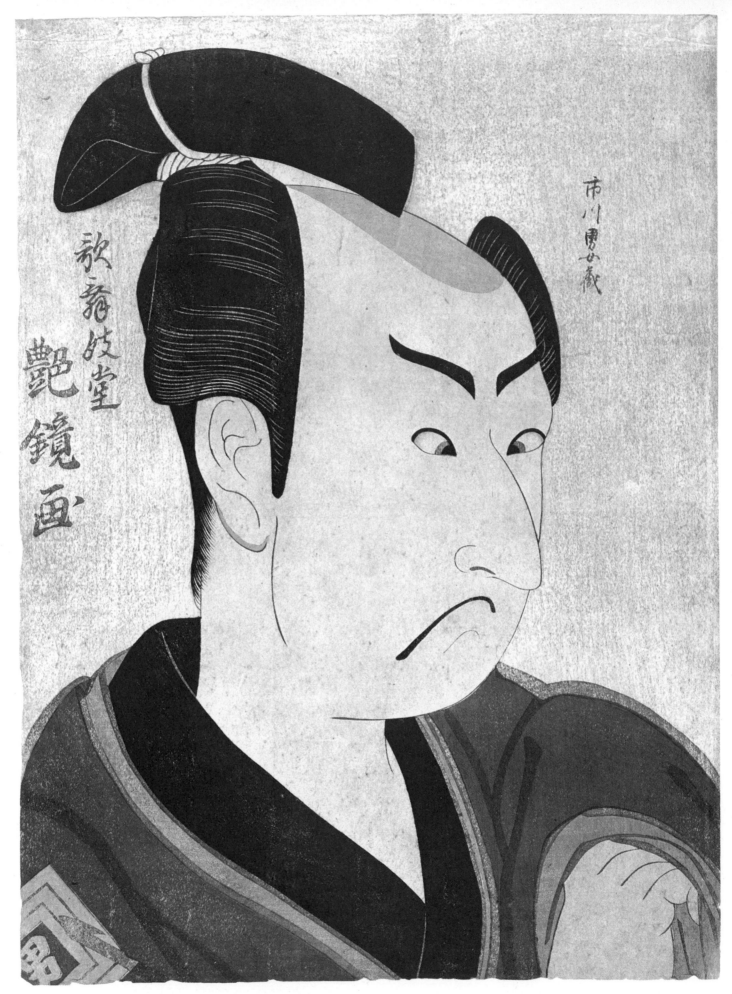

歌舞妓堂

艶鏡画

市川男女蔵

Enkyo *The Actor Ichikawa Omezo as Kanaya Kingoro*
Oban, Nishiki-e, 35.7 × 25.7 cm
Publisher: unknown. Date: c. 1796. Riccar Art Museum, Japan

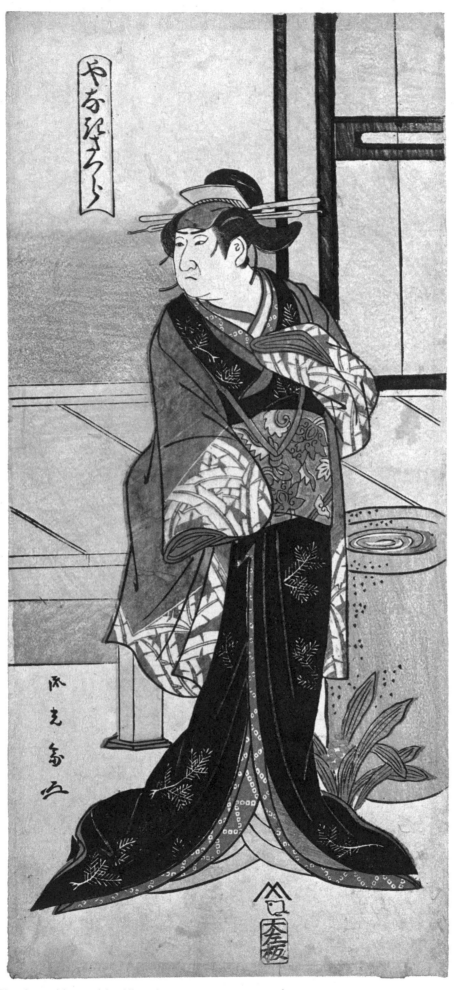

Ryukosai *The Actor Yamashita Kinsaku as Yanagisakura*
Hosoban, Nishiki-e, 32 × 14.6 cm
Publisher: Osa. Date: c. 1790's. The Art Institute of Chicago.

An *ukiyo-e* produced in Osaka, depicting a female impersonator of that city.

The Utagawa school

The Utagawa school

Of the *ukiyo-e* schools, the Torii school has continued the longest. It has specialized in billboards for *Kabuki* theatres and retained its style of painting to this day.

The Utagawa school, however, expanded more than the Torii school, and became a very large school, claiming most of the artists in the latter half of the period of *ukiyo-e*. This is because the Utagawa school turned out one talented artist after another to take the lead in every field of *ukiyo-e*; established a relationship between master and pupil closer than had existed previously, and systematized training and succession in its own way, making particularly strict regulations for succession; it also had close connections with theatrical people, writers and publishers and was good at advertising.

However, after the Utagawa school had grown larger, its pupils merely imitated the established style of the school, with the exception of such pioneers as Kuniyoshi in *musha-e* (pictures of historical warriors), and Hiroshige in landscapes, and Kunisada, who, like Rubens, illustrated a number of pictures of full-figures beautiful women. In the last period of *ukiyo-e*, artists belonging to the Utagawa school almost completely dominated the *ukiyo-e* world, but they lacked the spirit of the painter and did not produce any works which could be called masterpieces.

The following are early artists of the Utagawa school.

Utagawa Toyoharu (1735–1814)

There are various views about the birthplace of Toyoharu. He came to Edo to become an illustrator when Suzuki Harunobu was active. Accordingly, his pictures of beauties clearly show the influence of Harunobu. In time he began to produce *uki-e* (perspective pictures) including those of indoor scenes such as *Perspective View of Shinagawa Pleasure House*, as well as those depicting outdoor scenes such as the sights of Edo and festivals in Kyoto. It is interesting that Toyoharu took a great interest in this simple method of perspective. Probably Toyoharu, like Harushige (later called Shiba Kokan), an artist who imitated Harunobu, had become interested in the feeling of spaciousness and depth given by Chinese wood-block prints and Western copper-plate prints using perspective. Toyoharu seems to have been more familiar with Western copper-plate prints.

The evidence for this lies in his *uki-e* of foreign landscapes. Although most of them are imaginary ones, one of them is modelled on a copper-plate print by Antonio Visentini (1688–1782) based on an oil painting by Canaletto (Bernardo Belotto, 1697–1768) *Grand Canal: looking North-east from Santa Croce to San Geremia*. In this *uki-e*, the delicate lines in the copper-plate print are not reproduced, but similar devices are seen in the paralled lines representing the sky and in the expression of the surface of the water. Toyoharu can be said to have been one of the pioneers in the field of landscape prints.

Utagawa Toyohiro (1773–1829)

Toyohiro was a pupil of Utagawa Toyoharu. He was not as interested in actor portraits as a fellow pupil of his, Toyokuni, but took rather an interest in pictures of beauties and landscapes. The beautiful women in his early pictures are tall and slim like those in Eishi's pictures with the portion of the head to the body length being 1 to 12. *Ryoga Juniko* (*Twelve Months Portrayed*), the triptych series Toyohiro produced jointly with Toyohuni, is his masterpiece, with its dynamic representation of groups of people and balanced composition. Toyohiro executed fewer works than Toyohuni and depicted in a mature style in his later years.

Utagawa Toyokuni (1769–1825)

It is said that Toyokuni's father was a puppeteer who made likeness-dolls of Ichikawa Danjuro II, a great actor of the day. Toyokuni was raised in such an environment, and later made *nigao-e* (likeness pictures) of actors. He lost his parents at an early age, and became a pupil of Toyoharu to establish himself as an artist. But he remained in obscurity for some time. In the process of training, he made illustrations which show that his style was influenced by Kitao Shigemasa and Torii Kiyonaga.

The actor portraits among these illustrations show that he was already interested in the likenesses of actors. Toyokuni established himself as an *ukiyo-e* artist with his *Yakusha Butai no Sugata-e* (*Actors on Stage*) series at about the time Sharaku published his portraits of actors in the *okubi* (close-up) style. Almost every print in this series portrays one actor standing against a monochromatic background, showing his attempt to express the actor's individuality and the on-stage atmosphere through the actor's make-up and pose. In contrast with Sharaku, Toyokuni proceeded from full-size portraits of a standing actor to *okubi-e* (close-up portraits). He seems to have tried to capture the individuality of actors in a different way from Sharaku.

In addition to portraits of actors, Toyokuni made pictures of beautiful women. His *Furyu Nana Komachi Yatsushi-E* (*Elegant Modern Figures as the Seven Komachi*) series shows his detailed execution and advanced technique in the depiction of the background.

In his later years, Toyokuni suddenly switched from his pictures of beauties as tall, slim women to smallish women with sloping backs. About this change, some say that Toyokuni depicted popular female impersonators realistically, while others say that he sensitively caught the change in popular taste from tall, slim women to smallish ones.

He was also adept at brush-work painting.

Utagawa Toyokuni II (1777–1835)

This artist at first used the name Toyoshige. He became the adopted son of Toyokuni, thus inheriting the name Toyokuni II after the death of the first. He dealt with actors and beauties, but he was not as outstanding as the first Toyokuni. He executed such distinctive landscapes as *Meisho Hakkei* (*Eight Views of Famous Places*) in his later years.

Utagawa Kunimasa (1773–1810)

Kunimasa is said to have been the first pupil of Toyokuni. He was skilled in portraying actors, especially in the *okubi-e* style. His pictures make a bright and strong impression on the viewer quite unlike those of Sharaku.

Utagawa Kunitora (active during the early 19th century)

In his landscapes, Kunitora emphasized perspective and depicted mountains and hills in a wave-like style, influencing Hokusai's landscapes. His picture depicting a large bronze statue at the entrance to the harbour of Rhodes shows his deep interest in Western copper-plate prints.

Toyokuni had many pupils besides Kunitora, including Kuniyasu (1794–1832), Kuninao (1793–1854), Kunimaru (active during the early 19th century), and Kuninaga (1790–1829).

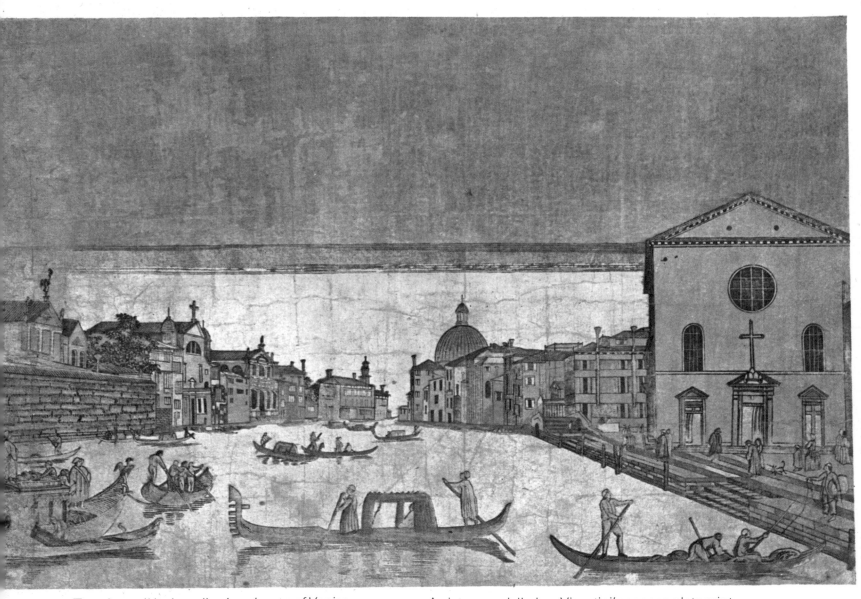

Toyoharu (Unsigned) *Landscape of Venice*
Oban, Nishiki-e, 24 × 36.2 cm
Publisher: Nishimura-ya Yohachi. Date: c. 1770's
Tokyo National Museum

A picture modelled on Visentini's copper-plate print based on Canaletto's landscape of Venice. Japan was closed to foreigners, and people had few opportunities to find out about foreign countries.

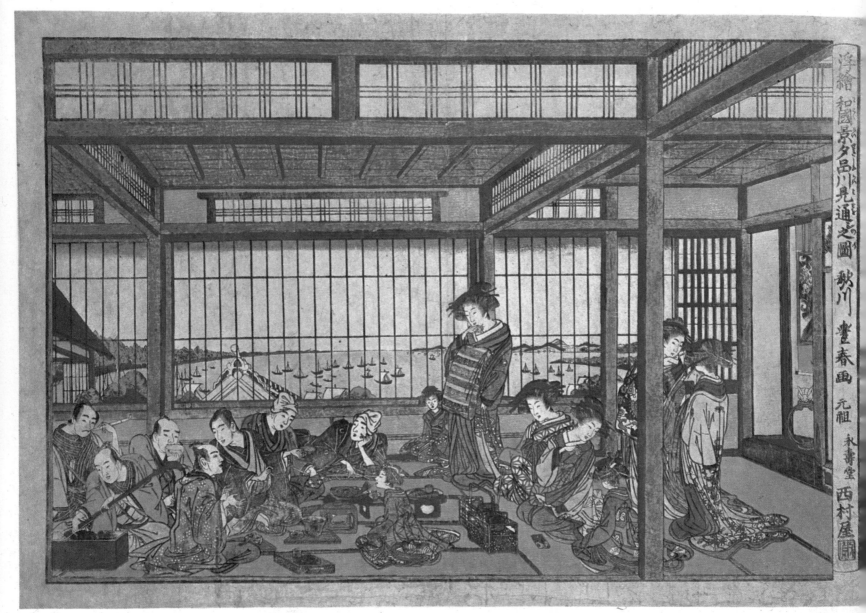

Toyoharu *Perspective View of Shinagawa Pleasure House (Wakoku Keiseki Shinagawa Mitoshi no Zu)*
Extra-oban, Nishiki-e, 30 × 43.4 cm
Publisher: Nishimura-ya Yohachi. Date: c. 1770's
Riccar Art Museum, Japan

An *uki-e* (perspective picture) of the interior of a tea house at Shinagawa. The figures are courtesans and their customers.

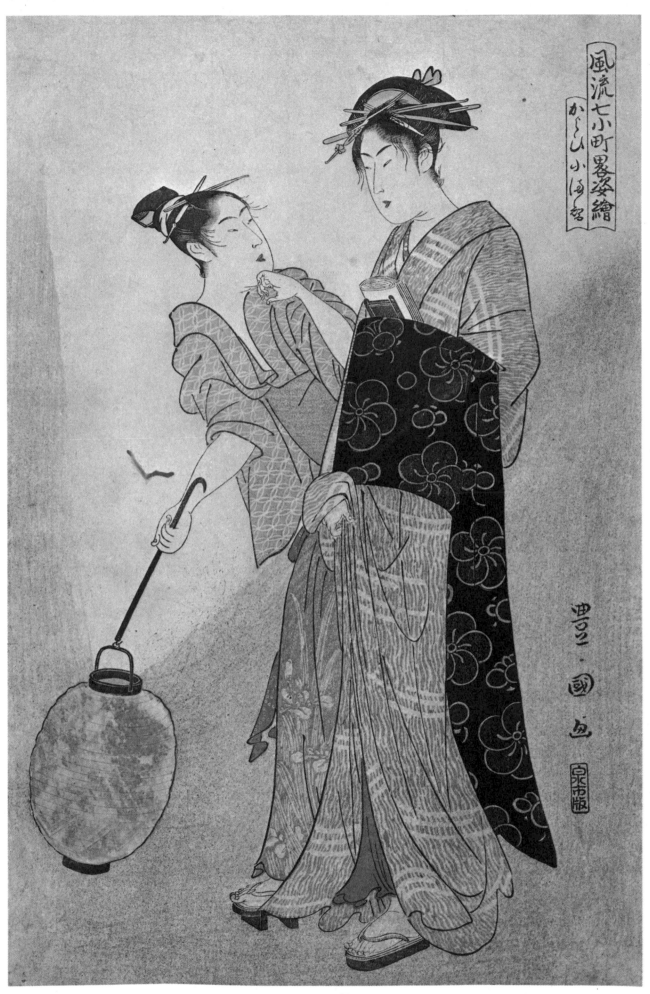

Toyokuni *Komachi Visiting her Lover*, from the
series *Elegant Modern Figures as the Seven Komachi
(Furyu Nana Komachi Yatsushi-e)*
Oban, Nishiki-e, 38.3 × 25.2 cm
Publisher: Izumi-ya Ichibei. Date: c. 1790's

The courtesan Komachi, being seen off by her maid.
The technique of spraying is used to depict light.

263

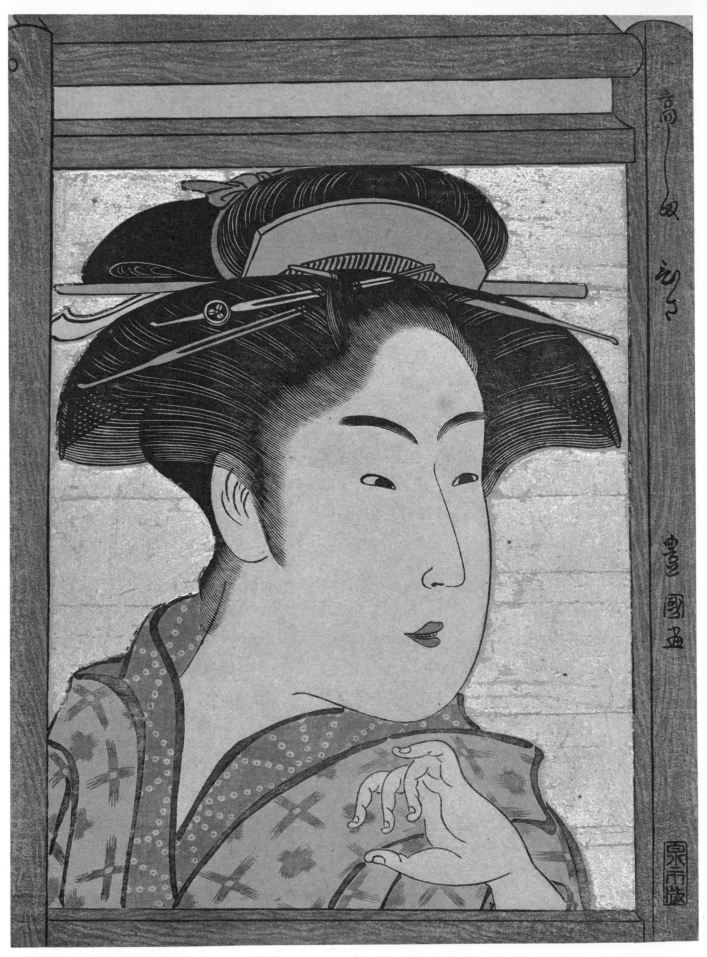

Toyokuni *Takashima Hisa*
Chuban, Nishiki-e, 25.9 × 19 cm
Publisher: Izumi-ya Ichibei. Date: c. 1790's
Takahashi Collection, Japan

Ohisa, famous beauty, reflected in a square glass
mirror, which was rare in those days. This is one of the
few *okubi-e* of women by Toyokuni.

264

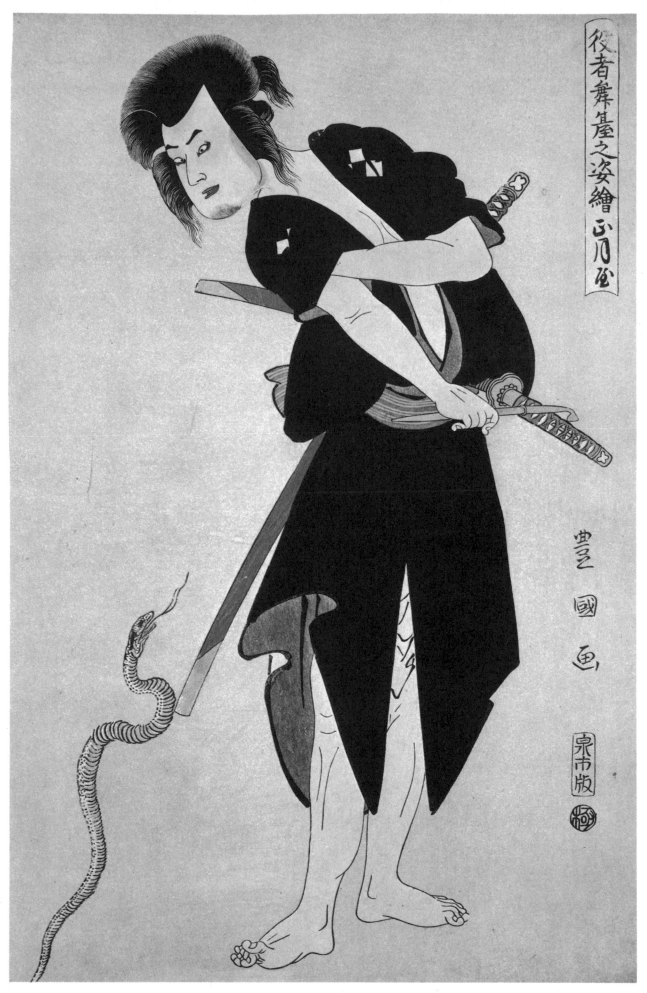

役者舞臺之姿繪 正月屋

豊國 画

泉市版

Toyokuni *Shogatsuya*, from the series *Actors on Stage (Yakusha Butai no Sugata-e)*
Oban, Nishiki-e, 37 × 24 cm
Publisher: Izumi-a Ichibei. Date: c. 1794. Museum of Fine Art, Boston

A work contemporary with Sharaku's, depicting the atmosphere of the performance on the stage.

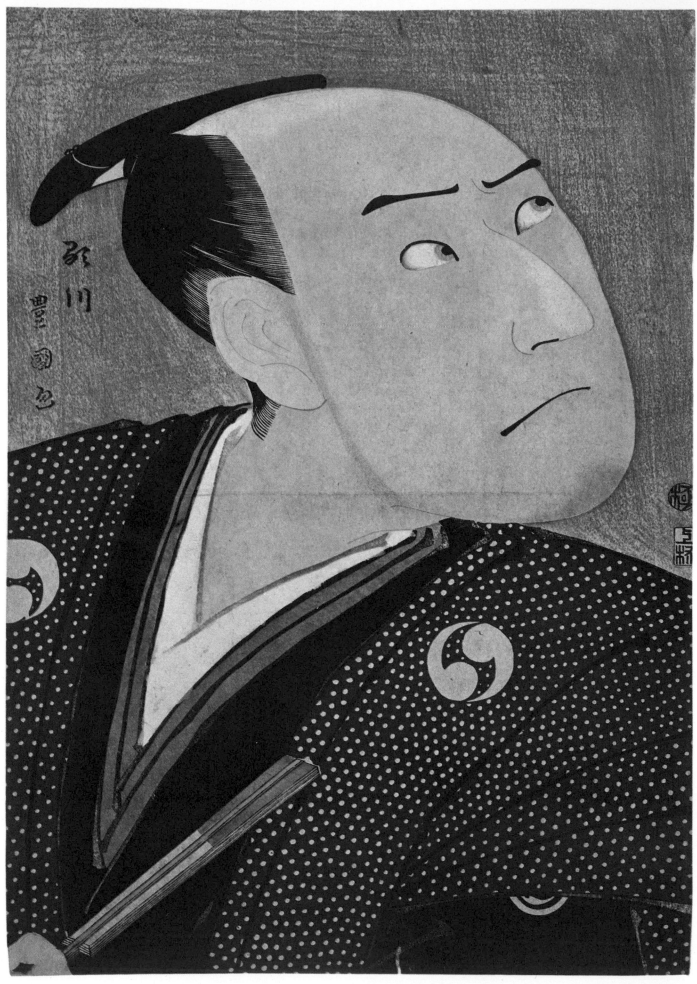

Toyokuni *The Actor Sawamura Sojuro III as Oboshi Yuranosuke*
Oban, Nishiki-e, 35.4 × 24.9 cm
Publisher: Uemu-ra Yohei. Date: c. 1796. Tokyo National Museum

An *okubi-e* of an actor, depicting the facial expression of the leading character of *Chushingura*, as he is popularly known.

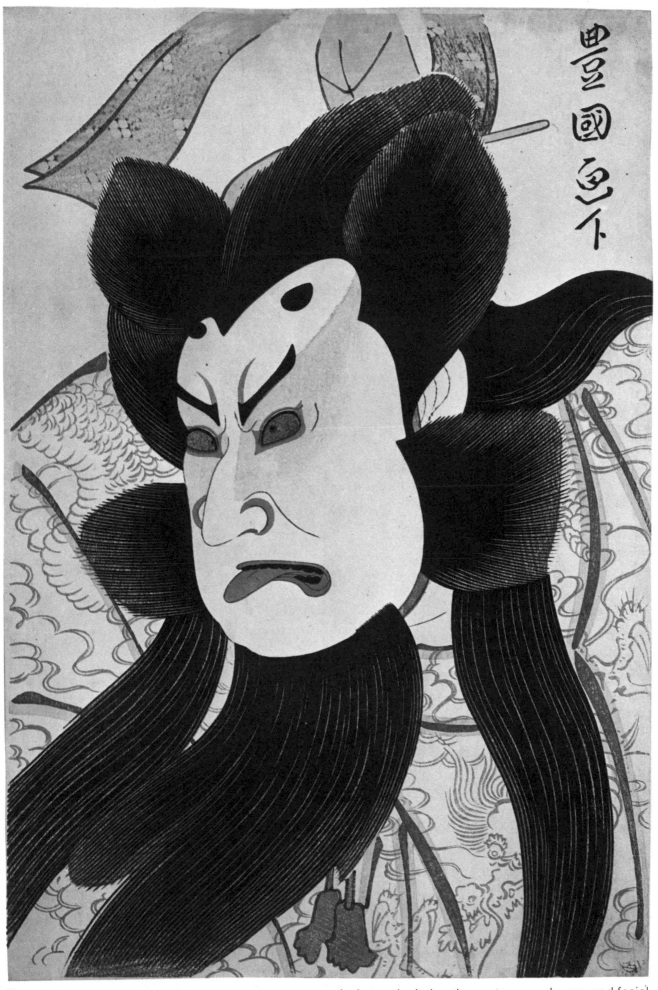

豊國画下

Toyokuni *The Actor Kataoka Nizaemon VII as Fujiwara Shihei*
Oban, Nishiki-e, 39.2 × 26 cm
Publisher: Yamaguchi-ya Chusuke. Date: c. 1796
Sakai Collection, Japan

A picture depicting the costume, make-up, and facial expression of a villain.

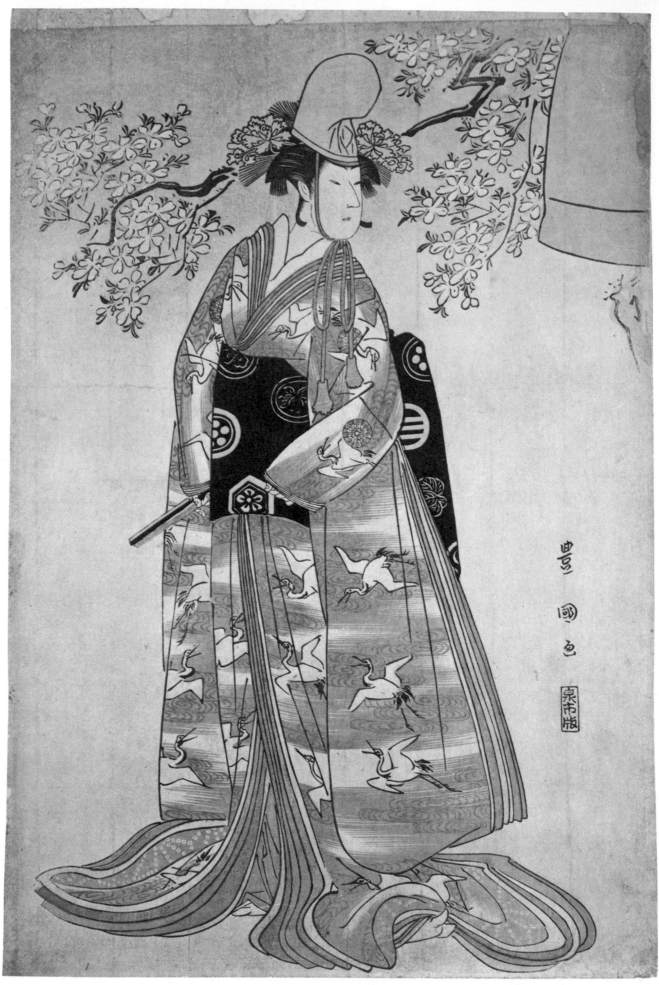

Toyokuni *The Actor Nakamura Noshio II in the dance "Dojoji"*
Oban, Nishiki-e, 39.4 × 26.3 cm
Publisher: Izumi-ya Ichibei. Date: c. 1796. Nelson-Atkins Gallery of Art, Kansas City

A famous *onnagata* (female impersonator) in stage costume, taking a stop-action pose during dancing. There is a pattern of cranes on the *kimono*.

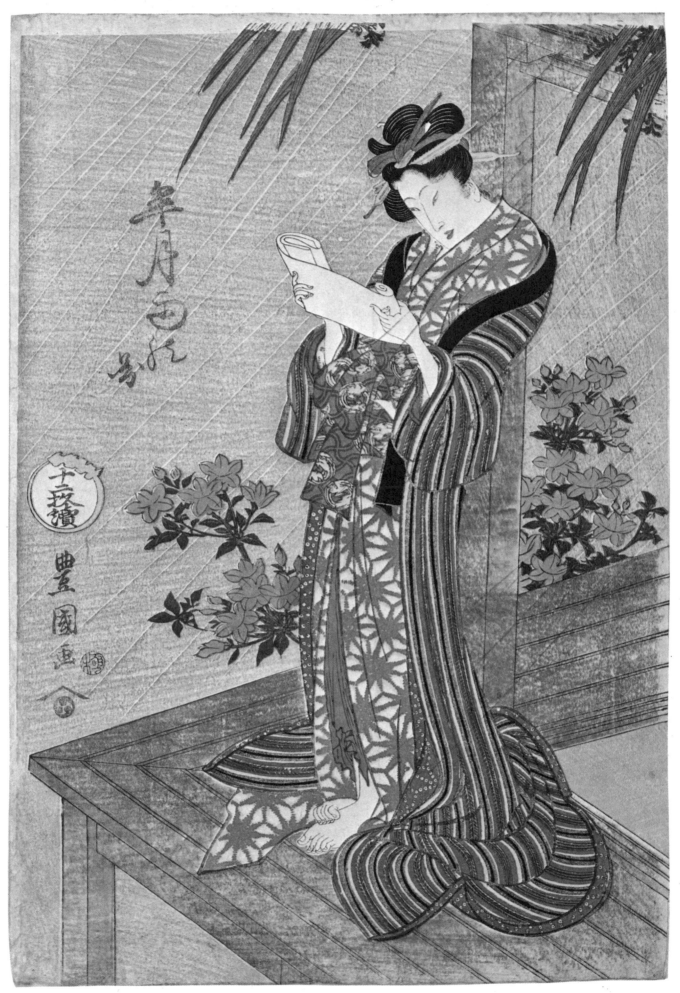

Toyokuni *Early Summer Rain (Samidare no Zu)*
Oban, Nishiki-e, 39 × 26.5 cm
Publisher: Nishimura-ya Yohachi. Date: c. 1810's
Sakai Collection, Japan

From his series of beauties' portraits. A picture with a psychological interpretation by Toyokuni in a period when he was establishing his distinctive style.

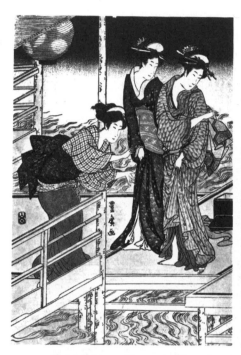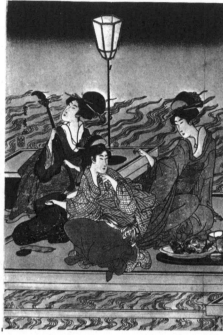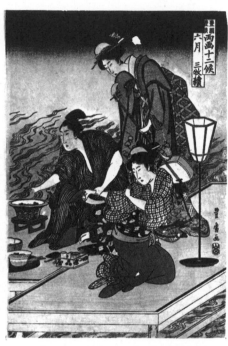

Toyohiro *Summer Evening by the Riverside at Shijo*, from the series *Twelve Months Portrayed (Ryoga Juniko)*
Oban, Nishiki-e, Triptych, left: 37.3 × 24.5 cm, centre: 37.3 × 25.1 cm, right: 37.4 × 25 cm
Publisher: Yamada-ya Sanshiro. Date: c. 1800's

Toyohiro's masterpiece with its dynamic composition, depicting courtesans and a customer enjoying the evening cool on the terrace by the riverside at Shijo, Kyoto.

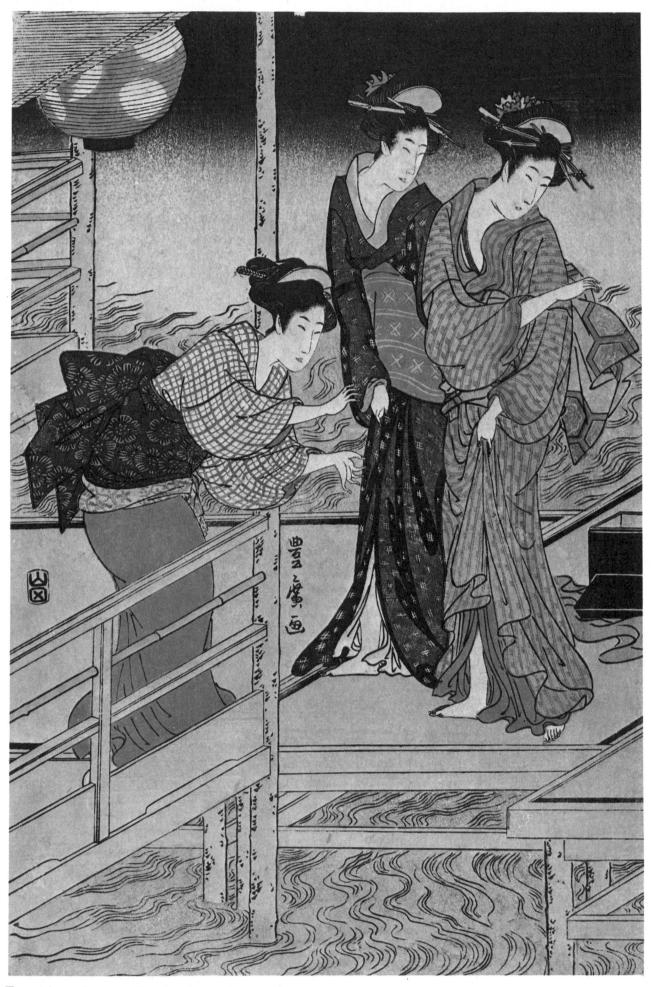

Toyohiro *Summer Evening by the Riverside at Shijo*
Left panel of the triptych.

271

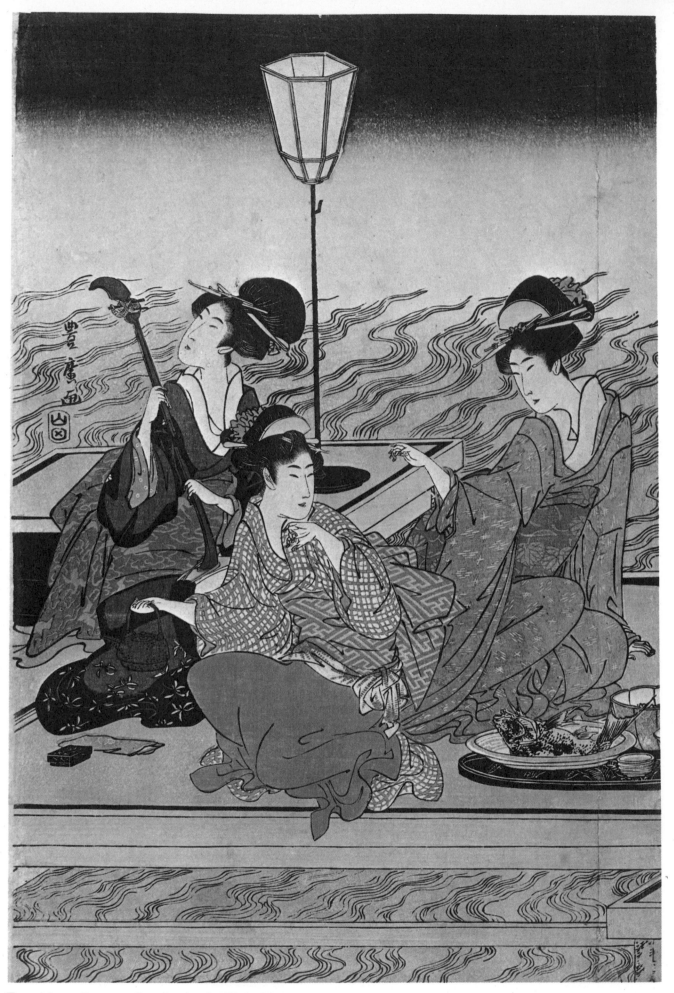

Toyohiro *Summer Evening by the Riverside at Shijo*
Central panel of the triptych.

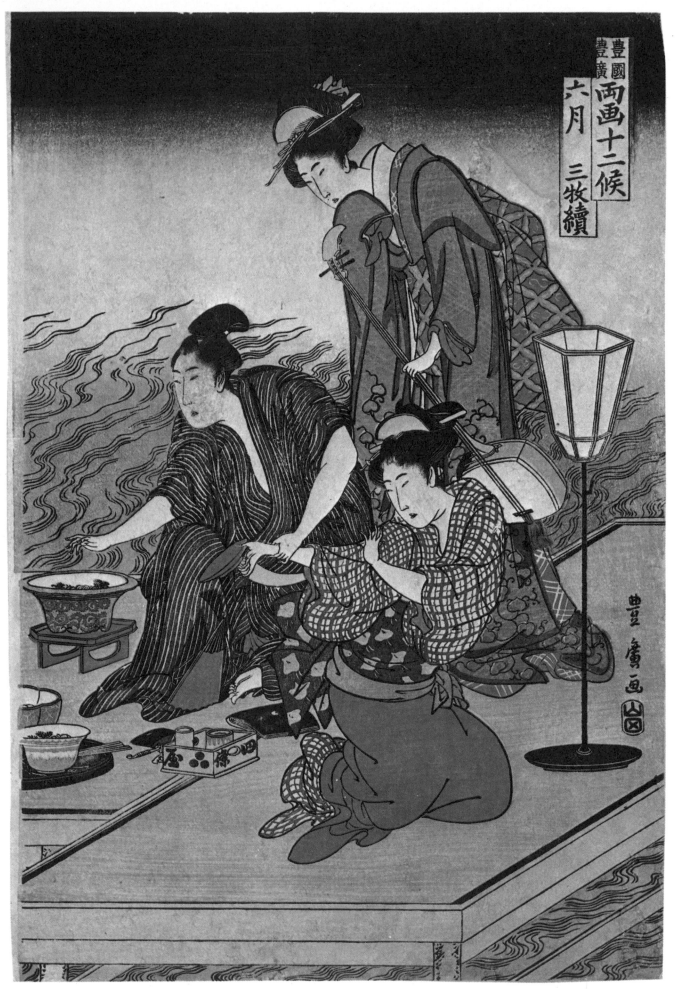

Toyohiro *Summer Evening by the Riverside at Shijo*
Right panel of the triptych.

273

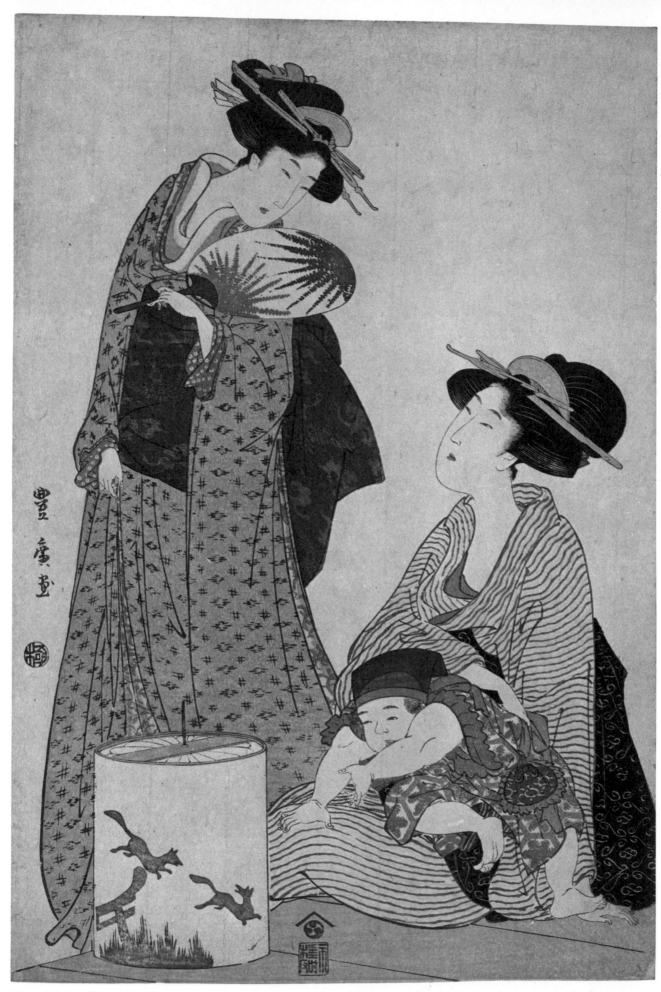

Toyohiro *Revolving Lantern*
Oban, Nishiki-e, 38.4 × 25.8 cm
Publisher: Nishimura-ya Yohachi. Date: c. 1800's
Riccar Art Museum, Japan

Women and a child enjoying the cool in the open air on a summer evening. The child is reaching for the revolving lantern on which foxes are depicted.

274

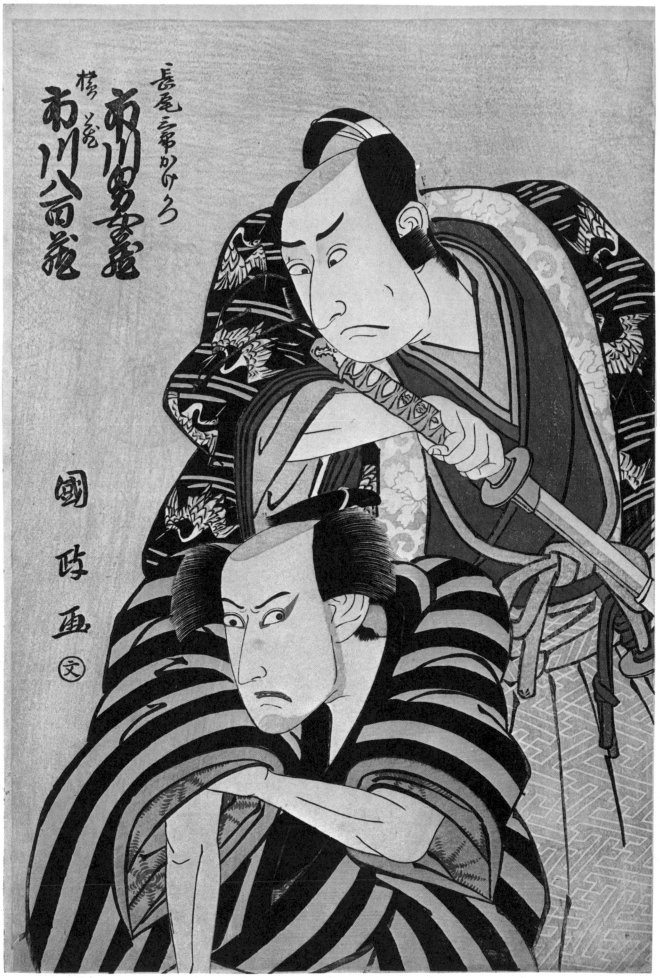

長尾三郎かけ勝
市川男女蔵
横蔵
市川八百蔵

國政画
文

Kunimasa *The Actors Ichikawa Omezo as Nagao*
Saburo Kagekatsu and Ichikawa Yaozo as Yokozo
Oban, Nishiki-e, 39.2 × 26.2 cm
Publisher: Maru-ya Bun-emon. Date: c. 1799. Sakai
Collection, Japan

A simple and plain picture of actors.

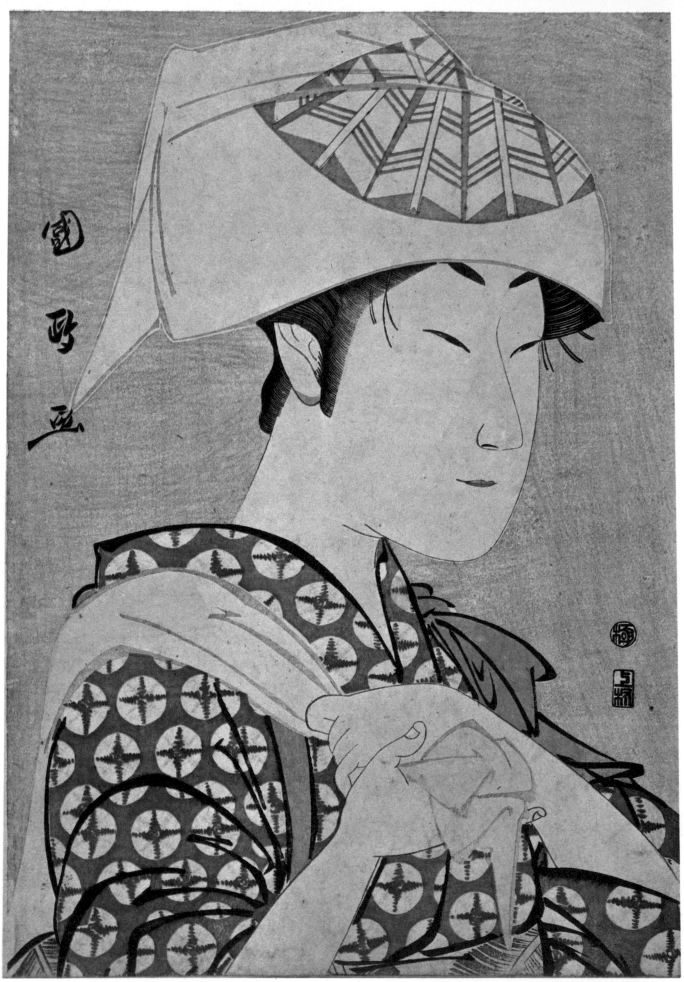

Kunimasa *Bust Portrait of the Actor Nakamura Noshio II*
Oban, Nishiki-e, 37.2 × 25.5 cm

276

Publisher: Uemura Yohei. Date: c. late 1790's
Theodor Scheiwe Collection, Germany

An *okubi-e* of a popular *onnagata* as a woman wearing a hand towel on the head as a housewife would do when she does household chores.

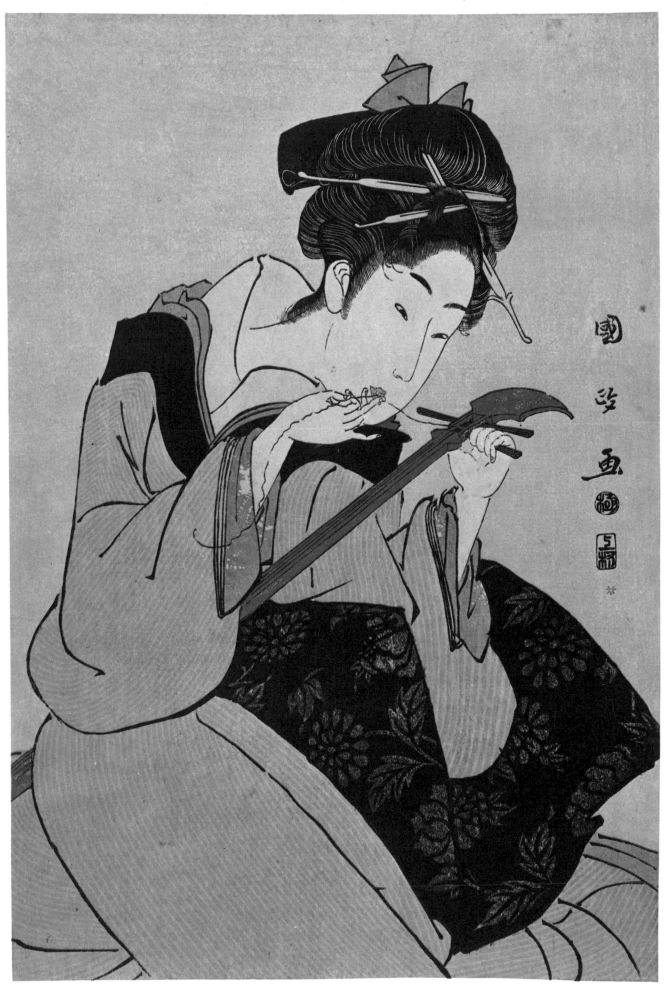

Kunimasa *Beauty Changing Strings on the Samisen*
Oban, Nishiki-e, 37.1 × 25.1 cm
Publisher: Uemura Yohei. Date: c. late 1790's

A masterpiece among Kunimasa's portraits of beautiful women. The *samisen* is the most popular Japanese musical instrument.

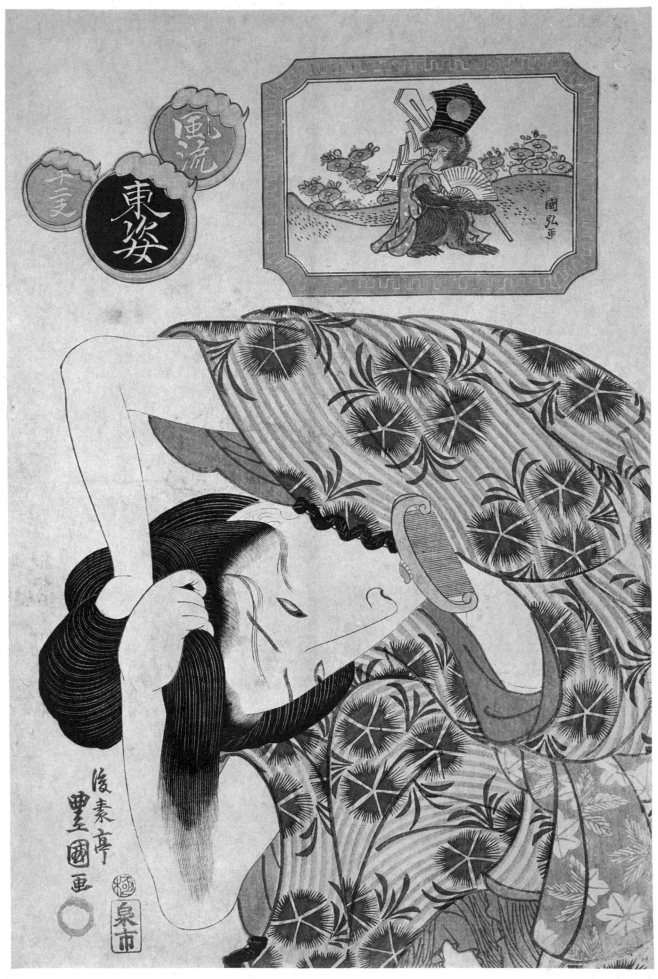

Toyokuni II *Monkey*, from the series *Fashionable Figures of Edo according to the Twelve Animals of the Zodiac (Furyu Azuma Sugata Junishi)*
Oban, Nishiki-e, 38 × 25.7 cm
Publisher: Izumi-ya Ichibei. Date: c. late 1820's

A woman is washing her hair with a comb in her mouth. Above her there is a picture of a monkey attired in *manzai* costume. The inlaid picture of the monkey is by Kunihiro.

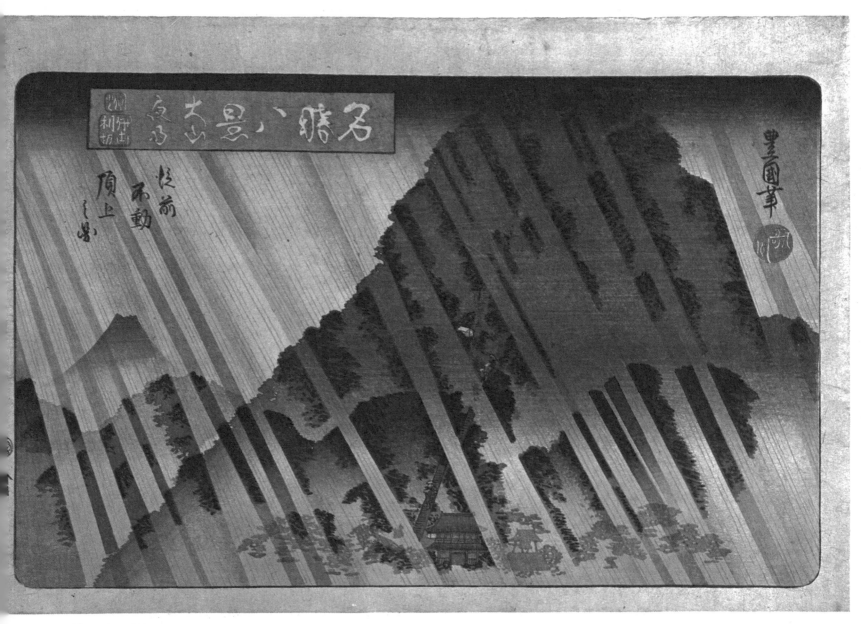

Toyokuni II *Night Rain at Daisen*, from the series
Eight Views of Celebrated Places (Meisho Hakkei)
Oban, Nishiki-e, 26.4 × 37.8 cm
Publisher: Ise-ya Rihei. Date: c. early 1830's

Daisen is a mountain with a shrine which is said to be
marvellously responsive to prayers for rain. Mount Fuji
is seen in the distance.

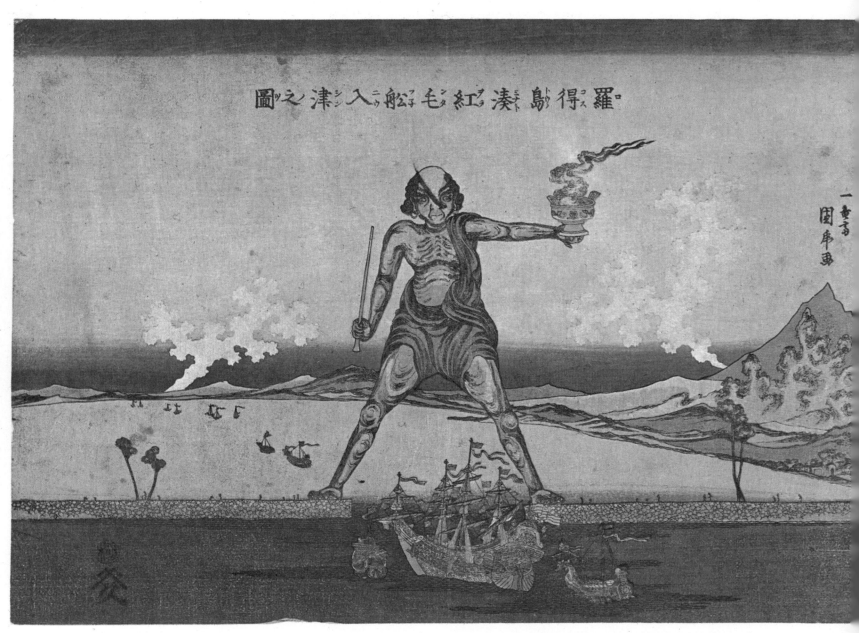

Kunitora *Colossus of Rhodes (Rokosuto no Minato Oranda Fune Nyushin no Zu)*
Oban, Nishiki-e, 26.6 × 38.2 cm
Publisher: Yamamoto-ya Heikichi. Date: c. 1810's
Tokyo National Museum

An imaginary picture based on a Western copper-plate print, depicting the bronze Colossus of Rhodes in the south-east Aegean, one of the seven wonders of the ancient world.

280

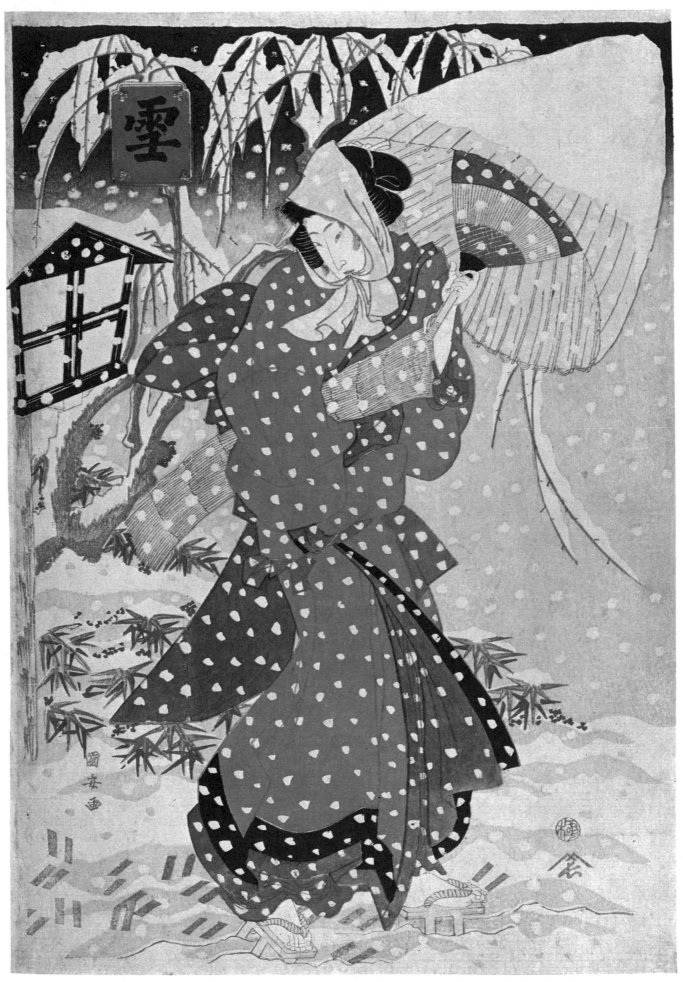

Kuniyasu *Snow (Yuki)*
Oban, Nishiki-e, 38.5 × 26.3 cm
Publisher : unknown. Date : c. late 1810's

A streetwalker going out for business on a snowy
night, carrying her stock in trade, a rush mat, under her
arm. In the background are depicted willow trees, a
lantern and bamboo bush.

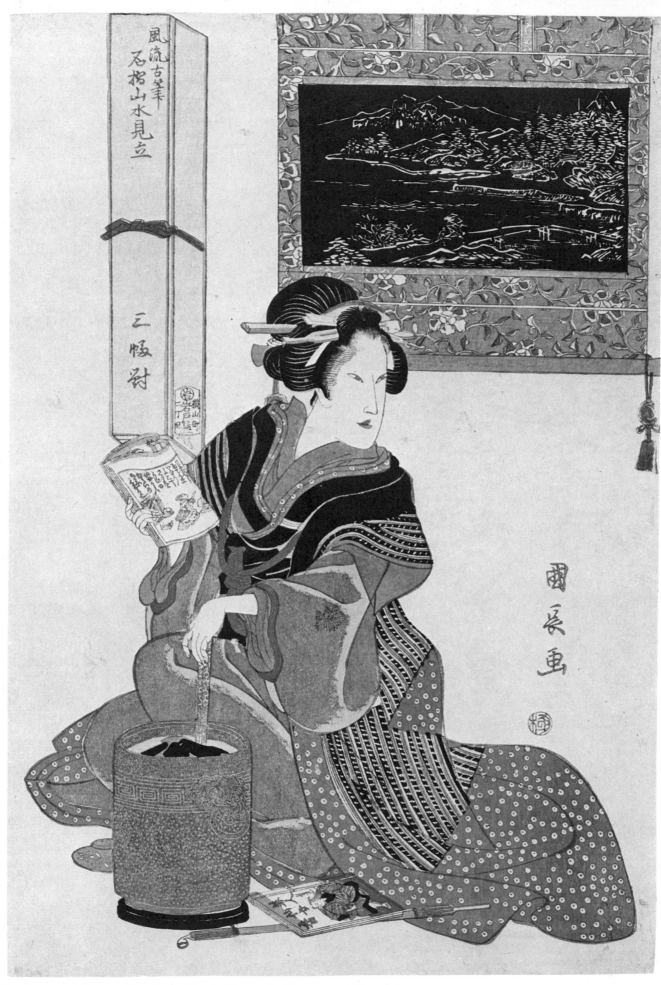

Kuninaga *Woman Reading a Book (Furyu Kohitsu Ishizuri Sansui Mitate)*
Oban, Nishiki-e, 38.1 × 26 cm
Publisher: Iwato-ya Kisaburo. Date: c. late 1810's
Sakai Collection, Japan

Winter. A woman is reading a book by a brazier. A very long tobacco pipe is seen. Pictures like the one on the hanging scroll were popular at that time. The title is written on the scroll container.

282

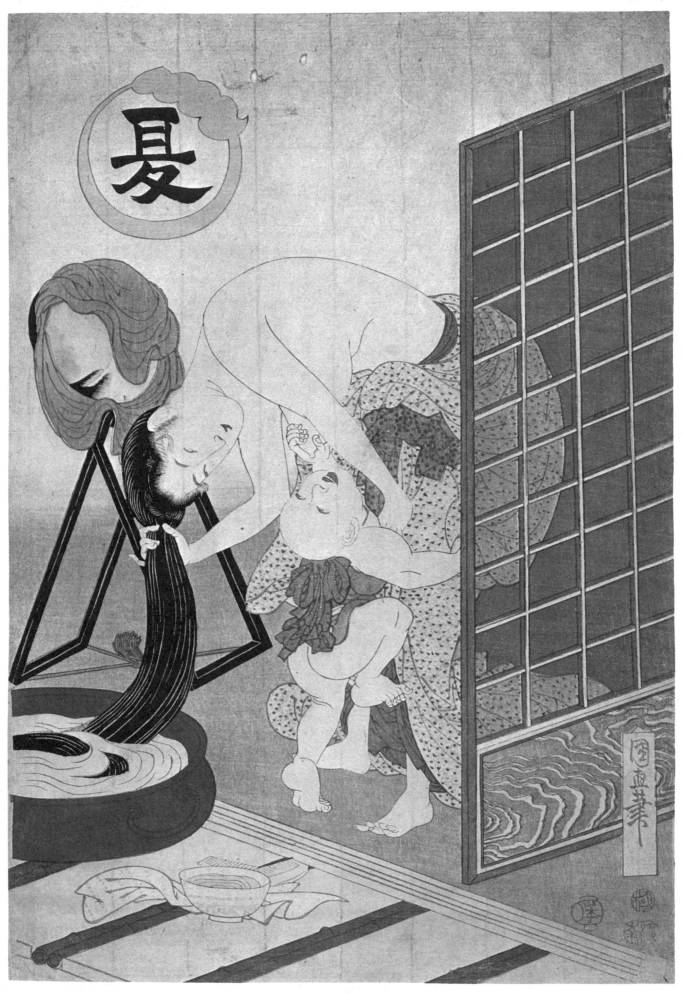

Kuninao *Summer (Natsu)*
Oban, Nishiki-e, 39 × 26.6 cm
Publisher: unknown. Date: c. 1811

A child demands his mother's attention while she
washes her hair. They are between a mirror and a *shoji*
(screen) covered with *moji*, cloth woven loosely of
twisted hemp yarn.

The search for formal beauty

The search for formal beauty

Katsushika Hokusai is world-famous for his prints of Mount Fuji, the most celebrated mountain in Japan. Hokusai depicts Fuji in an imposing and triangular form in his pictures of the sacred mountain in summer under floating massive clouds, and then with lightning on the mountainside. One look at such simple and effective composition gives the viewer an unforgettable impression.

On the other hand, Hokusai published a series of picture books, *Hokusai Manga*, consisting of about 4,000 sketches of human figures, plants and animals, which has something of the nature of a textbook of painting although comical, rough sketches are also included. This series shows his strength in light sketching and has won him a world-wide reputation in a different genre.

However, these works were the products of strenuous study and effort: Hokusai studied the art of various schools and experimented with their techniques, vacillating in his own style and changing many times in search of a new style.

Katsushika Hokusai (1760–1849)

Hokusai's early works suggest that he may not have had an inborn talent for painting. The exact details of his childhood are unknown, but he himself later said that he had had the habit of sketching from nature since the age of six. He early studied the art of wood-block engraving under an engraver of *ukiyo-e* prints and this knowledge was later to act as a hidden strength in his print-making. He also seems to have taught himself painting by the study of book illustrations, but at about the age of nineteen he became a pupil of Katsukawa Shunsho and started his career as an illustrator. In his early years, Hokusai used the art-name Shunro and worked mainly on actor portraits and book illustrations. He also began to make *uki-e* (perspective pictures) displaying an exaggerated perspective and his increasing interest in Western-style painting is revealed in his remaining pictures of theatrical performance and landscapes.

After the death of his teacher Shunsho, Hokusai secretly studied under Kano Yusen (1778–1815), the exposure of which caused discord between him and his senior Shunko and resulted in his dismissal from the Katsukawa school. This event reflects the antagonism between the *ukiyo-e* artists and the classic Kano school. However, Hokusai also quarrelled with Kano Yusen: Hokusai frankly criticized Yusen's picture of children and Yusen became angry and expelled him. Hokusai renewed his efforts to expand his knowledge of painting by studying the works of Chinese Ming and Ch'ing painting and the style of Maruyama Okyo (1733–1795), a painter of the Japanese school characterized by its realistic depiction.

After he changed his art-name to Sori in 1795, Hokusai began to display strength as an independent artist.

Hokusai changed his name many times, each time seeming to try to change his art-style as well. This may also have had something to do with his moving house as many as ninety-three times during his lifetime.

Although he also used other names, he most often used the name Hokusai during the period from 1797 to his later years, the period in which he increasingly displayed his individuality. "Hokusai" means the North Star. As the North Star serves as a guide in following one's course, it has been an object of various folk beliefs. In this respect the star shining in the centre of the north sky is a symbol befitting Hokusai's self-confidence.

About the time that he began to use the name Hokusai, he illustrated various books of *kyoka* (humourous verse of thirty-one syllables), among which is the excellent *Sumida-gawa Ryogishi Ichiran* (*Views of Both Banks of the Sumida River*). This work illustrates scenes along the banks of the river going upstream, depicting the life and manners of the townsmen.

Hokusai also produced series after series of landscapes in wood-block prints, imitating copper-plate prints of the Dutch school. These works reveal, in several ways, his extraordinary interest in Western painting: the effective adoption of minute engraving lines, especially parallel ones; the depiction of volume through the use of colour; and the imitation of English spelling by writing sideways the Japanese characters of the title of the print and also his signature. These attempts, though subjective and experimental, were in response to the social trend towards exoticism prevalent at that time.

Besides landscapes of noted places in Edo, Hokusai set out to produce a print series of the Tokaido, the main road from Edo to Kyoto. Making one picture of each station, he depicts human figures and their way of life with little in the way of landscape. This work soon proved an incentive to Horoshige's landscape series.

Hokusai excelled in the portrayal of human figures and, in particular, devoted a remarkable amount of effort to portraying figures in book illustrations because they gave full scope to the techniques of exact drawing through their being monochromatic. It is said that Hokusai had a dispute with the writer Takizawa Bakin (1761–1848) over the design of illustrations, without conceding an inch. His power of depiction in various styles is vividly demonstrated in *Hokusai Manga*. This book on painting technique is encyclopaedic and contains a section on Western techniques. Besides this he also published a textbook on rough sketches made by using a compass and ruler.

From 1831 to 1833, he produced *Fugaku Sanju-rokkei* (*Thirty-six Views of Mount Fuji*), the series actually totalling forty-six landscape prints which made him famous. Some of these prints are composed mainly of

human figures, but before long prints of landscape alone appear. Hokusai travelled from place to place in order to paint Mount Fuji from various positions and angles. Thus, he made the first independent landscapes and established this as a genre of *ukiyo-e*. It is his great achievement to have introduced to the public the beauty of pure landscapes in wood-block prints, a means of mass-producing pictures.

Furthermore, Hokusai produced fine prints of fish and of birds and flowers, as well as strange, grotesque works and voluptuous, erotic ones, displaying an astonishing variety of styles. He was so intensely driven by a passion for depicting the variety of objects existing in the world that he called himself a painting-crazed old man. In the booklet *Ehon Saishiki-tsu* (*How to Paint*) published in his last years, he also wrote about his original oil-painting techniques.

Always dissatisfied with his style, Hokusai intended to improve it even if it took 100 years; he excelled over all other *ukiyo-e* artists in strength of will and effort. He produced many surprising works but died before the dawn of modern Japan.

Totoya Hokkei (1780–1850)

Hokkei first studied painting in the Kano school and later became a pupil of Hokusai. The name Totoya (fish dealer) is derived from his being a fish dealer to a *daimyo* (feudal lord). He won fame by illustrating the literary works of the writer Takizawa Bakin, a partner of Hokusai. Besides a large output of book illustrations and *surimono* (literally "printed thing"; specifically, prints, usually of small size, for announcements, commemorative or verse-publishing purposes), Hokkei produced the fine print series *Shokoku Meisho* (*Famous Places in Various Provinces*). He was the most well-educated among the pupils of Hokusai.

Shotei Hokuju (active during the early 19th century)

Although the details of his career are not well-known, Hokuju studied under Hokusai and was especially influenced by Hokusai's Western-style painting. His landscapes have a simplified depiction and colouring, showing his own original style. He produced landscape series (depicting famous places in Edo and also Tokaido).

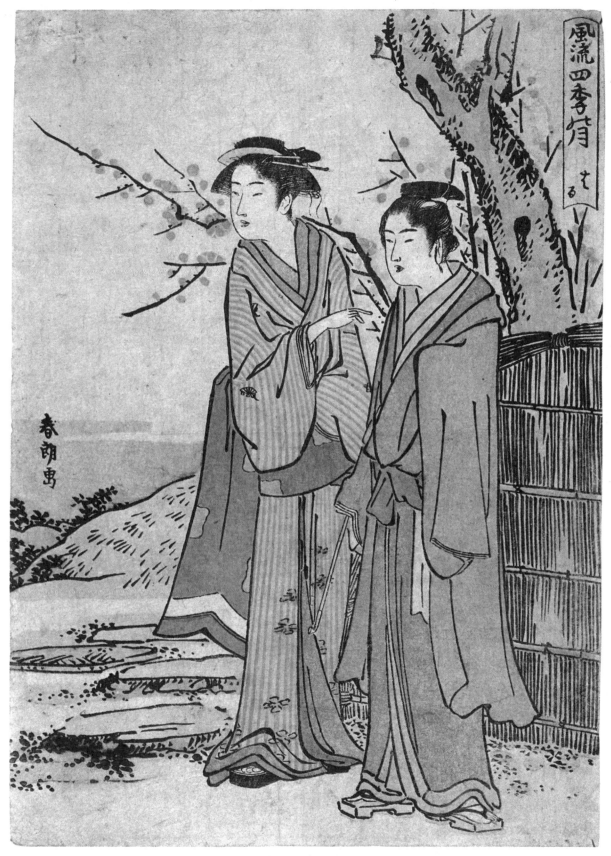

Hokusai *Spring*, from the series *Four Seasons*
(Furyu Shiki no Tsuki)
Chuban, Nishiki-e, 22 × 15.5 cm
Publisher : unkown. Date : c. late 1780's. Takahashi
Collection, Japan

A young man and woman. A work of Hokusai's youth
showing a fresh touch, but an elaborate composition.
Plum blossons are seen in the background.

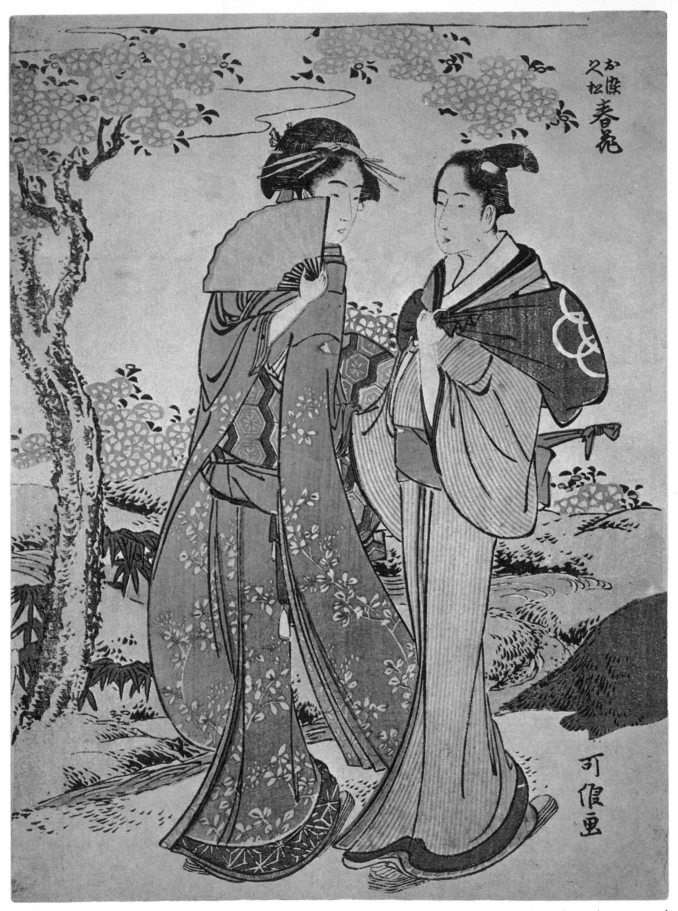

Hokusai *Osome and Hisamatsu under Cherry-tree*
Chuban, Nishiki-e, 23.4 × 17.4 cm
Publisher: unknown. Date: c. late 1790's. Worcester
Art Museum, Massachussetts

Lovers secretly clasping hands under a cherry-tree. A
hero and heroine in an account of lovers' suicide, a
famous theme of songs and plays.

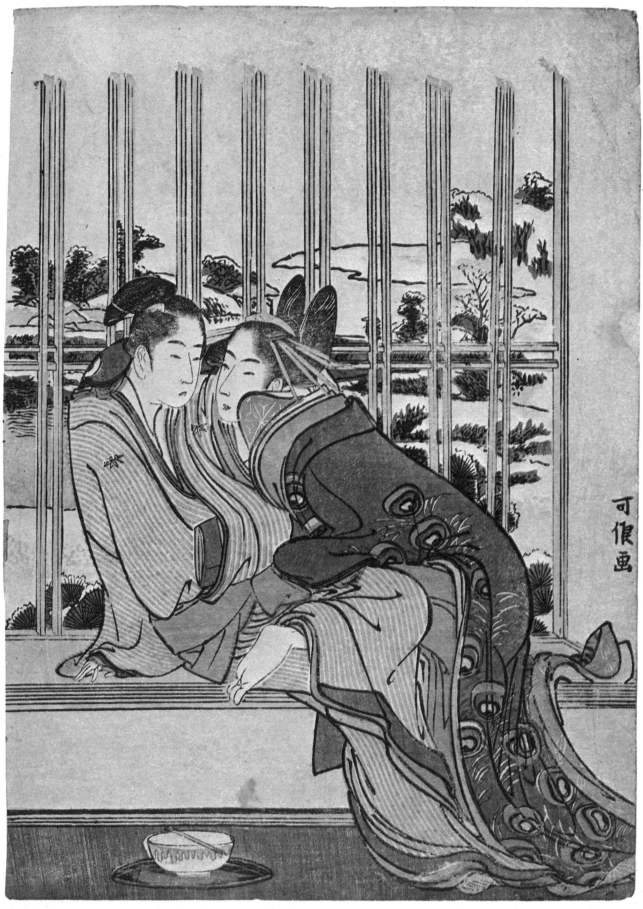

Hokusai *Azuma and Yogoro*
Chuban, Nishiki-e, 23.5 × 16.5 cm
Publisher: unknown. Date: c. late 1790's

A couple dallying: a hero and heroine in a *joruri*
(Japanese ballad-drama) popular at that time.

Hokusai Above: *Mount Fuji Seen under Takabashi Bridge (Takabashi no Fuji)*
Chuban, Nishiki-e, 18.2 × 24.5 cm
Publisher: unknown. Date: c. 1800's

Showing an exaggerated and concentrated composition: Mount Fuji is seen in the centre. A man on the left is fishing.

Hokusai Below: *Landscape at Ushigafuchi, Kudan (Kudan Ushigafuchi)*
Chuban, Nishiki-e, 19 × 25.6 cm
Publisher: unknown. Date: c. 1800's

A work in the style of Western painting that gives a massive impression by the depiction of a slope and the stone wall of a moat. Drawing shadows was a novel technique in Hokusai's days.

Hokusai
Sakanoshita, from
the series *Fifty-three
Stations on the Tokaido
(Tokaido Gojusan-tsugi)*
Oban, Nishiki-e,
13.1 × 17.8 cm
Publisher : unknown.
Date : c. 1804

Travellers taking a
rest. The young man
in the foreground
a baggage carrier.
A pine tree is on
the right.

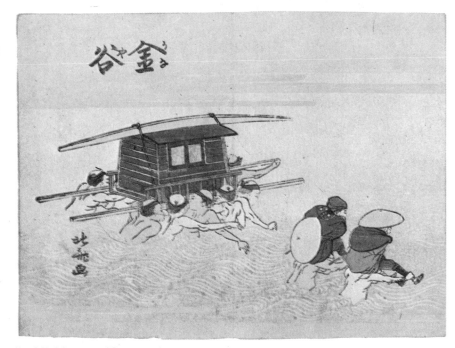

Hokusai *Kanaya,*
from the series *Fifty-
three Stations on the Tokaido
(Tokaido Gojusan-tsugi)*
Oban, Nishiki-e,
12.4 × 16.3 cm
Publisher : unknown.
Date : c. 1800's.
Sakai Collection, Japan

Crossing the River Oi.
At points where
bridges could not be
constructed for
physical reasons,
travellers crossed by
rendai (palanquin)
or riding on
porters' shoulders.

Hokusai *Tea-stall of Echizenya (Oyasumi-
dokoro Echizenya)* Surimono (prints for
announcement), 19.4 × 52.6 cm
Publisher : unknown. Date : 1804. Tokyo
National Museum, Japan

A scene of travelling in those days : a rest
house and travellers. On the right is an
announcement of a party.

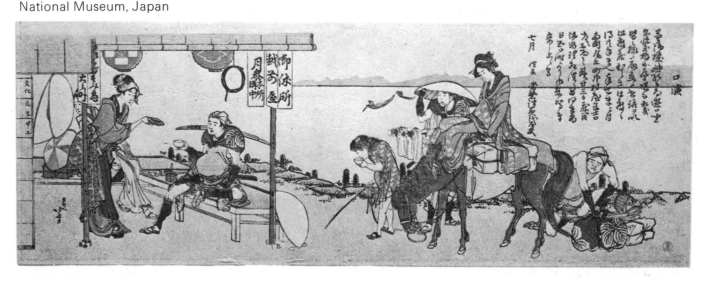

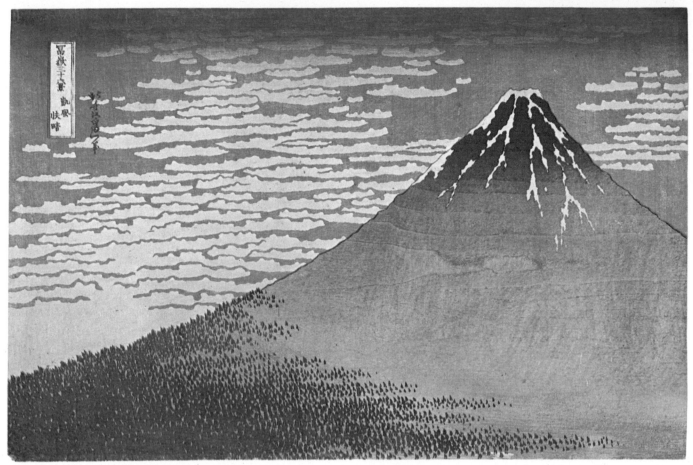

Hokusai Above: *Mount Fuji on a Fine Day with Breeze*, from the series *Thirty-six Views of Mount Fuji (Fugaku Sanju-rokkei)*
Oban, Nishiki-e, 25.5 × 38 cm
Publisher: Nishimura-ya Yohachi. Date: c. early 1830's. Takahashi Collection, Japan
Mount Fuji in summer against the fleecy clouds.

Hokusai Below: *Mount Fuji above Lightning*, from the series *Thirty-six Views of Mount Fuji (Fugaku Sanju-rokkei)*
Oban, Nishiki-e, 25.6 × 38.6 cm
Publisher: Nishimura-ya Yohachi. Date: c. early 1830's
Mount Fuji soars above thunder clouds with lightning playing on the mountainside.

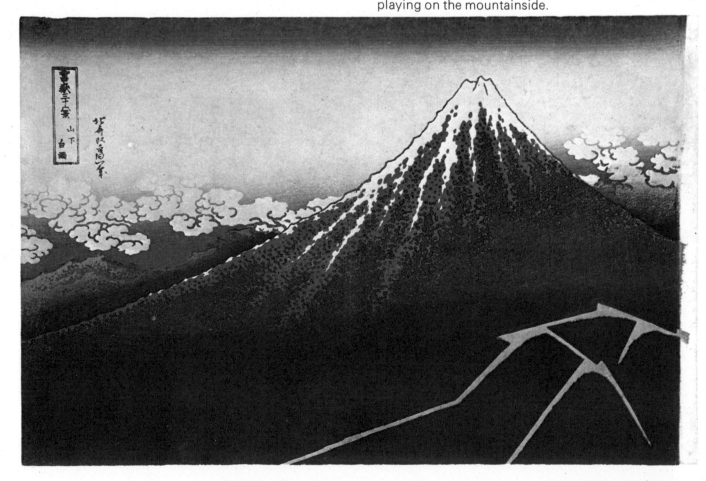

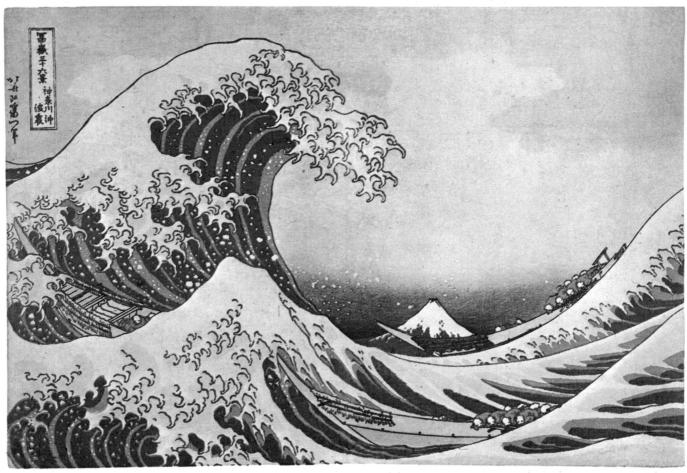

Hokusai Above: *Stormy Sea off Kanagawa*, from the series *Thirty-six Views of Mount Fuji (Fugaku Sanju-rokkei)*
Oban, Nishiki-e, 25 × 37 cm
Publisher: Nishimura-ya Yohachi. Date: c. early 1830's

Raging waves and boats being tossed about.

Hokusai Below: *Ejiri in Sunshu*, from the series *Thirty-six Views of Mount Fuji (Fugaku Sanju-rokkei)*
Oban, Nishiki-e, 25.4 × 37.6 cm
Publisher: Nishimura-ya Yohachi. Date: c. early 1830's

Travellers buffeted by a strong wind: papers in their pockets are blown away into the sky.

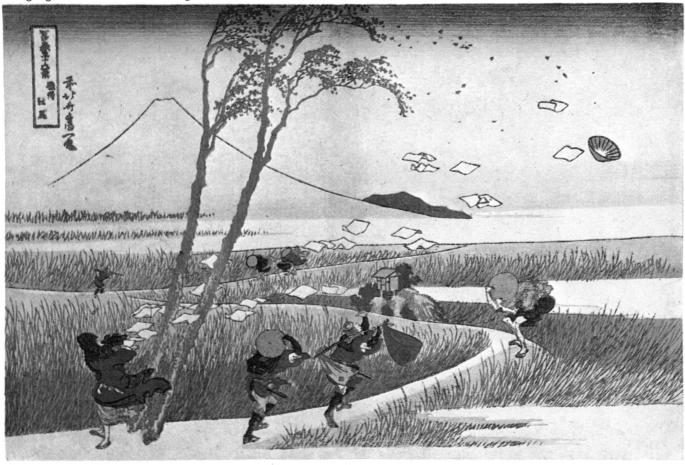

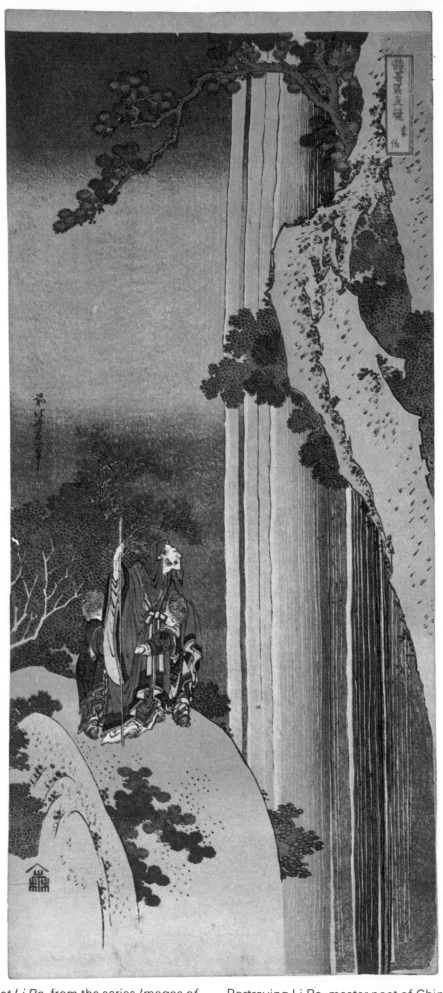

Hokusai *The Poet Li Po*, from the series *Images of Poets (Shiika Shashin Kagami)*
Long oban, Nishiki-e, 52 × 23.1 cm
294 Publisher: Mori-ya Jihei. Date: c. early 1830's
Honolulu Academy of Arts

Portraying Li Po, master poet of China, based on an ancient subject of Chinese painting.

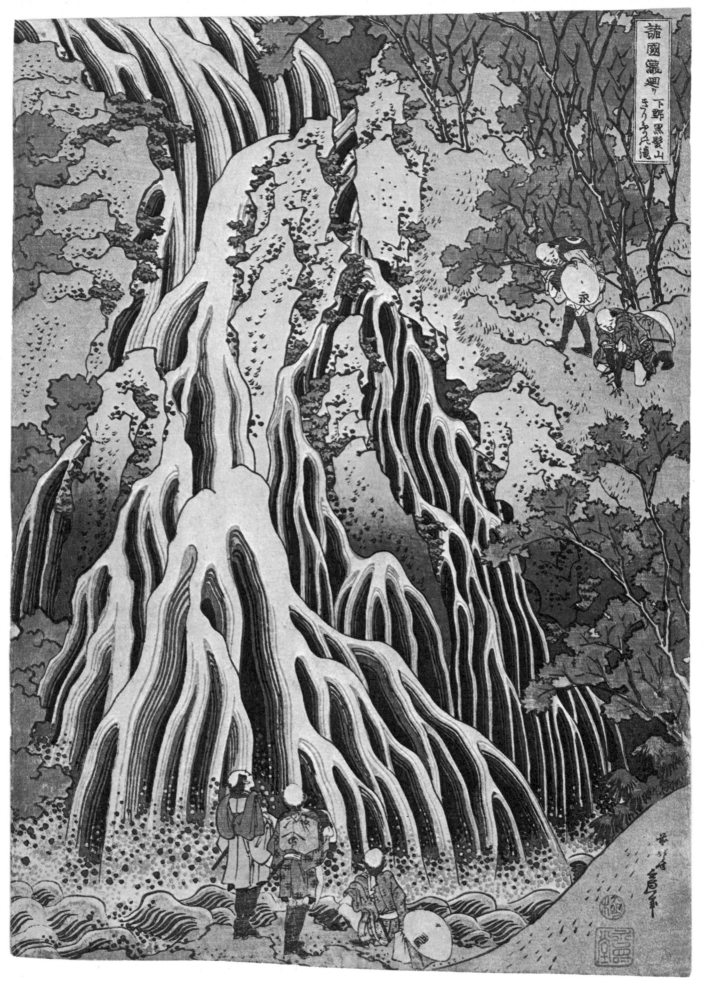

Hokusai *The Kirifuri Falls in Mount Kurokami, Shimotsuke*, from the series *Tour of Falls in Various Provinces (Shokoku Taki Meguri)*
Oban, Nishiki-e, 36.5 × 25.7 cm
Publisher: Nishimura-ya Yohachi. Date: c. early 1830's. Sakai Collection, Japan

Stylized depiction of a waterfall.

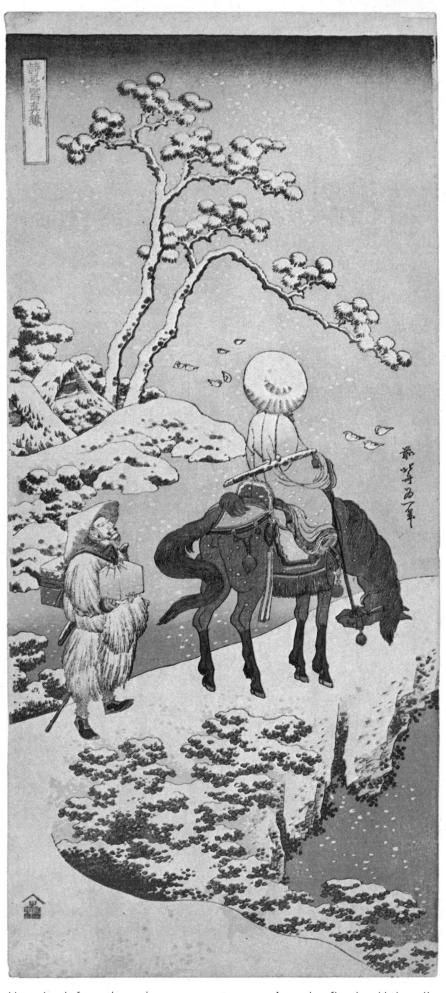

Hokusai *Toba on Horseback*, from the series
Images of Poets (Shiika Shashin Kagami)
Long oban, Nishiki-e, 51.9 × 22.9 cm
Publisher: Mori-ya Jihei. Date: c. early 1830's. Riccar
Art Museum, Japan.

A work reflecting Hokusai's taste for Chinese art.

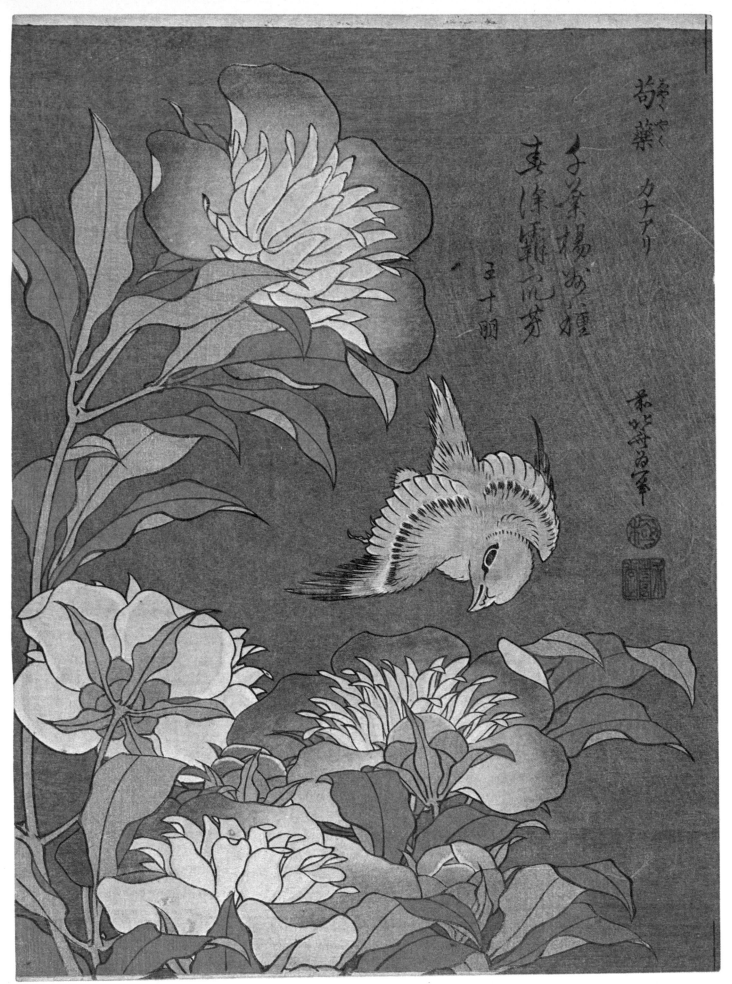

Hokusai *Peonies and a Canary*
Chuban, Nishiki-e, 25.9 × 19.3 cm
Publisher: Nishimura-ya Yohachi. Date: c. early
1830's. Tokyo National Museum

A flower-and-bird picture.

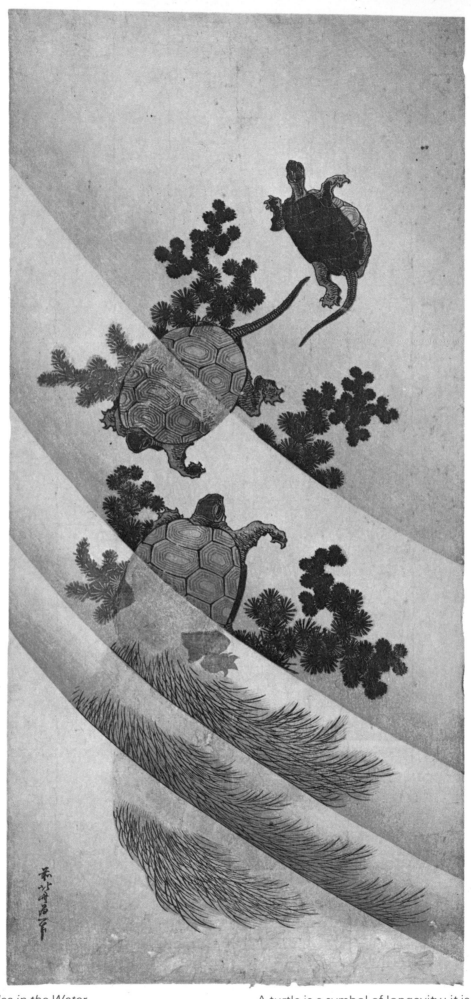

Hokusai *Turtles in the Water*
Long oban, Nishiki-e, 50 × 23.8 cm
Publisher: unknown. Date: c. early 1830's. Tokyo
National Museum

A turtle is a symbol of longevity: it is said that the shell
of a long-lived turtle is covered with seaweed.

298

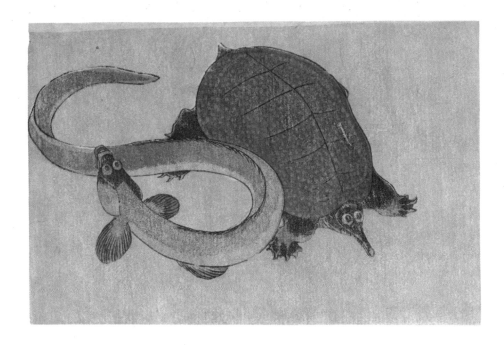

Hokusai (Unsigned) Above: *Sea-bream and Saurel*
Koban, Nishiki-e, 11.9×17.9 cm
Publisher: unknown. Date: c. 1830's

Hokusai (Unsigned) Top: *Terrapin and Eel*
Koban, Nishiki-e, 11.8×17.8 cm
Publisher: unknown. Date: c. 1830's

Hokusai *Throwing Nets at Ohashi,* from the picture book with *kyoka Views of Both Banks of the Sumida River (Sumida-gawa Ryogishi Ichiran)* vol. 1

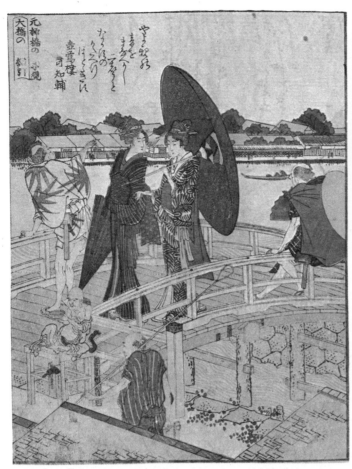
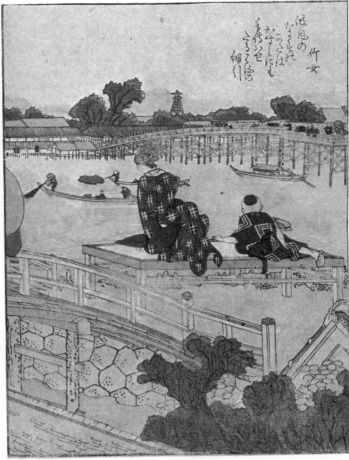

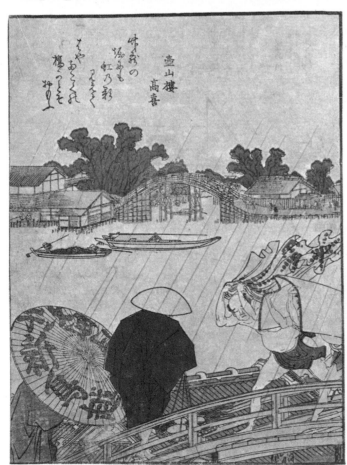
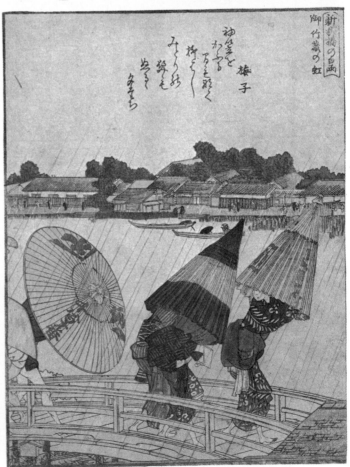

Hokusai *Shower at Shin-Yanagibashi,* from the same book , vol. 2

300

Each page 27.2 × 18.5 cm
Publisher: Tsuru-ya Kie-imon. Date: c. 1800's

A work illustrating scenes along the banks of the Sumida travelling upstream, depicting the life and manners of the townspeople. In the upper part of each picture is written a *kyoka* (humourous verse) associated with the place.

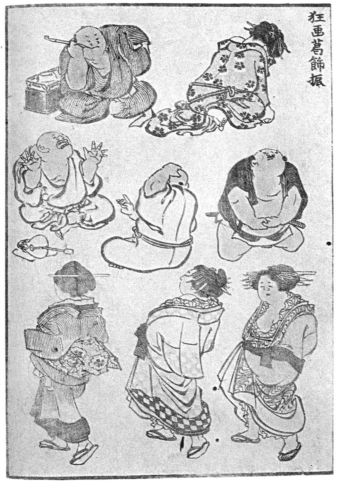

Hokusai *Wish to Become Fat*, from the book
Hokusai Manga, vol. 8.
Each page 22.7 × 16 cm
Publisher: Kakumaru-ya Jinsuke. Date: c. 1818

Caricatures from the picture book *Hokusai Manga* in
15 volumes, including sketches Hokusai made for his
own pleasure. Though called *manga*, they are different
from the present-day comic books.

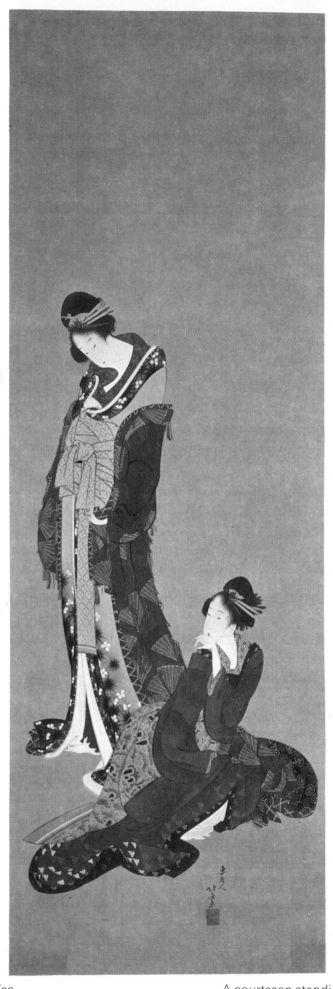

Hokusai *Two Beauties*
Painting on silk, 110.6 × 36.7 cm
Date : c. 1800's. Kyusei Atami Art Museum, Japan

A courtesan standing and another sitting.

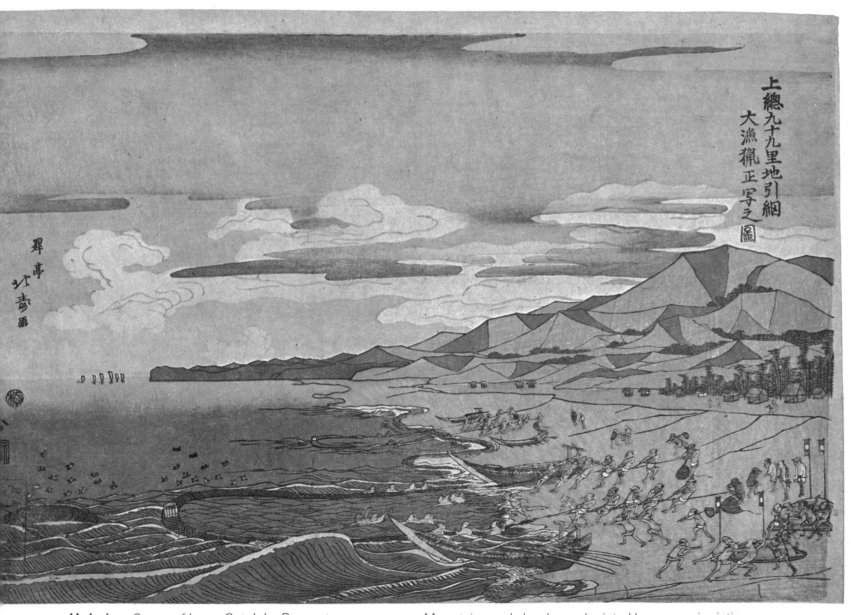

Hokuju *Scene of Large Catch by Dragnet on Kujukuri Beach, Kazusa (Kazusa Kujukuri Jibikiami: Daigyoryo Utsushi* no-Zu)
Oban, Nishiki-e, 26.8 × 39.3 cm
Publisher: Nishimura-ya Yohachi. Date: c. 1810's.
Takahashi Collection, Japan

Mountains and clouds are depicted by expressionistic touches.

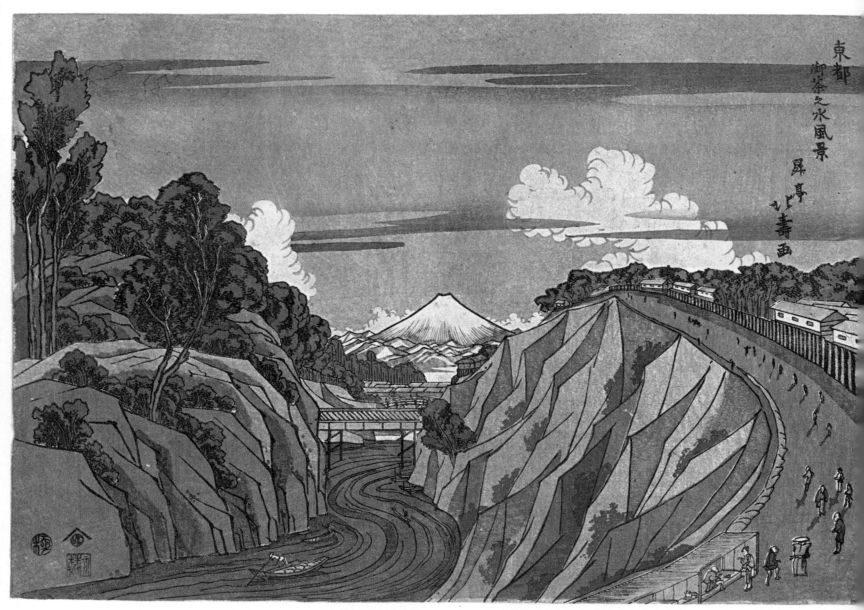

東都
御茶之水風景

屏亭
北壽画

Hokuju *View of Ochanomizu in the Eastern Capital*
(*Toto Ochanomizu Fukei*)
Oban, Nishiki-e, 26.6 × 38.9 cm
Publisher: Nishimura-ya Yohachi. Date: c. 1810's
Sakai Collection, Japan

View of Ochanomizu: an artificial canal to supply the
moat of Edo Castle with water, and a wooden conduit
pipe over it. Mount Fuji in the centre.

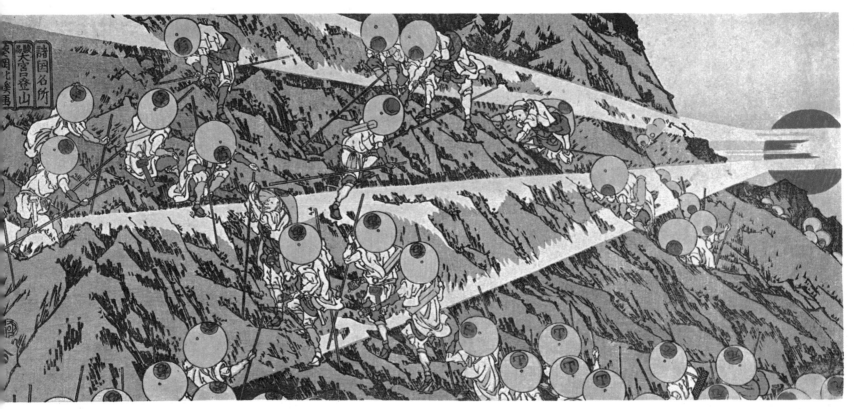

Hokkei *Pass of Omiya in Sunshu,* from the series
*Famous Places in Various Provinces (Shokoku
Meisho)*
Otanzakuban, Nishiki-e, 38.1 × 17 cm
Publisher: Nishimura-ya Yohachi. Date: c. 1830's
Sakai Collection, Japan

Ascetics are climbing the sacred mountain Fuji, as the
sun rises. Japanese characters on straw hats differ
according to group.

The poetry of landscape

A master of poetic landscapes

Traditional Oriental landscape painting has strong metaphysical and mental elements. That is to say, it is idealized and conceptualized, though it is naturally related to the actual climate and physical landscape. It was China that established the basic concepts and style of Oriental landscape painting, ones which strongly influenced Japanese painting as well. The treatment of landscape in *ukiyo-e* was no exception.

In early *ukiyo-e* streams and hills sometimes appeared in the background of a portrait, especially when it depicted the scene of a tale or a famous site. This tendency remained unchanged with the appearance of *nishiki-e* ("brocade pictures"). After Kiyonaga, the style of landscapes made a rapid change towards realism. However, the subjects of landscape pictures were restricted mainly to Edo and its environs.

Then with the gradual improvement of main roads in the country, more and more people were willing to travel and artists began to take these long journeys as the subjects of their pictures. *Tokaido Gousan-tsugi (Fifty-three Stations on the Tokaido)* by Hokusai was one of the earliest to do so. It was also Hokusai who had established landscape as an independent genre of *ukiyo-e* with his *Fugaku Sanju-rokkei (Thirty-six views of Mount Fuji)*.

In those days, as a traditional and academic Japanese painting, the conceptional, Chinese style *sansui-ga* (mountain and water pictures) was the main style of painting, to which both the Kano and literary schools of painting belonged. But those artists who kept their eye on the Western style of painting began to pay increasing attention to those drawn from nature and gradually even those who belonged to the academic painting groups began to depict Japanese scenic beauty differing from that of China because of the differences in climate. Here, Mount Fuji attracted attention as being archetypically Japanese. And the credit for making scenes of Mount Fuji popular among the people also belongs to Hokusai.

Then Hiroshige travelled along the Tokaido road, following in the footsteps of Hokusai. He depicted this journey of 490 kilometres, which he undertook on foot, in a series of prints which immediately won him a reputation as a master of landscape. After that Hiroshige maintained his leading position by portraying the noted sights of Edo and the provinces up to his later years.

Utagawa Hiroshige (1797–1858)

Hiroshige was born of a low-ranking *samurai* family; his father was a fire-fighter at Edo Castle. At the age of ten he had already done impressive works such as his painting of *Ryukyu* delegates in procession. It was not until he was twenty-seven years old that he devoted himself solely to painting, and transferred the headship of his family to his uncle, though he had become a pupil of Utagawa Toyohiro when he was fifteen years old and had been studying the art of the Utagawa school.

Hiroshige did not originally intend to become a landscape artist. He started his career as a book illustrator and then took up *bijin-ga* (pictures of beautiful women). *Soto to Uchi Sugata Hakkei (Eight Indoor and Outdoor Scenes)*, designed at the age of twenty-five, was one of his early works, but it already displays the distinctive style of a master artist.

However, Hiroshige ceased to be an artist of *bijin-ga*, and made his debut as a landscape artist with a series of ten prints, *Toto Meisho (Famous Places in the Eastern Capital)*. Stimulated by the publication of Hokusai's *Fugaku Sanju-rokkei (Thirty-six Views of Mount Fuji)* at that time, Hiroshige depicted his experiences and impressions while travelling along the Tokaido and published them as a series of fifty-five pictures, *Tokaido Gojusan-tsugi (Fifty-three Stations on the Tokaido)*. He included each relay-station's name, the travellers he had met and the customs of each locality. Portraying the changes in the weather and the scenery from season to season, he enhanced the lyricism of these pictures. As this series of prints proved successful, he gained confidence in his landscapes and further developed his abilities as a painter.

This success depended upon the lyrical nature of his works in which he harmoniously depicted scenery together with the life of different peoples and their manners and customs. His works make us feel close to remote places and peoples; sometimes these travellers are treated humourously and sometimes we are reminded that travelling can be as hard and lonely as life itself sometimes is.

After that he completed a series of prints of famous places such as Ohmi, Kyoto, Osaka and Edo, all of which were fine works. After the success of *Tokaido Gojusan-tsugi*, he published a longer series *Kisokaido Rokujukyu-tsugi (Sixty-nine Stations on the Kiso Kaido)*. Hiroshige started this series in collaboration with Eisen (who is referred to in the next chapter), but Eisen resigned in the course of the work so that Hiroshige completed it by himself. In this joint work, Hiroshige's lyrical characteristic was very pronounced.

Hiroshige in his last years published many series of landscapes of the Tokaido and the environs of Edo. The composition of his works became so bold that he drew both a distant view and a close object together in one print. This can be seen in his unfinished last major work *Meisho Edo Hyakkei* (*One Hundred Views of Famous Places in Edo*), two pictures of which were copied in oils by Van Gogh.

Hiroshige set about designing *kacho-ga* (bird-and-flower pictures) at the same time that he started landscapes. Compared with the *kacho-ga* of Hokusai, Eisen and other artists, Hiroshige's were more lyrical, as might be expected. Another difference was that he produced the feeling of a wider space on a small canvas.

Hiroshige often portrayed rain and fog in his landscapes, and he also left behind fine works of snow. White and soft paper of fine quality by itself is effective in depicting the feeling of a peaceful snow scene, but Hiroshige made the most of this effectiveness. He utilized various methods to express snow falling; his skilled brush-work and wood-block technique show his sharp sense for detail.

In contrast with the passionate Hokusai, Hiroshige was a gentle person. It can be said that Hiroshige observed more closely the natural features of Japan and perhaps loved his country more than Hokusai. In 1858, when cholera was prevalent in Edo, he died at the age of sixty-two.

Hiroshige II (1826–1869)

Hiroshige II, originally named Shigenobu, was a pupil of Hiroshige. He married Hiroshige's eldest daughter, after Hiroshige's death, and became Hiroshige the Second. He completed *Meisho Edo Hyakkei* (*One Hundred Views of Famous Places in Edo*) which was left unfinished by Hiroshige. Imitating his master's style, he drew landscapes of noted sights in Edo and on the Tokaido. His best works are *Shokoku Meisho Hyakkei* (*One Hundred Views of Famous Places in Various Provinces*) and *Toto Sanjurokkei* (*Thirty-six Views of the Eastern Capital*).

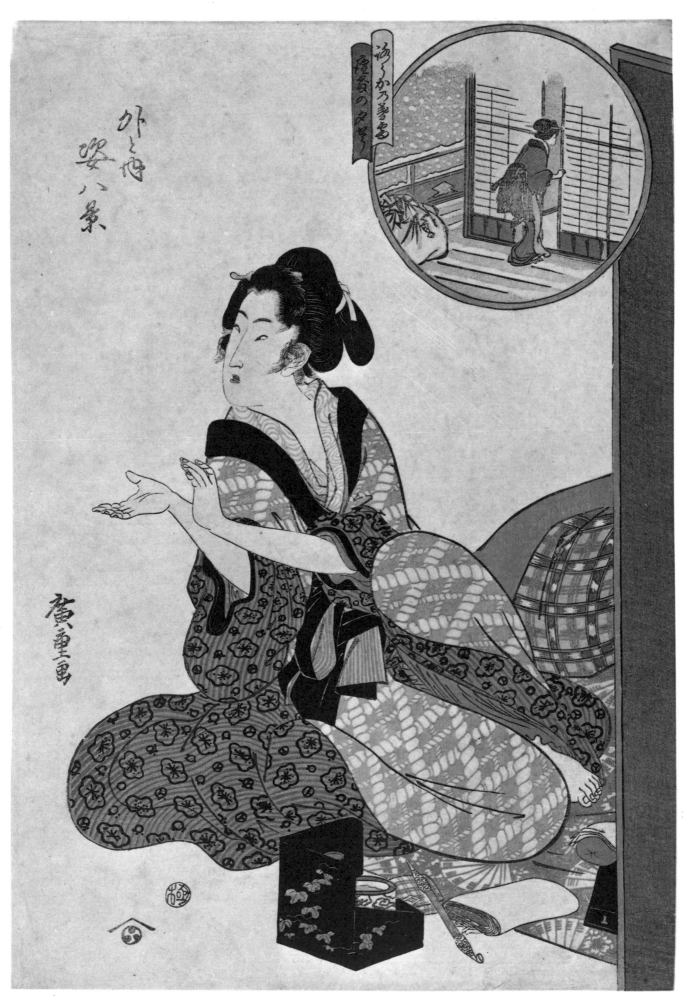

Hiroshige *Corridor in the Evening Snow and Courtesan in the Bright Room,* from the series *Eight Indoor and Outdoor Scenes* (*Soto to Uchi Sugata Hakkei*)
Oban, Nishiki-e, 37.9 × 25.7 cm
Publisher: Nishimura-ya Yohachi. Date: c. 1821

An excellent series from Hiroshige's early days. A courtesan clapping her hand for a maid, who then enters the room.

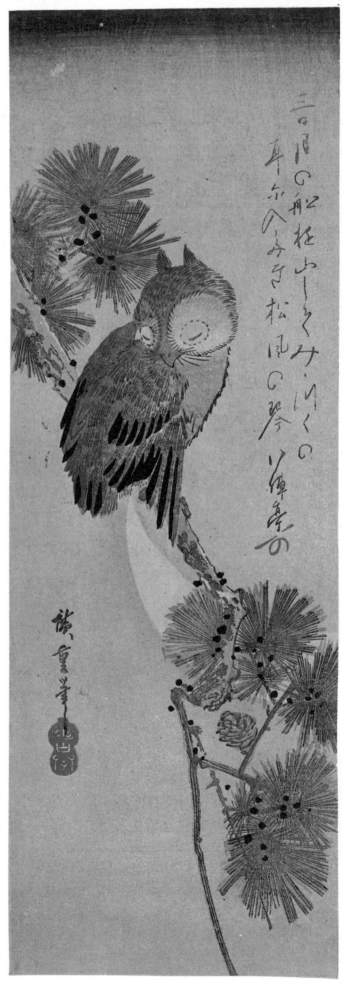

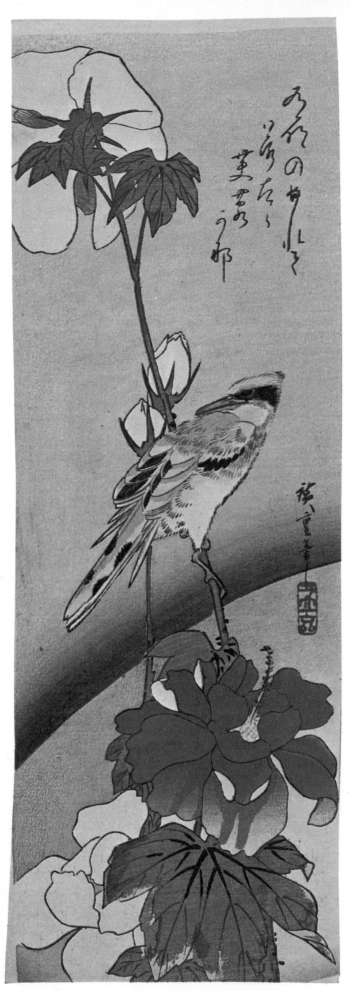

Hiroshige Left: *Owl in Moonlight*
Chutanzakuban, Nishiki-e, 37.3 × 12.7 cm
Publisher: unknown. Date: c. early 1830's

310 An owl perched on a pine tree in moonlight.

Hiroshige Right: *Rose Mallow and Bird*
Chutanzakuban, Nishiki-e 38.5 × 13.3 cm
Publisher: unknown. Date: c. early 1830's
Rose mallows with a bird perched on the stem.

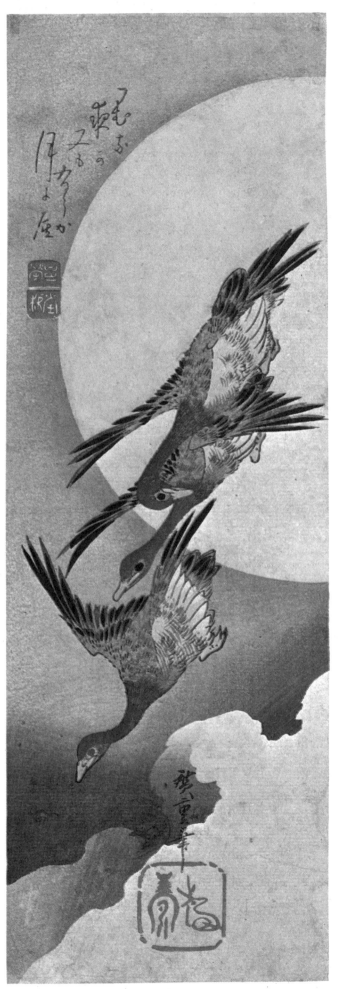

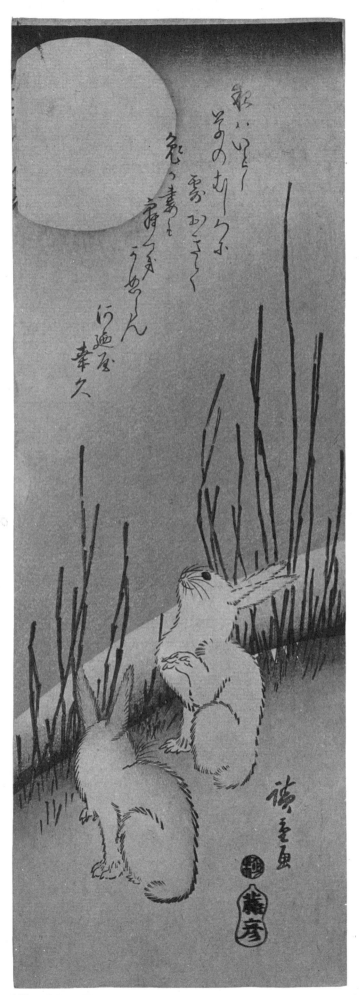

Hiroshige Left: *Wild Geese in Moonlight*
Chutanzakuban, Nishiki-e, 38.2 × 12.7 cm
Publisher: Kawaguchi Shozo. Date: c. early 1830's
One of the most popular subjects of *kacho-ga* (flower-and-bird picture). A work, which together with the following three, includes *kyoka* or *haiku* related to the picture.

Hiroshige Right: *Rabbits in Moonlight*
Chutanzakuban, Nishiki-e, 37.7 × 13 cm
Publisher: Fujioka-ya Hikotaro. Date: c. early 1830's
Tokyo National Museum
Rabbits and the moon. Rushes are in the background.

311

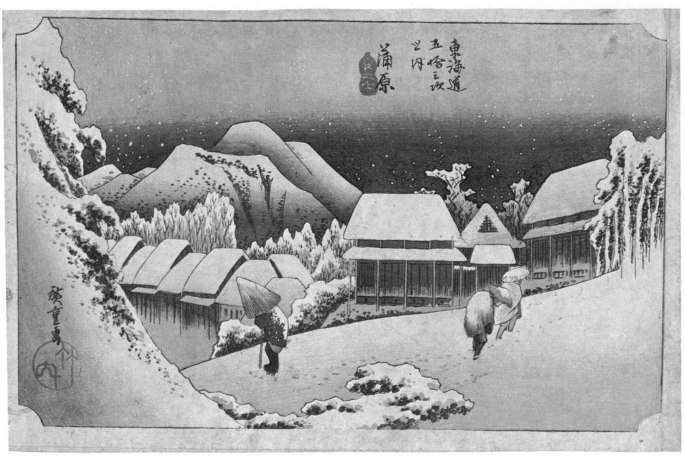

Hiroshige Above: *Night Snow at Kambara*, from the series *Fifty-three Stations on the Tokaido (Tokaido Gojusan-tsugi)*
Oban, Nishiki-e, 24.2 × 36.7 cm
Publisher: Hoei-do. Date: c. 1833. Tokyo National Museum

A desolate night scene at a post town in the snow.

Hiroshige Below: *The Lake of Hakone*, from the series *Fifty-three Stations on the Tokaido (Tokaido Gojusan-tsugi)*
Oban, Nishiki-e, 24.2 × 36.7 cm
Publisher: Hoei-do. Date: c. 1833. Tokyo National Museum

One of the *Tokaido* series which made Hiroshige famous. The procession of a *daimyo* (feudal lord) crossing over a steep mountain pass.

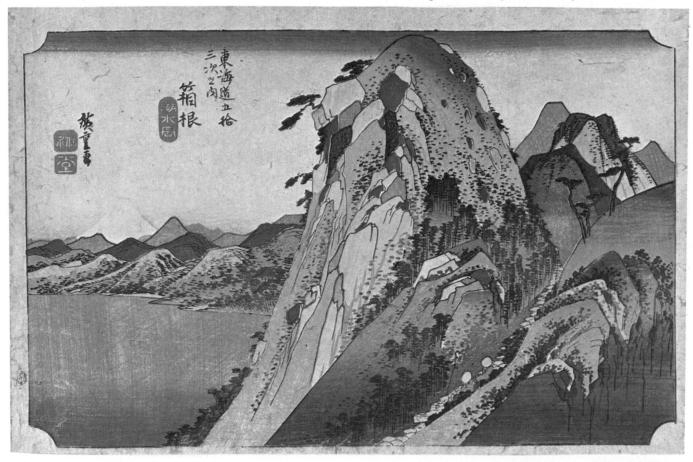

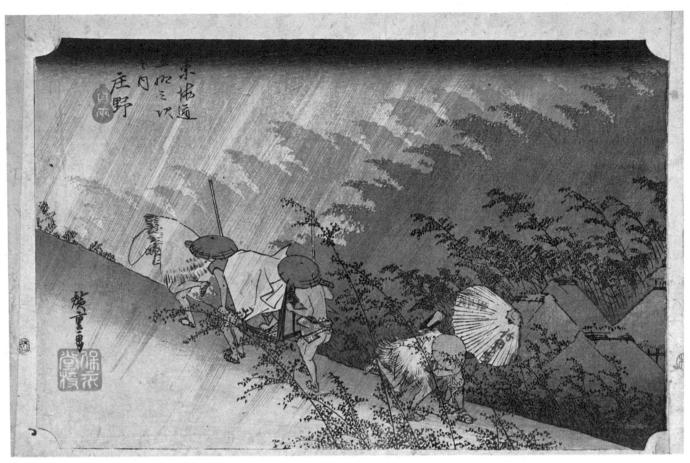

Hiroshige Above : *Shower at Shono*, from the series *Fifty-three Stations on the Tokaido (Tokaido Gojusan-tsugi)*
Oban, Nishiki-e, 24.2 × 36.7 cm
Publisher : Hoei-do. Date : c. 1833. Tokyo National Museum

A layered bamboo thicket is swayed by a rainstorm and travellers are hurrying on their way.

Hiroshige Below : *Seba*, from the series *Sixty-nine Stations on the Kisokaido (Kisokaido Rokujukyu-tsugi)*
Oban, Nishiki-e, 25 × 38.1 cm
Publisher : Ise-ya Rihei. Date : c. mid 1830's

Barges passing in the windy evening. The willow trees are swaying in the wind.

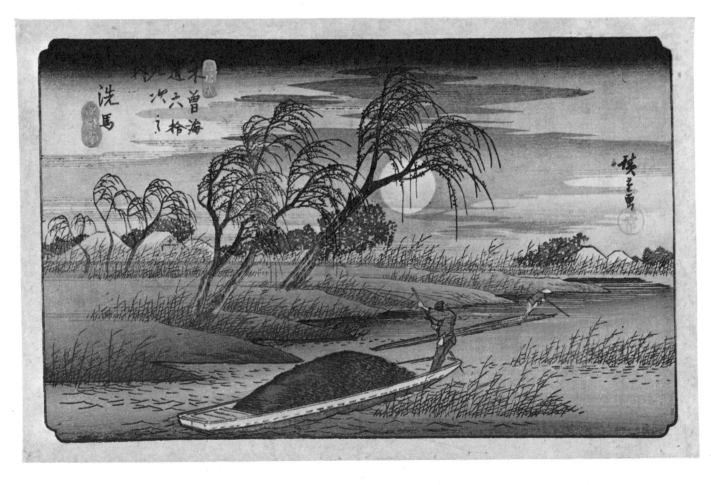

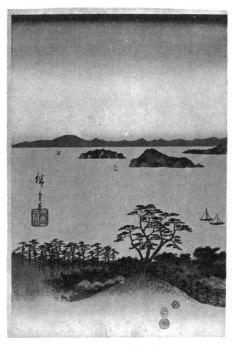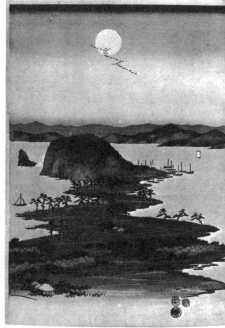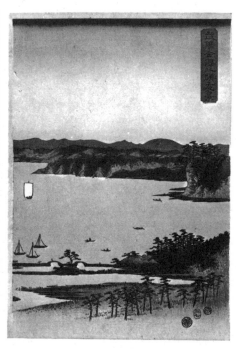

Hiroshige *Eight Scenic Views of Kanazawa under Full Moon (Buyo Kanazawa Hassho Yakei)*
Oban, Nishiki-e, Triptych, left: 38.1 × 25.7 cm, centre: 38 × 25.8 cm, right: 38.3 × 25.9 cm
Publisher: Okazawa-ya Taheiji. Date: 1857. Riccar Art Museum, Japan

One of Hiroshige's masterpieces in his late years. A series of three prints depict a panorama of the inlet of a scenic spot near Edo.

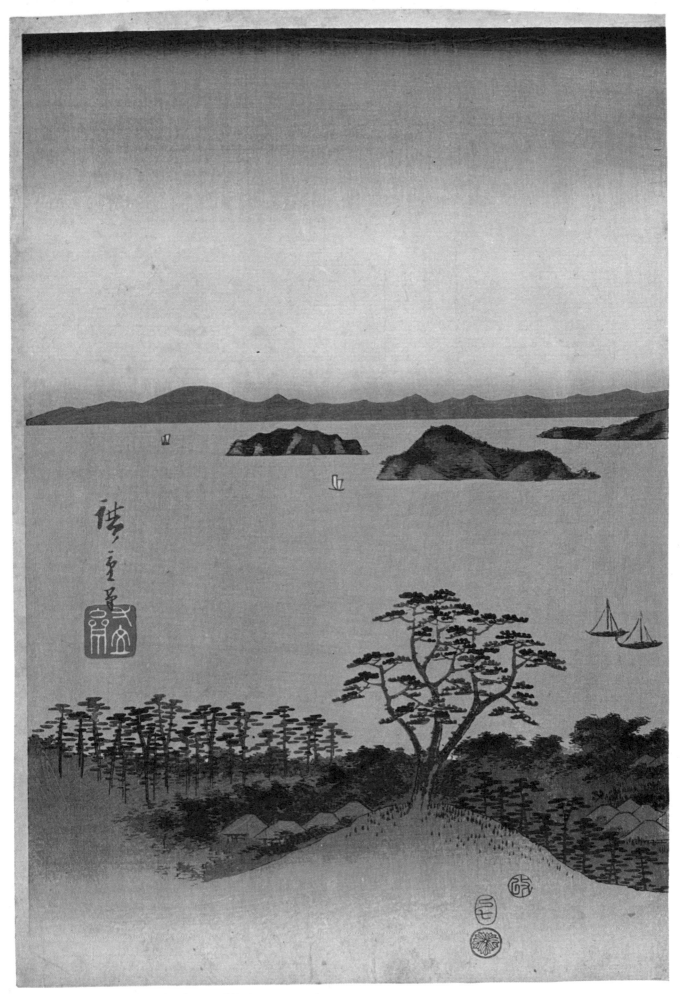

Hiroshige *Eight Scenic Views of Kanazawa under Full Moon*
Left panel of the triptych.

Hiroshige *Eight Scenic Views of Kanazawa under Full Moon*
Central panel of the triptych.

Hiroshige *Eight Scenic Views of Kanazawa under Full Moon*
Right panel of the triptych.

Hiroshige *Senso-ji Temple, Asakura*, from the series *One Hundred Views of Famous Places in Edo (Meisho Edo Hyakkei)*
Oban, Nishiki-e, 36.1 × 25 cm
Publisher: Uo-ya Eikichi. Date: 1856

The temple in the snow seen from its gate. Snow is printed by *karazuri*. A paper-lantern dedicated by believers hangs in the upper part.

Hiroshige *Plum Garden at Kameido*, from the series
*One Hundred Views of Famous Places in Edo (Meisho
Edo Hyakkei)*
Oban, Nishiki-e, 36.1 × 25.5 cm
Publisher : Uo-ya Eikichi. Date : 1857

A place in Edo famous for plum blossoms. This work
shows a bold, impressive composition. Van Gogh
made a copy of this print.

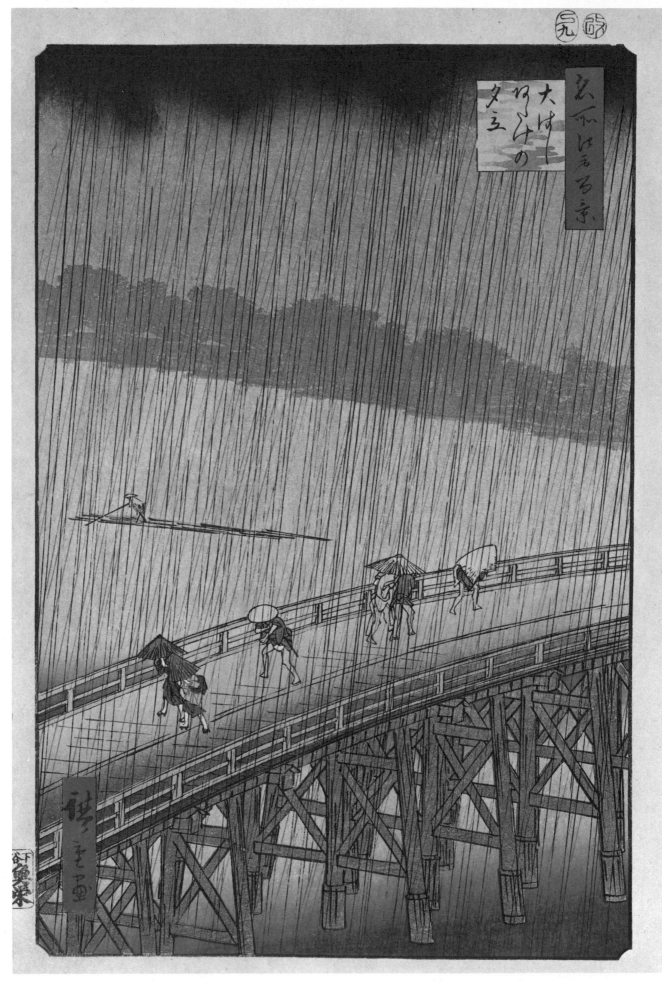

Hiroshige *Ohashi Bridge and Atake in Sudden Shower,* from the series *One Hundred Views of Famous Places in Edo (Meisho Edo Hyakkei)* Oban, Nishiki-e, 36.5 × 24.7 cm Publisher: Uo-ya Eikichi. Date: 1857

Townsmen hurrying on their way in a shower. There is another print depicting three ships. Van Gogh's copy made this work famous.

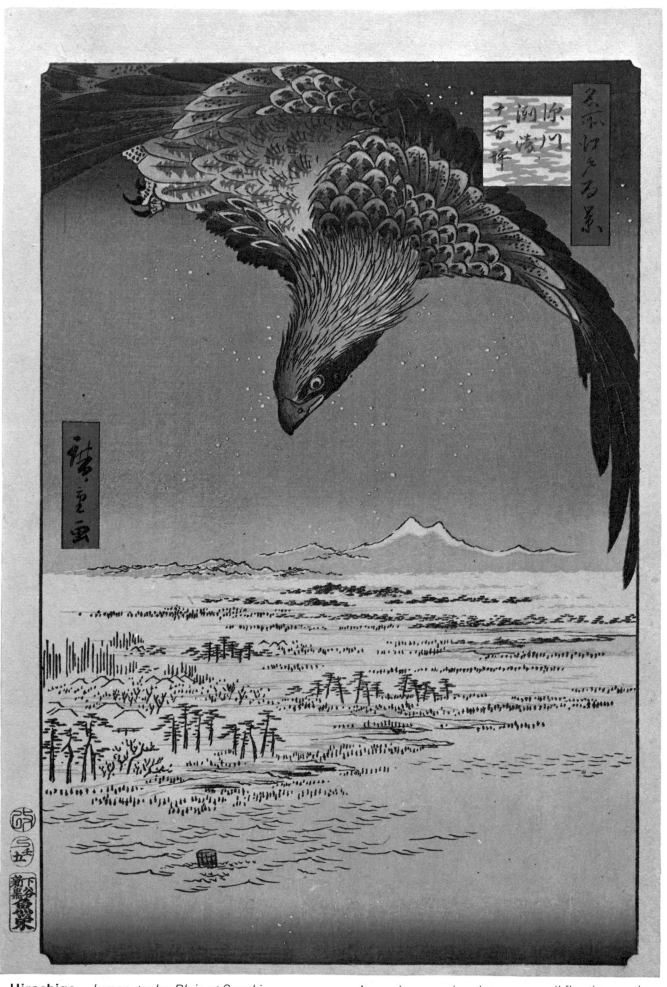

Hiroshige *Juman-tsubo Plain at Susaki, Fukagawa,* from the series *One Hundred Views of Famous Places in Edo (Meisho Edo Hyakkei)* Oban, Nishiki-e, 36.4 × 25 cm Publisher: Uo-ya Eikichi. Date: 1858

An eagle swooping down on a pail floating on the waves. A work of fantastic design.

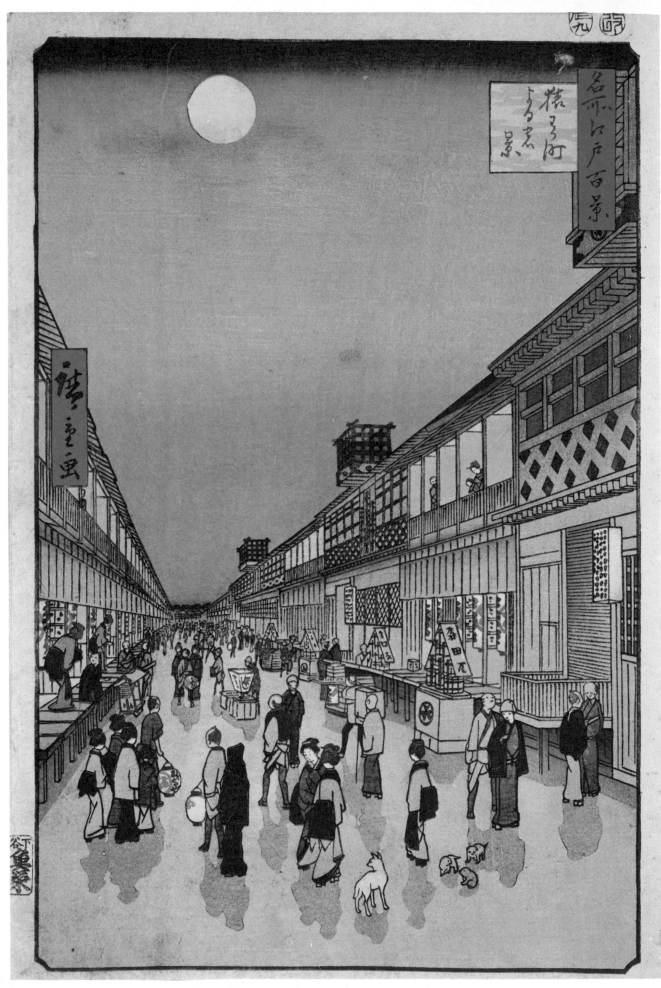

Hiroshige *Saruwaka-cho in Moonlight*, from the series *One Hundred Views of Famous Places in Edo (Meisho Edo Hyakkei)*
Oban, Nishiki-e, 35.3 × 23.8 cm
Publisher: Uo-ya Eikichi. Date: 1856

A theatre district in Asakusa in Edo. Scaffolds on the roofs of the right-hand buildings are theatre signs. On the left are tea houses.

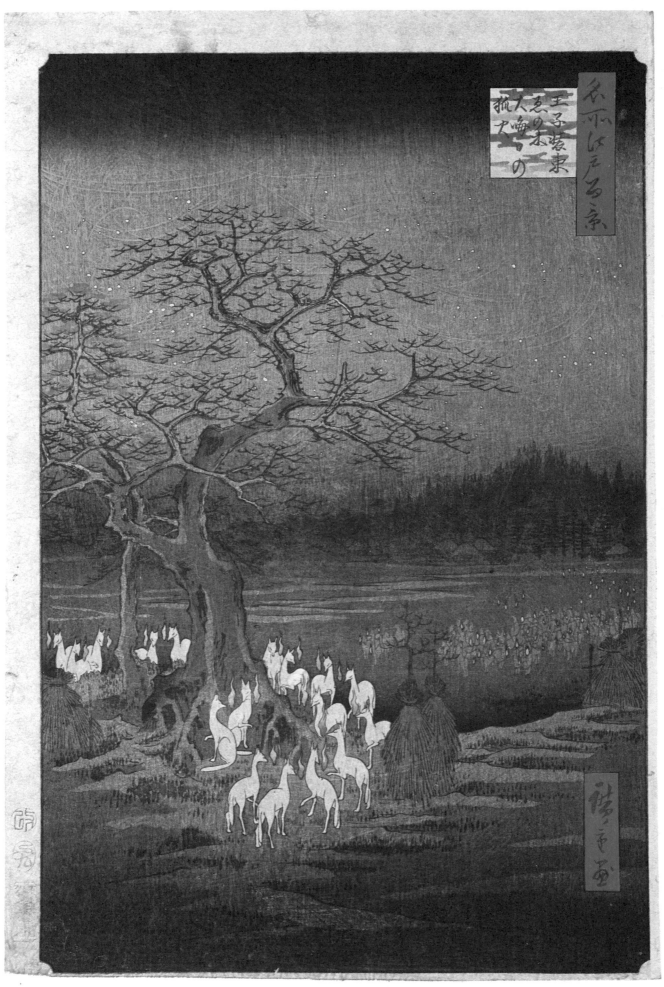

Hiroshige *Fox Fires on New Year's Eve under Enoki Trees at Oji,* from the series *One Hundred Views of Famous Places in Edo (Meisho Edo Hyakkei)*
Oban, Nishiki-e, 35.3 × 23.8 cm
Publisher: Uo-ya Eikichi. Date: 1857

A visionary work with the theme taken from the legend that foxes gather around Enoki trees at Oji.

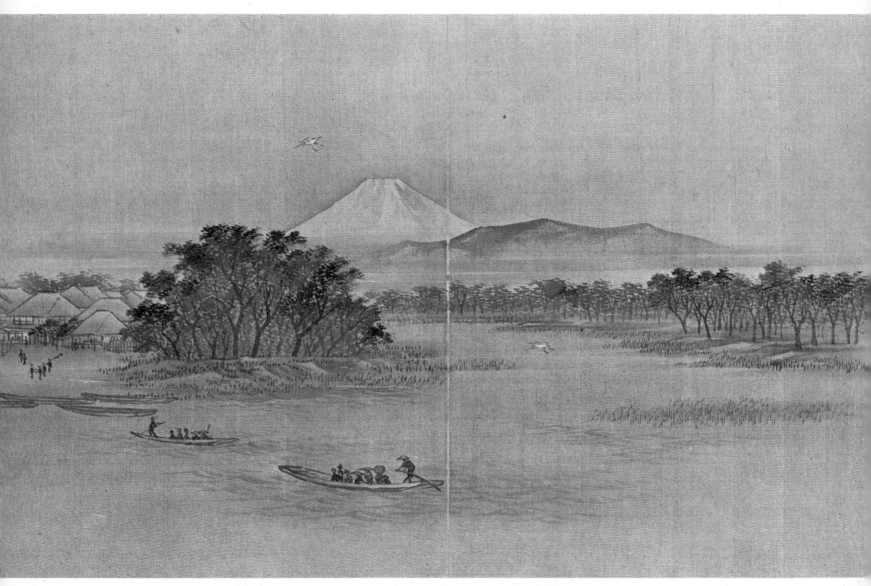

Hiroshige *Ferryboats at Rokugo*, from the album *Famous Places in Musashi and Sagami (Buso Meisho Tekagami)*
Painting on silk, 24.2 × 41.7 cm
Date: 1853. Riccar Art Museum, Japan

Ferryboats on the Tamagawa which flows along the southern border of Edo. Mount Fuji is seen in the distance.

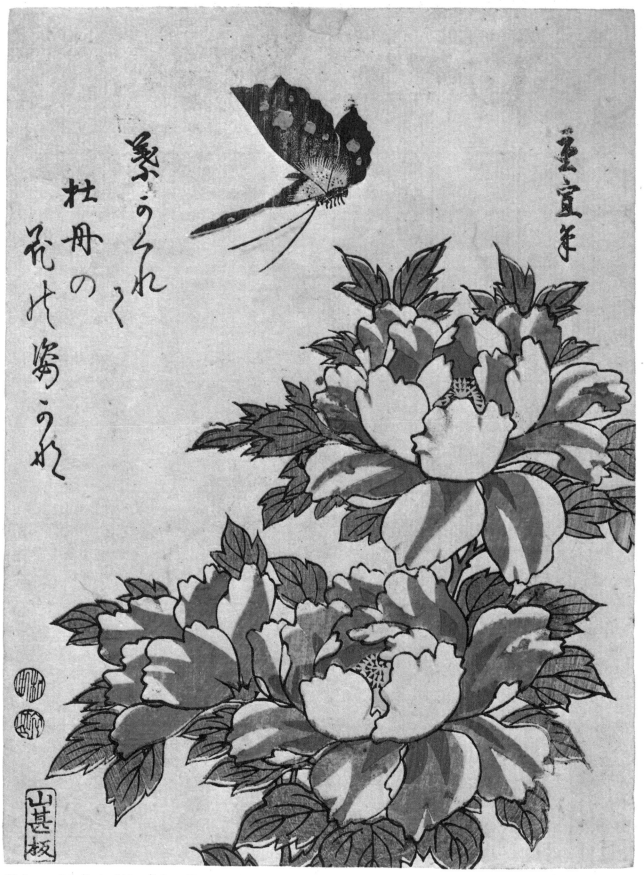

Shigenobu (later **Hiroshige II**) *Peony and Butterfly*
Chuban, Nishiki-e, 22.6 × 16.4 cm
Publisher: Yamashiro-ya Jinbei. Date: c. 1850's

On the upper left is a *haiku* (short verse) on the peony

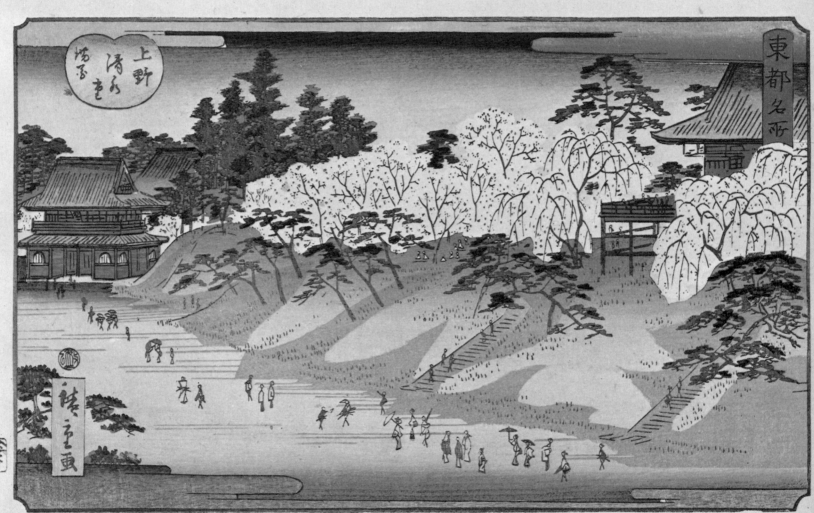

Hiroshige II *Full-blown Cherry Blossoms at Kiyomizu-do, Ueno,* from the series *Famous Places in the Eastern Capital (Toto Meisho)*
Oban, Aizuri-e, 24.6 × 37.6 cm
Publisher: Izumi-ya Ichibei. Date: 1862. Sakai Collection, Japan

The *Ueno* hill is a famous place for cherry blossoms in Edo. This work in *aizuri* (printed by mainly using indigo) is intended to produce different effects from *nishiki-e.*

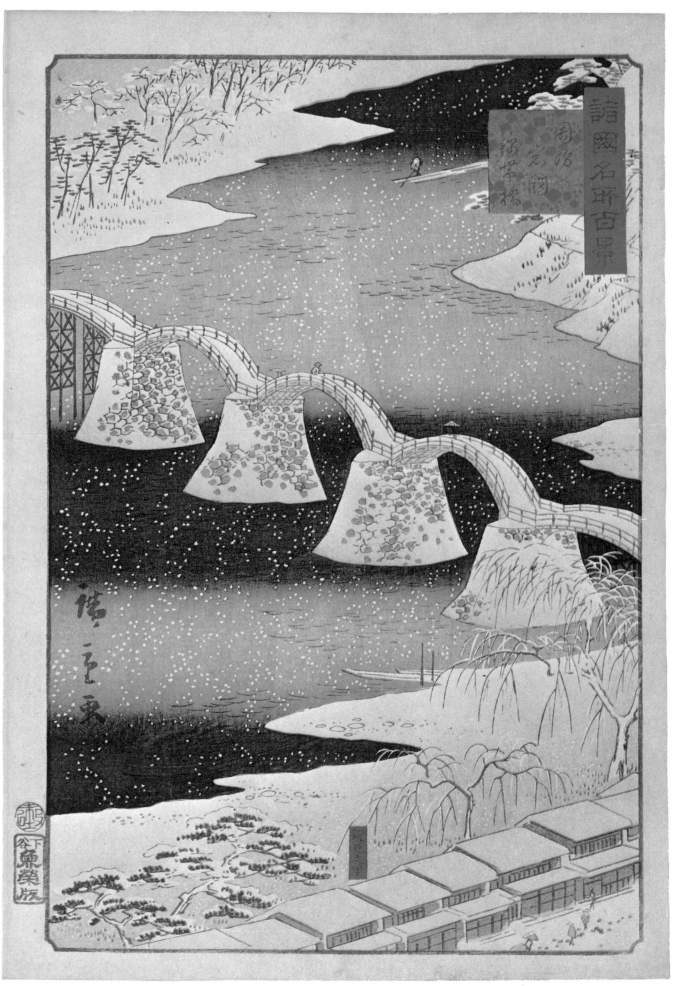

Hiroshige II *Kintaikyo Bridge at Iwakuni in Suo,* from the series *One Hundred Views of Famous Places in Various Provinces (Shokoku Meisho Hyakkei)* Oban, Nishiki-e, 36.2 × 24.9 cm Publisher: Uo-ya Eikichi. Date: c. 1859. Takahashi Collection, Japan

A masterpiece by Hiroshige II. A snow scene with a series of arched bridges in a place far away from Edo and famous from ancient times.

The eve of reform

The eve of reform

For two hundred years, Japan was closed to all foreign trade and exchange, with the one exception of the small, far, western port of Nagasaki, where a few Chinese and Dutch merchants were allowed. This two-hundred-year span was a large part of the Edo period.

However, Japan at that time was not a country going through the dark ages of feudalism. Japanese intellectuals were busy absorbing the best of European culture as brought by the Dutch merchants, and the newly-rich merchant classes were building a new culture of their own. There were public schools for the children of *samurai*, and gradually private schools for the elementary education of the lower classes began to be built in cities, towns, and villages across the country. Highways and waterways were also developed. Cultural development and fermentation was slow, however, because of the closing of the country to foreign access.

Although the economic situation was stagnant at times, there was much activity within the society of the townspeople. But the upper classes made many attempts to suppress this activity, and there were frequent prohibitions about luxury.

Thus, when beautiful clothes, etc., were banned, the people cultivated an appearance of plainness, but actually they used more and more luxurious items behind the backs of the ruling class. The base for business activity was realism, and the entire culture tended to lean in this direction.

Ukiyo-e was also commercialized. Publishers, woodcutters and printers became more organized and specialized, and could begin to produce prints with a high degree of technical excellence.

After the turn of the 19th century, *ukiyo-e* prints were used to realistically depict the atmosphere of the new merchant class. The women in the prints are beautiful, but their former feeling of weakness has been replaced by a strong femininity and spirit.

Foreign ships started to appear occasionally in Japanese waters, and the domestic situation lost some of its tranquillity. Mature femininity, full of worldly wisdom, began to be expressed in *ukiyo-e*.

Utagawa Kunisada (1786–1864)

Kunisada was active under Toyokuni. He was a flexible artist, and worked in a wide range of styles according to the tastes and fashions of the changing times. The content of much of his work appears as a compilation of the characteristics of the Utagawa school.

He started his active career around the age of twenty-three, and could not be called a child prodigy. However, he developed rapidly. His best work was produced during the period when he signed his name Gototei. The women in his works of this period are not idealized, but are depicted realistically in their environments of daily life, in various seasons and kinds of weather. The atmosphere of the period is expressed directly and strongly. In one *okubi-e* series, *Imafu Kesho Kagami* (*Mirrored Modern Women*), he placed images of mirrors in the centre of his prints, and the mirrored women's faces within them. This was a new idea, and the series shows his talent for innovation. The compositions of some of his triptychs also show great ability. In his later triptychs, such as *Seibo no Miyuki* (*Year-end snow*), the composition of the whole is organically unified, a departure from the earlier style of composing each member of a triptych independently.

Kunisada's activity in the publishing of illustrated books surpassed that of his teachers. His most influential and widely renowned work in this medium is *Nise Murasaki Inaka Genji* (*The Second Tale of Genji*). This novel was written by Ryutei Tanehiko (1783–1842), and it is a parody of Lady Murasaki's classic tale. It was quite popular with the townspeople and sold for around fourteen years, because it satirized the decadent, polygamous love-life of the rulers in Edo Castle.

After Toyokuni's death his name was adopted by the first Toyoshige. But when Toyokuni the Second was still alive, Kunisada inherited the Toyokuni name, and began to call himself Toyokuni the Second. This may have been necessary in the aristocratic ambience in which Toyokuni the First moved. Since the people wanted to avoid the confusion of having two well-known artists wth the same name, they called Toyoshige "Hongo Toyokuni" and Kunisada "Kameido Toyokuni", names derived from the addresses of both men. However, it would be more correct to refer to Kunisada as "Tokyokuni the Third".

His activity as Toyokuni III did not decline, although the pattern of his work became very noticeable, and sometimes ran contrary to the orders of customers. During this period he produced some *okubi-e* of actors and triptyches, which match the brilliancy of his Gototei period.

Utagawa Kuniyoshi (1797–1861)

Kuniyoshi was a pupil of Toyokuni, and a rival of Kunisada. His powerful presence resulted in the splitting of the Utagawa school into two sections. His character differed from Kunisada's, and he gained great popularity with his vitality and surprisingly new ideas.

However, during Kuniyoshi's youth he was only one of Toyokini's numerous pupils, and had little chance to display his unique talent. His chance finally came when he illustrated *Suikoden*, a long and heroic Chinese novel. He quickly became popular with his innovations in the depiction of heroes in the genre of masculine virility.

Kuniyoshi also made advances in *bijin-ga* and pictures of famous places. In his series of Edo landscapes, he adopted Western concepts in his treatment of clouds and mass. His portraits were also carefully shaded. During his later years, it is said that he made a study of the use of photographic wet-plates, a great concession to the realism of the West. He stands out among the many *ukiyo-e* artists as one who did not confine himself to the traditional, but always looked for something new.

Besides his unconventional ideas, Kuniyoshi had an interest in the grotesque. He imposed his unique fantasies on prints with historic subjects, and achieved a rare depth that is not to be found in the work of other artists of his time. He loved cats, and made many prints depicting them. Finally, he excelled in light and comic work. In short, he was extraordinarily skilled in many areas.

Kikukawa Eizan (1787–1867)

During the first half of the 19th century, *ukiyo-e* was dominated by Hokusai and the Utagawa school. It was very difficult for anybody else to start a new, independent school during this period. Eizan's father, Eiji, studied at the Kano school of painting. The family business was, however, artificial flower-making. Eizan was taught by his father, and studied the styles of both Hokusai and the Utagawa school before starting a school of his own. His speciality was *bijin-ga*, painted in a long, vertical format.

Keisai Eisen (1790–1848)

Eisen started his *ukiyo-e* career while living at the house of Kikukawa Eiji. He was especially proficient at depicting decadent, coquettish women. Although his work differs from that of Kunisada and Kuniyoshi, he strongly reflected the atmosphere of the period.

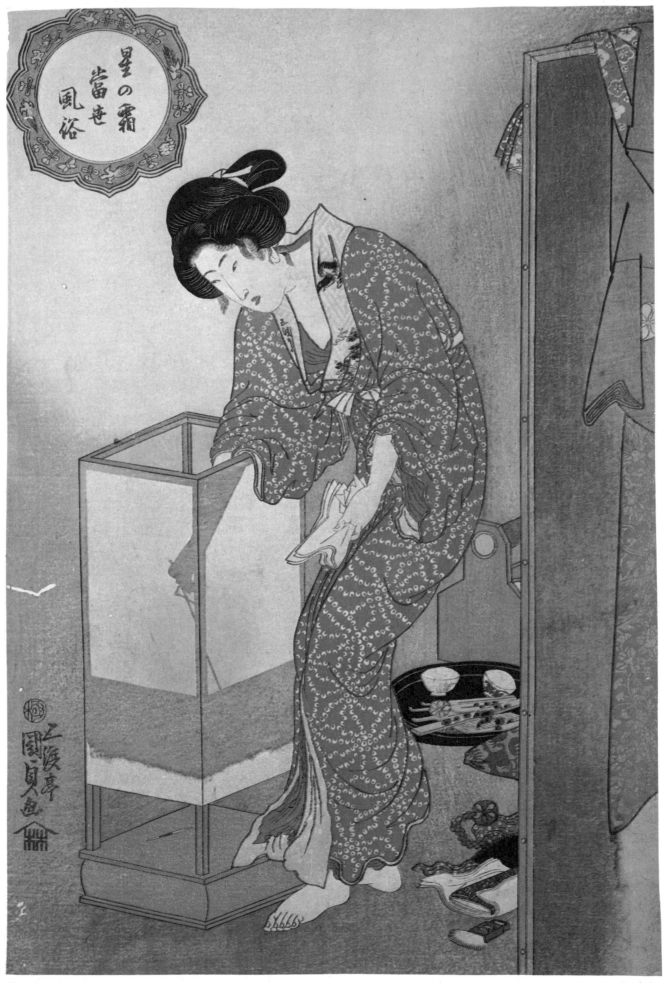

星の霜
當世
風俗

Kunisada *Lantern,* from the series *Customs of This World on Starry, Frosty Nights (Hoshi no Shimo Tosei Fuzoku)*
Oban, Nishiki-e, 36.9 × 24.9 cm
Publisher: Ise-ya Rihei. Date: c. 1818. Seikado
Bunko, Japan

A woman in underclothes is poking up the wick of the lamp. A man's *kimono* is hanging on the folding screen.

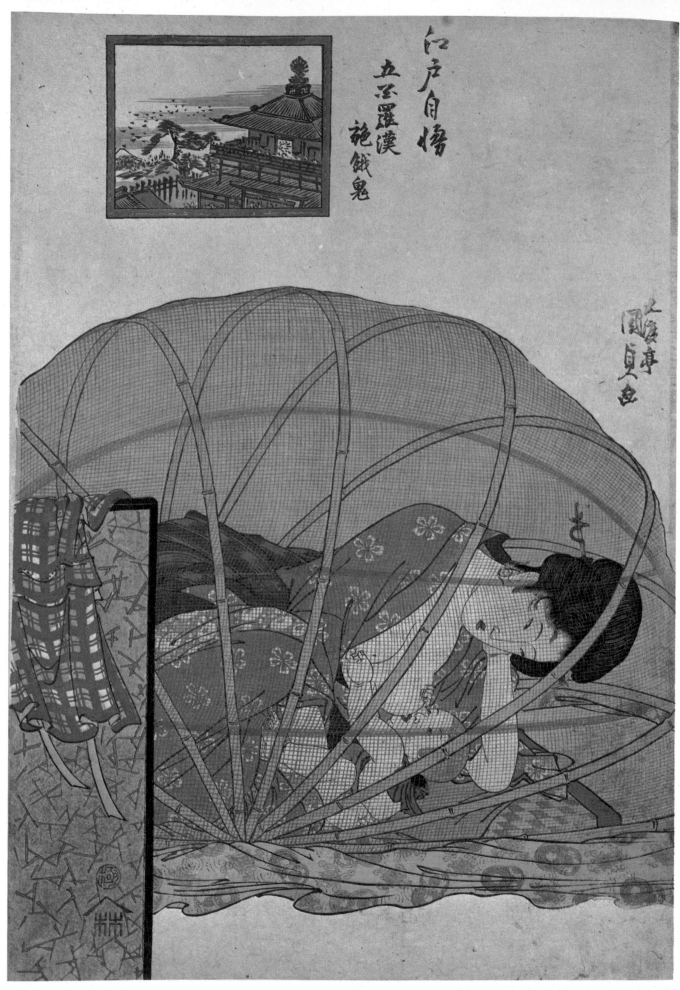

Kunisada *Mother Feeding an Infant*, from the series
Edo's Pride (Edo Jiman)
Oban, Nishiki-e, 36.6 × 25.4 cm
Publisher: Ise-ya Rihei. Date: c. 1818. Seikado
Bunko, Japan

Summer. A mother is suckling a child in a small bed
protected by a mosquito net. The inlaid picture shows
a famous temple, where a festival is held at this
season.

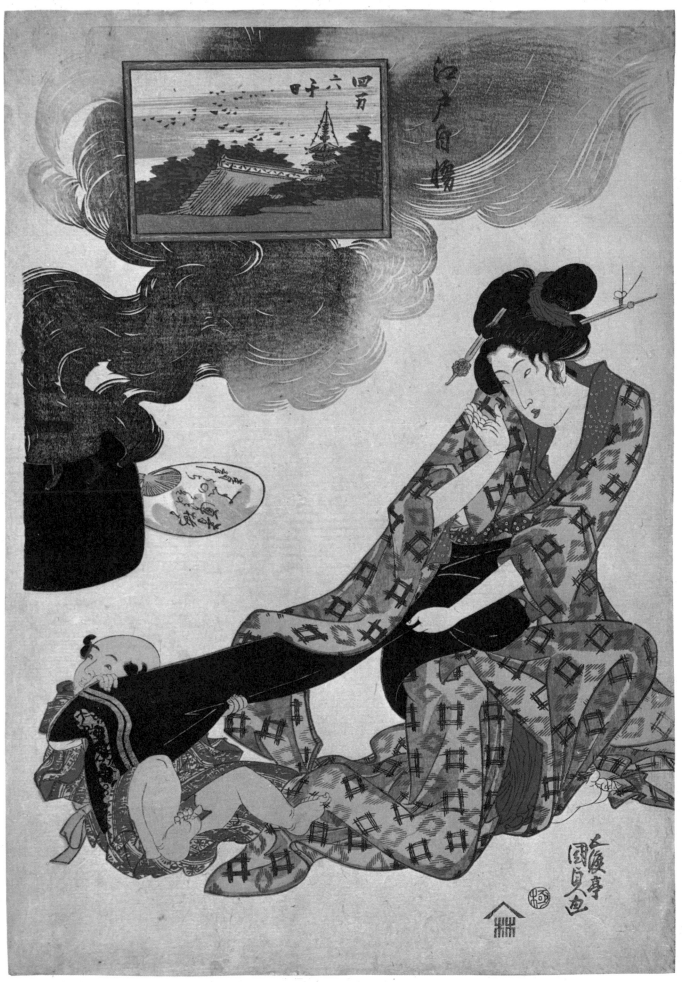

Kunisada *Smudge for Mosquito*, from the series *Edo's Pride (Edo Jiman)*
Oban, Nishiki-e, 38.8 × 26.9 cm
Publisher: Ise-ya Rihei. Date: c. 1818

A girl in summer wear with an urchin. The inlaid picture shows a noted temple where *Kannon* (merciful Goddess) is enshrined. Those who worship the goddess on July 10th, the fete day, are given a divine favour equal to forty-six-thousand successive visits to the temple.

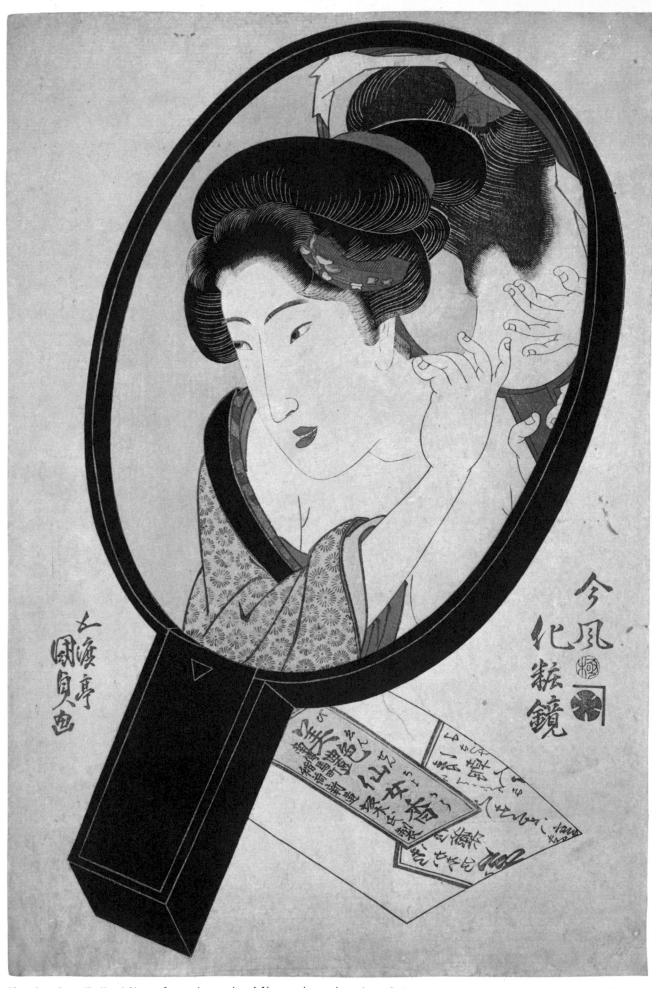

Kunisada *Toilet Mirror*, from the series *Mirrored Modern Women (Imafu Kesho Kagami)*
Oban, Nishiki-e, 38 × 25.8 cm
Publisher: Azuma-ya Daisuke. Date: c. 1823

A series of pictures composed with a beauty reflected in a mirror. The paper parcel below the mirror contains some powder.

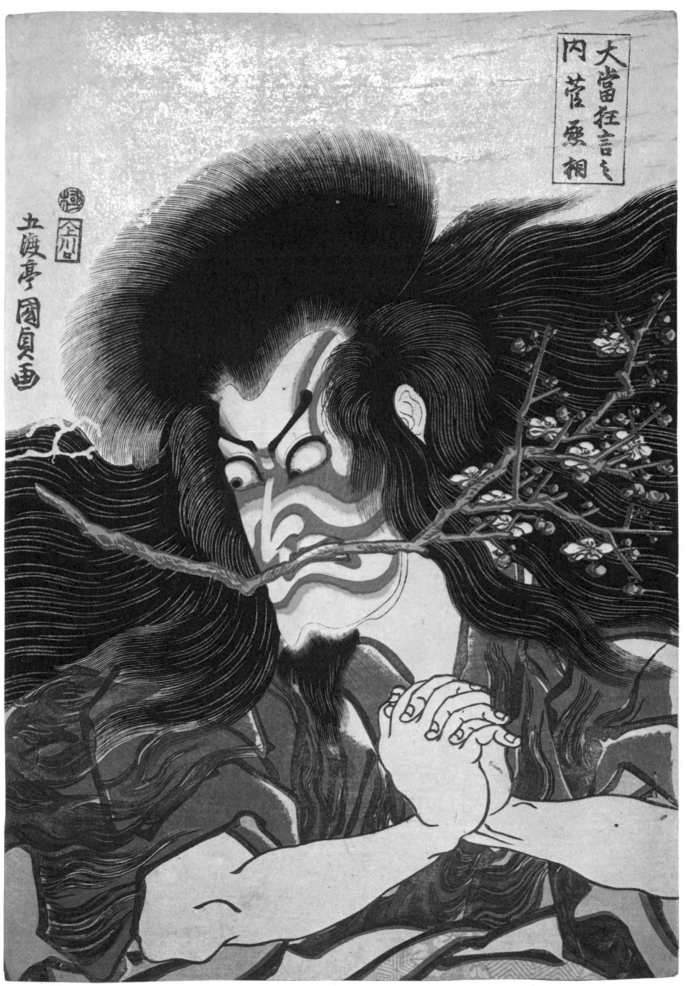

Kunisada *The Actor Ichikawa Danjuro VII as Sugawara no Michizane*, from the series *Big Box-Office Hit Play (Oatari Kyogen no Uchi)*
Oban, Nishiki-e, 37.1 × 25.9 cm
Publisher: Kawaguchi-ya Uhei. Date: c. 1814. Sakai Collection, Japan

An actor's picture. Both make-up and dress show his strong spiritual power. He is invoking the aid of Heaven to become, after his death, god of thunder in order to avenge himself against his sworn enemies.

 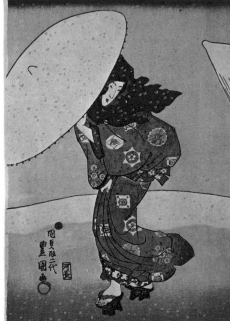 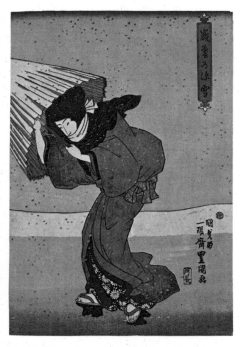

Toyokuni III (Kunisada) *Year-end Snow (Seibo no Miyuki)*
Oban, Nishiki-e, Triptych, left: 35.6 × 24.5 cm, centre: 35.6 × 24.7 cm, right: 35.8 × 24.9 cm
Publisher: Kawacho. Date: c. late 1840's. Seikado Bunko Collection, Japan

A characteristic depiction of snowfall. The hood is a shelter against the cold. The girl is shod in *geta* with two raised bars, because the snow lies deep on the ground. The paper lantern has the name of the publisher.

336

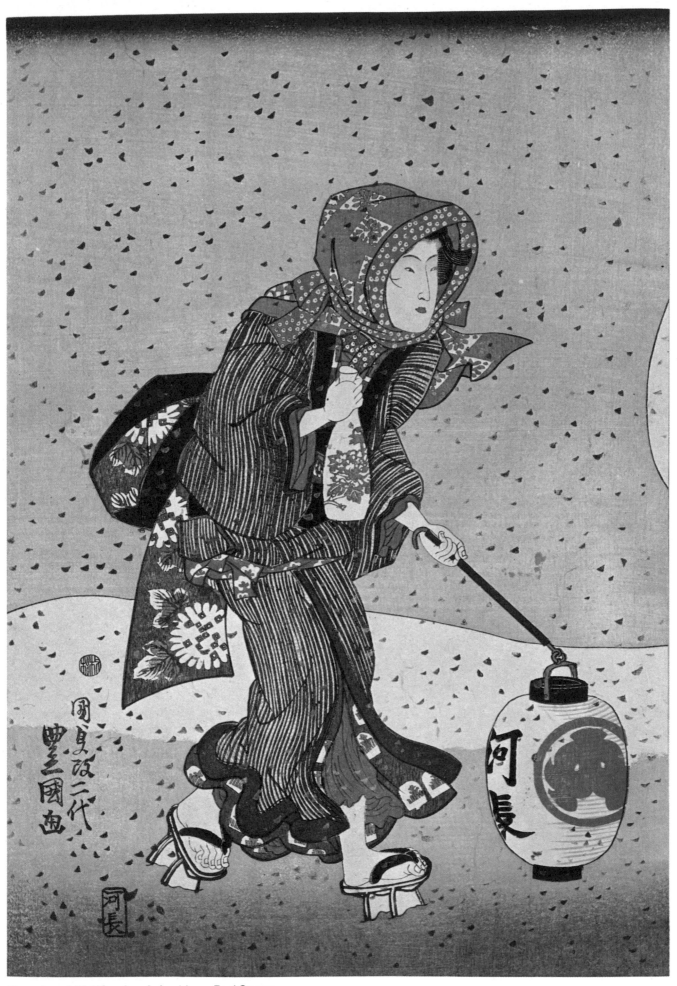

Toyokuni III (Kunisada) *Year-End Snow*
Left panel of the triptych.

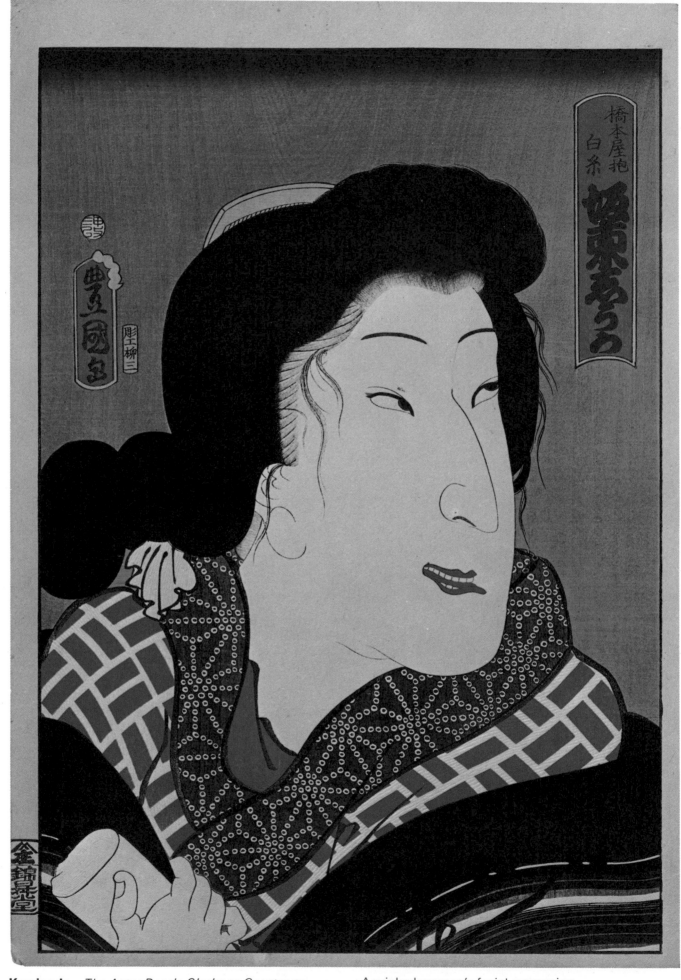

Kunisada *The Actor Bando Shuka as Courtesan Shiraito*
Oban, Nishiki-e, 36 × 24.7 cm
Publisher: Ebisu-ya Shoshichi. Date: c. late 1850's

A wicked woman's facial expression.

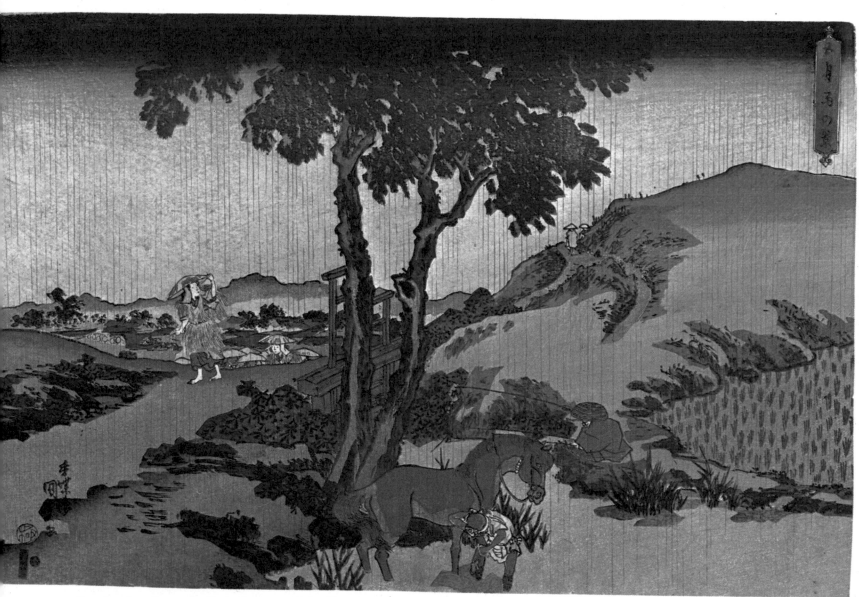

Kunisada *Scene in Early Summer Rain (Samidare no Kei)*
Oban, Nishiki-e, 24.8 × 36.8 cm
Publisher: Yamaguchi-ya Tobei. Date: c. 1830's

This is one of the few landscape pictures by Kunisada. Rice-planting season, and a patch of paddy field is seen on the right. A farmer is washing his horse in the brook.

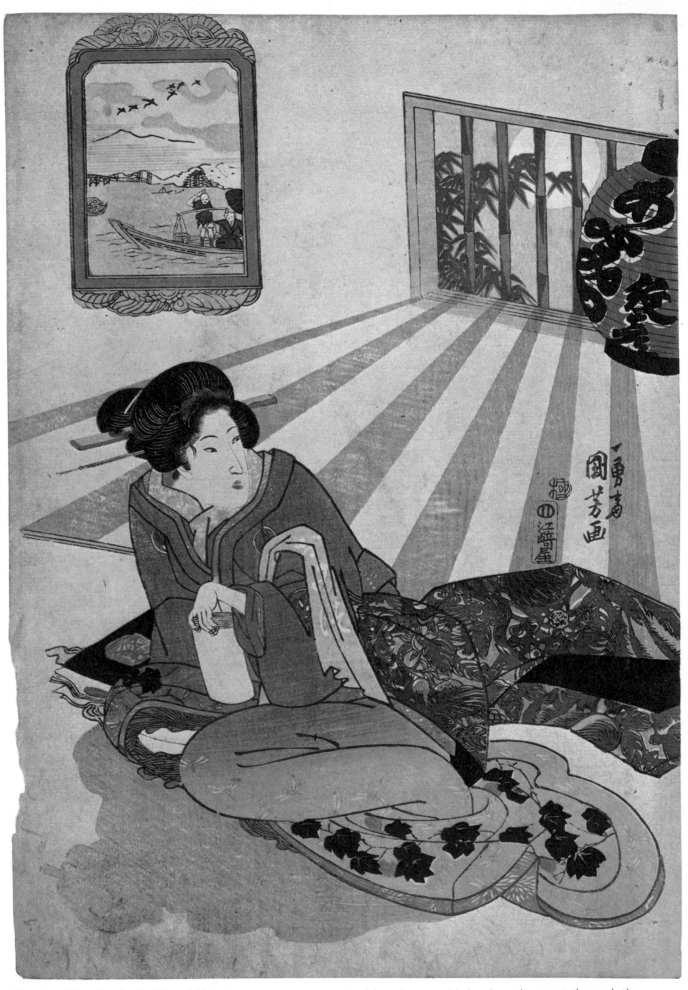

Kuniyoshi *Beauty in Moonlight*
Oban, Nishiki-e, 37.8 × 25.8 cm
Publisher: Ezaki-ya Kichibei. Date: c. 1830

Moonbeams shining into the room through the
window. The courtesan's shadow is expressed
skilfully. The inlay shows the place where the house is.

Kuniyoshi *Dancing Cat*, from the series *Scribblings on the Wall of a Warehouse (Nitakaragura Kabe no Mudagaki)*
Oban, Nishiki-e, 35.4 × 25.3 cm
Publisher: Ise-ya Senzaburo. Date: c. 1840's

Scribbles drawn with a broken nail, portraits of theatrical actors of the time.

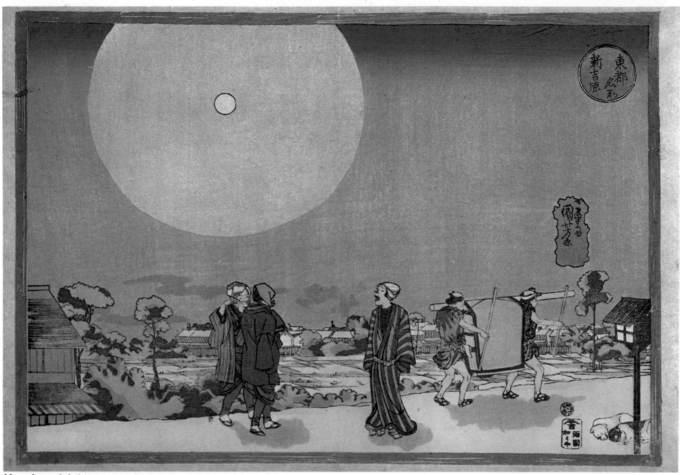

Kuniyoshi Above: *Shin-Yoshiwara*, from the series *Famous Places in the Eastern Capital (Toto Meisho)* Oban, Nishiki-e, 25.7 × 36.9 cm Publisher: Kaga-ya Kichibei. Date: c. 1830. Sakai Collection, Japan

A causeway leading to Yoshiwara. Men with a palanquin going to Yoshiwara, and tipsy men returning home, singing.

Kuniyoshi Below: *Pine Tree "Shubino Matsu" in the Eastern Capital (Toto Shubino Matsu no Zu)* Oban, Nishiki-e, 24.4 × 36.5 cm Publisher: Yamaguchi-ya Tobei. Date: c. early 1830's

In the foreground, a crab is crawling on the rock exposed by the receding tide. In the background is the pine tree.

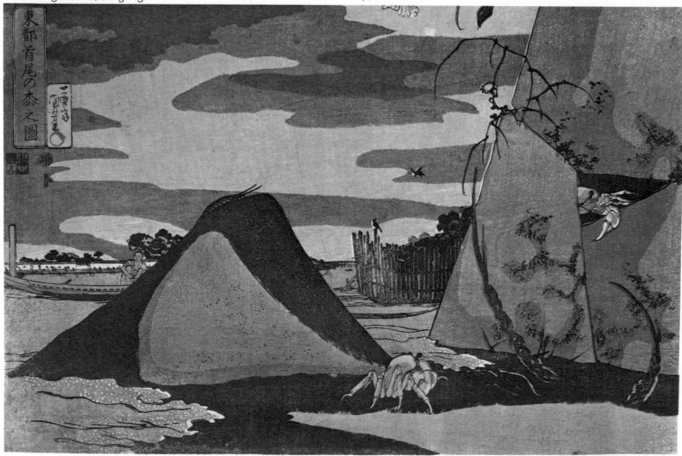

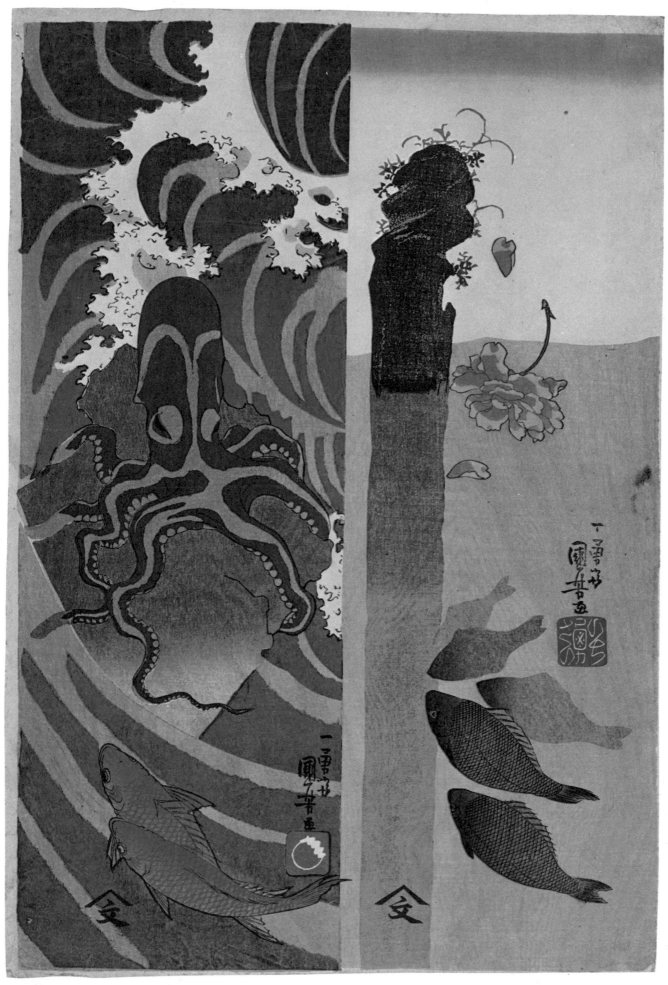

Kuniyoshi *Crucian Carps and Octopus*
Oban, Nishiki-e, 38.7 × 26.3 cm
Publisher: Tsujioka-ya Bunsuke. Date: c. late 1830's

The two pictures were printed together, but cut into two later, and sold separately.

343

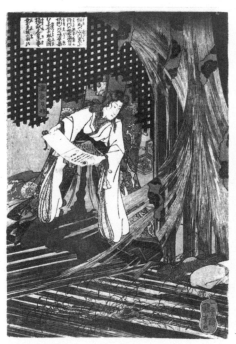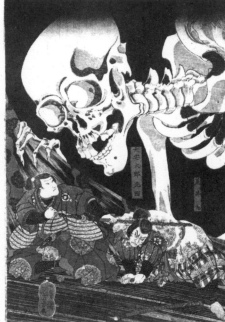

Kuniyoshi *Old Imperial Palace at Soma*
Oban, Nishiki-e, Triptych, left: 37.4 × 25.1 cm, centre: 37.4 × 25.1 cm, right: 37.5 × 25.1 cm
Publisher: unknown. Date: c. late 1840's

The subject is taken from the best-seller novel of the day. A grotesque fantasy. The artist may have copied the skeleton in a Western textbook of anatomy.

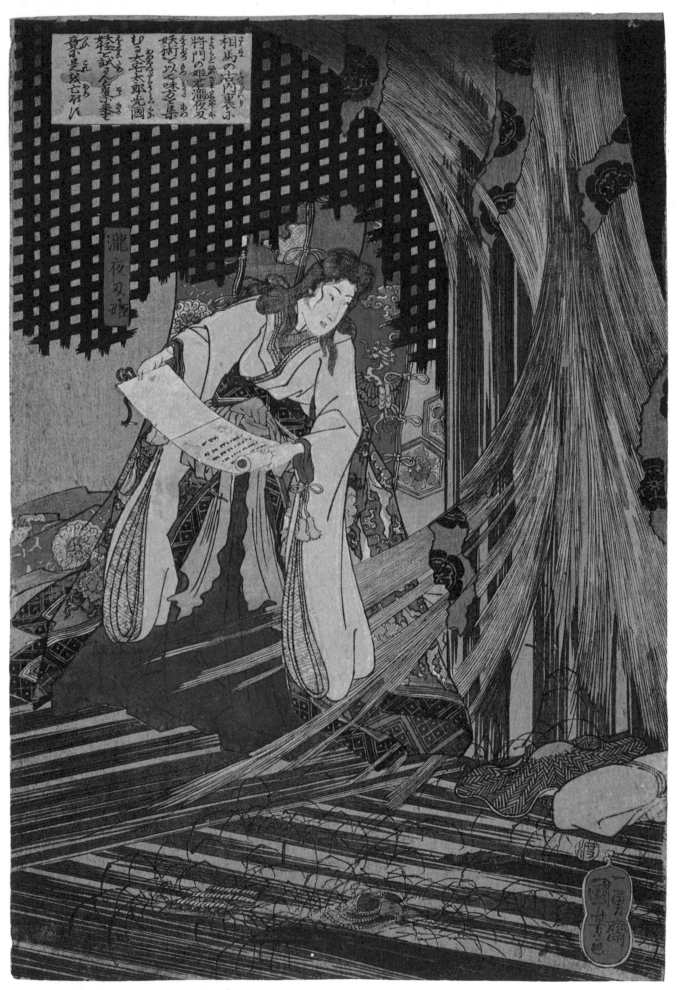

相馬の古内裏示
将門の姫名瀧夜叉
妖術ニ以テ味ヲ集
もる大宅太郎光國
荒七試さんと葉奉

瀧夜叉姫

Kuniyoshi *Old Imperial Palace at Soma*
Left panel of the triptych.

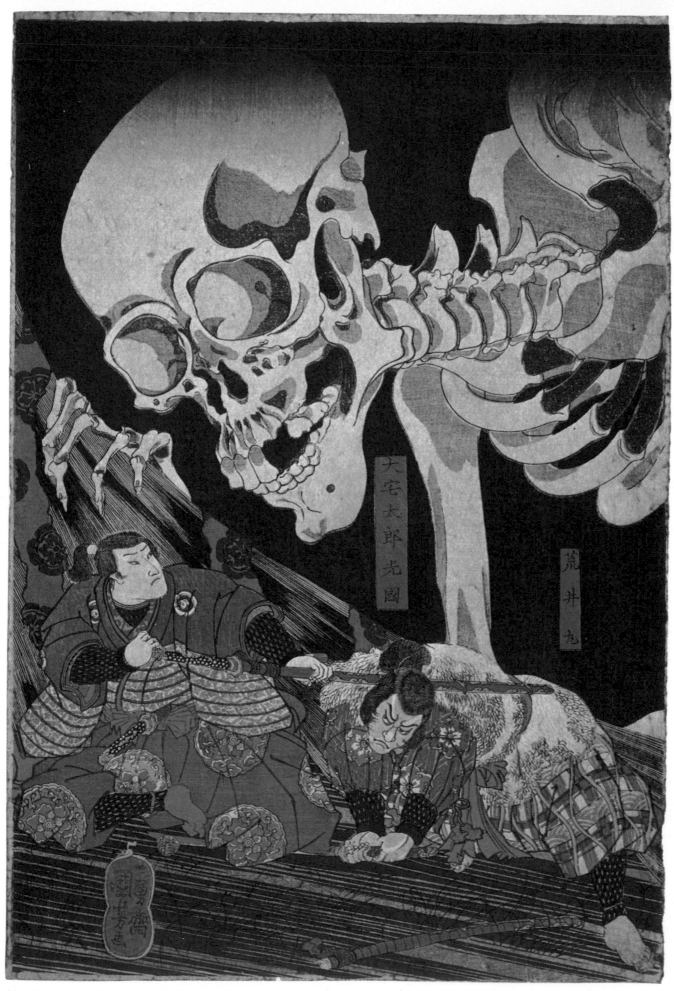

Kuniyoshi *Old Imperial Palace at Soma*
Central panel of the triptych.

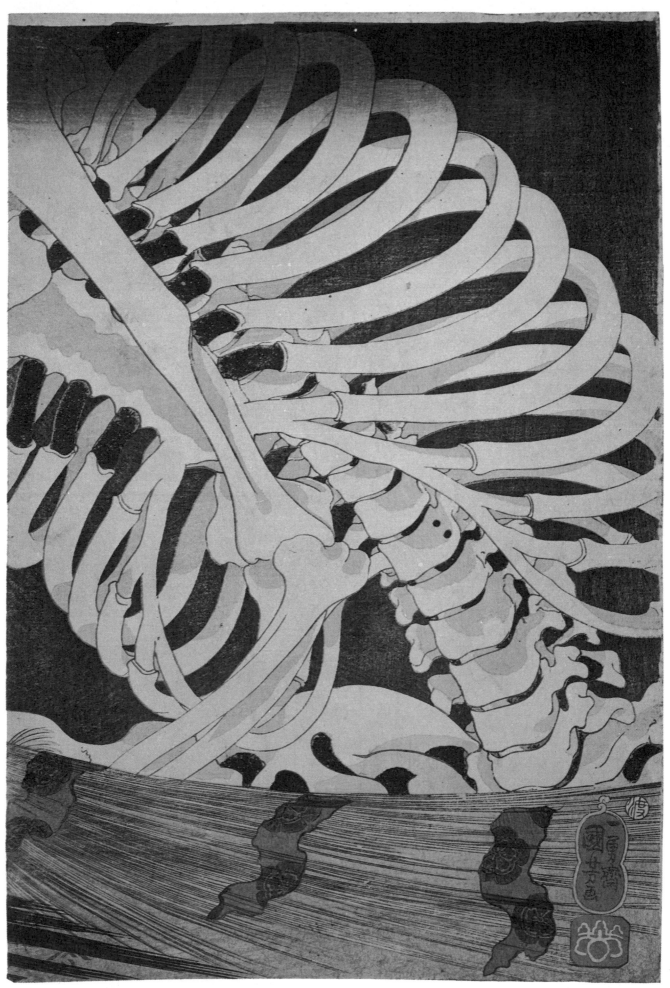

Kuniyoshi *Old Imperial Palace at Soma*
Right panel of the triptych.

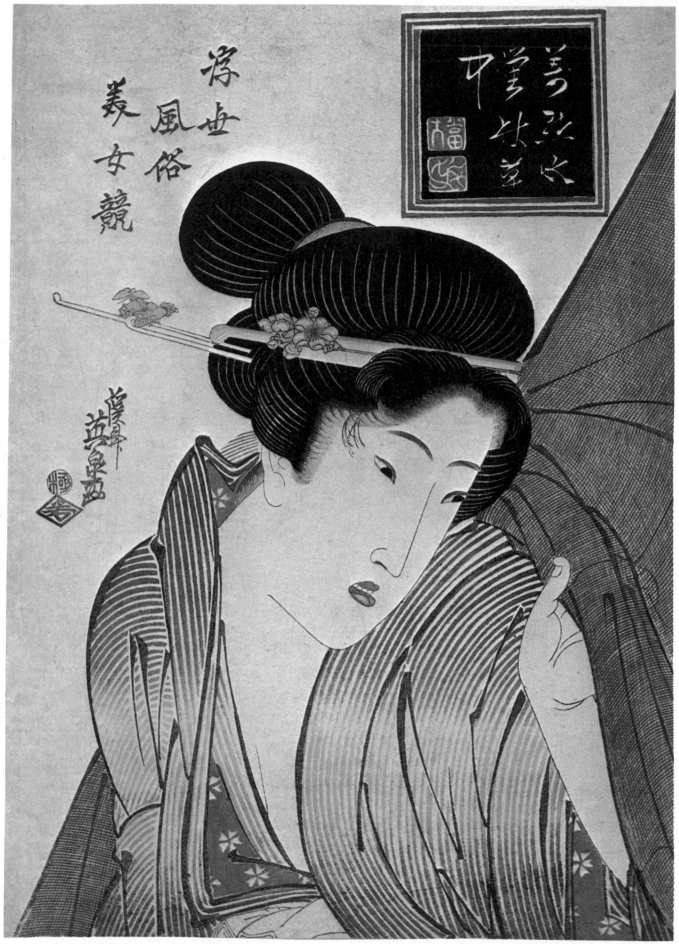

Eisen *Beauty Hearing Voice of a Cuckoo,* from the series *Contest of Contemporary Beauties (Ukiyo Fuzoku Mime Kurabe)*
Oban, Nishiki-e, 35.9 × 25.5 cm
Publisher: Wakasa-ya Yoichi. Date: c. 1822. Sakai Collection, Japan

A woman getting out of a mosquito net.

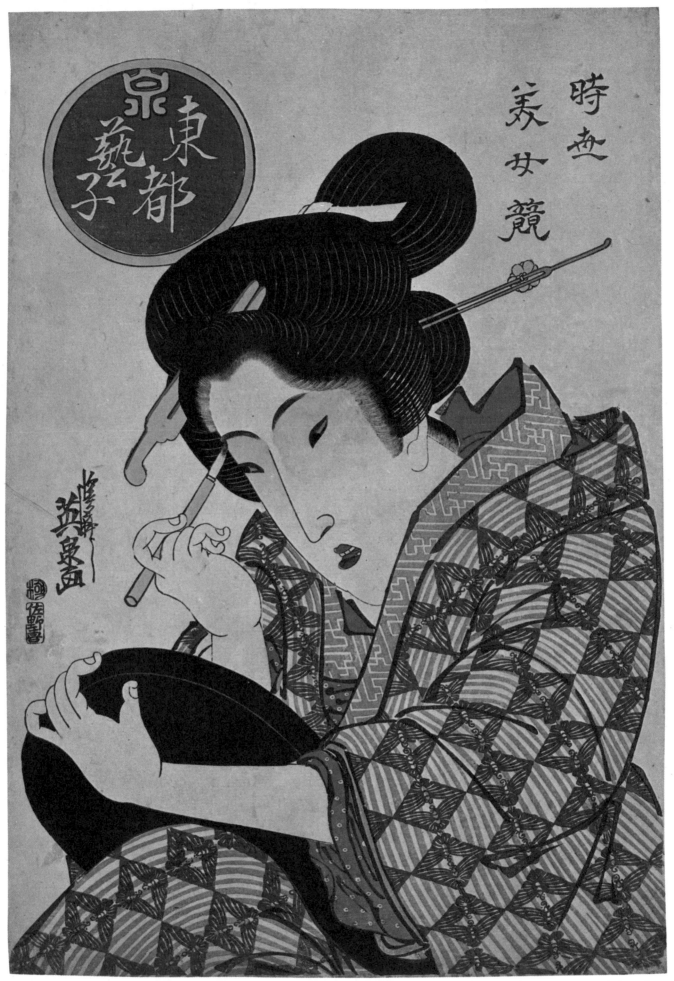

Eisen *Geisha Girl in Eastern Capital,* from the series *Beauty Contest of the Present (Imayo Mime Kurabe)* Oban, Nishiki-e, 38.5 × 26.3 cm Publisher: Sano-ya Kihei. Date: c. late 1820's

A geisha is painting her eyebrows, holding a mirror in one hand.

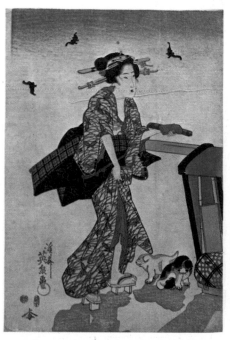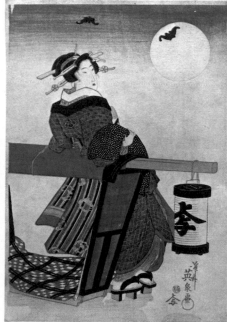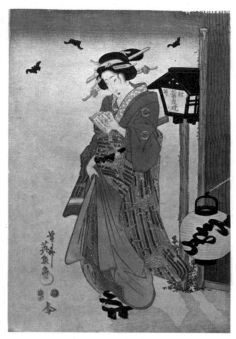

Eisen *Three Beauties at Evening*
Oban, Nishiki-e, Triptych, left: 38.4 × 26.5 cm, centre:
38.5 × 26.3 cm, right: 38.4 × 26.2 cm
Publisher: Uemura Yohei. Date: c. 1822

Courtesans with lanterns bearing the tea-houses'
names. In the centre is the full moon, and bats flying in
the sky.

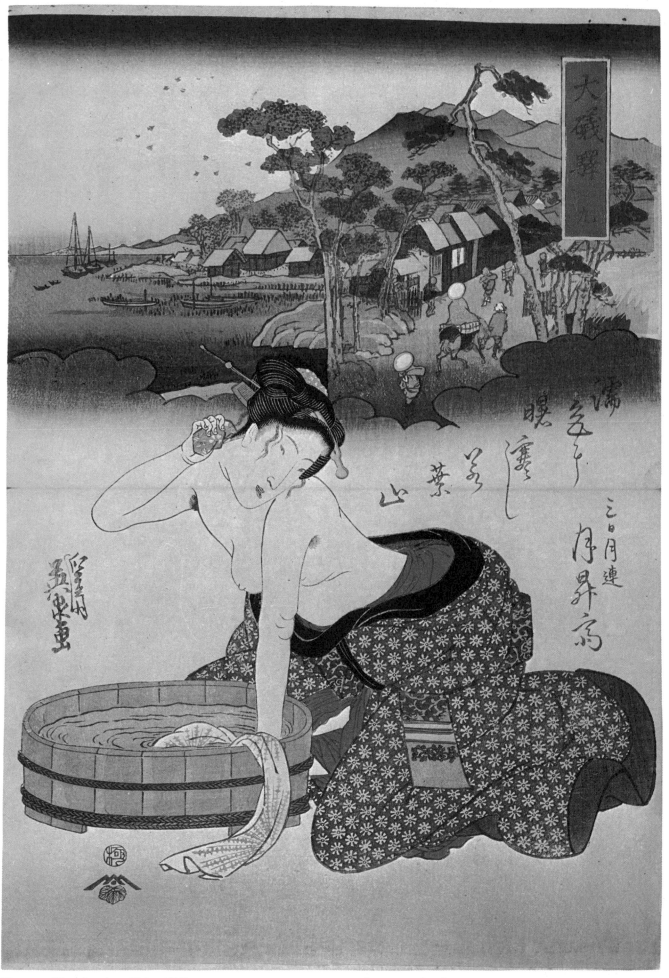

Eisen *Oiso Station (Oiso Eki)*
Oban, Nishiki-e, 37.8 × 25.8 cm
Publisher: Tsuta-ya Kichizo. Date: c. late 1830's

A woman having a tub-bath. The landscape at the
Oiso Station on the Tokaido.

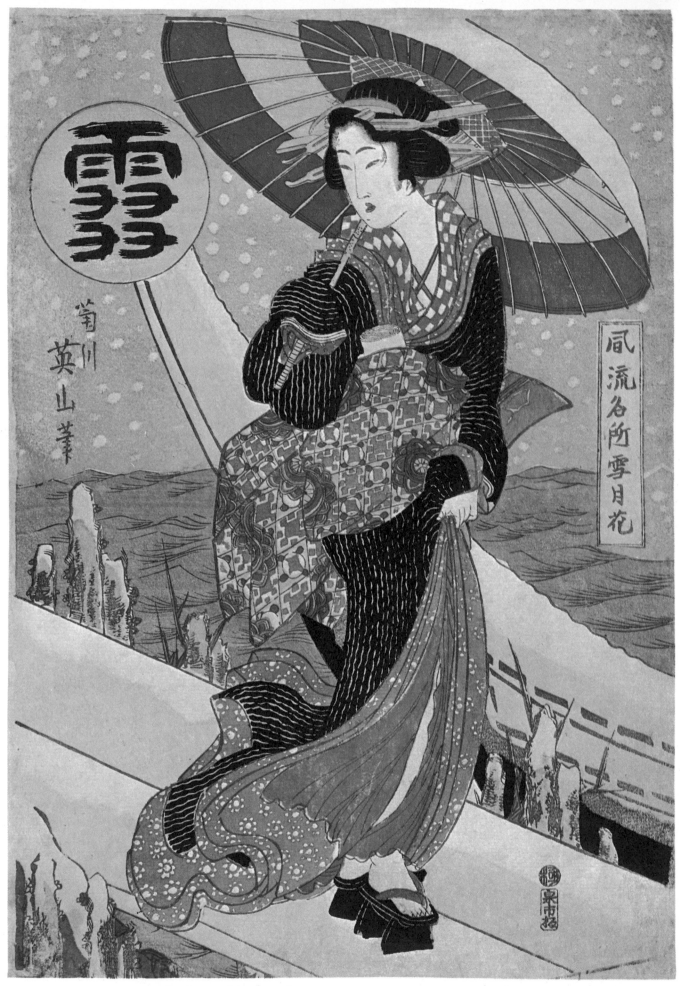

Eizan *Snow,* from the series *Snow, Moon and Flower in Celebrated Places (Furyu Meisho Setsugekka)*

352 Oban, Nishiki-e, 38.6 × 26.3 cm
Publisher: Izumi-ya Ichibei. Date: c. late 1800's

A courtesan standing at a landing place in the snow.

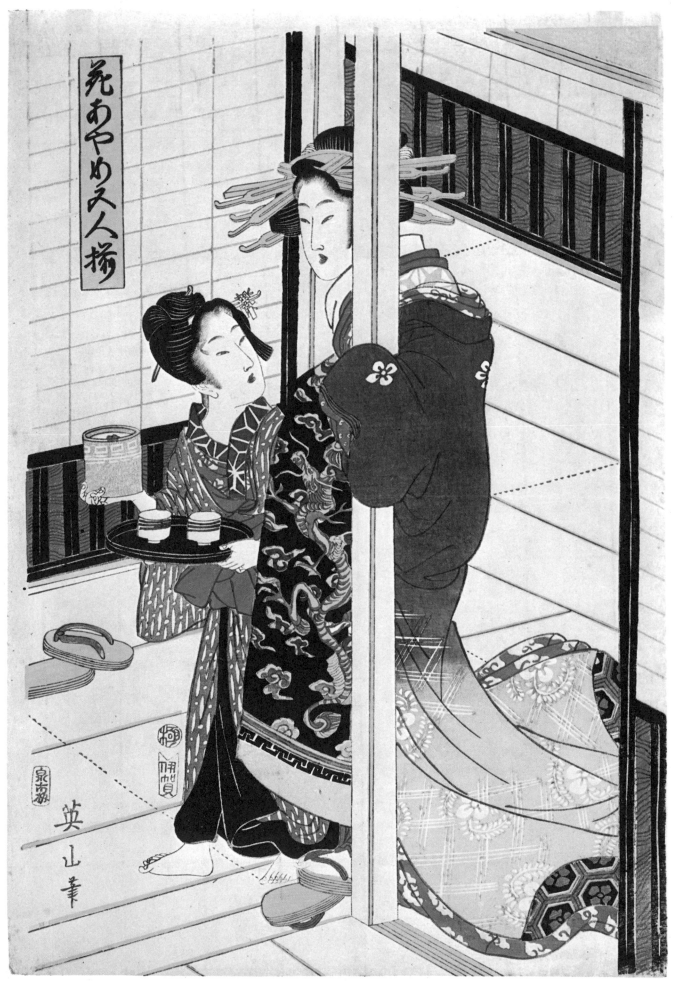

花あやめ人揃

Eizan *Beauty Resting Against the Pillar,* from the series *Five Courtesans Beautiful as Sweet Flags (Hana-Ayame Gonin Soroe)*
Oban, Nishiki-e, 39.7 × 26.9 cm
Publisher: Izumi-ya Ichibei. Date: c. 1811. Riccar Art Museum, Japan

A courtesan of the highest rank with her girl attendant. From a series of courtesans. *Ayame* (sweet flag) is usually compared to the beauty of women.

The end of traditional wood-block prints

The end of traditional wood-block prints

After the fall of the Edo Shogunate, the Emperor Meiji was restored to power. He left the old capital of Kyoto and entered Edo, now called Tokyo, during 1869, the second year of the Meiji period.

That year, 1869, was the year of the opening of the Suez Canal, which would connect the East and West, and the year before the start of the Franco-Prussian war. Japan, suddenly opened to the West, was deluged with European culture and scientific technology. The common people, still used to traditional customs, were bewildered at the flood of unusual objects and ideas. However, this flood had been preceded by a slight trickle of Western culture, which had come through the port of Nagasaki, via the Dutch merchants. Also, there were some progressives who, for a while, had taken a strong interest in the products of Western civilization. Western concepts concerning shading, perspective, and volume in painting had also been studied for some time.

However, the changes that took place after the Meiji Restoration were very rapid. The *ukiyo-e* world naturally reflected the new developments. The end of the century was depicted in prints, and they served as means of communication at a time when newspapers were as yet non-existent. However, with the turn of the 20th century, traditional techniques began to decline, and *ukiyo-e* approached its end.

There were four main divisions in the work that was produced during this last period. Each had its own directions and attitudes, and for each group there is one artist who is most representative. The four groups are:
I. The school in which actors and other traditional subjects were depicted in the traditional manner: Kunichika.
II. The school in which traditional subjects were depicted, with attempts made at developing a new sensibility: Yoshitoshi.
III. The school in which Western style subjects were depicted in the traditional manner: Hiroshige III.
IV. The school in which Western techniques were employed, such as shading, to make prints with a new sensibility: Kiyochika.

Toyohara Kunichika (1835–1900)
In contrast to many Meiji-period artists, Kunichika continued to express the tastes and atmosphere of the end of the Edo period. Except for a few *bijin-ga*, he devoted himself to illustrations relating to the theatre.

He did exactly what he liked in regard to his work, and he led an extraordinary and eccentric life: he had 40 wives (by serial monogamy) and changed his residence no less than 83 times.

One of his most famous works is the series of *okubi-e* of actors. In it, the highest printing techniques were used, and it stands out as a unique work during the last period of *ukiyo-e* production.

Although the root of Kunichika's work was deeply embedded in *Kabuki*, the classic theatre, he was gradually influenced by the changing times, and in his later years began to produce works with the qualities of the new era.

Yoshu Chikanobu (1838–1912)
Chikanobu was a pupil of Kunichika's, but he rarely made works related to the theatre. He was more interested in genre pictures. This interest was expressed in his prints of royalty and aristocrats dressed in European style.

Tsukioka Yoshitoshi (1839–1892)
Yoshitoshi became a pupil of Kuniyoshi's when he was still very young. He worked in keen competition with Ochiai Yoshiiku (1833–1904), an older student in the same school, and became a unique artist. Together with Yoshiiku he produced the series *Eimei Nijuhasshu Ku* (*Twenty-eight Stories of Violence*), all of which depicted bloody murder scenes. The series became notorious for its macabre illustrations. To make the bloody scenes more realistic, the two artists mixed *nikawa* (a shiny, sticky animal glue) with red paint.

Following this series, they continued their violent themes, adding erotic and grotesque subjects as well. These subjects must have reflected the turmoil the artists felt at the conflicts over the rapid changes from old traditions to new styles.

Yoshiiku brought out a *nishiki-e* ("brocade picture") newspaper, and Yoshitoshi drew competing newspaper illustrations, as well as a series of prints of women. These were produced at the beginning of the Meiji period.

Later, Yoshitoshi found his subjects in folklore and various legends. He published the series *Tsuki Hyakushi* (*One Hundred Moonlit Historical Scenes*). However, he was also familiar with more ordinary painting.

During his last years, Yoshitoshi made the series *Shinkei Sanjuroku Kaisen* (*Thirty-six New Ghost Stories*). The *shinkei* (new form) in the title has a homonym meaning (nerves or nervous). In this series one can see the neurotic fantasies of an old Yoshitoshi. Soon after the completion of this series, he went insane and died.

Hiroshige III (1842–1894)

Hiroshige III, as Hiroshige II, was a pupil of Hiroshige's. His original name had been Shigemasa, but after Hiroshige II's divorce from the daughter of Hiroshige, he married her and inherited the name. Although he is remembered as Hiroshige III, he called himself Hiroshige II. During his early years, he produced scenes of famous places in Edo, following the examples of his predecessors. Later he came under the influence of the tide of European culture that was flowing into the country. He was especially interested in the products of Western science, such as locomotives, balloons, and architecture, and illustrated these new objects with great enthusiasm. Although he used traditional *ukiyo-e* techniques, his themes were quite liberal. Regretfully, though, he lost the gentle lyricism which can be seen in the work of Hiroshige I.

Kobayashi Kiyochika (1847–1915)

Kiyochika was born to a *samurai* family of the lower class, which belonged to the Edo Shogunate. When he was grown he experienced the collapse of his master's house (the Shogunate) and thereafter was forced to adopt a wandering life. Consequently, he studied painting mostly by himself, although some scholars contend that he once studied under the English painter Charles Wirgman (1835–1891), who lived in Yokohama.

In 1867, Kiyochika produced the first series of Tokyo landscapes in the new style. In contrast to contemporary *nishiki-e*, his work was very Westernized. He carefully studied the moving, changing light of morning and evening, and developed his Western style. His interest in the depiction of rain, mist, snow, dawn, and sunset can probably be attributed to the influence of Hiroshige. He was especially good at expressing gaslights and streetlights, and the glittering reflections of their light upon water.

Kiyochika had other interests as well. He appreciated lithography and etching (copper-plate printing). Like Hiroshige, he produced still-life prints and *kacho-ga*, pictures of birds and flowers. However, after 1881, the economic situation changed and there was a nationalistic reaction against the influx of European culture. He stopped the progress of his work, and returned to the traditional, easy style.

Among Kiyochika's students was Inoue Yasuji (1864–1889). Yasuji produced lyrical landscapes equal in quality to his teacher's, but unfortunately he died at an early age.

Another print-maker who was probably influenced by Kiyochika was Ogura Ryuson whose dates and teachers are unclear. He produced several landscapes at about the time that Kiyochika was working on his Tokyo landscape series, and there are some similarities between the styles of the two.

Later, wood-block prints of war scenes gained popularity. This trend naturally produced work of a violent nature, with the exception of Kiyochika's, which retained its lyrical, poetic quality.

Kiyochika was the last great artist of wood-block prints in the traditional *nishiki-e* technique. With him, the vitality of the *ukiyo-e* world ended. At the end of the Meiji period, the *ukiyo-e* artists grew old and died. With them, the society that loved and patronized *ukiyo-e*, as well as formed its base, came to an end, and the world changed.

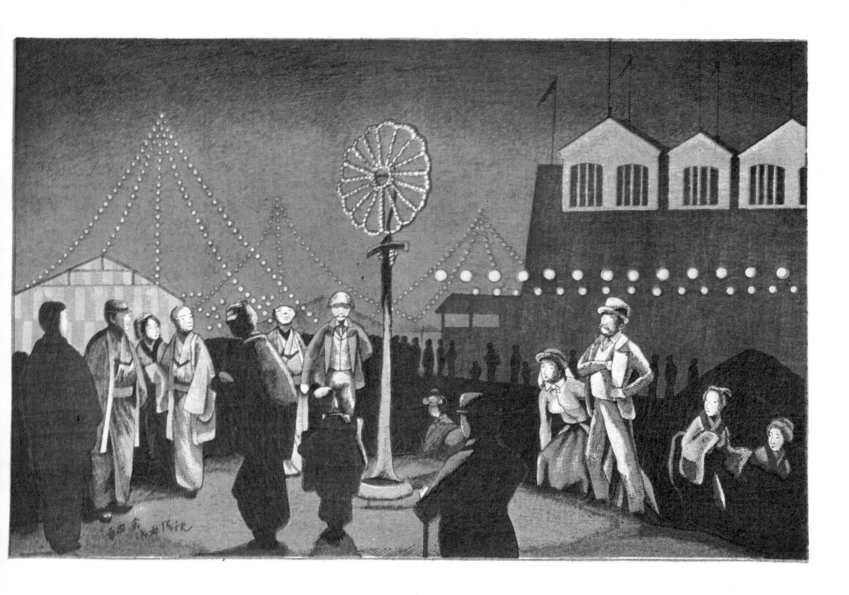

Kiyochika *Illumination*
Oban, Nishiki-e, 24.9 × 37.1 cm
Publisher: Matsuki Heikichi. Date: 1877

A coal-gas hall at the Industrial Exhibition held in the 10th year of Meiji (1877). One of Kiyochika's masterpieces in the initial period. He developed the techniques of traditional woodcut prints and also created his own. A decorative illumination by gas light.

Kiyochika *Field-Guns of Our Army (Waga Yasenhohei Kurenjo Bakuei Kogeki)*
Oban, Nishiki-e, Triptych, left: 37.3 × 25.1 cm, centre: 37.5 × 24.8 cm, right: 37.5 × 25 cm
Publisher: Inoue Kichijiro. Date: 1894

A scene in the Sino-Japanese War, Japanese army cannonading the headquarters of the Kiulieu Cheng fortress. Flashes of shells in the stormy rain are expressed vividly.

擊攻營幕城連九兵砲戰野我

Kiyochika *Field-Guns of Our Army*
Central panel of the triptych.

Kiyochika *View of Mount Fuji from Lake Suruga
(Surugako Nichibotsu no Fuji)*
Oban, Nishiki-e, Diptych, left: 36.6 × 24.7 cm, right:
36.5 × 24.7 cm
Publisher: Matsumoto Heikichi. Date: 1880
Takahashi Collection, Japan

The hunter has a matchlock in his hands. His boy's hairstyle is old-fashioned, though the expression of the picture is something like a copper-plate print, a novelty of the day.

Yasuji *Wool Mill at Senju (Senju Rasha Seizojyo)*
Koban, Nishiki-e, 11.7×17.3 cm
Publisher: Fukuda Kumajiro. Date: c. 1881
Sakei Collection, Japan

A newly-built woollen factory in the suburbs.

十住ラシヤ製造場

Yasuji *Night View at Nihonbashi (Nihonbashi Yakei)*
Koban, Nishiki-e, 11.7×17.3 cm
Publisher: Fukuda Kumajiro. Date: c. 1881
Sakai Collection, Japan

A night view of the Nihonbashi bridge.

日本橋夜景

Yasuji *Kurama-e Street at Asakusa (Asakusa Kuramae-dori)*
Koban, Nishiki-e, 11.7×16.8 cm
Publisher: Fukuda Kumajiro. Date: c. 1881
Sakai Collection, Japan

A rice-dealers' street with horse-drawn trams. These three scenes were used as picture-postcards for the new showplaces of Tokyo.

浅草蔵前通

362

Yasuji Above: *Scene at the Riverside of Kakigaracho (Kakigaracho Kawagishi no Zu)*
Oban, Nishiki-e, 24 × 35.9 cm
Publisher: Matsuki Heikichi. Date: 1881

A lyrical view of the riverside with floating clouds in the evening sky. A paddle-wheeler floating on the river. This is one of Yasuji's masterpieces.

Ryuson Below: *View at Yatsuyama (Yatsuyama no Kei*
Oban, Nishiki-e, 23.6 × 35.3 cm
Publisher: Arai Hachizo. Date: 1880

A mysterious landscape. Yatsuyama means literally "eight hills".

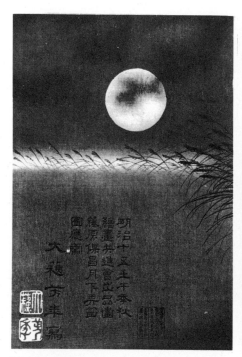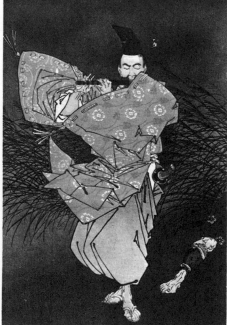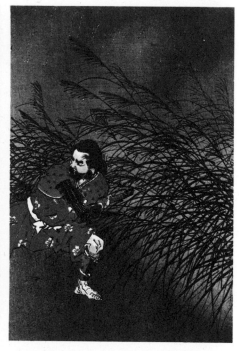

Yoshitoshi *Fujiwara Yasumasa Playing the Flute under the Moonlight (Fujiwara Yasumasa Gekka Roteki Zu)*
Oban, Nishiki-e, Triptych, 35 × 23.3 cm each
Publisher: Akiyama Buemon. Date: 1883. Takahashi Collection, Japan

A subject taken from the old story in *Uji-shui-i Monogatari.* A master flute-player overwhelms a robber by his playing.

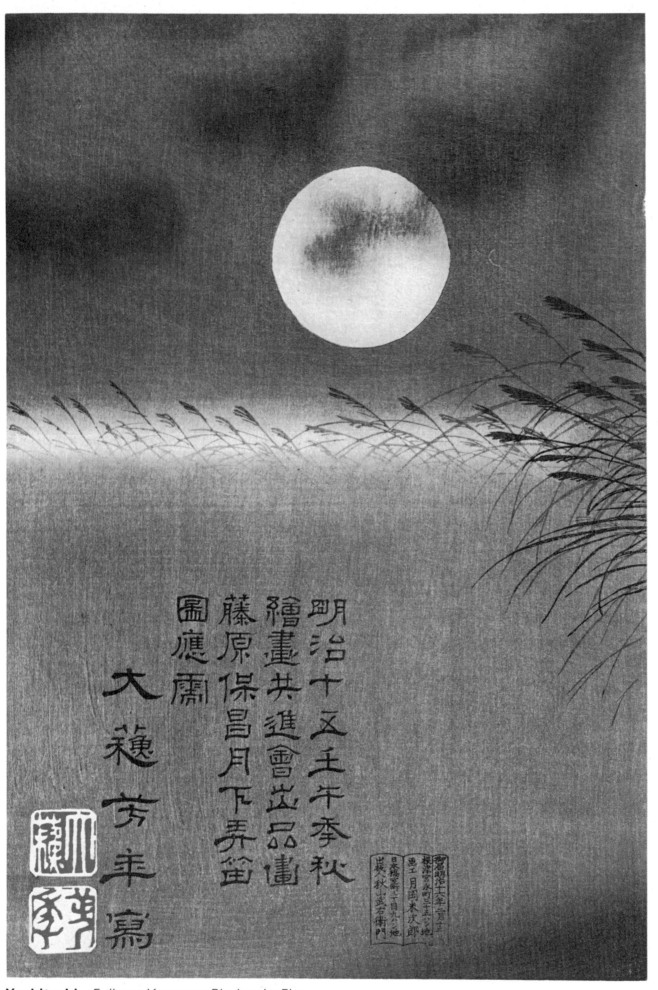

Yoshitoshi *Fujiwara Yasumasa Playing the Flute under the Moonlight*
Left panel of the triptych.

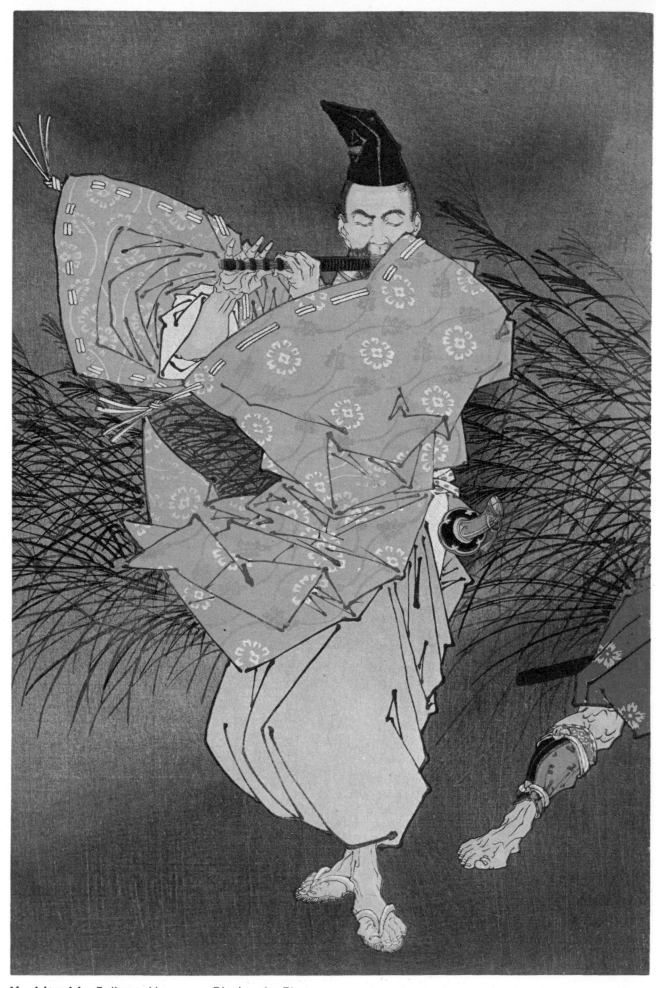

Yoshitoshi *Fujiwara Yasumasa Playing the Flute
under the Moonlight*
Central panel of the triptych.

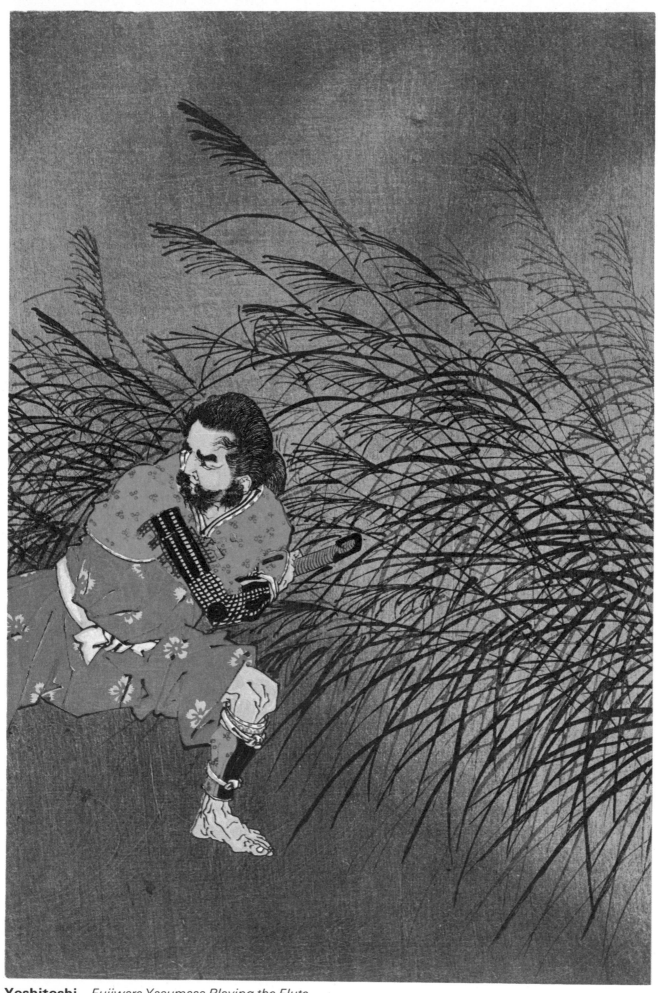

Yoshitoshi *Fujiwara Yasumasa Playing the Flute*
under the Moonlight
Right panel of the triptych.

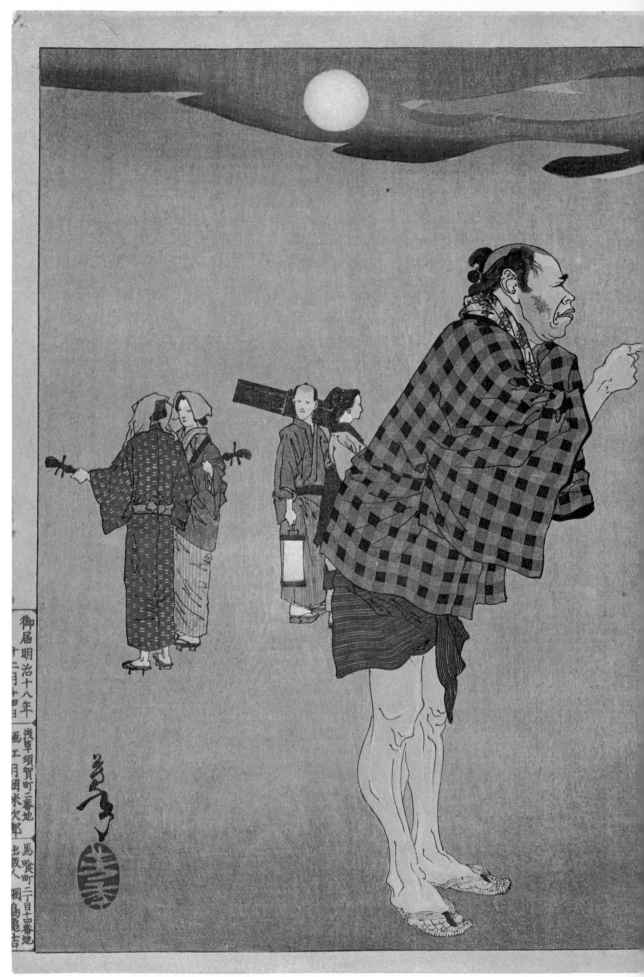

Yoshitoshi *Story of Otomi and Yosaburo*, from the series *Newly Selected Nishiki-e in Tokyo (Shinsen Azuma Nishiki-e)*
Oban, Nishiki-e, Diptych, left: 35.9 × 23.9 cm, right: 35.8 × 23.9 cm
Publisher: Tsunashima Kamekichi. Date: 1885
Takahashi Collection, Japan

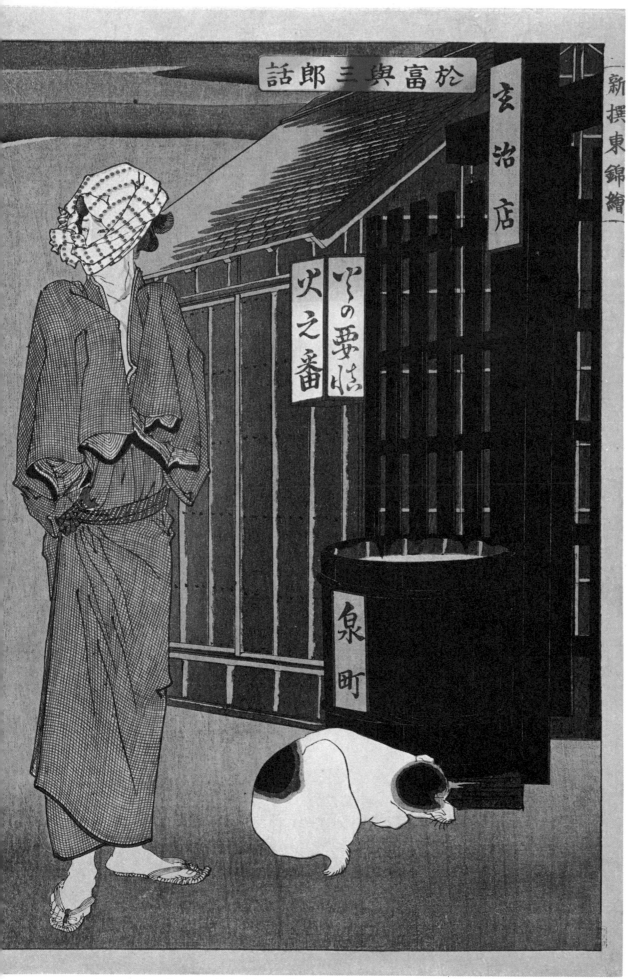

A scene in a famous *Kabuki* play. Two hooligans conferring with each other on how to extort money from the mistress of a rich man. The couple with *samisen* in the background are strolling musicians.

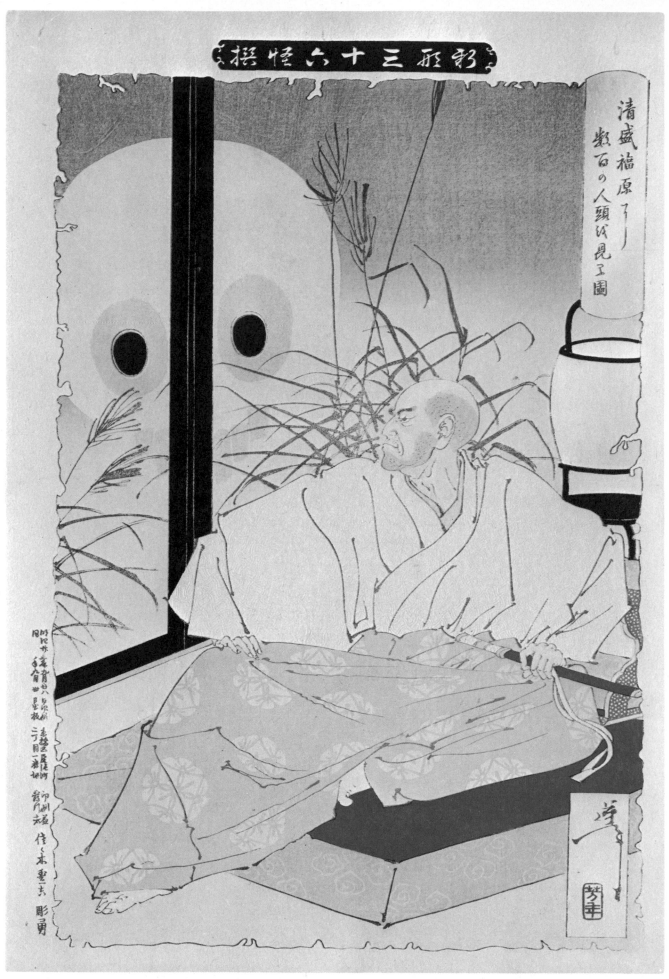

Yoshitoshi *Kiyomori Confronting Hundreds of Skulls at His Home in Fukuhara,* from the series *Thirty-six New Ghost Stories (Shinkei Sanjuroku Kaisen)* Oban, Nishiki-e, 37.2 × 25.4 cm
Publisher: Sasaki Toyokichi. Date: 1890. Takahashi Collection, Japan

A hallucination of the Prime Minister Kiyomori in ancient Japan who was suffering from a fever. A well-known episode in history. A full-moon in autumn is painted on the sliding doors in the background.

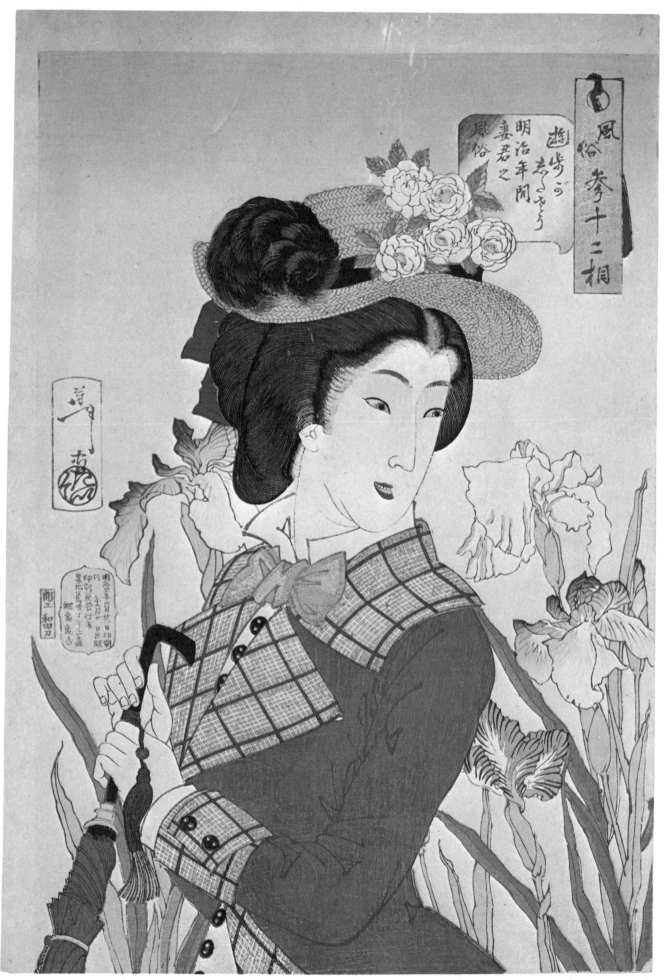

Yoshitoshi *Married Woman Strolling*, from the series *Thirty-two Contemporary Scenes (Fuzoku Sanjuni So)*
Oban, Nishiki-e, 38 × 25.8 cm
Publisher: Tsunashima Kamekichi. Date: 1888

A Japanese married woman in the Western dress of the new fashion in the Meiji era, enjoying the sight of beautiful irises.

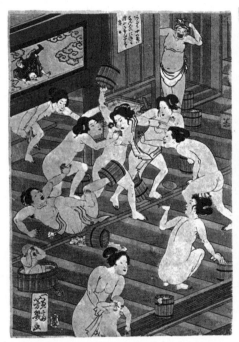 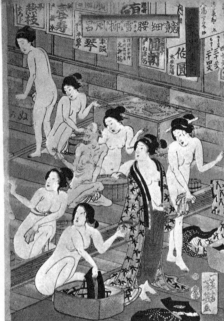 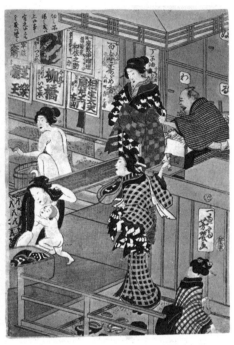

Yoshi-iku *Women in a Public Bath*, from the series *Various Aspects in the Daily Life of Common People (Imayo Nenchughoji no Uchi)*
Oban, Nishiki-e, Triptych, left: 36.4 × 25 cm, centre: 36.6 × 25 cm, right: 36.3 × 24.9 cm
Publisher: Hiroka-ya Kosuke. Date: 1868

A fight between women in a bathhouse, while others look on.

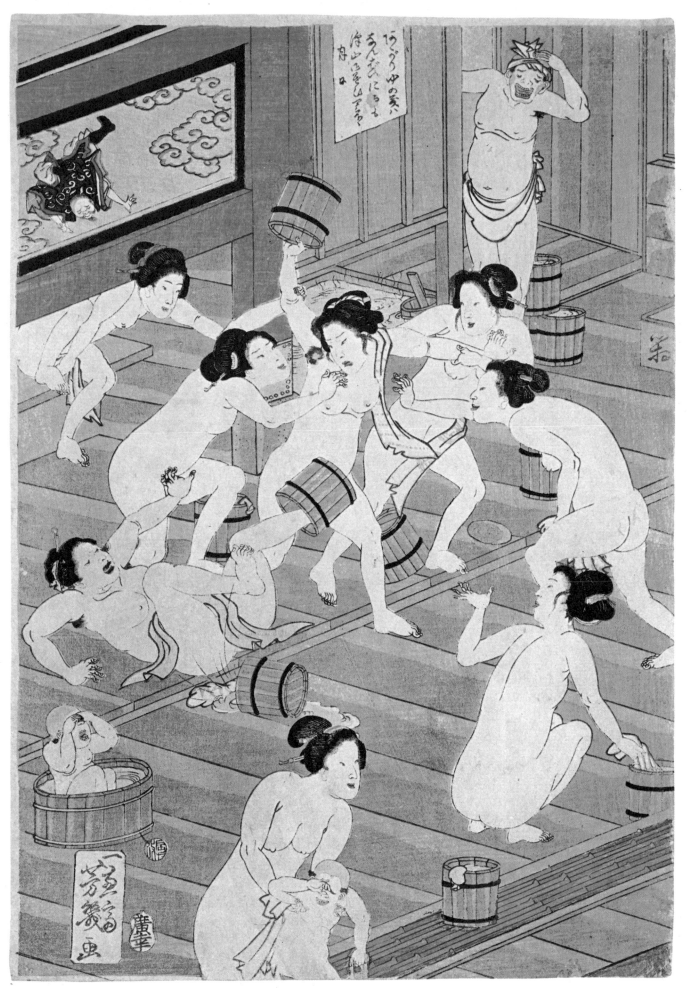

Yoshi-Iku *Women in a Public Bath*
Left panel of the triptych.

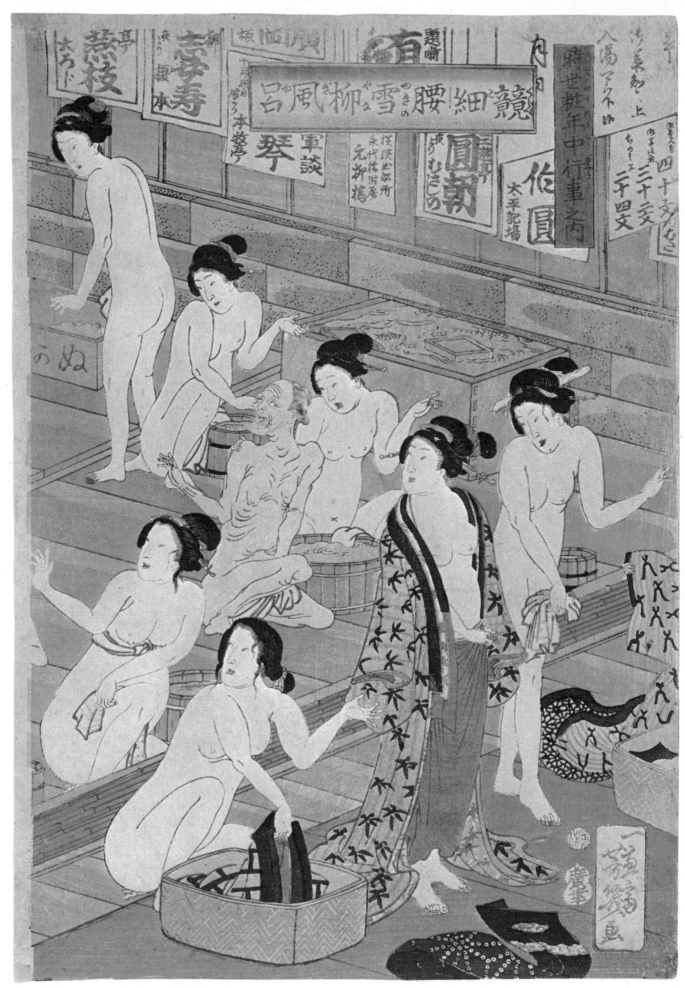

Yoshi-Iku *Women in a Public Bath*
Central panel of the triptych.

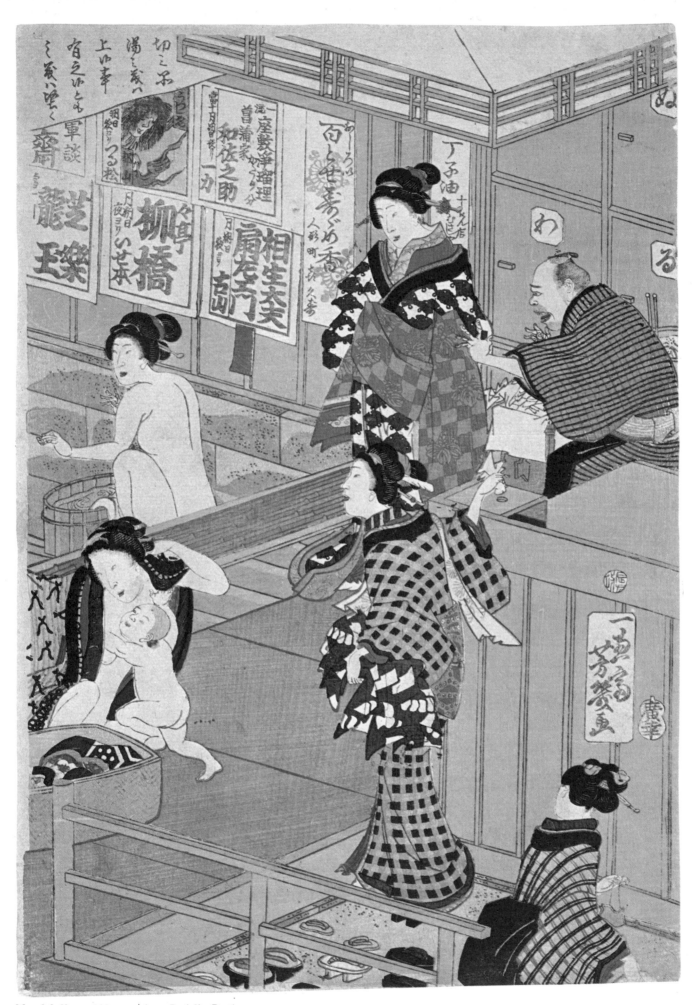

Yoshi-Iku *Women in a Public Bath*
Right panel of the triptych.

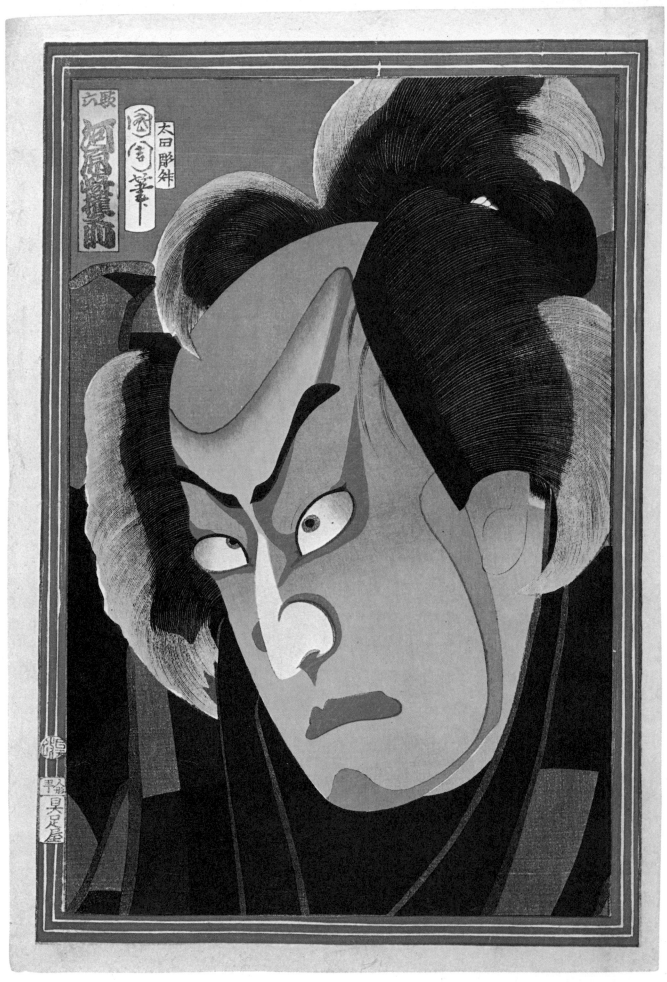

Kunichika *The Actor Kawarazaki Gon-nosuke as Daroku*
Oban, Nishiki-e, 37.5 × 25.1 cm

Publisher: Gusokuya Kahei. Date: 1869. Sakai
Collection, Japan

A series of *o-kubie* (close-up portraits) of *Kabuki*
actors. An excellent technique is employed to express
valour by accentuating the make-up round the eyes
and the hair.

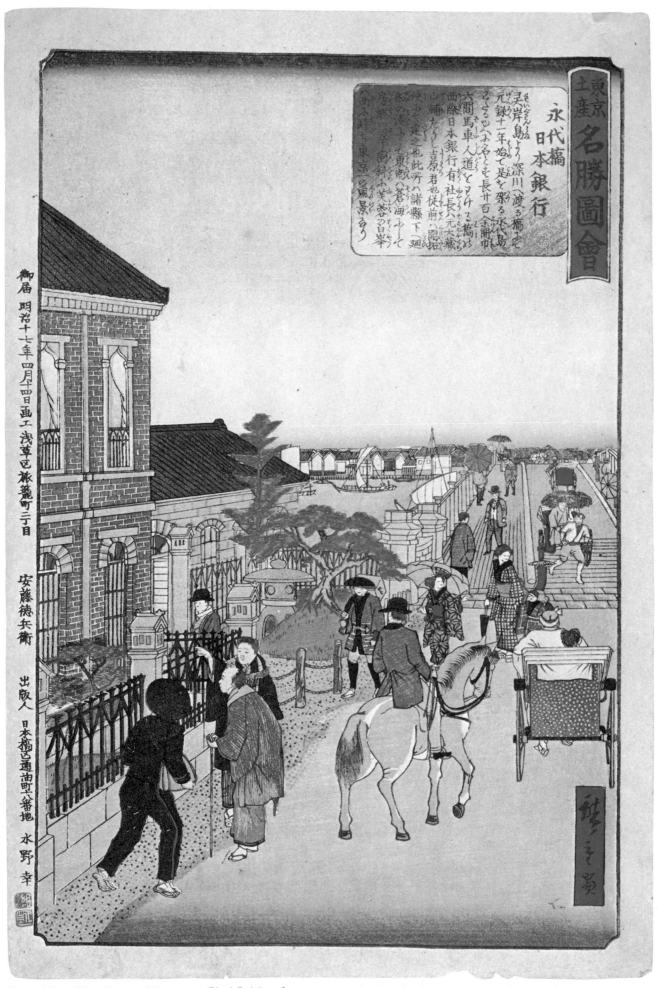

Hiroshige III *Bank of Japan at Eitai Bridge,* from the series *Album of Celebrated Places as a Souvenir from Tokyo (Tokyo Miyage Meisho Zue)*
Oban, Nishiki-e, 36.7 × 24.4 cm
Publisher: Mizuno Yuki. Date: 1884

The Bank of Japan, newly built in brick, with passers-by in foreign style among the more traditionally dressed.

377

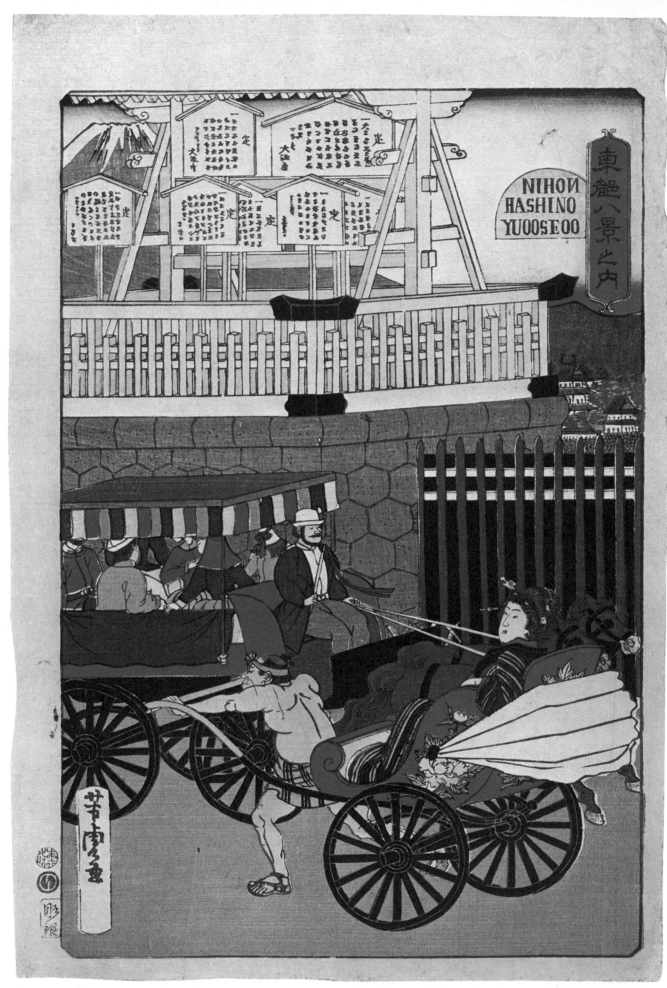

Yoshitora *People Going Back and Forth at Nihonbashi,* from the series *Eight Views of the Eastern Capital (Toto Hakkei)*
Oban, Nishiki-e, 36.9 × 24.9 cm
Publisher: Sawamuraya Seikichi. Date: 1871. Sakai Collection, Japan

A notice-shed at the foot of Nihonbashi bridge. A horse-driven bus and a rickshaw pass each other. A very modern scene of the time. The title is written in *Romaji.*

378

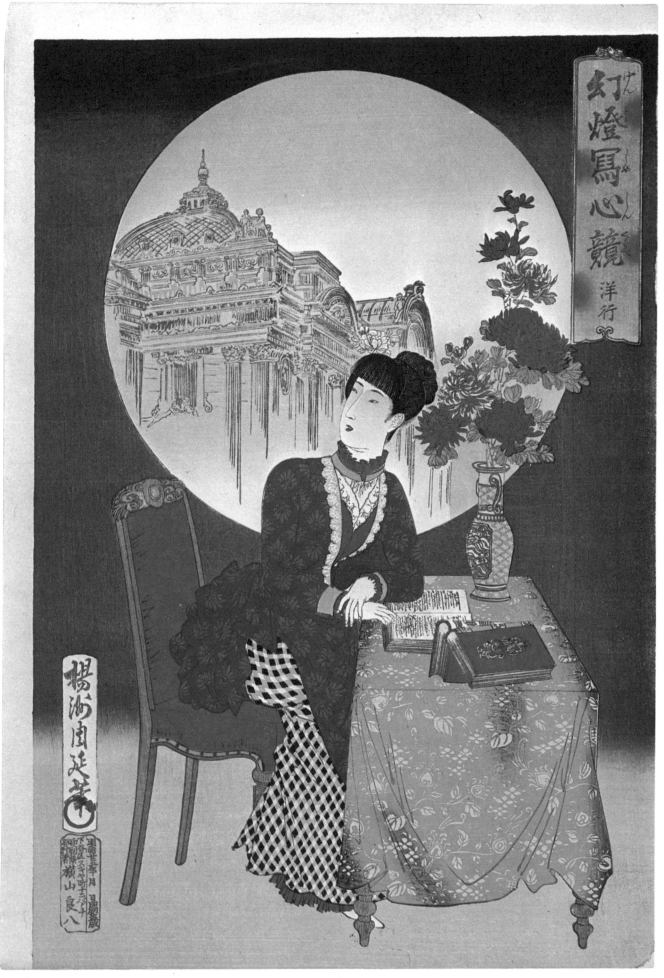

Chikanobu *Travelling Abroad*, from the series *Selected Scenery by Magic Lantern Projection (Gentoshashin Kurabe)*
Oban, Nishiki-e, 36.9 × 25 cm
Publisher: Yokoyama Ryohachi. Date: 1890. Sakai Collection, Japan

A lady is explaining a foreign scene projected in the background. The film was brought back home as a souvenir of her trip abroad. Some foreign books are on the desk.

379

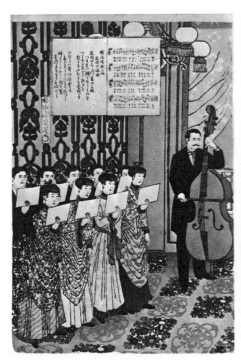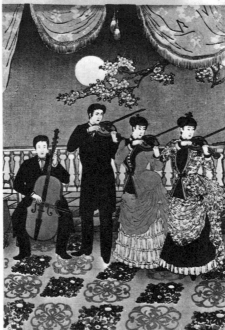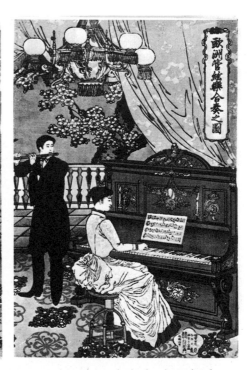

Chikanobu *Concert of European Orchestra (Oshu Kangengaku Gasso no Zu)*
Oban, Nishiki-e, Triptych, left: 37.3 × 24.3 cm, centre: 37.3 × 24.4 cm, right: 37.3 × 24.3 cm
Publisher: Egawa Hachizaemon. Date: 1889

A scene when women players took their place in the orchestra for the first time in Japan. They were the first alumnae from the Tokyo Music School. They were mostly from distinguished families. Cherry blossoms are seen from the veranda.

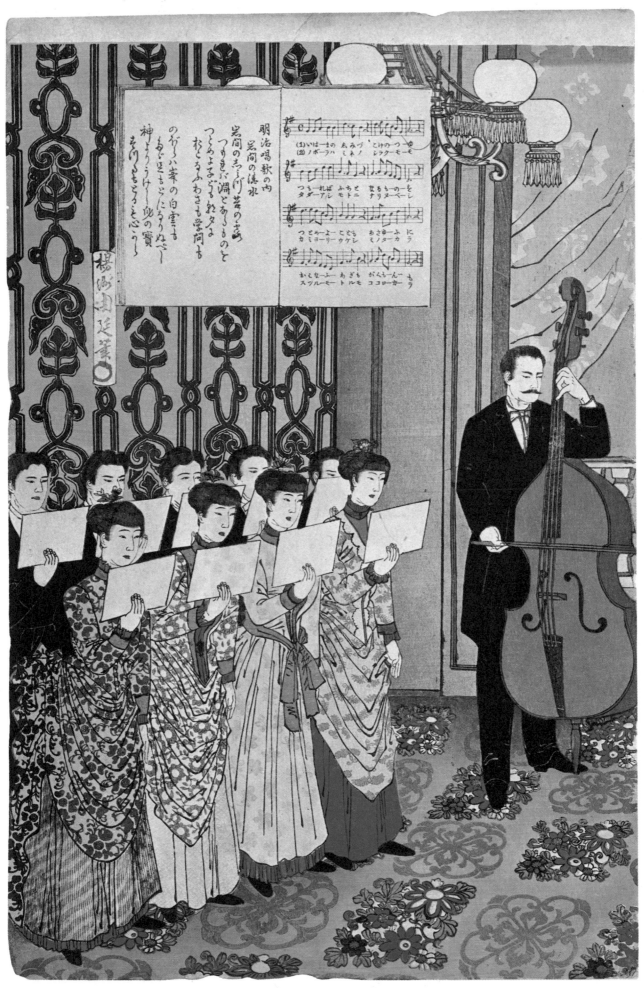

Chikanobu *Concert of European Orchestra*
Left panel of the triptych.

Chikanobu *Concert of European Orchestra*
Central panel of the triptych.

Chikanobu *Concert of European Orchestra*
Right panel of the triptych.

Glossary

Aiban
Size of a print (approximately 31 × 22 cm) between *chuban* (medium) and *oban* (large)

Aizuri
Print in which indigo is mainly used

Aragoto
Stylized and emphatic recitation used in the *Kabuki* theatre of the Edo period to exalt the superhuman force

Asanoha
Hemp leaf

Awase
Game, contest

Ayame
Siberian iris

Beni
Pink

Beni-e
Black print on which a pale pink is spread by hand, while other coloured parts are gone over with lacquer or glue to make them shiny

Beni-girai
Delicate pink; in these prints purple is used with yellow and grey

Benizuri-e
Paintings printed in bi- or tri-chrome with a pale pink

Bijin
Beauty, beautiful woman

Bijin-ga
Picture of a beautiful woman, a genre typical of *ukiyo-e*

Binzashi
Hair pins

Biwa
Musical instrument; a kind of mandolin with four strings

Chonin
(Literally: citizen) new town classes, the middle classes, that is to say merchants and artisans. It denotes the urban middle class which developed during the Tokugawa or Edo period (1603-1868)

Chuban
Medium-sized print (approximately 25 × 17 cm)

Chutanzakuban
Medium-sized *tanzaku*

Daimyo
Feudal lord

Ebusshi
Painters of religious paintings

Egoyomi
Small calendar prints

Ehon
Illustrated books

Enoki
Nettle plant of Chinese origin

Eshi
Painter

Furisode
Jacket with extremely long sleeves

Futon
Padded quilt

Geta
Wooden clogs raised by two small bars, also made of wood. These are parallel, with about eight to ten centimetres between them, and are placed across the clog, in the middle

Gofun
White pigment of chalk or pulverized shells

Goh
Pseudonym; assumed or stage name

Habahiro-hashira-e
Wide pillar painting; a long and narrow print to hang on a pillar

Hagi
Meadow with Japanese clover

Hanamichi
Passage-way (inside the stage)

Hanga-ehon
Books (*hon*) which are illustrated (*e*) by paintings (*ga*) that are xylographic (*han*)

Hanmoto
Publisher

Harimaze-e
Paintings obtained by fragments of pasted paper (collage)

Harugoma
Dance of the *Kabuki* theatre, performed by holding the head of a toy horse in one's hand

Hashira-e
"Pillar" print; long and narrow print, with variable dimensions (approximately 75 × 12 cm) to hang on a pillar

Hashiraeban
Print with the pillar format; size (*ban*) of painting (*e*) which is narrow and long, like a pillar (*hashira*)

Higa
Erotic picture

Hikite-Jaya
House of the "initiation of eroticism"

Hon
Book

Hoso-ban
Narrow print (approximately 32 × 22 cm)

Hoso-ban sanpuku-tsui
Narrow triptych

Ichimai-e
Illustrated prints on single sheets of paper

Ise monogatari
The Tales of Ise, Japanese literary work attributed to Ariwa-no-Narihira (825-880)

Ishizurie-e
Paintings executed on silk

Jidaimon
A kind of theatrical performance based on historical subjects

Joruri
Japanese dramatic ballad

Kabuki
Popular classical theatre, which owed its greatest period of development to the growth of the middle classes during the eighteenth century

Kacho-ga
Paintings and prints of flowers and birds

Kakemono
(From *kake*: hanging; and *mono*: object.) Rectangular painting which is hung vertically on the wall

Kamuro
Apprentice courtesan

Kan
3 × 75 Kg

Kanjo-bugyo
Minister of the Treasury

Kannon
Goddess of mercy (of Mahayanic Buddhism)

Karazuri-e
Print obtained by means of embossing

Kawaramono
Beggar

Kento
Technique of blind-printing, invented in the eighteenth century

Ki
Art, talent

Kiboyoshi
Popular novels

Kimekomi
Method employed to create a three-dimensional effect

Kimono
Ki (to dress) *mono* (object): open garment like a dressing-gown

Kirazuri
Mica printing technique, which consists in applying mica powder

on the paper to obtain a silvery
background effect

Kizuri
Engravings with a yellow
background

Koban
Small print (approximately
12×9 cm)

Kotatsu
Foot warmer

Koto
Musical instrument with strings,
such as the harp or the lyre

Kyoka
Humorous thirty-one syllable
verses

Manzai
Strolling comic dancer

Mikaeri bijin
Beautiful woman looking back

Moji
Rough fabric of twisted hemp yarn

Monogatari
Novel

Musha
Warrior

Musha-e
Paintings of historically important
warriors

Nagasaki-e
Illustrations from Nagasaki, with
foreigners as their subjects

Nenbutsu Odori
Buddhist religious dance to invoke
the protection of Amitabha

Nezumi-Tsubushi
Engravings with a yellow and grey
background

Nigao-e
Likenesses

Nikawa
Brilliant and viscous animal glue

Nishiki-e
"Brocade prints" (polychrome);
technique of polychrome prints

Noh
Dramatic performance with a
religious content

Oban
Rectangular print (approximately
37×25 cm)

Obi
Kimono sash

Okubi-e
(Literally: large heads) close-up
portraits

Onna-e
Pictures of women

Onnagata
Kabuki actors who took the part of
female nudes

Oshi-egata
Relief painting

Otanzakuban
Large *tanzaku*

Rakan
The followers of Buddha (500)
who conquered Nirvana

Rendai
Palanquin carried on the shoulders

Ro
Transparent silk

Romaji
(Literally: Latin, Roman letters.)
The Latin alphabet used to
transliterate Japanese words

Sake
Typical Japanese drink derived
from fermented rice

Samisen
Musical instrument; a kind of
guitar with three strings

Samurai
Provincial military aristocracy,
which characterizes the Japanese
feudal system

Sansui
(Literally: mountains and waters)
landscape

Sansui-ga
Landscape painting

Sembei
(Literally: rice-crusher)
Habit of bestowing a spare or
professional name on an actor

Sensu
Folding fan

Sewamono
Type of performance based on
daily life

Shaku
Japanese measure of one foot
(30.03 cm)

Shogun
Military leaders who ruled the
government of Japan between
1186 and 1868

Shoji
Screen

Shosagoto
Danced performance

Shunga
(Literally: paintings of spring)
erotic prints

Sugizuri-e
Black-ink prints

Sumi
Ink stick

Sumizuri-e
Black-ink prints, obtained by a
single mould, and hand-coloured

Sumo
Japanese all-in wrestling

Sun
Japanese thumb measure
corresponding to roughly 3.04 cm

Surimono
(Literally: printed things) small

prints, rectangular or square,
commissioned for gifts,
announcements, greetings

Suzuri
Hollowed out slab for ink

Tamigata-e
Illustrations characteristic of the
Osaka district

Tan
Lead-based orange pigment

Tan-e
Print coloured by hand with *tan*
and other colours (green and
yellow)

Tanzaku
Strip of paper on which verses
were written

Tayu
Very young and beautiful prostitute

Torii
Entrance to a Shinto sanctuary

Tsuzumi
Hand drum

Uchiwa
Fan

Uchiwa-e
Fan painting

Uki-e
Perspective print

Ukiyo
Floating world

Ukiyo-e
Prints, paintings and pictures of
the "floating world". Denotes the
pictorial and graphic production of
the Edo period

Urushi-e
Prints painted with lacquers or
glues to emphasize the black or red
colours

Uta
Song, poem

Ya
Shop

Yakusha-e
Portraits of actors

Yamoto
Japan's ancient name. Originally it
indicated the region which was the
birthplace of Japanese culture

Yokohama-e
Illustrations from Yokohama, with
foreigners as their subjects

Yujo
Courtesans

Yukata
Cotton bath robe

Index of names and works

Bibliography

W. von Seidlitz, *Geschichte des Japanischen Farbenholzschnittes*, Dresden 1897

E. Strange, *The Japanese Illustration: A History and Description of the Arts of Pictorial Woodcutting and Colour Printing in Japan*, London 1897

« Die Insel - Monatschrift mit Buchschmuck und Ill. » vols. 1-3, Ed. O. Bierbaum, A. Heymel, R. Schröder, Berlin 1899-1902

M.S. Bing (editor), *Dessins, estampes, livres illustrés du Japon réunis par T. Hayashi*, Paris 1902

M.S. Bing (editor), *Collection Ch. Gillot. Estampes Japonaises et livres illustrés*, Paris 1904

J. Hillier, *Sharaku*, Munich 1910

J. Hillier, *Suzuki Harunobu*, Munich-Leipzig 1910

E. Strange, *The Colour Prints of Japan*, London 1910

W. von Seidlitz, *Les Estampes Japonaises*, Paris 1911

J. Kurth, *Der Japanische Holzschnitt*, Munich 1911

E. Strange, *Japanese Colour Prints*, London 1913

F. Succo, *Utagawa Toyokuni und Siene Zeit*, 2 vols., Munich 1913-14

A.D. Ficke, *Chats on Japanese Prints*, London-New York 1915

L. Binyon, *Catalogue of the Japanese and Chinese Woodcuts in the British Museum*, London 1916

A.D. Ficke, *Rare and Valuable Japanese Prints*, New York 1920

B. Stewart, *Subjects Portrayed in Japanese Colour Prints*, London-New York 1922

A.D. Ficke, *The Japanese Print Collection of A.D. Ficke*, New York 1925

J. Kurth, *Masterpieces of Japanese Woodcuts, from Moronobu to Hiroshige*, New York 1925

J. Kurth, *Die Geschichte des Japanischen Holzschnitts*, 3 vols., Leipzig 1925-29

Hirano Chile, *Kiyonaga - A study of his Life and Works*, 2 vols., Cambridge 1939

H.G. Henderson-Luis V. Ledoux, *The Surviving Works of Sharaku*, New York 1939

J. Hillier, *Japanese Masters of the Colour Print*, London 1954

J.A. Michener, *The Floating World: The Story of Japanese Prints*, New York 1954

J. Hillier, *Hokusai-Paintings, Drawings and Woodcuts*, London 1955

H.C. Gunsaulus, *The Clarence Buckingham Collection of Japanese Prints, The Primitives*, vol. 1, Chicago 1955

E. Earle, *The Kabuki Theatre*, London 1956

Hajek-Forman, *Harunobu*, Prague 1957

Hajek-Forman, *Der Frühe Japanische Holzchnitt*, Prague 1957

J.A. Michener, *Japanese Prints from the Early Masters to the Modern*, Rutland, Vt.-Tokyo 1959

L. Binyon-J.J. O'Brien-Sexton, *Japanese Colour Prints*, London 1960

J. Hillier, *The Japanese Print: A New Approach*, London-Tokyo 1960

J. Hillier, *Utamaro*, London 1961

D.B. Waterhouse, *Utamaro, Colour Prints and Paintings*, London 1962

R. Lane, *Masters of the Japanese Print*, London 1962

B. Smith, *Japan, History in Art*, London 1964

D.B. Waterhouse, *Harunobu and His Age: The Development of Colour Printing in Japan*, London 1964

M.O. Gentles, *The Clarence Buckingham Collection of Japanese Prints*, Chicago 1965

I. Kondo, *Hokusai's Thirty Six Views of Mount Fuji*, Tokyo 1966

Muneshige Narazaki, *The Japanese Print: Its Evolution and Essence*, Tokyo-Palo Alto 1966

F. Maraini, *Pitture giapponesi Ukiyo-e del primo periodo*, Florence 1967

H.P. Stern, *Master Prints of Japan*, New York 1969

J. Hillier, *Gale catalogue of Japanese Paintings and Prints*, 2 vols., London 1970

M. Bonicatti *Ukiyo-e. Mostra di stampe giapponesi a colori dal XVII al XIX secolo*, Istituto Giapponese di Cultura, Rome 1971

Weltkulturen und moderne Kunst - Ostasien und Südostasien, catalogue, Munich 1972

M. Bonicatti, *Hokusai-Hiroshige. Stampe paesistiche giapponesi*, Rome 1974

G. Frabetti-E. Kondo, *Hokusai-Hiroshige, Paesaggi*, Genoa 1974

M.O. Gentles, *Masters of the Japanese Print, Moronobu to Utamaro*, New York 1974

L. Hajek, *Japanese Graphic Art*, Prague 1976

G.C. Calza, *Le stampe del mondo fluttuante*, Milan 1976

G. Frabetti-E. Kondo, *Hiroshige: Immagini della natura*, Genoa 1976

K.J. Brandt, *Hosoda Eishi, 1756-1829. Der Japanische Maler und Holzschnittmeister und Seine Schüler*, Cologne 1977

G.C. Calza, *Vedute celebri di Tokyo*, Milan 1977

The quotations which appear in the Neuer-Libertson text have been taken from the following works:
Charles MacFarlane: *Account of Japan*, 8 vols., London 1852
Engelbert Kämpfer: *The History of Japan*, 3 vols., Glasgow 1906
George Sansom: *A History of Japan: 1615-1867*, London 1964

Black and white photographs kindly supplied by G. Costa, Milan; M. Saporetti, Milan; Shogakukuan Publishing Co., Ltd., Tokyo; The Zauho Press, Tokyo.

The editors wish to thank Marinella Chiorino and Takashige Yoshida for their kind collaboration.